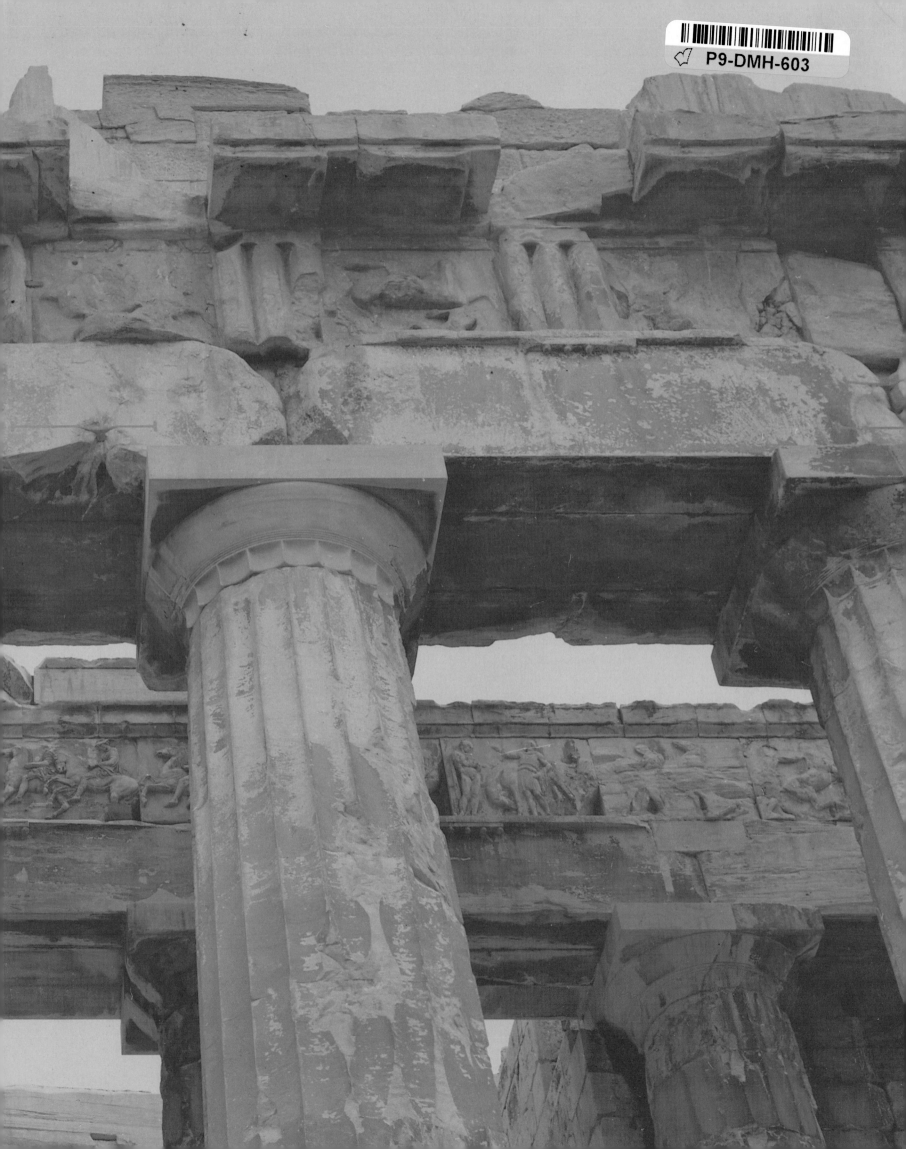

THE PARTHENON AND
ITS SCULPTURES

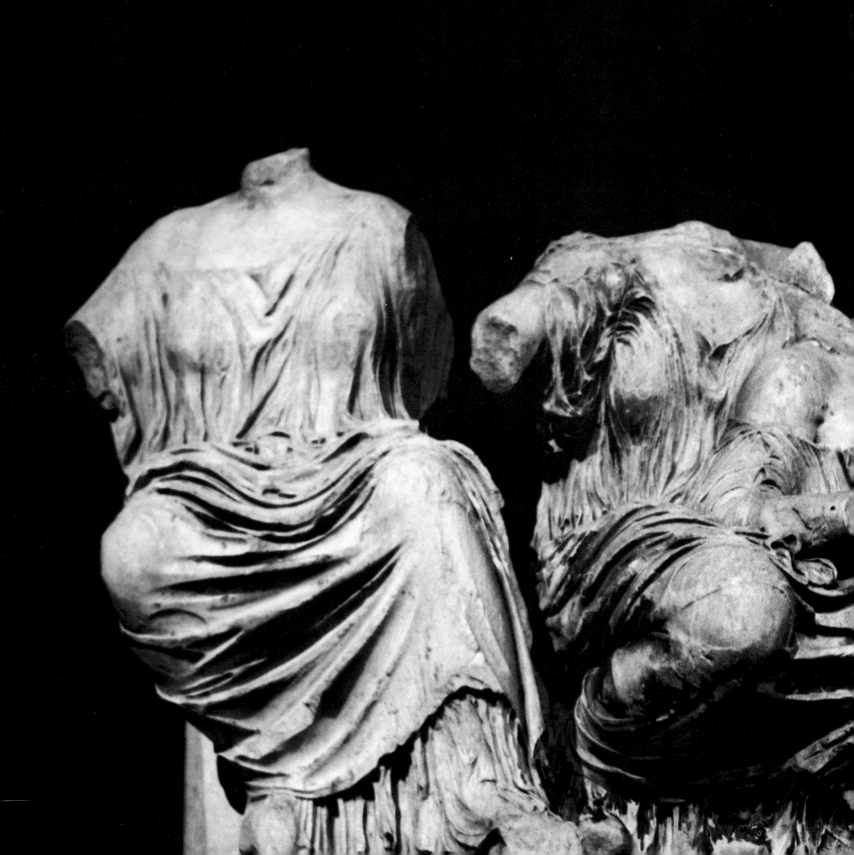

JOHN BOARDMAN

THE PARTHENON AND ITS SCULPTURES

PHOTOGRAPHS BY DAVID FINN

UNIVERSITY OF TEXAS PRESS

AUSTIN

International Standard Book Number 0-292-76498-7
Library of Congress Catalog Card Number 85-50467

First University of Texas Press Edition, 1985
First published by Thames and Hudson Ltd, London

Publication of this book was assisted by grants from
George and Virginia Ablah of New York and from
Mrs. H. Lutcher Brown of San Antonio, Texas.

End papers: West front of the Parthenon
Title pages: East Pediment: Hestia, Dione and Aphrodite
(figures K, L, M)

CONTENTS

PREFACE

TIME and chance have determined that the Parthenon and its sculptures are the most fully known, if least well understood, of all the monuments of Classical antiquity that have survived. Our view of Classical Greece is conditioned by them, unless we think to prize its literature more than all other manifestations of the culture that produced it. The architecture and the sculpture are the best, of their type, that we have, and very probably the best that were created, but this is art history, and a descriptive account of them would be a mere formality which easily disguises what more there is to understand. There are several different ways of approaching such fuller understanding for any observer who has not the time or taste for the minutiae of scholarship. In a way the story of the Parthenon begins with the arrival of Greeks in Greece, with the Greek land itself. It embraces the beginnings of organized religious life in Greece and of Greek religion (not the same thing); the absorption into Greek life and thought of foreign ideas and arts; the history of architecture and sculpture; the development of the narrative and symbolic functions of myth; the physical, political, economic, social and military history of Athens itself.

Some aspects of all these subjects are touched upon in this presentation of the Parthenon and its sculptures, but the method adopted is not altogether conventional. Our evidence is so incomplete, and we stand at so great a remove in time and temperament from Athens of twenty-five centuries ago, that an honest account has to be hedged about with caution, alternatives explored, doubts expressed, ignorance un-ashamedly paraded.

Our method here has been, *first*, to let the building and its sculptures speak for themselves through photographs and the sympathetic imagination of the photographer's eyes. *Secondly*, to present a narrative account not only of the Parthenon's final appearance, its planning and construction, but also of the fifty years which preceded the first work upon the building, since within these years we may hope to uncover much that goes to explain its purpose and its meaning for the citizens of Athens (surely of somewhat greater moment than its meaning to us). In this 'story' the difficulties, doubts and gaps in our evidence are quietly avoided or filled, so that the reader not professionally involved in such problems need not be detained or deterred by them (and

the professional who *is* will recognize where the surgery lies). But, since this perhaps makes too easy what is essentially a complex and important issue, *thirdly*, a review is offered of the nature of our evidence, of what it tells us, of what we have to guess, of where the author has made more concessions to his own views of Classical Greece than always to those of 'current scholarly opinion' (in so far as this can be identified or presents any sort of consensus). So this is no less a personal book than any other on such a distant and emotive topic, but the reader will not find it difficult to make such corrections as he wishes to an account of the Parthenon and its sculptures presented through the eyes of one photographer, the pen of one writer.

In the first part of the book the narrative is disposed round five celebrations of the Great Panathenaic festival, which plays an important part in the Parthenon's history, figures in its sculptural decoration, and was the occasion of its dedication. The *celebration* in what we call 490 BC, less than six weeks before the Athenians defeated the Persians on the plain at Marathon, introduces those characteristics of the festival which help explain the Parthenon frieze, in a historical setting which will also be found to explain the purpose of the building. The festival of 478 BC, after the *destruction* of Athens by the Persians, took place with Athens and the Greeks ultimately triumphant and devoted now, through the Athenian League, to the expulsion of the barbarians from all Greek lands. By 450 BC that aim had been achieved and Athens was turning her attention and resources to the rebuilding of her city and the *conception* of a new temple for her city goddess, which would honour both her and her city's achievement. Eight years later, in 442 BC, the workshops and masons' yards were busy in the *creation* of the subtlest of all Greek buildings and the carving of sculptures which would typify the essence of the Classical ideal in its depiction of the human and the divine. Finally, in 438 BC, comes the *completion* and dedication of the building, and a description which demonstrates how Athens' role at Marathon and in the defeat of the Persians, and the conduct of her Great Panathenaic festival, can explain the symbolism and narrative of the great sculptures.

In the concluding part of the book the survey of the evidence is divided between the principal topics which lie behind the preceding narrative – historical, archaeological, religious; together with an account of the building's later chequered history, how we have come to learn about it and how it might be assessed in the history of art, ancient and modern.

8

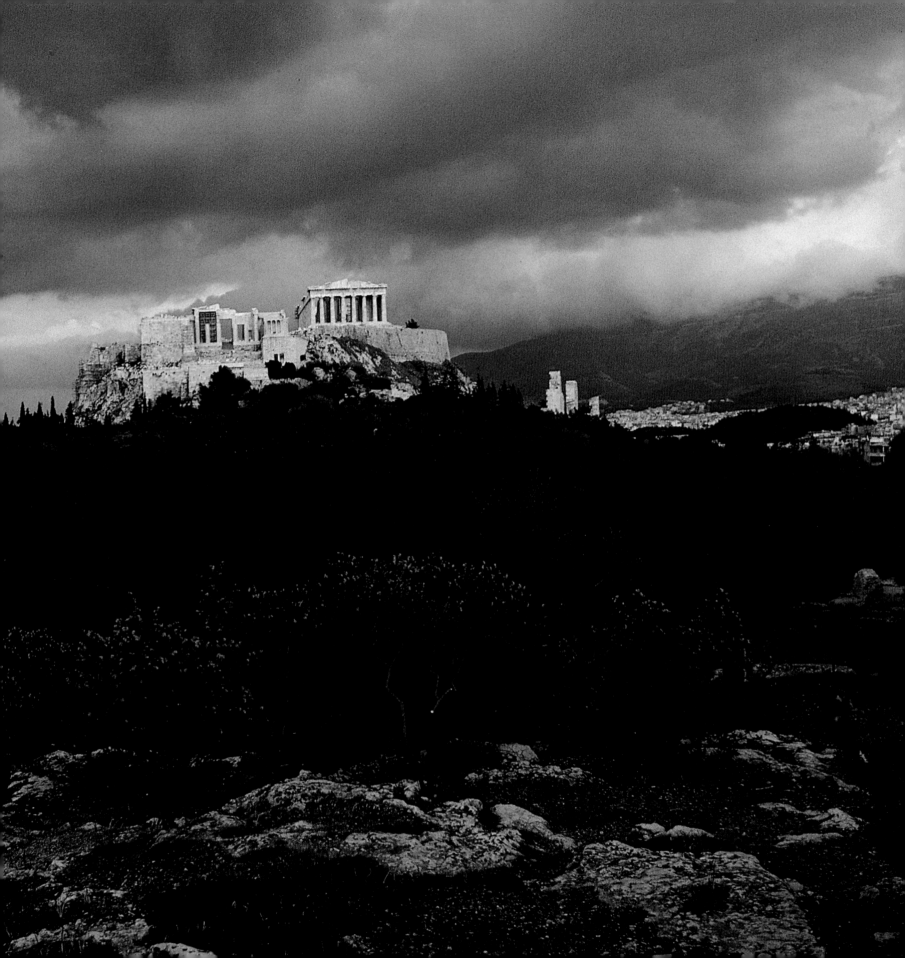

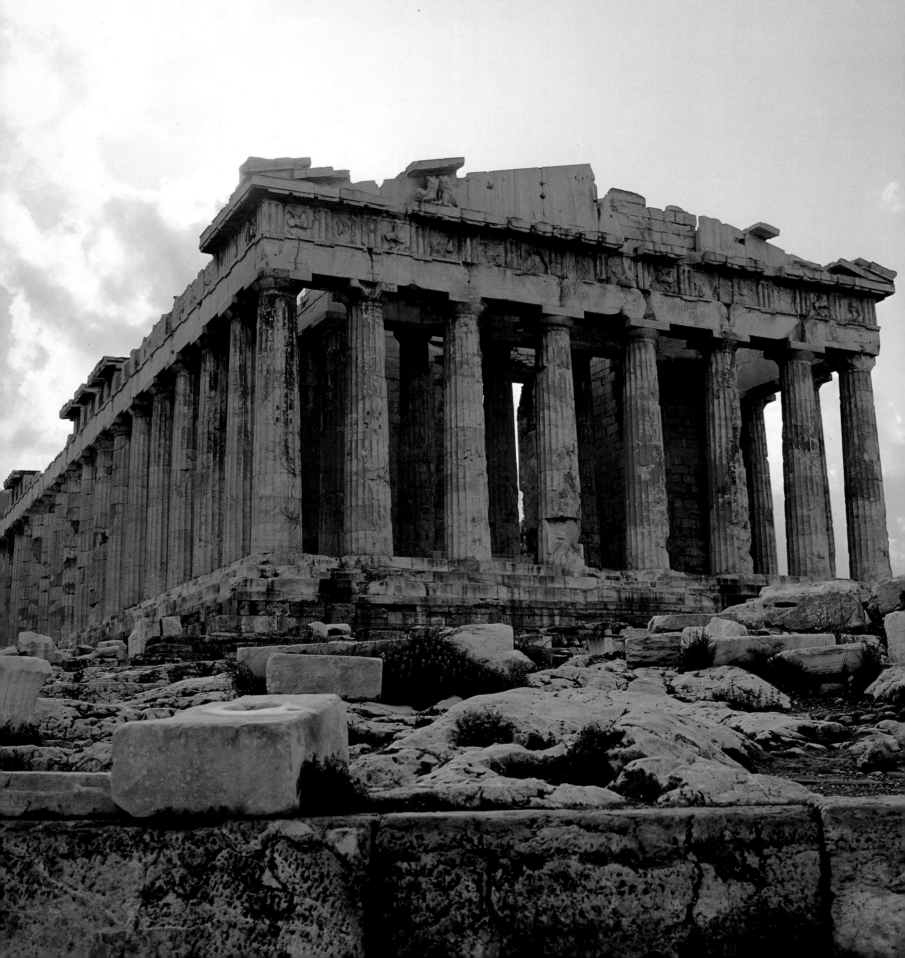

THE NARRATIVE

CELEBRATION

Athens, high summer; the last days of the month Hekatombaion, in the archonship of Phainippos, the third year of the seventy-second Olympiad; the anniversary of the birthday of the city goddess.

Athena had sprung fully armed from the head of her father Zeus, a miraculous birth acclaimed by her Olympian kin, and an occasion of alarm only for the smith-god Hephaistos whose axe had cleft Zeus' head to release the newborn. Her armour and weapons proclaimed her a warrior goddess, but when she came to struggle with Poseidon for control of the city of Athens and its countryside she succeeded through her gifts of peace – crafts and the olive tree. Poseidon had threatened to flood their land, and this was the first occasion on which the citizens of Athens had found salvation in their goddess. Now they were gathering to celebrate the festival designed to thank her for favours received and to guarantee favours to come.

The celebration of these 'Panathenaca' occurred annually but every fourth year there was a special festival of thanksgiving, the 'Great Panathenaea', and this was such a year. Its high point was the procession which escorted to Athena's temple on the Acropolis the newly made *peplos* robe, to be wrapped around her sacred olive-wood image. There would be prayers, hymns, sacrifice of cattle, feasts. But there were games too, athletics to match the contests at Olympia, musical competitions, a torch race, events to occupy the eyes, ears, imagination and belly for several days.

The procession was assembling around the north-western gate of the city, where the road ran out through the cemetery towards the hills in the west and, beyond them, to Eleusis and the goddess Demeter's Hall of Mysteries. There was little room to manoeuvre within the walls for the mêlée of brown bodies; the older men had wrapped themselves in a light cloak, but the hoplite soldiers were reluctant to encase themselves too soon in bronze and leather, though the sun was still low and not yet scorching. The young riders calmed their fretting horses, women gathered to serve the procession and rites along the way, and, waiting beyond the walls, there were the cattle for sacrifice. Priests, magistrates and marshals sought to impose order on the apparent chaos, to observe the due process of a festival which, in this form, had been inaugurated less than a hundred years ago but which had acquired new offices to perform and which had a new civic conscience to express.

The walk to the Acropolis was less than two thousand paces, but today hours would pass between the procession's first move into the open market-place towards the lower slopes of the Acropolis, and arrival on its summit with the burden of offering and sacrifice. There was much to do along the way, rites to perform, visits to be paid to shrines and altars, ceremonies which equipped the procession for its sacred task, displays of martial and cavalier skills. But this was no military parade: elders and citizens walked the Panathenaic Way, as well as troops of soldiers, cavalry and clattering chariots, and citizens viewed its progress and ceremonies. There was no real distinction between participants and viewers in the city's celebration of itself and of its divine patron.

Groups were beginning to form, with their gear, to take their place at the head of the procession where the priests and magistrates had gathered: elders carrying branches of Athena's sacred olive – her tree on the Acropolis would soon be heavy with fruit, and the sacred groves had, since the last Great Panathenaea, yielded their harvest of oil to reward success in the Games; girls with baskets laden with the sacrificial knives and the barley to be thrown over the victims; girls with stools and parasols to serve the comfort of their betters at the ceremonies along the way; girls with water jars, the daughters of

metoikoi, the non-citizen residents who were allowed a place in the civic event, with their brothers carrying trays of offerings on their shoulders.

There was no signal for the start of the procession, hardly more than a general agreement that the dignitaries should move towards the market-place and the crucial opening ceremonies. The occasion had the informality of a family gathering but its purpose was a serious one. Only formal observation of the rites could ensure success, and Athens could not afford the wrath of a jealous or disappointed goddess. By visiting her annually in this way, and by their regular gift of a new robe for her statue, her favour and their security were renewed and guaranteed.

From within the city gate the Panathenaic Way led to the corner of the market-place, the Agora – a place of assembly as much as of trade, where the citizens were summoned for matters both of state and of entertainment. On the right, just before the road entered the open space, stood the Royal Stoa, a little colonnaded building in front of which were displayed Athens' first written laws and where the Royal Archon, who had control of the religious life of the city, had his offices. In a workshop close by, in the quarter where potters' kilns and smithies lent more than their fair share of noise and dirt to the air of Athens on working days, a group of women were folding the new *peplos* for Athena on which they had been busy for the past nine months: a woollen robe, fit for a goddess, woven with scenes of the gods battling with giants, Athena herself prominent in the struggle beside her father Zeus. The sacred loom had been dismantled to await its next service in four years' time, but its heavy bronze legs were displayed at the door and the robe was received by two of the *arrhephoroi*, the young girls who lived on the Acropolis to serve the goddess. It had been their duty to initiate the making of the new *peplos*, though the weaving was left to stronger and more experienced hands, and it was their duty to deliver the finished robe to the Archon who stood before the Royal Stoa with the priestess of Athena to receive and inspect it.

There would be many more such stops on the processional way. Stools were carried for the leading officials and the priestess so that they should not be too weary for their tasks at Athena's temple. The rest of the crowd, denied any clear view of the rites, were more patient at these early ceremonies than at later ones, and some were already moving forward to vantage points for viewing the more active events to come.

Once the robe was accepted there followed visits and offerings to nearby altars: first, to the tribal heroes. Barely a generation ago the city had shaken off the rule of a tyrant family, which had been beneficent enough in its early years of power but which eventually succumbed to the pressure of exiled families and Spartan arms. In a new constitution whereby the government of the people was more clearly laid in the hands of the people themselves, the four old tribes of Athens were replaced by ten new ones, their members territorially distributed through Athens and its countryside. By these ten tribes Athens' army was now marshalled, and their representatives were ready for the procession, in distinct troops. And for the ten tribes ten heroes and kings of Athens' past were chosen, to give their names and in spirit lead the citizens in war or peace. These, the Eponymous Heroes, were worshipped on the other side of the Panathenaic Way, and after due gifts and prayers were offered to them the Archon and his party returned to the road, and to another altar beside it, where the Olympian family was worshipped. Athena was the city's goddess, but the family of gods, for whom the poets had fashioned genealogies and stories, had here, for the first time by Greeks, been given a religious status and a focus for worship which transcended their individual functions or their significance to different localities or professions in Athens and Attica.

The gods of the Greeks and the heroes of Athens' tribes were not the only supernatural presences

whose attention had to be sought along the Panathenaic Way. Within the market-place, when it had been cleared for assemblies some hundred years before, old graves had been found, perhaps of Athenians who had fought and died for the city many years before, some of them even from families who remembered their names and deeds with reverence. A disturbed grave cannot be ignored; the dead have their due, and the long dead, even the nameless, demand the attention of the living. Horses and chariots were prominent features in the cult of the heroized dead, and contests of strength and skill accompanied the rites of remembrance as they had of burial. In Athens displays of riding and of chariots in the market-place had celebrated them, and the displays had been incorporated in the Panathenaic procession, along the flat straight road, called the *dromos* – 'race course' – where it crossed the open space ending in a gentle rise towards the Acropolis and beside the hill of Ares.

The riders paraded in their troops, by tribes; they dashed and wheeled along the road. It was not so much a race as a display of cavalier skills. In Athens' army the cavalry was relatively unimportant and victories were won through the steady discipline of the ranks of heavy-armed soldiers – the hoplites with their bronze armour and long thrusting spears. The soldiers were in the procession too, but for the moment attention was held by the horsemen. Possession of a horse or horses had long been a symbol of status, and the symbolism extended to the world of the heroized dead in their cavalier Elysium. Chariots were an even more emphatic indication of status. In the age of heroes chariots ruled the battlefield. The Athenians knew their Homer and his poems were recited at the festival, so the heroic connotations of chariots in the Panathenaic procession were the more apparent. At Troy, it seems, chariots carried heroes from duel to duel, but the massed charge, as on the plains of Asia or Egypt, had in fact been the commoner practice, and one not altogether forgotten beyond the Greek world. In Athens chariot-teams were trained for races at the Games, and they appeared on some civic and private occasions, bestowing special honour on their riders. On the Panathenaic Way they offered the grandest spectacle. A soldier stood beside each charioteer, and as the team galloped he leapt on and off the car, stumbling to keep his balance and his grasp of shield and spear, then racing to seize the wooden chariot rails and haul himself again on to the bucking car. The crowd cheered the agile, hooted the clumsy, and thoughts of worship or sacrifice might seem far from their minds. But the chariot display was meaningless as a military exercise, and the young men, bruised and dirty from the chase, were cheered as surrogates for those Athenians who had died as heroes, and would die in days to come, in defence of their homeland.

The rites performed, the dust settling after the displays of horses and chariots, the main body of the procession moved on out of the market-place towards the Acropolis. Carts and chariots were abandoned as the path grew steeper and rockier, and the cattle jostled and nudged their way up the difficult slope, through the small colonnaded gateway, past the great walls of unhewn boulders (built by giants, it was said) on to the Acropolis top, to the Temple of Athena and her altar. The temple was an old building, but refurbished by the new democratic regime of Athens, and its gables were now graced by marble groups: at one end symbols of supernatural power, lions tearing a bull – at the other, gods fighting giants, the theme of Athena's *peplos*. The olive-wood statue of the goddess, quaint, stiffly old-fashioned, almost foreign in appearance, had been decked in gold and jewellery. The new robe was brought forward and wrapped around the figure. In a moment it was translated from an inert to a living majesty. The Athenians' goddess was with them, her blessings renewed as visibly as her servants

III Head of Dionysos (D) in the east pediment
IV Horse from Selene's chariot (O) in the

14 east pediment

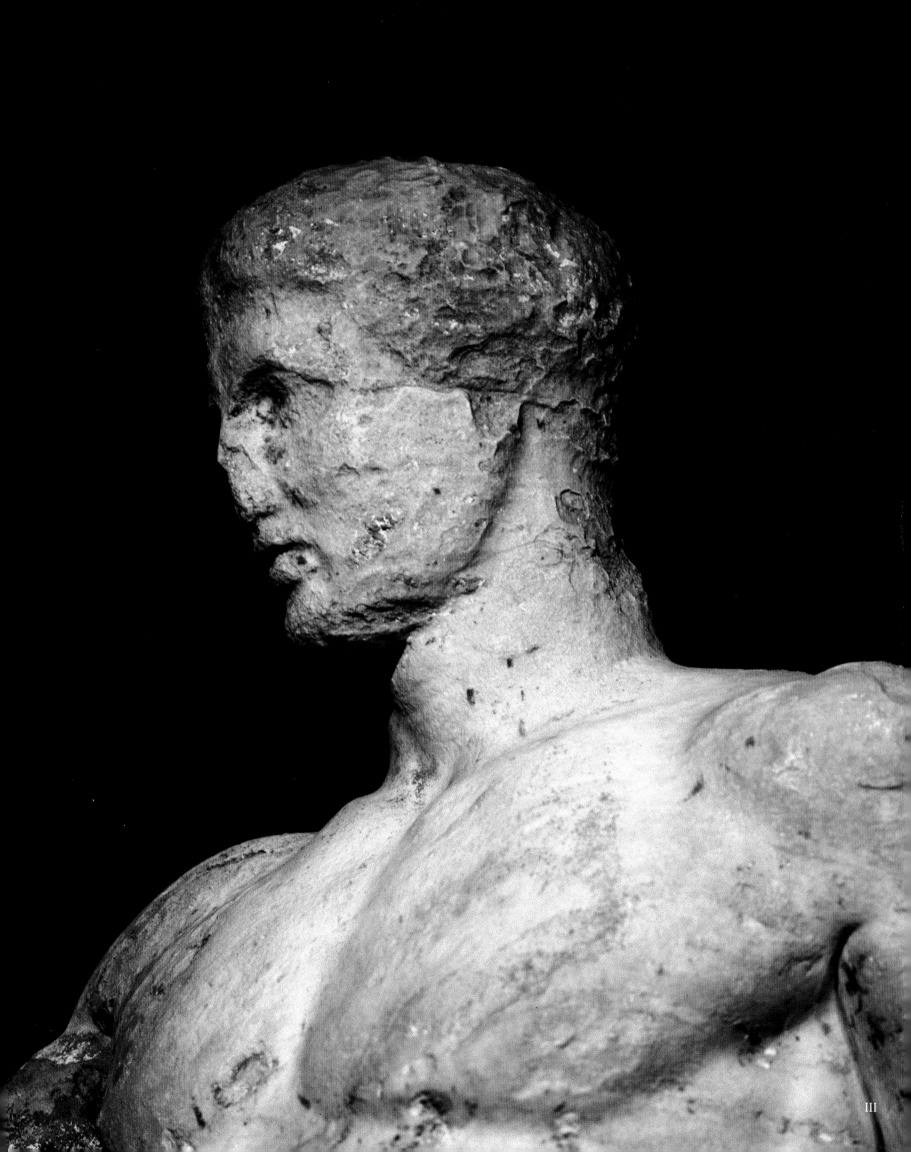

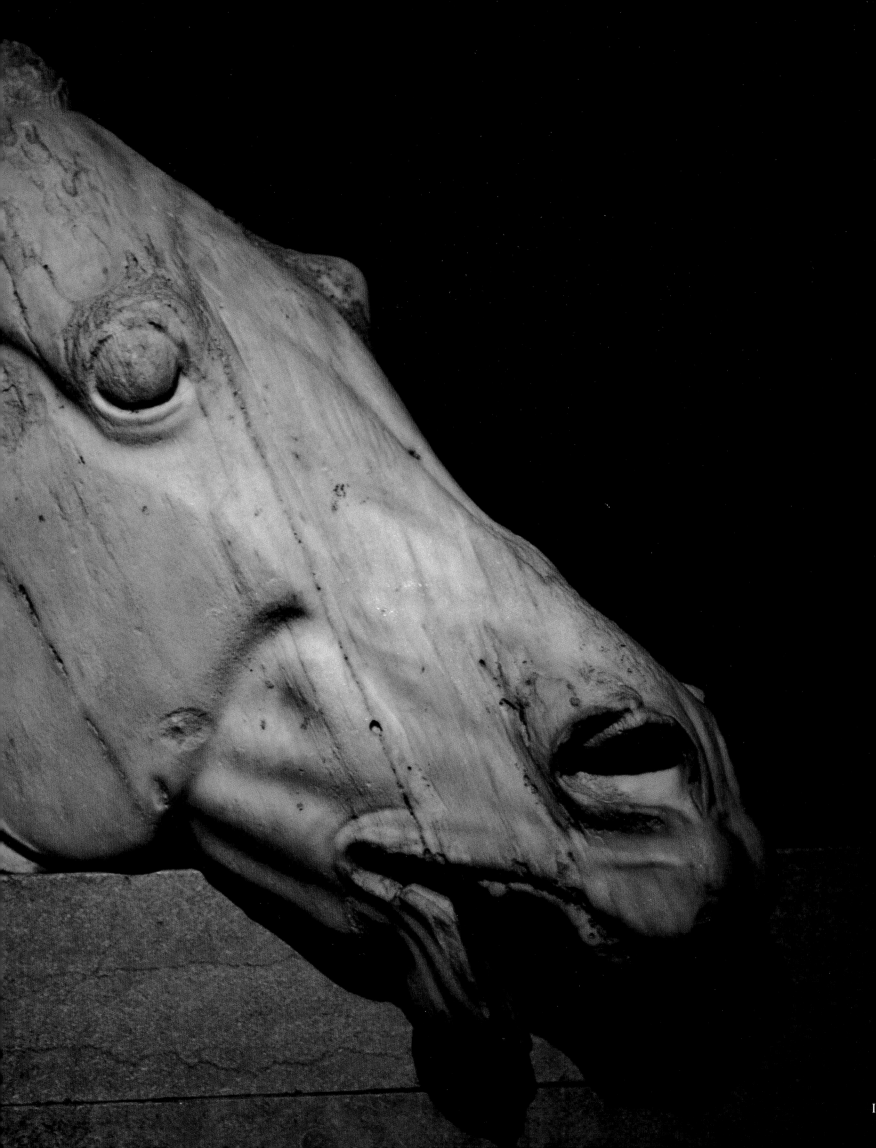

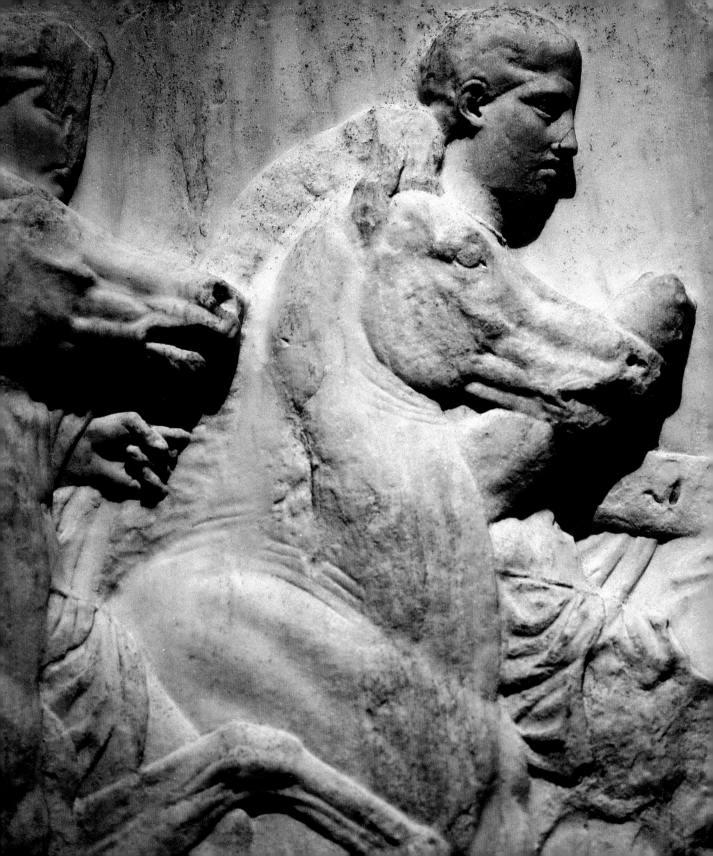

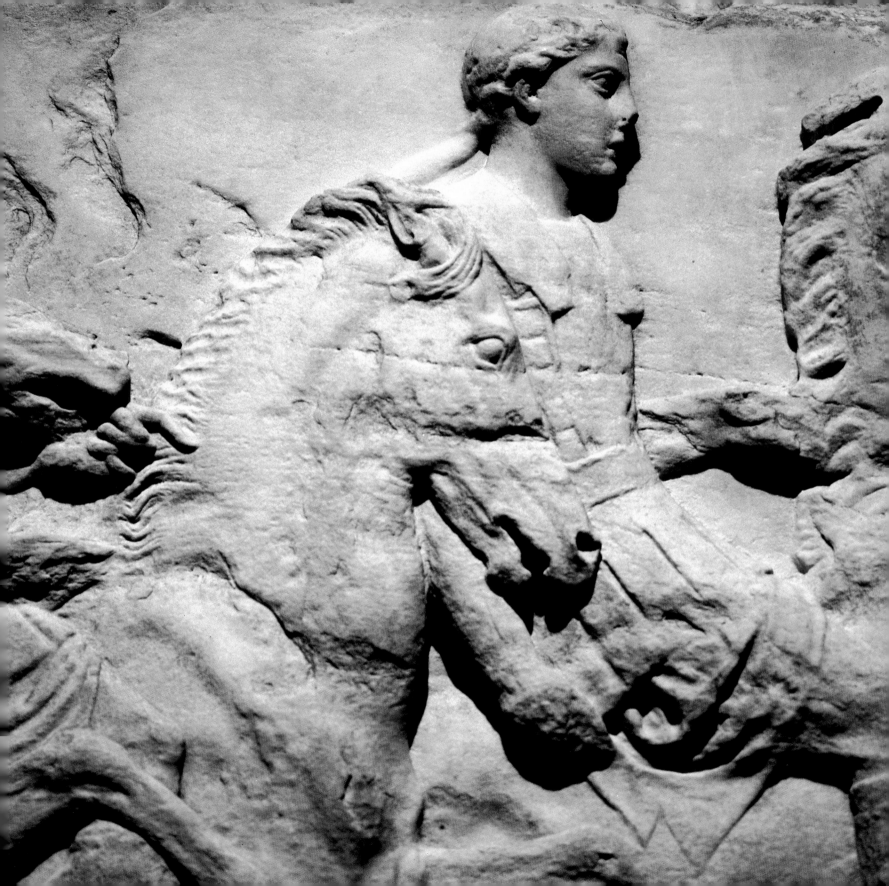

had restored her image to its deserved splendour and dignity. Hymns praised her strength and beneficence, and recalled the old kings and heroes of Athens who had taught the city how to worship her and secure her favour. But there was an even more direct means of communication with her, the sacrifice of a hundred cows, and the bellowing of the frightened beasts signalled the start of the last, most important, and bloody, act of worship on that holy day.

Years ago, when men talked with gods, Prometheus had tricked Zeus into agreeing that the gods' portion of a sacrificed animal should be its bones and offal, wrapped in rich but unappetizing fat, while the lean meat was left for mortals. In this way a conspicuous display of offering for the gods – the fat burnt well and smokily – was combined with a feast for worshippers, for many of whom a meat meal was something of a luxury. Athena's altar was a long, low platform. Fire had been kindled on it already from a torch carried in a race of youths from the Academy, a mile beyond the city gates. One by one now the beasts were dragged before the altar, the stunning axe rose and fell, the knives lost their lustre beneath a coat of fat and blood. The rock was slippery with blood, the air heavy with the smell of guts and sweat. The slaughter bred excitement, shouting anticipation of the feasts to come, while the black smoke rolled thick and heavy up into the still and shimmering air, a clear signal to Athena that her citizens had paid their due respect. That smoke would rise for hours to come, while the lean meat – and there was not that much, even on a hundred of Athena's chosen cows – was dragged and carted down to the market-place for distribution. Other fires would be kindled in the city that night, and new wine jars broached, with other prayers for the goddess, her city and the homes of her people.

The festival of the Panathenaea was the main religious event of the year for the Athenians; the Great Panathenaea, when its year came round, especially so. This year the procession and sacrifices had been as others had been, and would be again, but the Athenians who made their way down to the city, refreshed with their acts of worship and dedication, had more on their minds than the feasting yet to come. To explain why we must go back to events of nine years before, events in which many of the celebrants had taken part.

The Athenians were Ionians by race, and their kin in Greece lived mainly in the islands or on the far side of the Aegean Sea, to the east, on the coast and offshore islands of Asia. The Aegean was a Greek sea and communications were hardly more difficult or time-consuming than journeys across the mountain-strewn mainland. But the eastern Ionians had fallen on hard times. The Empire of Persia had spread explosively through the lands of the east, to the Indus, into Egypt, and now on to the coast of the Aegean where many Greek cities had fallen to the easterners or were in the control of Persian-appointed governors, paying tribute to the local capital of the province, Sardis, former home of the philhellene Lydian king, Croesus. Now the Ionians had appealed to Athens to help them throw off the Persians, and the city had responded by sending a substantial part of her available fleet and men. The distances seemed enormous, the prize remote, but the appeal, which other Greeks had turned aside, found a response in the confident new Athens, which had already rejected other demands of the Great King. From Ephesus the Athenians, with the Ionians, had marched north and inland over one hundred miles to sack and burn the lower city of the Persian capital at Sardis. Thereafter the Ionians fared less well, but the Athenians returned from Ephesus with their story of a triumph over the barbarians. The Great King would not forget, however; daily at dinner his servant reminded him thrice, 'Master, do not forget the Athenians'. This summer his fleet and army were on the move, already in the Greek

V Horsemen (figures 27, 28; slab x)
in the south frieze
VI Horsemen (figures 35, 36; slab xiii)
in the south frieze 19

islands burning towns and temples, deporting the people. Eretria would be next, the town in nearby Euboea which had also, though modestly, responded to the Ionians' appeal; then Athens. This the Athenians knew. The Great King was coming for revenge and they could not, after this year's festival, put away their armour and spears to return with quiet minds to their fields or workshops. The danger was imminent and could not be escaped; their mood was of exhilaration, but tinged with fear. The pall of smoke from the altar rose high over the Acropolis and the stench of the blood of sacrifice was in their nostrils.

DESTRUCTION

The debris of the small columned gateway to the Acropolis had been piled at either side of the path, to leave a clear way for the procession. It was the third Great Panathenaea since the festival twelve years ago which had so narrowly preceded the call to arms, the forced march over the Attic hills to the Plain of Marathon, and the rout of the Persian army, come to wreak on Athens the vengeance already exacted on Eretria. The Athenians had good reason to thank their goddess for their virtually single-handed success. On the field of battle they had been joined by a small contingent from the town of Plataea in neighbouring Boeotia, but the Spartan army had dithered and arrived only in time for the Athenians to display the Persian dead – 6,400 – and their own – 192. The odds had been heavily against them, but their homes and freedom were at stake. The Persians would not lightly forget the shock of a disciplined charge by Athenian hoplite soldiers, glistening with bronze armour and ten thousand levelled spear points. The Athenian dead were cremated on the battlefield and their ashes buried there beneath a tumulus-mound where offerings were laid as to heroes, in a rite which the young men of Athens would continue to observe for generations to come. Inscribed slabs (*stelai*) recorded their heroism, and on these their names were listed by tribe, and their number could be read.

The Persians had not lightly forgotten, and less than ten years later a new Great King, Xerxes son of Darius, sent a new host into northern Greece, to drink its rivers dry, to march and sail south against the cities of central and southern Greece. Spartan heroism had delayed them at the Pass of Thermopylae but the advance was irresistible, and in the face of it the Athenians could do no better than evacuate their city and leave it to the mercies of the barbarians. The Persians sacked and burned it, overthrew its temples, and from their refuge on the island of Salamis the Athenians saw the veil of smoke rise over their homes. The decisive battle was this time to be fought at sea, and from an Attic hillside Xerxes watched his warfleet being crushed by the Greeks in the narrows of Salamis, and fled back home. At Salamis the Athenians had again distinguished themselves and in that campaigning year there had been no main trial of strength on land, but in the next year the Persians returned and it was the Spartans that led the Greeks to a resounding victory over the Persian army in the territory of Plataea, the state that had sent its troop to Marathon. The remnants fled from the Greek mainland, and were even pursued, and beaten again on that eastern, Ionian coast which had seen the Athenian expeditionary force twenty years before. But Athens had suffered for a second time, its city evacuated, its remaining houses burnt. The citizens' return may have been triumphant, but it was to ruins.

Barely a year had passed before this renewed celebration of Athena's birthday. Upon the Acropolis the prospect was desolate. The Temple of Athena had been burnt to the ground and only the jagged profile of its lower walls marked its place. To the south, the surface had been terraced for a new temple to Athena, begun in commemoration of the success at Marathon. Blocks ready for its walls and

columns still lay on the ground, but many had been bundled into a hasty refortification of the Acropolis, achieved by the Athenian leader Themistocles in the face of Spartan fears that any fortified place in central Greece might tempt and serve returning Persians. Athena had lost her old temple, and of her new one there was nothing to show but the foundations and the unfinished column-drums and blocks in the Acropolis' new walls. At least the altar still stood to receive the sacrifices; the scorched stump of Athena's sacred olive had put out a new green shoot; Athena's statue, which had been evacuated with the citizenry, survived to receive her new robe; and Athens was the richer, not with buildings but with loot from the abandoned Persian camps.

But the threat remained. Athens was to lead Greece in a continuing struggle to free all Greek lands from the Persians, and in the course of this to turn a contributory league which she led into a tribute-bearing empire which she dominated. It was not the time to rebuild Athens' temples, and after the battle of Plataea the victorious Greek states, in a show of unwonted national unity, had agreed in the 'Oath of Plataea' to leave ruined the temples destroyed by the Persians as a memorial to the barbarity of the invaders and to the bravery of the defenders. Athens, Eretria and the islanders had suffered most, with some other areas of central and northern Greece, and the cities were for a while content to devote their energies and resources, even Persian gold, to the call of aggressive defence. In Athens civic energies were directed to purposes other than the rebuilding of temples, but military success, wealth, personal ambition and the need to create a city which could serve an empire, would inevitably persuade them that their goddess should be housed with the dignity she deserved.

CONCEPTION

The third year of the eighty-second Olympiad. Of the men who had fought at Marathon few survived, old and proud of the part they had played in the battle which had set the seal on Athens' greatness. The gods and heroes of Athens had as surely fought beside them on that day forty years ago as they had beside Achilles and Hector at Troy; in death their comrades had been touched with divinity, and their sons each year paid offerings to the tomb at Marathon, as to heroes.

The Athens that prepared for another Great Panathenaea was a different city now. Her army and fleet had become the strongest in the Greek world. Her new leaders had been mere children when Marathon was fought, teenagers when the city was evacuated and sacked. Athens had led an alliance, fed by contributions of ships and money, which had succeeded in driving the Persians from Greek lands. The fighting continued, Cimon was sailing east again, for the last time, and soon the Persians would accept that Greece was for the Greeks, not for them. Athens' supremacy had been bought at the cost of no little ill feeling – the jealousy of Sparta, the rivalry of other Greek cities which had once been her equals or betters (Argos, Corinth), the need to keep in bounds any show of independence in the League States by action which looked far more like the repression of revolt than policing in the face of a common foe. At home political fortunes had fluctuated dramatically. The victor of Marathon, Miltiades, had died soon afterwards; Themistocles, who had helped save Athens when the Persians were at the gate and had rebuilt her walls, had fled to the Persian court after Plataea, discredited, and was recently dead. Miltiades' son Cimon had become a dominant figure through his military successes and munificence at home, but he too had been discredited, and though he had returned to fight again this was his last campaign. The new name was Pericles. His vision of Athens' role was no less ambitious than that of his

predecessors and rivals, but his exercise of leadership was different. Athens' constitution became increasingly democratic, while the control of her League became more despotic. The League Treasury had already been moved from the neutral, sacred island of Delos to Athens itself. Democracy and empire-building make notable demands on public expenditure.

The appearance of the city of Athens had changed dramatically since the devastation of thirty years ago. The fortifications of the city, her port Piraeus and the Long Walls that linked them were complete. In the city new public buildings had arisen around the market-place. Some of these were simply to serve the democracy, others were the result of private patronage. Cimon had been busy here, sponsoring new building like the Painted Stoa, with its great mural friezes executed in an imposing new style. They depicted the Athenians' heroic success at Marathon; the sack of the greatest eastern city of the heroic past – Troy; and the defence of Athens against earlier eastern invaders, the Amazons, under the leadership of Theseus and his hero companions. It was Theseus' bones that Cimon had recovered from the island of Skyros and installed in his shrine in Athens, and Theseus, who had become the archetypal hero of the Athenian democracy, had been virtually adopted by Cimon and his family. Greeks saw and explained their fortunes in terms of the heroic past which was their birthright and had been rehearsed for them by Homer and the other poets. The successes of a city's god or heroes could serve as parallels for the successes of the city itself; new adventures could even be invented the better to demonstrate the heroic or divine paradigm. In the Painted Stoa the message of the juxtaposition of Marathon, Troy and the defeat of the Amazons was not lost on any Athenian. The narratives of Theseus' successes were a reminder of Cimon's successes in a society which did not dramatize contemporary events explicitly. This use of the stories of their past, intimately linked with the practice of their religion, had been familiar to the Athenians since the days of Homer. And in a society where the story narrated, at mother's knee or by a bard, counted for more than stories read, the familiarity was increasingly enhanced by pictorial display on buildings, walls, and objects of everyday use. Of all Greeks the Athenians especially lived in a world of icons, and the associations evoked by an image were the same as those evoked by a story, poem, or play, and far more immediate. This had been a determining factor in the decoration of public and private buildings, of works large and small, expensive or expendable, and it would be exercised subtly in the new Athens.

For it was high time that Athens' Acropolis matched its city and market-place. The time for dramatic gestures, ruined memorials, had passed. The city that led Greece desired to look the part, and the Acropolis, where her goddess lived, and which was now graced only by the many statues and votive monuments which had been erected since the Persians left, called for temple buildings to match them. The promising young Athenian sculptor Phidias had already made a colossal bronze Athena, the Promachos, which stood just inside the Acropolis entrance to greet worshippers and processions. It celebrated success at Marathon, paid for from Persian spoils. Phidias' studio had also made a bronze group of gods and heroes, including Miltiades, for dedication at Delphi to commemorate in the eyes of all Greece both the battle and Athens' glorious stand alone against the Persians. Pericles had in mind a formal revocation by the Greek states of the Oath of Plataea, but Athens hardly needed the consent of others to her policies, and now that she had led the Greeks to what she regarded as freedom she felt entitled to use her wealth as she wished. Some complained, but the promise of the rewards of

VII Horsemen (figures 99, 100; slab XXXII) in the north frieze

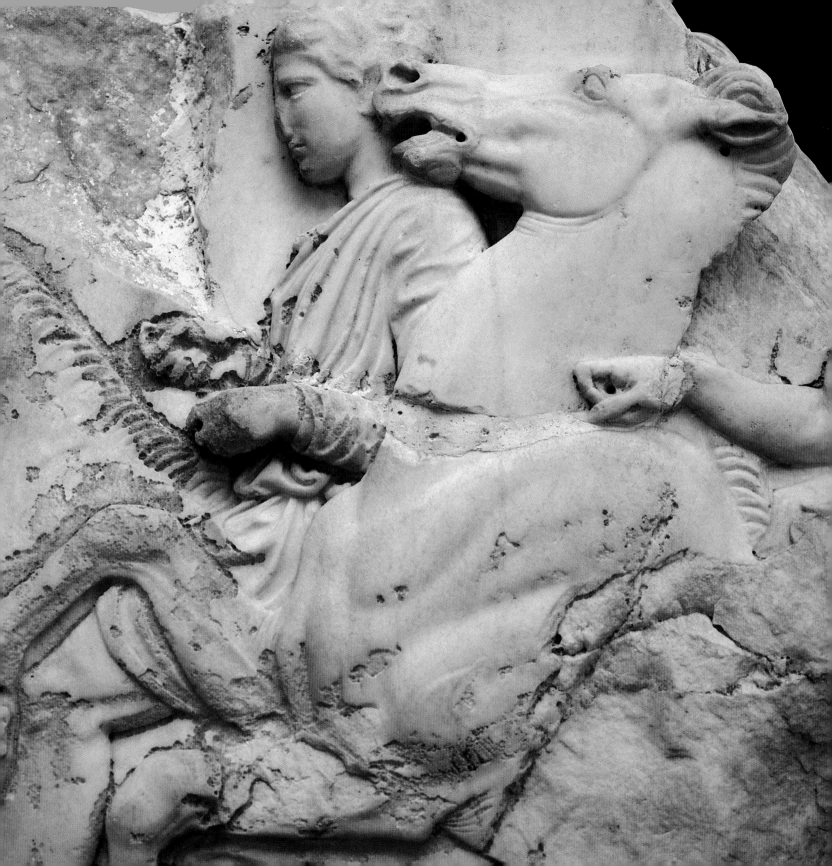

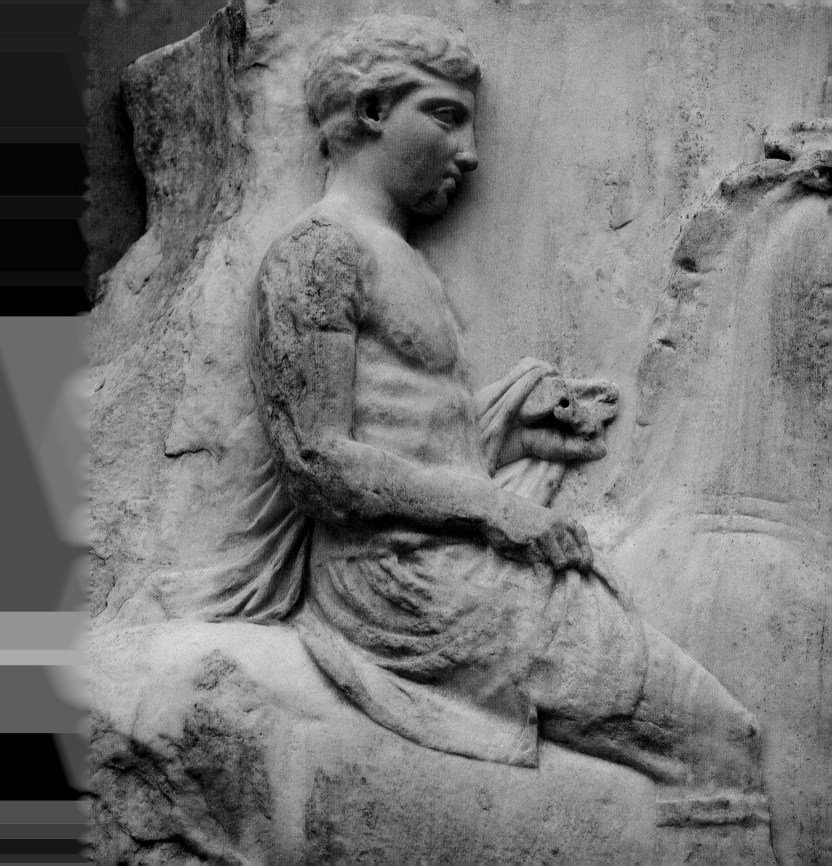

employment on the new projects, and the glory they would bring their city, determined their acceptance.

The plans were comprehensive, for Athens and for the countryside of Attica. They were costly and they would take long to realize. Pericles turned to Phidias for advice about the new temple for Athena, but there was much to decide, requiring the intervention of architects and masons and, not least, priests, since the decoration of the new buildings, drawing on stories of the divine and heroic rather than of the everyday, required their guidance too. Of necessity, plans would be altered, construction deferred, even beyond the lifetime of their creators, but the general concept and many of the details of its execution were the work of Pericles, Phidias and their advisers. Work was already beginning on a Temple of Hephaistos overlooking the north-west corner of the market-place. It was, in its way, experimental, testing new variations on the established architectural styles of Athens and mainland Greece, allowing for the eventual placing of sculptured friezes within the outer colonnades at each end – a total innovation which considerably increased the opportunities offered for iconic and narrative displays. Its exterior sculptural decoration had already been agreed – old-fashioned with its scenes of the deeds of Heracles and of Theseus in the outer metope panels, subjects the Athenians had used on the Treasury they had dedicated at Delphi soon after Marathon but which they now tended to ignore, and a centaur fight. But it would be long before the whole sculptural decoration was complete, and there were other temples to replace in the city and in the countryside, at Acharnae, Sunium, Thorikos, Rhamnus.

The Acropolis itself posed special problems. The old temple had served various old and revered cults, and was not just the home of Athena's statue. For these varied roles a new building of special design would be required. The entrance to the Acropolis demanded a new monumental design, which would also have to allow for a new temple for the goddess as Victory where an older shrine had stood. But the prime consideration was the goddess herself and what she now symbolized – the pride and success of Athens as leader and liberator of Greece. This was a question of both piety and politics. The building and its sculptures had to demonstrate for all time what Athens had, through her goddess, achieved. This would be realized by size, quality of workmanship, opulence of material and decoration, and a lavish visual display of those divine and heroic stories which would remind the viewer of the building's purpose and the achievements which were celebrated. Other temples in Greece had been planned, built and decorated to commemorate success, but none with such a conscious attempt not merely to demonstrate military success and the resources lent by the spoils of war, but to lay claim to the rewards of both unrivalled mortal heroism and divine favour.

The site for the new temple was ready – it could rise over the foundations of the temple of Athena which had been begun to commemorate the success of Marathon, but whose completion had been irrevocably abandoned with the Persian sack. It lay just to the south of the foundations of the old temple, which were still exposed to recall the Persian attack. On this, northern side of the Acropolis the old cults must later be housed. But the new temple would be broader than its intended predecessor; eight columns at each end, not six, a new proportion better suiting its place on the broad Acropolis rock and better accommodating the wealth of sculptural decoration planned for it. For this there would be the two broad gables, and, unusually for such a large building, all the exterior metope panels over

VIII Horseman (figure 26; slab x)

in the south frieze

the columns would carry relief sculpture. Moreover, there was room at the top of the walls within the outer colonnade: metopes again at each end, as on Zeus' new temple at Olympia – or perhaps a frieze at each end, sketched in the plans for the new Temple of Hephaistos in the lower city – or, best of all, a frieze around the whole inner block within the colonnade, a revolutionary innovation for a building whose architectural idiom was traditionally opposed to such decor. The subjects would require special attention: to celebrate the goddess, but also to celebrate her city and what it had achieved. A new cult statue, too. Athena's presence could be symbolized in many different guises. The old wooden statue remained the most sacred but the maiden warrior goddess deserved a more martial appearance, such as that of her bronze Promachos which stood outside. A warrior goddess then, fully armed, holding a figure of Victory in the palm of her hand: and the metal, not bronze, but a monumental and extravagant display of an old technique combining ivory for flesh with gold for dress, and colossal in size. The resources were at hand, the Treasury full (this too would need accommodation in the new temple). All that was needed were the hands to execute the project, and the call went out to the sculptors and masons of the islands to hire their skills to Athens, while her own citizens acquired and practised new expertise. This might not be the last of the Great Panathenaic processions to cross an Acropolis bare of temples, but next time the promise of its eventual splendour would already begin to be apparent to citizens and visitors.

CREATION

The marble dust lay like snow on the Acropolis rock. The clamour of masons, the clatter of their mallets had been stilled for the days of the festival but the feet of the worshippers and the sacrificial animals kicked up the white dust on to hair, clothes and flesh as they shuffled past the half-finished blocks, the sheds and workshops, towards the altar and the climax of the procession.

Work had started on the Parthenon five years before. The outlines of the new temple already stood clear. The capitals were in position on the columns but the work of fluting their shafts would wait until they were unlikely to be damaged by the building operation. The upperworks were taking shape and the sculptured metopes lay in rows ready to be raised into position. The marble walls and shafts asserted their hard, true lines through the maze of wooden scaffolding. Beyond the mason's yards and wooden shelters, on the terrace below the temple, a large, more secure structure was rising where the gold and ivory cult statue was to be made and assembled.

The creation of such a great temple, its sculptural decoration and its cult statue, had been a project more complicated than any military operation, more costly and more time-consuming. It required money, men, skills and foresight in planning, which could anticipate the effect of such a large and unusually proportioned building in its setting, and more than a touch of genius in design and execution.

The money was there, and still flowing in from subject states, which had once been partners in the league to fight Persia. The one-sixtieth part of the tribute which was set aside for Athena was accounted annually, from each contributory state, on an inscribed *stele* set up on the Acropolis. The spending of the money had to be accounted too, and another *stele* recorded in detail the expenditure on men and materials. The tight, regimented script cut in tiny letters on the smooth marble slabs was never easy reading, but the important thing was that it was there, for reference and checking, a safeguard both for those who were spending Athens' accumulated wealth, and for the many who were ready to suspect

the motives and honesty of officials and their agents. Most of the men employed were citizens of Athens, but a town of little more than one hundred thousand free citizens could not easily meet all the new demands for specialist skills, and the resident alien body – the *metoikoi* – had been noticeably swelled by an influx of craftsmen, especially from the islands, whose marble quarries had been the first to be exploited for sculpture in Greece, and where the traditions of marble cutting were still strong and well taught.

The architect Iktinos – 'the Kite': an unflattering sobriquet which reflected more on his appearance than any rapacious habits – was an islander. He was not the obvious choice for the job, but, as it turned out, a brilliant one, for architecture in Athens over the last fifty years had not offered the opportunities for a strong local school to develop. The traditional style in Athens, as in the rest of mainland Greece, was austere though subtle. The core of any temple was a single room which housed the cult statue – a physical symbol of the presence of the god. It might also serve as a store for treasure, or spoils, or as a showplace of historically significant bygones, but no acts of worship or cult took place within it other than those associated with the cult image itself. More direct communication with the gods was effected through sacrifice, and this centred on the altar, outside the temple, towards the east and the rising sun. Around the god's house, his *oikos*, ran a colonnade, the columns rising like tree trunks directly from the three steps which lifted the floor of the whole building as on a low platform. The fluting on the columns, with the sharp ridges and shallow concave grooves, abetted the illusion, but the colonnade rose with a precision unmatched by any forest. At their tops the columns spread to low conical capitals topped by square slabs, so that the weight of the entablature and roof seemed to do no more than settle gently on the columns, lightly poised despite the obvious weight and mass of the marble. In the older temple of Athena the bulging outline of the columns had, if anything, exaggerated the sense of crushing weight, as though the building were a strongbox, welded to the rock. The new style was to be lighter even though the material was weightier – more marble, even to the roof-tiles, rather than limestone, brick and wood. The outline of the columns for the Parthenon still swelled slightly, but this in effect lightened the appearance of the building and countered the static impression given by straight lines. The stepped floor too sank very slightly to the corners, imperceptibly, yet giving an almost elastic effect to a structure which might otherwise have seemed squat and lifeless. Over the columns would run the smooth flat epistyle, then the pattern of alternating metope slabs and grooved triglyphs, petrified forms of the woodwork in older temples, in which a satisfactory compromise had been achieved between apparent structural function and sheer pattern.

To this simple formula, which had come to be called Doric, Iktinos had brought innovations inspired by his training and experience with an architectural style which expressed a more decorative idiom. The Ionians of the islands and East Greece gave their temples volute capitals and turned, fluted bases, like massive furniture, and inspired by the furniture patterns of the Near Eastern world which had played a significant role in the development of Greek art and architecture two centuries before. There was a different flair and pattern to the decorative mouldings too, and the architectural sculpture was disposed in friezes, not crushed into metopes and gable ends. Minor elements of these styles had been long familiar in Athens, and introduced in her architecture. The outward appearance of the Parthenon would be traditional, but closer inspection would reveal the novelties – slender Ionic columns compassing the greater height of its rear room, the Treasury of the temple, a new range of mouldings, a general readiness to display ornament and sculpture (the metopes on the exterior of Zeus' temple at Olympia were all plain), even a sculptural frieze that rivalled the most ambitious of the Ionian world.

The marble quarries of Mount Pentelikon lay ten miles from Athens, clearly visible from the Acropolis and half way to Marathon. Its marble had a fine uniform grain, unlike the coarser-crystalled island marble. Cut to sharp, crisp corners and edges in architectural mouldings, or for fluted columns, even for wall blocks, it did not blur appreciation of the mason's firm hand and true eye, and it offered a clean unmottled surface for paint. The Athenians had begun to use it for sculpture a hundred years before, but this was the first Athenian temple for which only Athenian marble would be used.

The architect's specifications to the quarry master defined the overall dimensions of the finished blocks. They were cut from the marble beds by channelling around the mass desired, leaving a good margin for final trimming and to allow for minor surface damage during removal and transport, but close enough to the ultimate form to save weight. The raw blocks, slabs and plump discs for column-drums were loaded on to waggons or, for the first part of their journey from the steeper slopes, on to sleds, and in Athens they had again to be hauled up on to the Acropolis where they were trimmed to the correct size. Even then the final detail was ignored until the blocks or drums were in position – the fluting of the columns, the smoothing of surfaces and finish to vulnerable corners.

For all its novelties the layout and construction of the temple looked conventional enough. Iktinos had determined the basic proportions he would use, and expressed them in clear instructions about sizes of blocks, thickness of walls and the like, so that the master masons could assemble the building without constant recourse to him for advice or decisions except where unfamiliar details intruded. He had provided models of the mouldings and capitals for the masons to copy. He had to approve the quality of the marble provided from the quarry and he had ordered the Cretan cypress, the elm and pine to season for the temple roof, ceiling and doors. Rule of thumb and common sense, backed by intelligent anticipation of problems, had dictated the manner and pace of construction. The scaffolding had risen with the walls, to give easy access to where the blocks were swung from cranes to be levered into position on the unfinished courses. On working days a small fire, clear of the cut blocks which it might blacken, kept in readiness a pot of molten lead to pour around the iron clamps and dowels of iron or wood by which the wall-blocks and column-drums were fastened one to another. The inescapable logic of construction dictated by the traditional form of the colonnade and upperworks had meant that the main problems were logistic not structural, by the time the blocks were ready for hoisting.

But this was a building whose sculptural decoration was to be no less ambitious than its structure. The carved metope slabs lay ready and some of the wall frieze within the colonnade, at its west end facing the Acropolis entrance, was in position. It would be some time before the roof and pediments were also in position, but the sculptors' yard would soon have to be cleared to prepare for work on the pedimental figures. In these matters architect and sculptor-designer had to work closely together. The new eight-column façades meant that there would be fourteen metope slabs at each end (two above each space between the columns) and thirty-two along each side, where there were seventeen columns. The height of the frieze within the colonnade was dictated by the proportions of the columns of the porches at each end, over which it ran, and along the flanks of the building the width of the frieze blocks was determined by the width of the wall blocks beneath them, which they matched. There had been talk of putting metopes over the porches, it seems, and some had even been carved. But Phidias had yielded to Iktinos' bold suggestion of a frieze within the colonnade, and that it should be not merely at each porch, as was intended for the Temple of Hephaistos in the city below, but around the

IX Athenian hero (figure 20; slab IV)
in the east frieze

X Athenian heroes (figures 20–23; slab IV)
in the east frieze

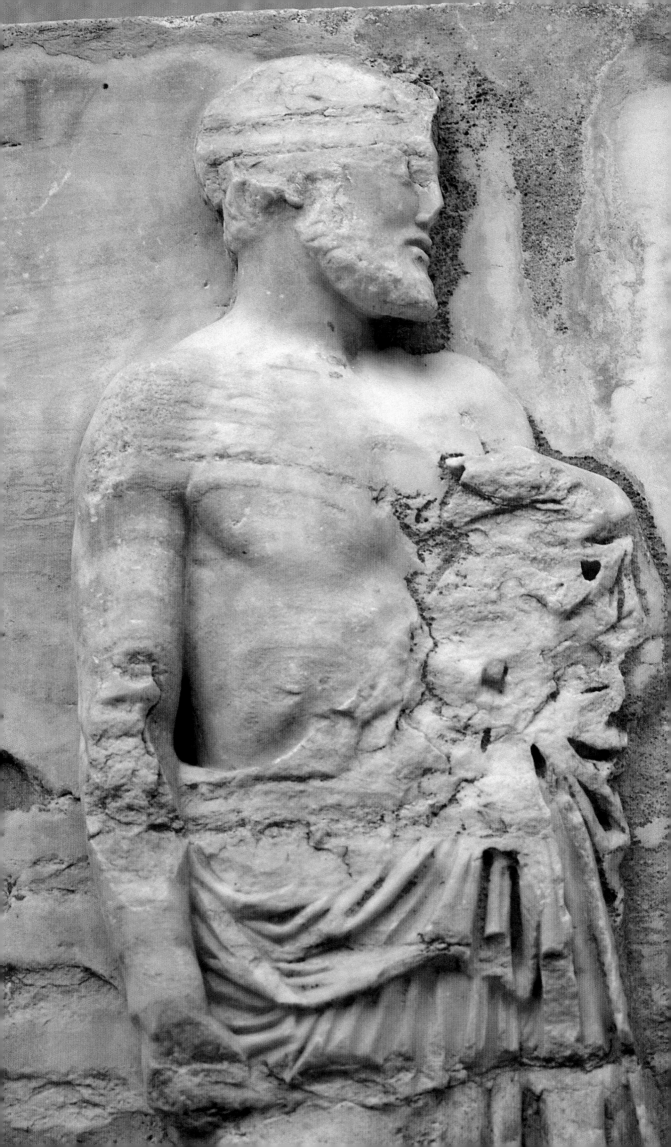

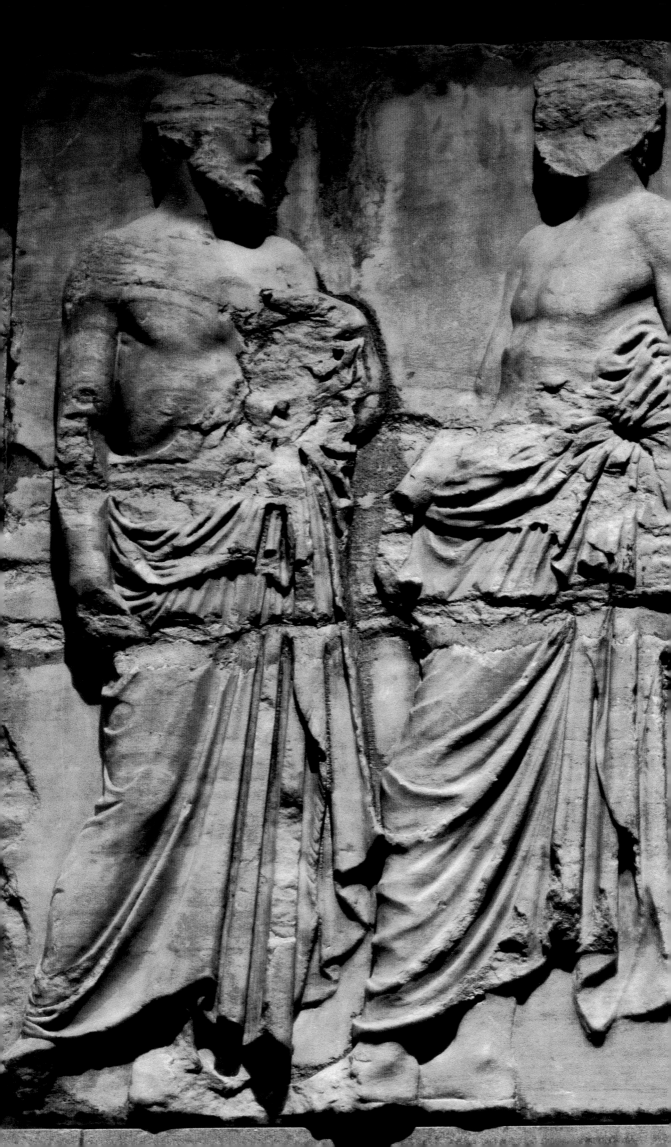

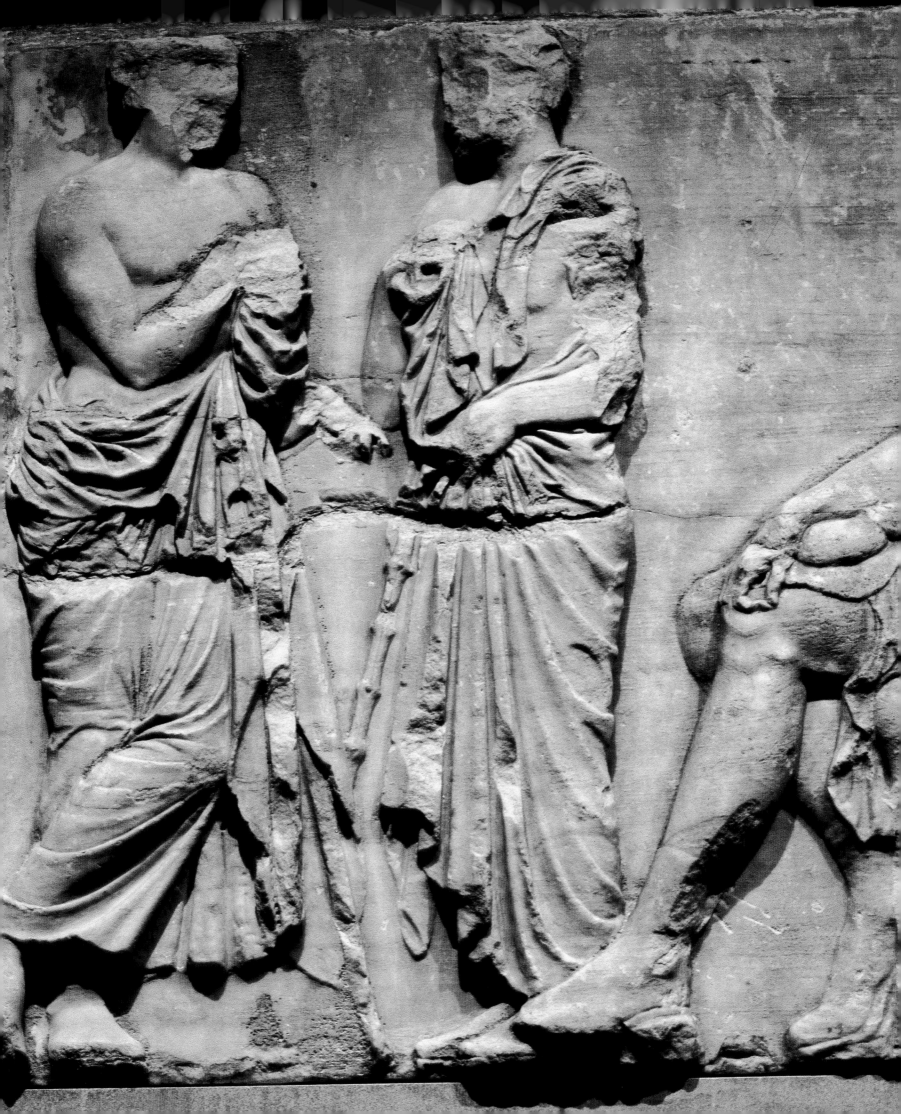

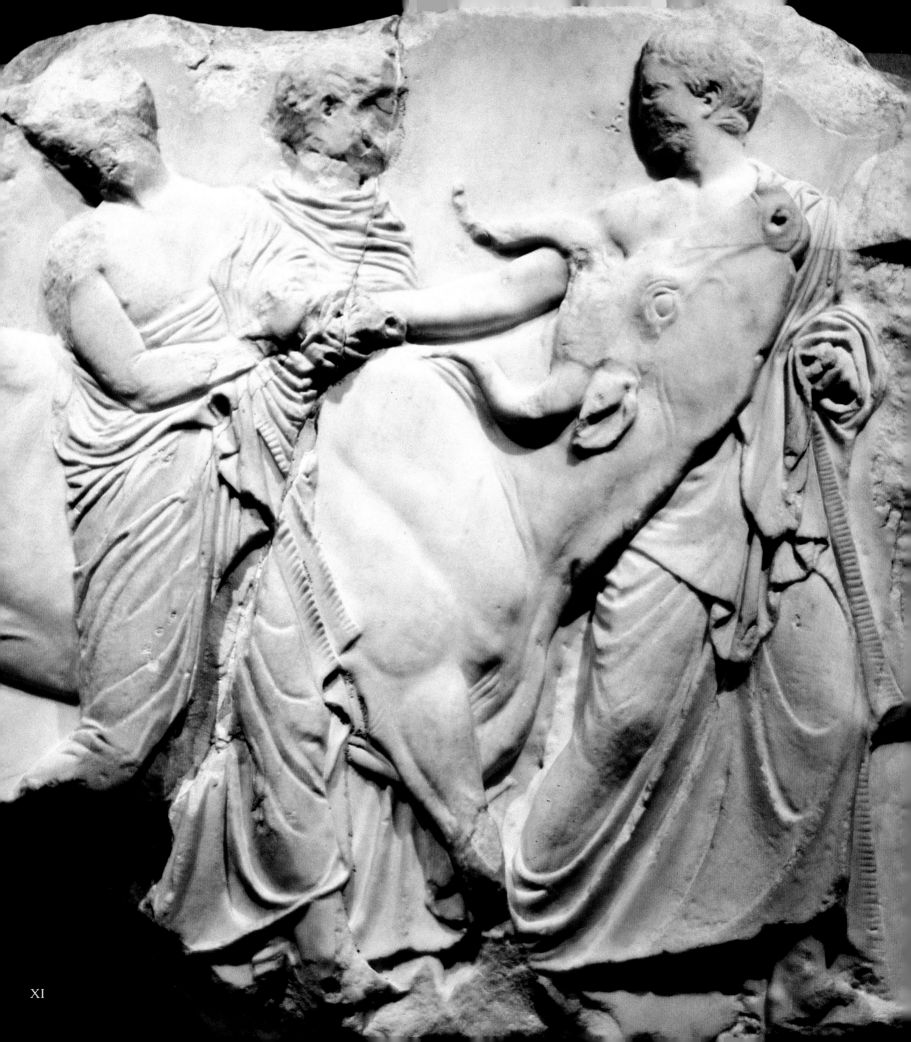

XI

whole central block of the building. So the metopes were abandoned and the few finished ones were to be relegated to a relatively inconspicuous position on the exterior, while there was still time to adapt the design of the rising walls to accommodate a frieze. And the subject for such a bold sculptural innovation – some five hundred feet of continuous frieze – came soon and triumphantly to mind: it would be something for Athens to relish and the rest of Greece to envy.

The carving of each metope had been assigned to an individual artist, some executing several, the less skilled few or no more than one if their competence proved inadequate. With so much to be done it took time to identify the hands which would best express the style that Phidias sought. Drawings were provided for some groups where their narrative needed to be carefully designed, sometimes in ways not wholly familiar to artists in Athens or elsewhere. There were traditional ways of showing stock subjects in Athenian art, but even these traditions diverged in different media, and in an Athens long starved of monumental expression of narrative in sculpture there was an opportunity here for the creation of new stories, suiting the special needs and functions of the Parthenon, or new ways with old stories. Through the period of Athens' dearth of monumental sculpture on architecture – the principal medium for such narrative – the minor arts like vase-painting had maintained and developed older traditions, and new ones too had been established by the muralists like Polygnotos and Mikon, in their work on Athens' new public buildings. The themes of the Parthenon's metopes called for some familiar schemes, some new. For many, contracted to tried and expert sculptors, the specification need be no more than 'one Lapith youth fighting a centaur', yet even for this sequence of metopes, each showing just such a group on the south side of the Parthenon, Phidias had to dictate principles of design, weapons and furniture which would suit the overall narrative scheme of the series. The figures and details had to be drawn on the face of the unworked blocks provided, be approved, and then the sculptors could set to work, letting the apprentices cut to the depth of the eventual background where there was no figure, working quite swiftly with the sharp iron point that brought off large marble flakes. Then the master took over, refining his sketch, working slowly towards the surface he sought with the claw chisel, which safely gouged broad swathes on the stone, then the flat chisel, and rasps and rubbers to smooth away the tool marks. Where dress fell in deep, shadow-catching folds, or there was deep cutting to be attempted between the legs of horses, or even undercutting, since some of the metope figures seemed to spring clear of their background, then the bow drill was brought out. An assistant spun the shaft, and rows of close-set holes were drilled straight into the surface to define masses which could be safely broken away, leaving the chisel to finish the folds in drapery, or intricacies of anatomy.

The metopes were ready. The frieze had its own problems. The relief was shallower, the figures shorter, but the execution was the same. The great unified theme needed careful planning in the placing of figures and their numbers. For the west end the artists had been able to enjoy some freedom in the planning and execution of figures on each slab – 'two horsemen and a youth', 'a horseman, a youth and a marshal', 'a bearded horseman' – though specifications of dress were still important. It was going to be more difficult on the rest of the frieze which was more crowded, and it looked as though much of it might have to be carved on the slabs after they had been set on the building itself, high on the scaffolding forty feet above the marble pavement.

For the pedimental figures planning had barely begun and the procedures of design and execution would be far different from those for the reliefs. They too would be carved here, on the Acropolis: it would be too difficult and dangerous to move the finished marble figures, over life-size, any great

XI Attendants with cows for sacrifice
(figures 112–114; slab XL) in the south frieze 33

distance from workshops to their final resting place. And this would mean that once they were finished they would be appraised and enjoyed at close quarters, before they were set high on the building. Iktinos had predicted well enough the exact dimensions of the gable opening in which they would fit. The subjects were agreed, but there was some room for discussion about the number and identity of the figures to be carved. Here special considerations of cult and history had intervened which meant that these would be crowded compositions, more crowded than any yet seen on a Greek temple. They would be carved wholly in the round, to stand on the three-foot-deep pediment floor. Iktinos was anticipating the problems posed by the extra weight of the central figures by planning for iron bars to be set in the floor, to carry some of the load back on to the rear wall of the pediment and not leave it to be supported wholly by the projecting floor. Small clay models had been prepared to test how many figures, in what poses, might be set in the awkward, low triangular field. Once these were agreed the overall dimensions for each figure could be determined, the marble blocks for them chosen and inspected. But it would be long before point or chisel would be set to them and their delivery could be long deferred. For each figure a full-size clay model had to be created, worked on a wooden and metal frame to ensure its survival through the months that might pass before it could be dismantled. Some of the broader modelling would be left to apprentices, but the master intervened at every stage to check pose and proportions and eventually to check and execute detail. The process was familiar enough despite the relative lack of experience in Athens in the production of major sculpture in marble, because it was exactly that required for the creation of bronze statues, and for Phidias' team the Marathon group at Delphi and the colossal Athena Promachos on the Acropolis had required just such models, from which the bronzes were cast, albeit piecemeal. The translation to bronze was direct. The translation to marble, an inferior material in the sculptor's eyes, but necessary for this setting, was no less demanding technically and far more laborious. An array of plumb lines, setsquares and drills, frames and tripods, were required to enable the masons accurately to predict, and sometimes to mark by drilling, significant points in the marble block to which they could safely work before the desired, ultimate surface of the figures was approached. By then there was need for yet more precise measurement to determine the set and placing of features, or locks, or dress, or limbs. In the final stages the masters would take over and, however painstakingly completed had been the stages executed by other hands, it was theirs that revealed the finished surface, and added the ultimate detail to what in outline had also been the master's design.

It would be years before the gable figures were ready. When they were, the minor errors of measurement or pose would be revealed, and slices discreetly cut from bases or backs so that they could fit each other in their appointed places under the sloping pediment roof.

The final preparation of the sculptures before installation was not simply a matter of carving or adjustment of size. There were accoutrements to add in metal – a horse's harness, a spear – for which drill holes had been left in the stone. These had to be cast or hammered and affixed. And then came the paint. The surfaces had all been smoothed, the flesh parts received a slightly higher polish and would be left in the plain white marble, but dress, weapons and backgrounds had to be painted, and the waiting metopes had already received their colours. A dark red background helped to lift figures even more realistically off the stone. Reds, blues and yellows picked out the dress and trappings, and the hair, eyes, brows and lips of the figures were painted so that their features stood out boldly even at the great distance from which they would ultimately be viewed. And on the dress intricate patterns were depicted, borders and figures. Little matter that they would no longer be seen when on the building. For the perfect building the execution and finish claimed perfection too. What the human eye might

miss, the divine might criticize. The backs of the pedimental figures would be carved and finished with no less skill than their fronts, but would be admired by mortals only for as long as they were visible in the sculptors' yards, or until time or impiety brought them down again, off the building, to instruct and delight even barbarian successors to the tradition that had formed them.

The already finished sculpture displayed to Athenian eyes a style and presentation not altogether familiar. Bronze statues from the same studios expressed somehow a different fire and presence, and those who had visited the Temple of Zeus at Olympia might have looked for greater nuances of emotion. But the pervasive effect was of calm control, even in violent situations such as those which were the dominant themes on the metopes. Here human and animal bodies expressed brilliantly motion or energy, or peace and repose, almost introspectively. The mortal figures behaved with the calm assurance of gods, and the gods fought or observed with an almost human indifference to their supernatural powers or immortality. Never before had the divine and human been so closely assimilated, even confronted, and the heroic figures, of which there were many on the metopes, and whose status lay between gods and men, seemed to demonstrate that spiritually as well as physically there was more in common between them than divisive.

The persistent theme was the naked male body – nothing surprising in that to the Athenians. Indeed, familiarity with nakedness was one thing which marked Greeks off from the barbarians. Not only did their athletes compete and exercise naked in public view, but the common dress for young men, a short cloak fastened at the neck, was totally revealing and there were no trousers, such as Persians wore. Even in battle only defensive armour, if it could be afforded, concealed bodies which moved the more effectively untramelled. The male body (not the female), completely bared, was admirable and admired. Lean muscled bodies had teased sculptors with their patterns of anatomy long before that anatomy was at all well understood. Before Marathon sculptors had been trained in a tradition which at first demanded the presentation of the body as a series of patterns, assembled in a manner which made it possible for a four-square, symmetrical figure to be carved with no more guidance than sketches on a grid drawn on the block sides, to determine the basic relative proportions. This the sculptors had learned from Egypt, together with the notion of making colossal figures of hard stone. Gradually, however, the patterns and masses of the body came to resemble life more and more – usually in unrelated details and still with a strict symmetry except for the few active figures, generally carved for buildings, which were little more than enlarged reliefs. The figures had symbolized live bodies without being lifelike, but from about the time of Marathon the function of the muscles and bones that created the admired surface patterns was appreciated, and by successfully denoting a shift of weight or balance in the standing figures the sculptors showed that at last (and in a way never seized by barbarian peoples whose monumental sculpture was so much older than the Greeks') their figures could express the structure, the inner life of the body, and not just its exterior patterns. For all this, of course, the naked male provided the ideal model, and the ideal male nude had become the archetypal image for god or man. The Parthenon sculptors carved as they had been taught. Phidias, by example or instruction, guided them to a common style, without eliminating individuality of execution. But life was studied now, not patterns learnt by rote. Yet it was not slavishly copied, and preoccupations of pattern and proportion were as vital to the sculptor as to the architect. Neither sculptor nor viewer considered what later generations might contribute to this craft, since for the period and purpose for which the sculptors had worked they expressed perfection, as they saw it and as they had learnt to create it.

The gaunt unfinished building was being assembled as a showpiece of architectural elaboration and of evocative narrative sculpture, expressing the power of the divinity honoured. But it was also a

house, and the only inescapable reason for a temple was the cult image of its god which it would protect. For the Parthenon an image was planned such as Greece had never seen before. The warrior goddess would stand nearly forty foot tall in her temple, her flesh ivory, her dress gold, her base, dress and armour decorated with yet more figures. The technique was an old one, and wooden, sometimes gilt figures could be given marble faces. But the scale combined with the materials was new. The old, quaint wooden statue had acquired its sanctity from its sheer age and appearance. The new one would demand, even impose, respect for its size and opulence, as well as the quality of its workmanship.

The building being prepared for its construction had to be secure. A fortune in ivory and gold would be handled and had to be accounted for. They said that Phidias, anticipating trouble, was going to make the gold removable so that its weight could be checked. Accountability was of more moment to many Athenians than artistry.

For the figure of Athena Parthenos, the maiden, a full-size model was also required. The flesh parts would be carved separately in ivory strips to be dowelled and glued together. From the dress, moulds would be taken so that the gold could be pressed and beaten upon them and then reassembled piece by piece; not on the model, which could not serve as mount since its material was insecure and impermanent, but on a wooden frame which copied it in all but detail of surface. There would be metal too, to cast and hammer, not least the gilt relief figures which would be applied to the goddess' shield (Phidias had in mind to have the shield of his bronze Promachos decorated in the same way); and inlays of coloured glass to be cast, of stone and wood to be carved.

In four years' time the cult statue should be ready and the temple ready to receive it. With so much of the building already standing, so much of its decoration already carved, there was a sense of euphoric anticipation in the procession this year. Many Athenians were proud and happy enough to share their city's wealth by being paid to work on the new temple. Already there was much to show for their labours and from the lower city it became possible to imagine how their Acropolis might again look, crowned by a temple which would be the envy of all Greeks. The city had had its problems, even defeats; its politicians could be devious; its empire was restive, but under control; last year they had promoted a joint Greek resettlement of Sybaris in Italy, a city whose name had become a legend for luxury and prosperity before the disaster which many interpreted as the just deserts for its pride. The mood in Athens was constructive, optimistic, but wary.

COMPLETION

'Really, Pamphilos, I have never seen a city so gorged with icons as your Athens. Everywhere I look, in your home, in the streets, in the fine buildings of your market-place, I see the stories of our gods and heroes, and your new great temple seems alive with them. I have never seen anything like it. We live well of course, if modestly, in Plataea; we admire good things and fine craftsmanship. The honours and wealth heaped on us by the Greeks in days when the Persian army was defeated on our land and my father was young have brought us a fine new temple of Athena too: but nothing like this. I know the stories, of course; I learnt them at home, at school, and I read the poets and listen to the rhapsodes at the festivals when they recite the epic poems about our past, but there is a lot here in Athens that I do not recognize or understand, and in the excitement of the great procession and sacrifice yesterday, I really couldn't take it all in.'

Pamphilos' guest was impressed, and puzzled. He had been invited to attend the Great Panathenaea in which the new temple to Athena was to be dedicated. Any Plataean evoked a natural sympathy in Athens, not least on an occasion such as this. Of all the Greeks the Plataeans alone sent men to fight beside the Athenians at Marathon – a small contingent, but highly valued and never forgotten. Of all the Greeks the Plataeans were remembered in the prayers for the good fortune of Athens at the start of each celebration of the Great Panathenaea. That festival had been celebrated thirteen times now since Marathon.

When the Persians had come again to Greece, and sacked and burned Athens, they had burnt Plataea too before they were defeated on Plataean fields. The Greeks had honoured the Plataeans for this, and gave them money from the Persian spoils to rebuild their city. Every year the Plataeans paid honours to the tombs of the Greeks who had fallen there, as to heroes, and every four years commemorated Greek deliverance from Persia with a festival, the Eleutheria. But in Athenian hearts they held a special place for standing at their side at Marathon. They too had built a new temple for Athena – the warlike, Areia – and for their temple Phidias himself had created a cult image: not as lavish as the Parthenos, but with gilt wood for her dress, and Athenian marble for her features, hands and feet, where the goddess in Athens had sheet gold and ivory.

Pamphilos and his friend returned to the Acropolis on the day after the sacrifice and processions. The rock still lacked any major entrance-way or other substantial buildings apart from the Parthenon, and closer inspection revealed that the Parthenon itself was not quite complete. Most of the work was still to be done on the pedimental figures, only one or two of which were in place, and the workshops would in a few days be busy again. The carving of the colossal figures was the most time-consuming of all the sculpture and required more regular attention from the master sculptors. The slackened tempo would mean a long wait before the last figures were raised and the accounts closed. But the giant workshop in which the gold and ivory cult image had been constructed, before being dismembered and reassembled in the temple itself, had already disappeared. In all other important respects the temple was complete and, the vital factor, the image of its goddess had been installed and consecrated.

Athens' priests, poets and artists had always taken an original view about the stories of their past, of the age when heroes and even gods might walk with mortals. The stories were part of their history and some Athenians could trace their families back to divine or near-divine ancestors. But it was a history which was not so much known or even recorded as revealed. It provided them with a constant example and parallel to contemporary events and problems, and it was natural to view the present in terms of the past, which could serve as a guide or warning, even a promise for the future. The stories were passed by word of mouth, learnt as one learns the techniques of living, but an oral tradition is an ever-shifting one, prey to variations through inventiveness, to a desire to introduce a topical new element, to inaccurate or muddled memories. The stories were more formally expressed in poems, hymns and plays, but performances were few and far between, and reading was boring and difficult. There was no absolute version of any story and part of the joy of hearing them, at home or at a public festival, was the excitement of discovering novelties which might shock the conservative, or seem suddenly right because relevant. The creation of such novelty was not a question of tampering with truth, but of helping to create a past which had meaning to the present. Poets could be liars, but their inspiration came from the gods. Moreover, familiarity with the stories was daily strengthened by familiarity with images – well-known ones like the hero wrestling with a lion which provoked the instinctive response 'Heracles', but also more obscure ones where visual signals of dress or behaviour, sometimes helped by inscriptions, gave the clues. These were not puzzle pictures since they appeared in and for the society

for which they were created, whether they were painted on a water jar or carved on a temple. The level of understanding differed, of course, from child to labourer to bookish adult, but the general message was clear – here are the gods and heroes of our past performing to please and instruct us, to warn us or protect us. The fact that the message was different at different times to different people, did not mean that it was misunderstood, and the fact that one image could carry many messages enhanced its value rather than turned it into an intellectual game. But Athens was supremely rich in these images. At this time no other Greek city had painted scenes of gods and heroes, as well as scenes of daily life, on mere clay jars, let alone on the wooden plaques and panels that hung on walls or the many more expensively decorated objects of gold, silver, or bronze. The images that an Athenian accepted and understood could not all of them communicate as readily to a Greek from another city, except of course for those images which employed the conventions of pictorial narrative common to all and in the service of the best-known stories. There were figures and stories and allusions that belonged to this time and city only, and even a Heracles could seem a very different hero in his Boeotian home, while the Theseus that the Plataean had seen on the walls of buildings in Athens' market-place was by no means the hero he knew from stories and pictures. No wonder he was puzzled.

As the two friends approached the Parthenon and looked up to its western gable they saw only two figures in place, at the centre. 'Yes, Pamphilos, I see your Athena, and there is Poseidon with his trident, but they are quarrelling and I don't know any such story. Poseidon was for the Trojans, of course, and Athena for the Greeks, but surely they never fought at Troy. And Poseidon is the father of your Theseus and has been worshipped on your Acropolis, though I know he is not held in as much honour in Athens as he is in some other Greek cities. Forgive me for pestering you with questions but please tell me why? – when?'

'I see your problem; it would have seemed odd to us some years ago, but our priests find that Poseidon once claimed our land of Attica, and even threatened to flood it if he did not have his way. But Athena fought him and promised us the olive – you can see it up there too, and her tree there to our left: that proves the story. Zeus parted them and awarded her the prize but left Poseidon his due share of worship here as well. High between them Phidias intends to put a golden thunderbolt to show Zeus' judgment. It will make a fine showing in the rays of the evening sun. As for Theseus, somehow our songs and hymns tell less of him now than they did when I was a child and when those paintings that you saw were first displayed. We think as much of others now – you heard them honoured in the hymns yesterday – our old kings and heroes of Athens and the Attic land. It is their figures that will fill the rest of the gable, but now you can see only the models for most of them and certainly would not be able to identify them without my help. They have not yet even chosen the blocks for most of them on Pentelikon.'

The subject in the gable at the front, eastern end of the temple, presented no problems. It was, as the Plataean recognized, another statement of Athens' origins, this time the birth of her patron goddess, possessor of temple and city. She stood fully grown and fully armed before Zeus, having sprung thus from his head in the miraculous birth, helped by the axe of the god Hephaistos, who appeared also, starting back. This was a well-known theme throughout Greece, and, as expected, the divine birth was attended by other gods and goddesses on Olympus. For these figures Pamphilos had to turn to the workshops where the guest marvelled most at the almost languid sensuality of the goddesses, a mood he had never encountered before in images of the divine. Pamphilos named figures readily but they lingered over one whom the Athenian named as Dionysos – 'Look, he is seated on his panther skin.' 'We know Dionysos well enough,' his guest replied, 'indeed it was from us that you learnt of the god.

But here he sits apart, looking away from the birth, and he seems so youthful, not at all like the master of the vintage and ecstatic revels that we know.' 'You are right,' said Pamphilos, 'but remember that Dionysos was a newcomer to Olympus, and on the temple he will be looking out over the edge of the Acropolis towards where his temple lies on the lower slopes. We know of those wilder aspects of his worship as well as you, but it is for him that our poets offer their plays each year, and in his honour they stage their stories of gods and heroes. You should have seen Sophocles' play about Theban Antigone two years ago. It troubled the heart and conscience of us all. The festival is in the spring and we have a procession then, more exciting than yesterday's, passing through the market-place to Dionysos' temple and the theatre above it, paying respects to the shrines and altars along the way, as we did.' 'I can see, Pamphilos, that Dionysos too has many different faces for us Greeks.'

They turned back to the temple to walk around the outside, viewing the sculptured metopes, and the Plataean marvelled again at the pictorial wealth of the building. 'We can leave the south side,' said Pamphilos, 'you can see it later. It is the old story of the Lapiths fighting the centaurs at the wedding feast of Peirithoos, which they had disturbed by their drunkenness, and at the centre is a clutch of slabs from an earlier scheme for decorating the temple, that do not make much sense because the series is incomplete. There is a grand centaur fight on Zeus' Temple at Olympia, you know: ours is fine enough but is just a series of duels. It shows us all how civilized Greeks can triumph over the wild and uncivilized – a simple message we all understand. But come along to the temple front again and look above the columns, at the metopes. The battle of gods and giants is an old and loved story – you saw it woven on the robe we gave the goddess. The Olympians defeated the powers of darkness as triumphantly as the hero Lapiths did the monstrous centaurs, and as triumphantly as our grandfathers, Athenians and Plataeans, drove off the Persians from Marathon years ago. Pericles, the priests and Phidias chose this pattern of stories to remind us how mortals can sometimes rival even divinity when their struggle is just, as ours was, and I know that any Plataean like you will share with us a pride in Marathon greater even than in that other battle, the last in Greece against the Persians, fought near your home.'

'Yes, Pamphilos, we remember, and the way your festival and temple call back those heroic days is inspiring. They say that gods and heroes long dead joined in the fight for Greece that day.' 'I know,' said Pamphilos, 'but there is yet more here to answer pride in our city and what its fighters won, as you will see. Look now along the north side.' 'Troy sacked,' said his guest, 'of course I know the story well and recognize the icons – the Greek ship, Menelaos threatening Helen but Aphrodite saving her, Aeneas escaping with his father and son. The songs of Homer and the other poets tell a sorry tale for Greeks which I never tire of hearing and seeing.' 'Yes,' said Pamphilos, 'in this we Athenians see the sack of a mighty city, as ours was sacked, and we see cruelty and hope, and we see how those who conquer through right can wreak vengeance wrongfully, how those who deserve defeat can still behave with honour and win respect. Our playwrights could not create a more troubling story, and they turn often to its themes. It was all the gods' will, of course, and gods fought beside both the Greeks and the easterners on the Trojan Plain. At the right there you see the gods who supported the Greeks, and on the final slab our Athena standing before the mother of the gods, Hera.'

They passed round to the west end, beneath the gable where Athena and Poseidon waged their timeless battle for Athens. 'The fight with Amazons,' cried the Plataean, 'but where is Heracles? And I see you dress your Amazons like Persians; I know the costume from pictures and the rich garments displayed with the Persian spoils in our temples at home. This is all new to me.'

'It is a complicated and fascinating story,' said Pamphilos. 'After we sailed with the Eretrians to help

our Ionian kin, and marched on the Persians to burn their city at Sardis, the start of all our troubles with Persians, ours and yours and all Greece's – our priests found that Athenian Theseus himself had joined Heracles' famous expedition to the east against the Amazons long ago; and then that the Amazons had invaded Attica in revenge, just as the Persians did when our grandfathers fought them. But the Amazons reached Athens and had to be driven back from the Acropolis by Theseus and his hero companions. This is the battle we celebrate here.' 'But where is Theseus,' asked the guest, 'and will I see him also in the centaur fights around the corner?' Pamphilos, for once, had no answer ready. 'Somehow', he said, 'we have come to think less of Theseus, just as Heracles too figures less on our icons now than he did in our fathers' and grandfathers' day. Perhaps we had too much of him – some have even doubted his Athenian blood, you know.' He paused. 'But here we can start looking at the great frieze. If you look up between the columns . . .' 'I know,' said his guest, 'I saw yesterday how your sculptors had decorated the top of the wall behind the columns, and I was amazed, for I had never seen a building with such a frieze. I looked for a battle or encounter of gods and heroes, and instead I seemed to recognize Athenians in a procession to their goddess. I must confess I was a bit afraid you might pay the price of arrogance, but at this end of the building all I see is a grand cavalcade of heroes, not warriors, it seems. And it runs on along the sides, and there in front – I understand now – the chariots with men leaping from them. These are the holy exercises we saw in the procession where it crossed your market-place, where we paid respect to the graves of the long dead. In front come the officials of the procession. I see your elders, musicians, the animals of sacrifice, water-carriers. I recognize all this, but where are the citizens, the soldiers?'

'Think,' said Pamphilos, 'of what we have seen already on our temple. Think of why you are here, a Plataean. Have we not many times already mentioned Marathon and recalled our stand against the Persians. The first temple that we started to build here was for Marathon, but the Persians destroyed it, and over there stands the great bronze Athena Promachos built from the spoils of the battle. Our common stand at Marathon inspired Greece and surely determined that we were fated to lead Greece to final victory.'

The Plataean was slightly disturbed by the vehemence of the young man's pride, but was too polite to allude again to Athenian arrogance. 'Our goddess, through us and our heroic dead, saved Greece,' Pamphilos continued, 'and each year we go to Marathon to give thanks and worship at the tomb of our dead, just as you do at the tomb of the Greeks who fell at the last great battle at Plataea. It was their sacrifice that led eventually to this' – he gestured at the whole great building, gleaming in the morning sun with a brilliant reflection of fresh-cut marble, garlanded with its coloured sculptures. 'We fought at Marathon . . .': even those who were not born then seem to claim the glory still, thought his guest. 'We fought at Marathon, and won; we led Greece to final victory, and we reward ourselves and our goddess with this temple.'

'Our Marathon-fighters had celebrated the Great Panathenaea hardly more than a month before the battle: did you know that? The goddess' blessing was still fresh on them. And so we celebrate the dead both at their graves and in this memorial to that holy day. We come close to the heroes of our past on these occasions. Those men and boys certainly did when they went from worship to battle, and showing them in the hero races and chariots makes it clear enough that this marble procession is of no ordinary Athenians. They say that if you count them – but my neck aches staring up at them too long and we can trust Phidias to have seen that things are as they should be. But have you seen where the cavalcade is being led?'

XII Centaur and youth on south metope 31
XIII Detail of centaur on south metope 31

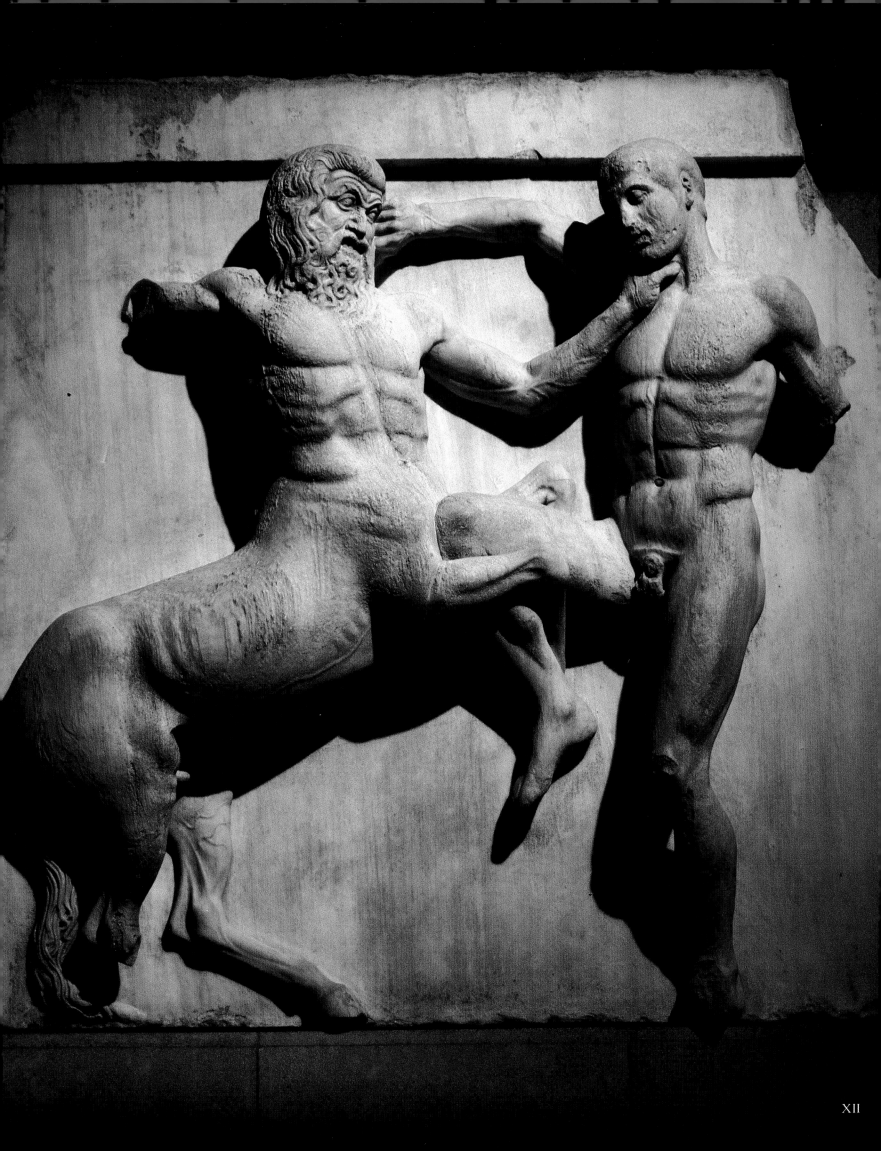

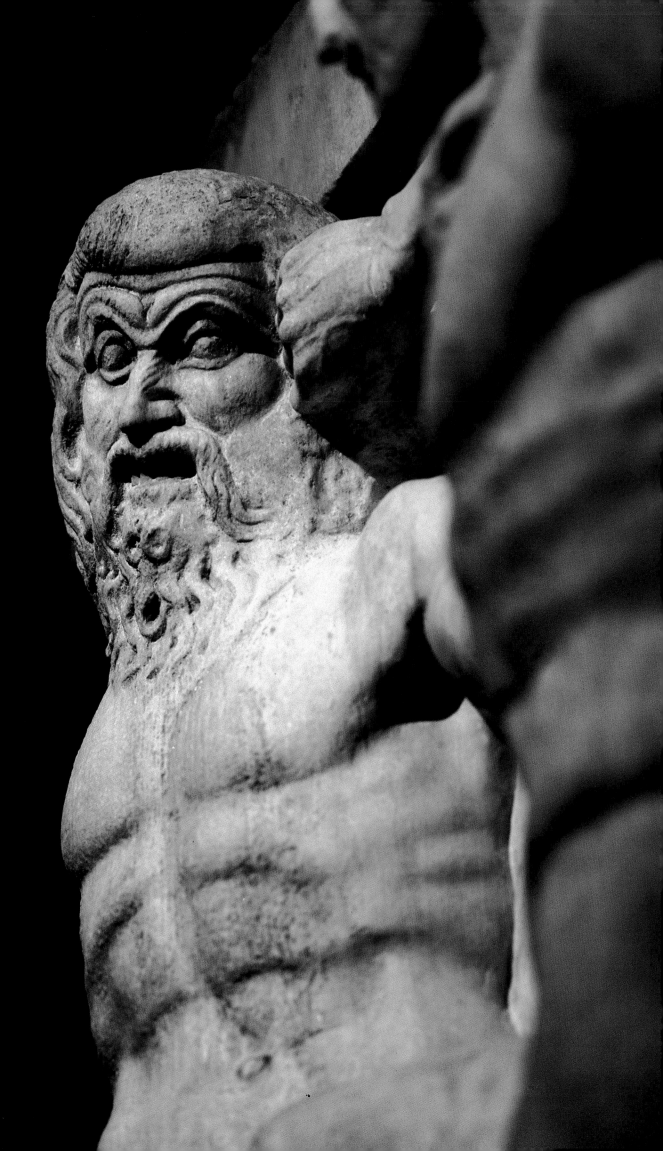

XIII

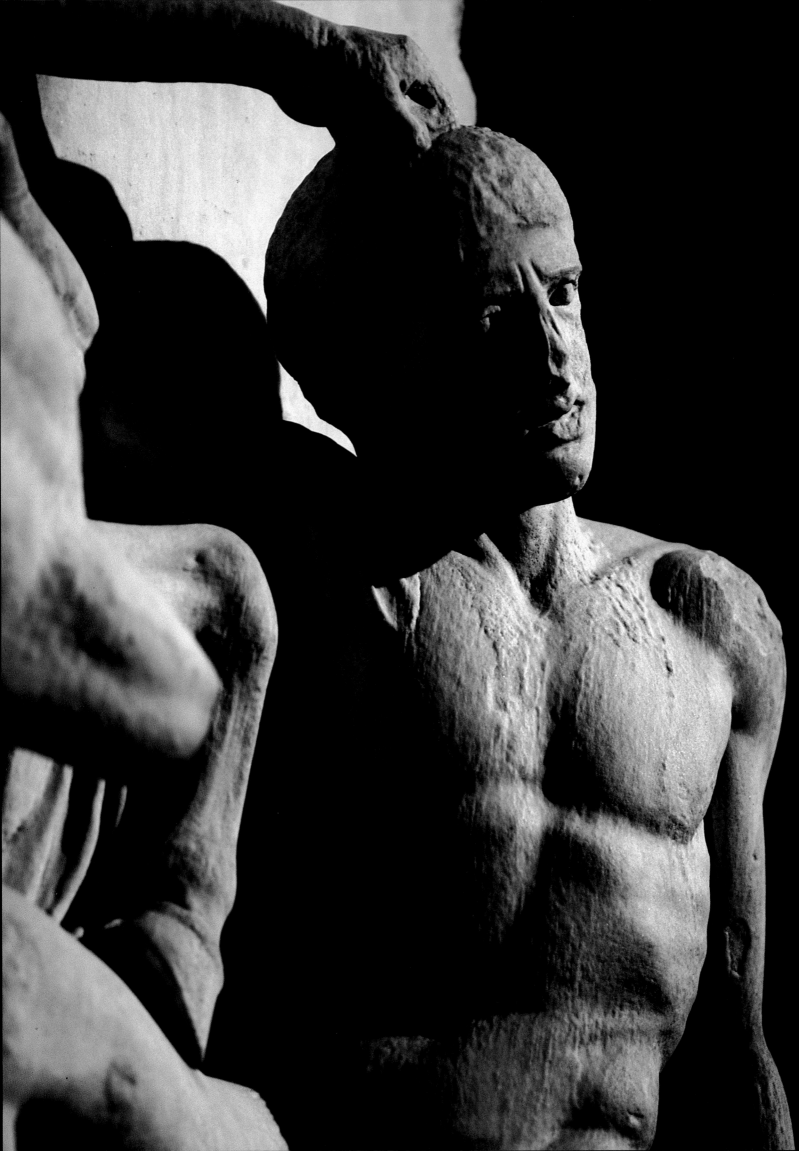

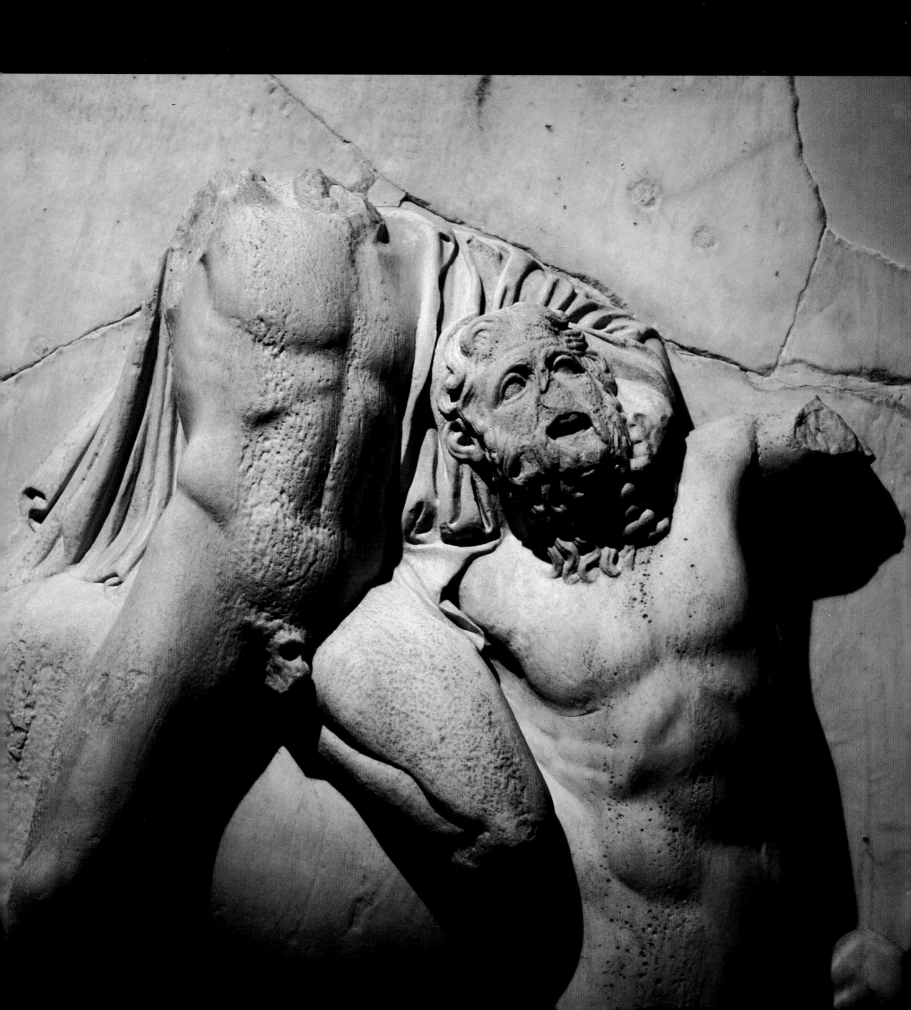

They moved to the front of the temple again, and spent a while moving across the façade, peering up between the columns. 'Now I understand,' said the Plataean, 'we are in the market-place and there in the centre the sacred robe is handed to the magistrate, with the priestess and attendants with their stools. But the procession is greeted by the gods, just as we visited their altar in the market-place – another novelty for me, Pamphilos, an altar for the twelve Olympian gods. Our poets tell us they are a family, but we have never worshipped them other than as individuals, for their special gifts or as guardians of our cities. I recognize them all, I think. They look wonderfully alive, yet more than mortal. There is Hermes, his travelling hat on his lap, nearest the mortals as usual, and I suppose it is your youthful Dionysos that leans in that familiar way on his shoulder. Demeter, the goddess with the torch; Ares with his spear; Hera and Zeus – they are easy, and the winged goddess beside them, Iris, or perhaps Victory in these circumstances. Then on the other side Athena – is that her aegis on her lap, snake-edged – I can barely see? Hephaistos has his crutch, then, I suppose, Poseidon. Apollo and Artemis, obviously, then Aphrodite and, how charming, Eros with her parasol. You do bring your gods down to earth, Pamphilos; don't you sometimes think you are too familiar? In front of the gods the groups of young and old men are, I suppose, heroes.' 'Yes, the ten who led our tribes.' 'And the women at the head of the procession are those I saw who attended the ceremony of the robe, and they seem to carry symbols of their work – those must be the legs of the sacred loom that we saw displayed. And along the south side, I see, the rest of the procession, rather as on the north. It all makes sense, Pamphilos, you are right. A brilliant way to celebrate the gods, your goddess, your heroes, your city. You must be very proud.'

It would take many more visits before the friends had exhausted the detail of the sculptures on the new temple, and for a while they stood before it, contemplating the Olympian messages of its façade. But there was more to see – the cult image of Athena Parthenos, the glory of the temple, the scandal, some said, of the whole project for its opulence. They approached the porch, already festooned with a selection of Persian spoils dedicated to the goddess, and stood before the open doors. The interior was lined with a double tier of columns and, at the back, the goddess seemed to dwarf even the massive architecture of her house. Light from the windows at either side of the door filtered through the colonnades within, and light from the door played on her, some reflected up on to her dress and features from the shallow film of water on the floor before her. Pamphilos explained that this would keep the ivory from cracking, but it also reflected an unearthly, pallid light on the image itself. The first impression was of size, then of gold, gleaming from her armour and dress, then, as their eyes grew accustomed to the shady room after the sun outside, the warm flesh tones of the ivory, the colours of wood, glass and stone on the dress, armour and base. Victory had alighted on the palm of her outstretched right hand. Her shield stood at her side, its rim held steady by her left hand, and within was coiled the great serpent. 'They say our earliest kings were snakes,' explained Pamphilos, 'and some show them with snake legs even now. King Erechtheus was a serpent. He had been protected by Athena, and he introduced her worship to the city, built her oldest temple, first harnessed four horses to a chariot. I told you how much we now hold in honour our earliest kings and their hero sons. They too were close to our goddess; they taught us about her power and showed us how to win her favour.'

They moved into the side colonnades for a closer view of the image. It seemed alive with figures. The helmet had three crests, raised on the figures of recumbent sphinxes, its cheekpieces bore griffins, its peak the foreparts of winged horses, silvered, gilt. The thick soles of the goddess' sandals carried a

XIV Detail of youth on south metope 30
XV Centaur and youth on south metope 2 45

fight with centaurs, and there were other echoes of themes the friends had admired on the temple exterior. Within the hollow of the great shield, as in the vault of heaven, was painted yet another battle of gods and giants, and on its exterior gilt bronze figures were attached to narrate another fight with Amazons. The warrior women were not on horseback here, as they had been on some of the metopes, but seemed to battle their way on foot up the shield, as to the Acropolis, and were hurled back by the Athenians. The guest forebore to ask where Theseus was this time, but could not resist some speculation about the names of the heroes.

Before they left the building they turned again to the image and Pamphilos drew his guest's attention to the statue base and the figures on it. 'Now this is something I can understand,' was the response, 'for our poet Hesiod sang of Pandora – I had to learn the poem – the woman created by the gods and endowed by them with all qualities and gifts to offer man. But, Pamphilos, she was the deceiver of mortals, of Epimetheus, just as his brother Prometheus had been deceiver of the gods, persuading them to take from the sacrifices of animals only the inedible bones and fat, and so she withheld Hope from mankind. I cannot understand why you have her story on the base of your goddess, and it seems I must end our visit to your temple with questions, as I began it.'

'I know the tale,' said Pamphilos, 'but we have a different one and we view Pandora – sometimes we call her Anesidora – in a different light. She was fashioned by Hephaistos from clay, dressed by Athena herself, who gave her the skills of weaving. Then the other gods blessed her with all the gifts that mankind requires for a life of god-fearing peace. These were also their gifts to us Greeks, just as Demeter taught us how to grow crops, Hephaistos how to forge weapons, and our heroes how to use them. She symbolizes for us those gifts of peace, for which we bless our goddess, as much as for those more warlike ones which have proved Greece's salvation, and which we celebrate elsewhere, in other ways. Athena is a warrior, but she is also a woman. She strengthens our citizens' right arms in the fighting line, she counsels their wives at the loom and in their homes. She is served by women, as you have seen in life and in marble – the priestess, the girl delivering the robe, the weavers of the robe, our sisters and daughters who stand with jug and bowl for the libation of sacrifice, greeting and victory. You have seen the gods, in the gable above us, attending the newborn goddess; in the metopes there, defeating the giants; in the frieze over the porch, greeting our heroic forefathers; and now here, on the goddess' base, bestowing the gifts of peace. Athena is everywhere with them, and yet above them since this is her house. Your Hesiod took a hard view of man's lot and his relations with the gods. I think we Athenians have come to feel more immediately the warmth of their favour and blessings. This is why we have survived, why we think of ourselves as natural leaders of those who share with us the Greek tongue, why we above all Greeks dare claim their patronage.'

The Plataean said nothing, and as they retraced their steps to the city below his wonder at what Athens had achieved in honour of their goddess was tinged a little with apprehension at what they might be courting from jealous gods or jealous mortals, and he thought of the wealth contributed by Greek cities that lay in the treasury behind the goddess. He knew the Athenian poet better than Pamphilos had guessed. *Wisdom is by far the better part of happiness and there must be no irreverence towards the gods. High-sounding words of proud men are punished by great misfortunes and, in old age, teach them to be wise.*

THE PLATES

The plates are numbered thus:

*Captions follow immediately after the plates
on page 209*

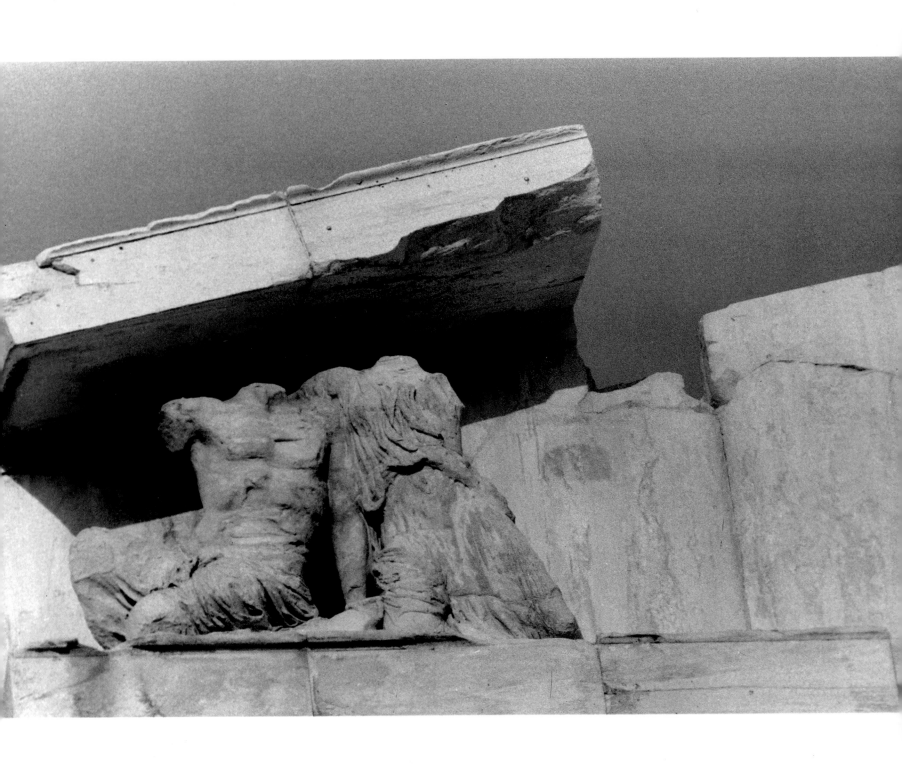

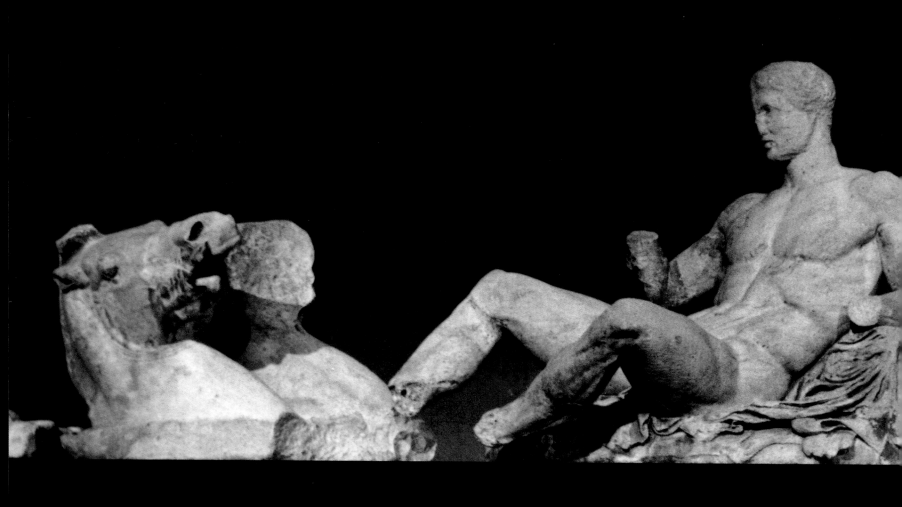

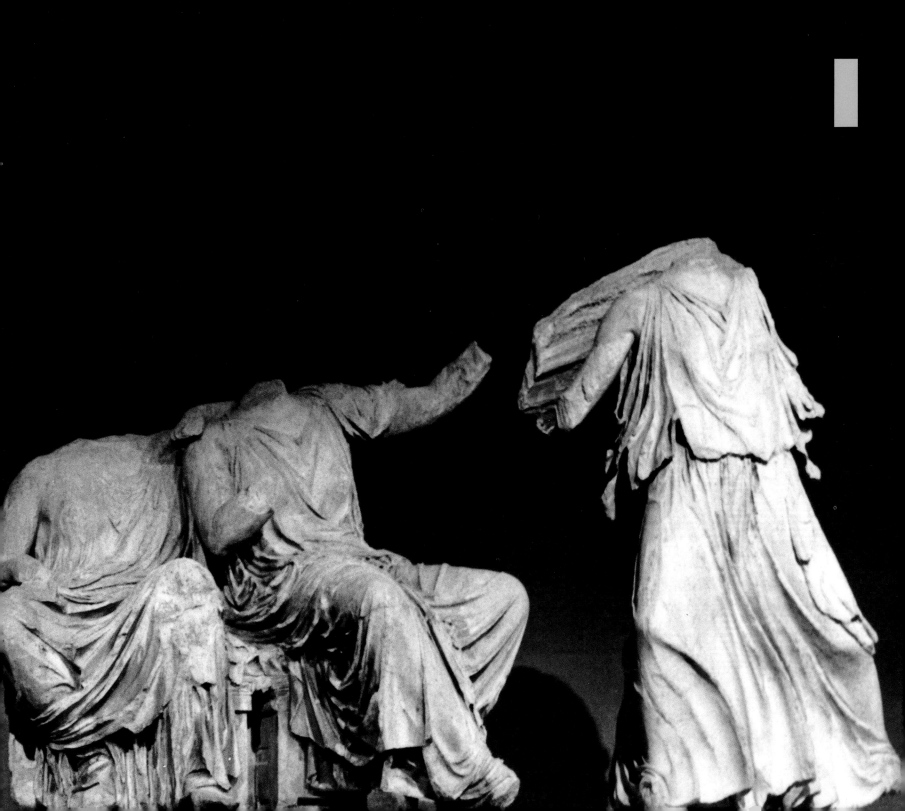

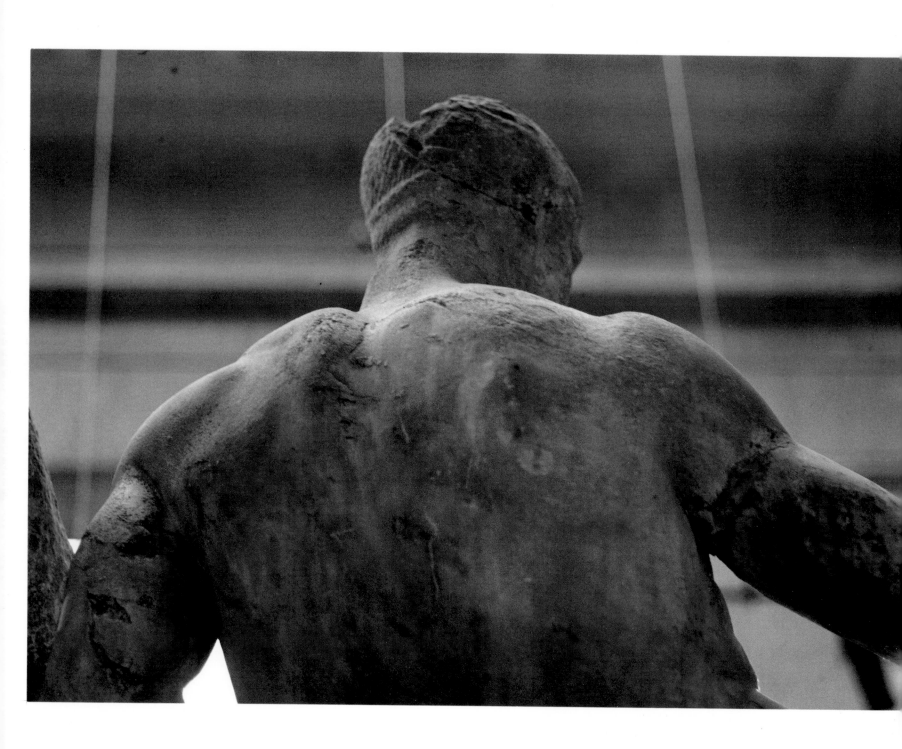

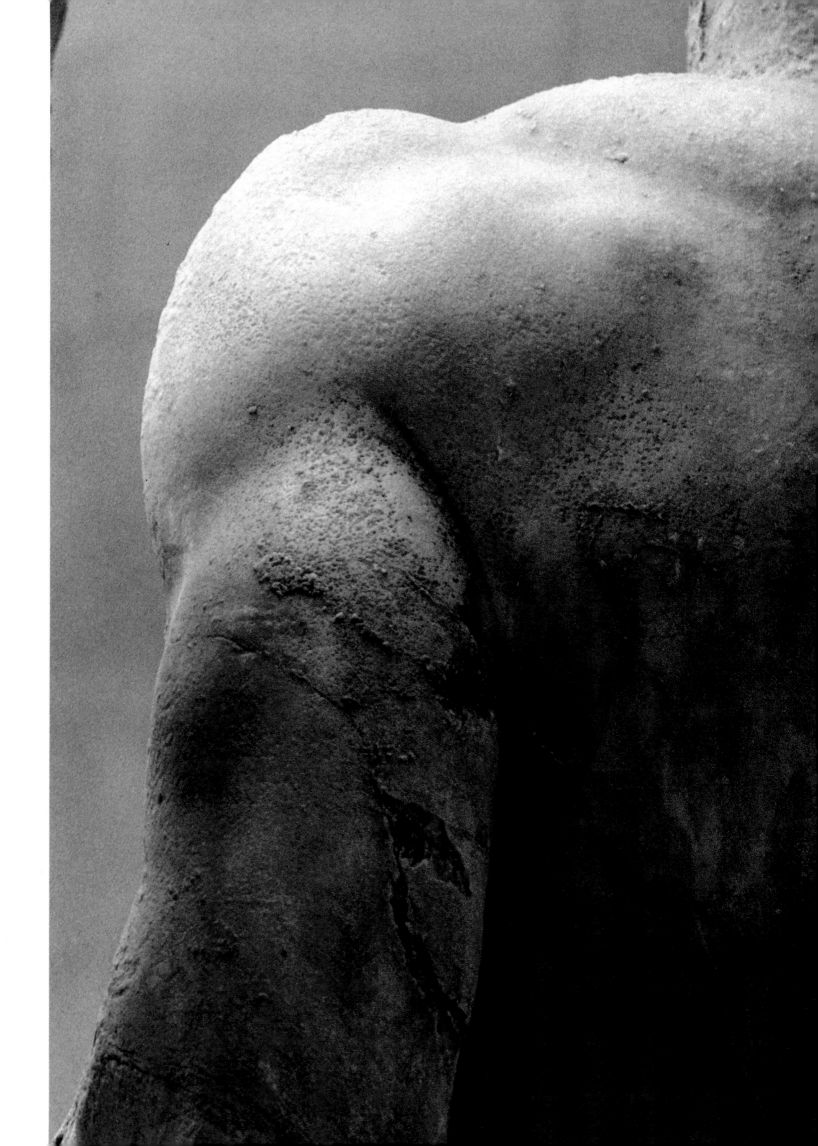

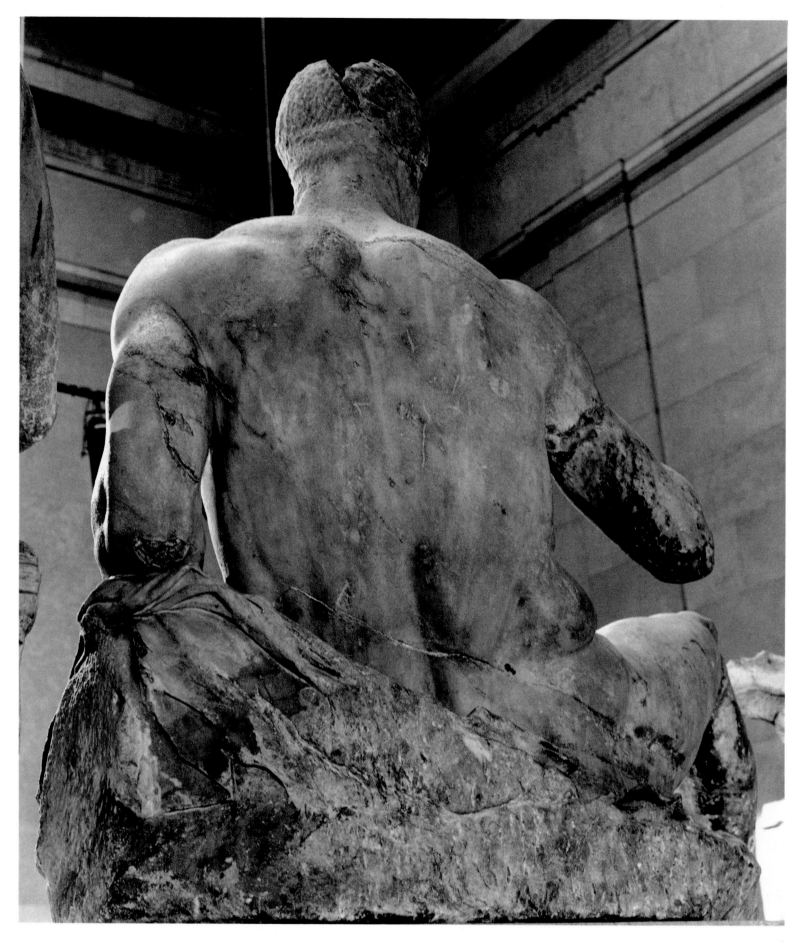

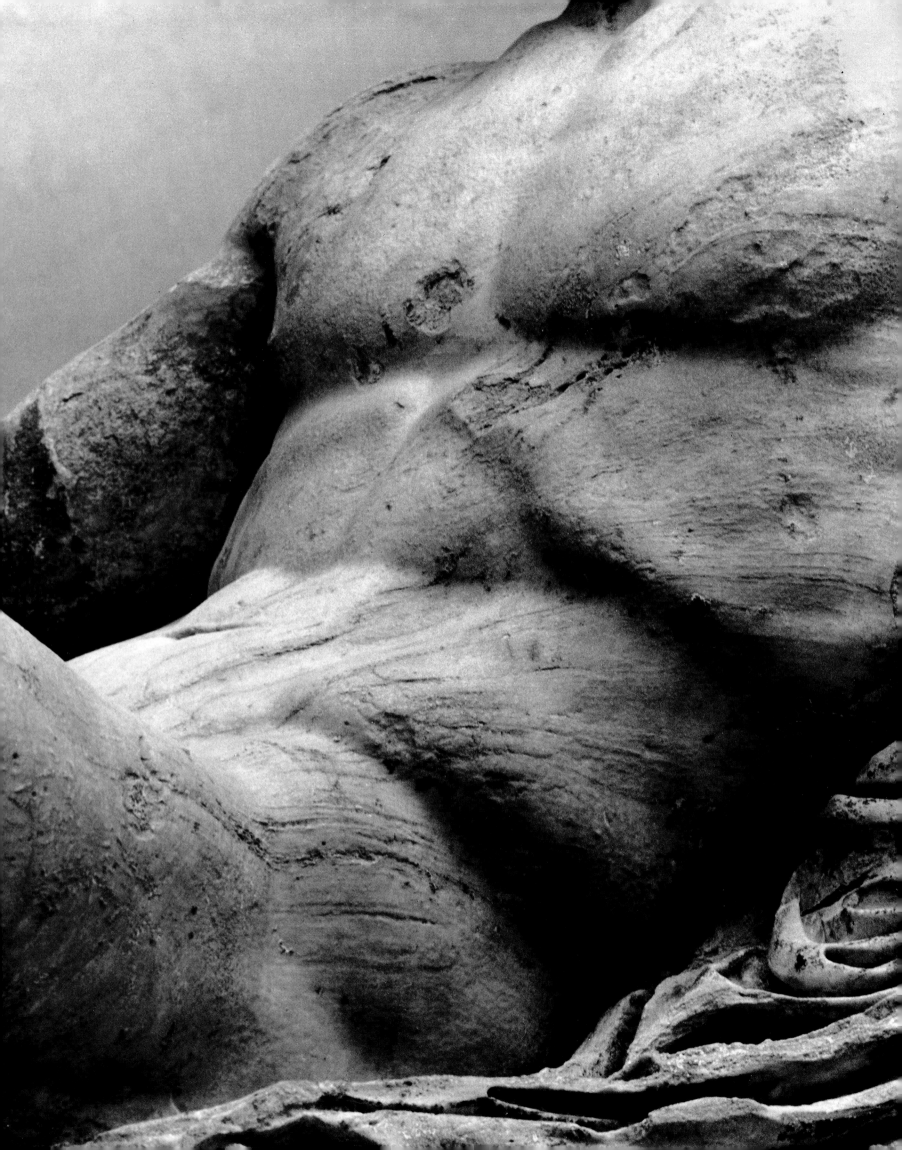

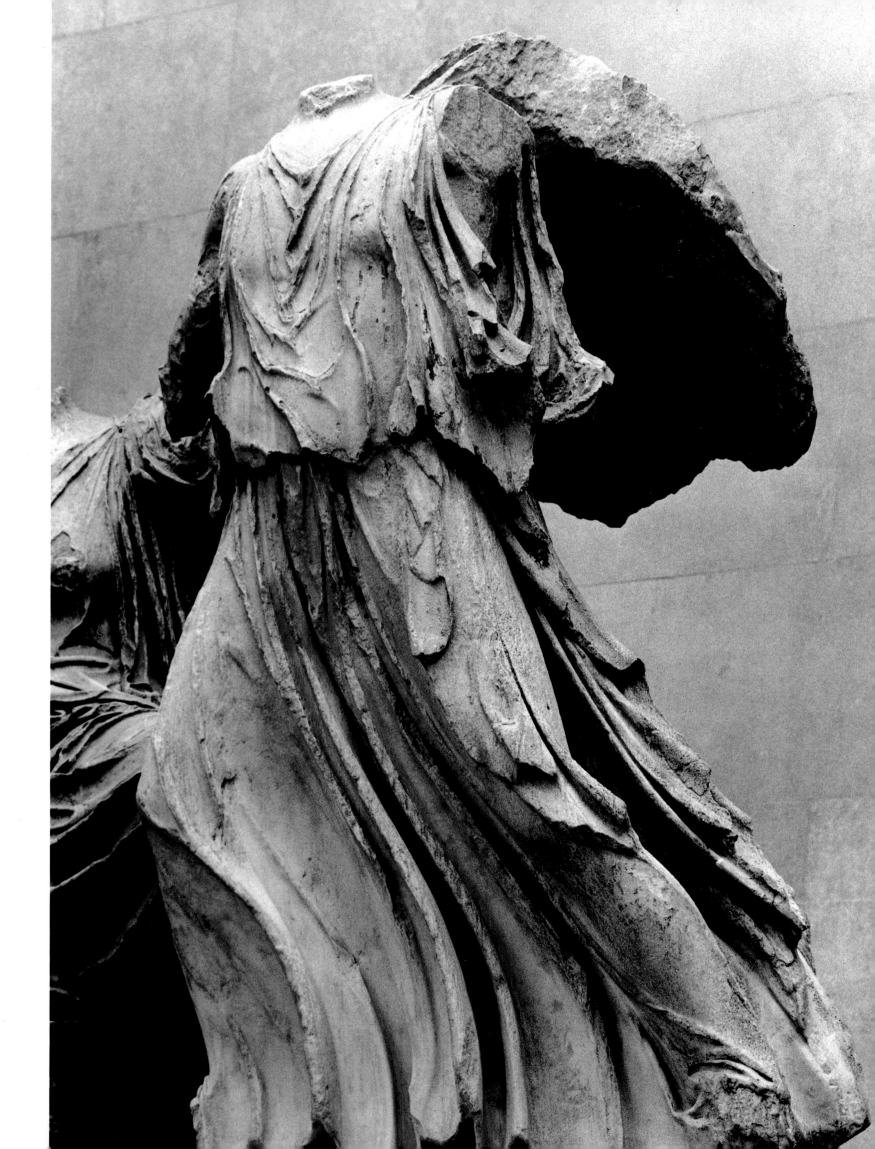

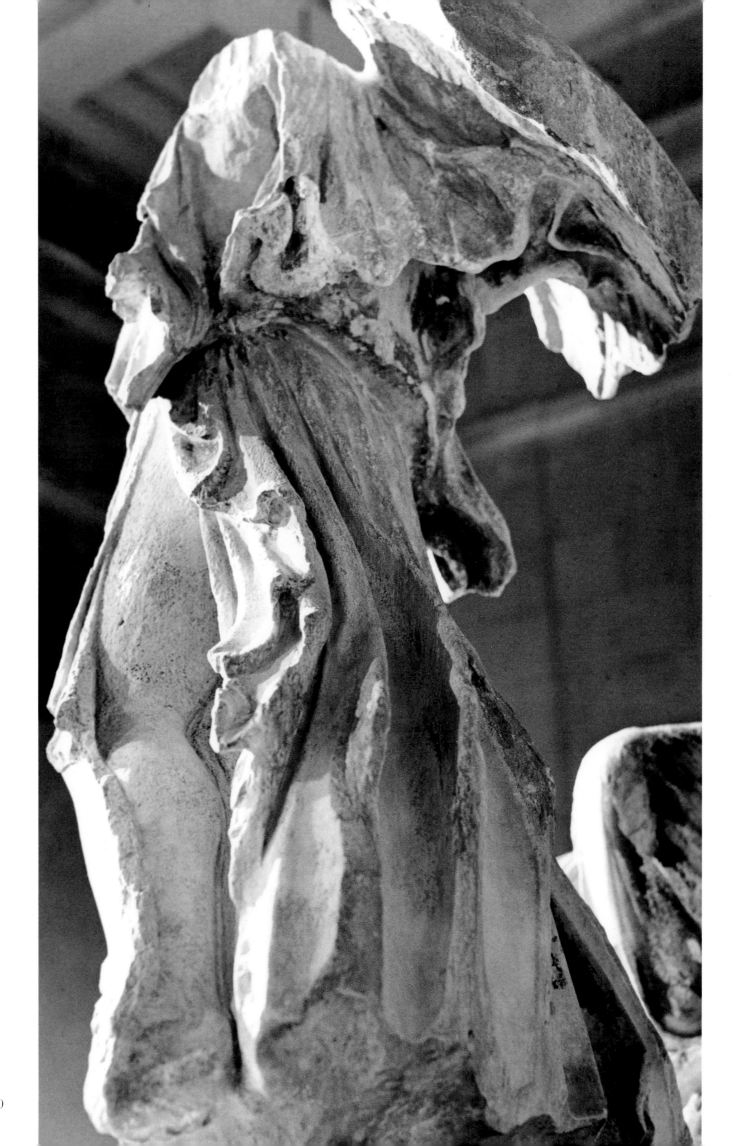

9 10

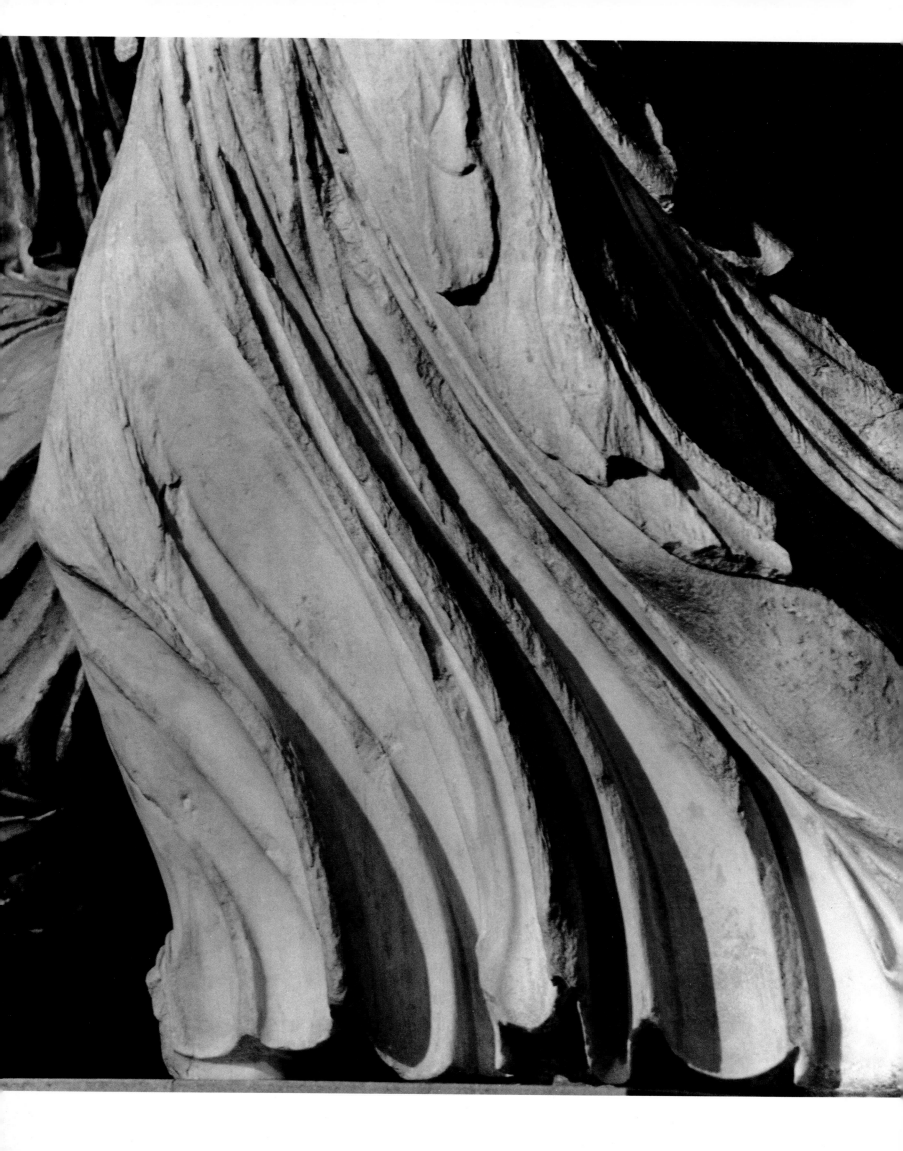

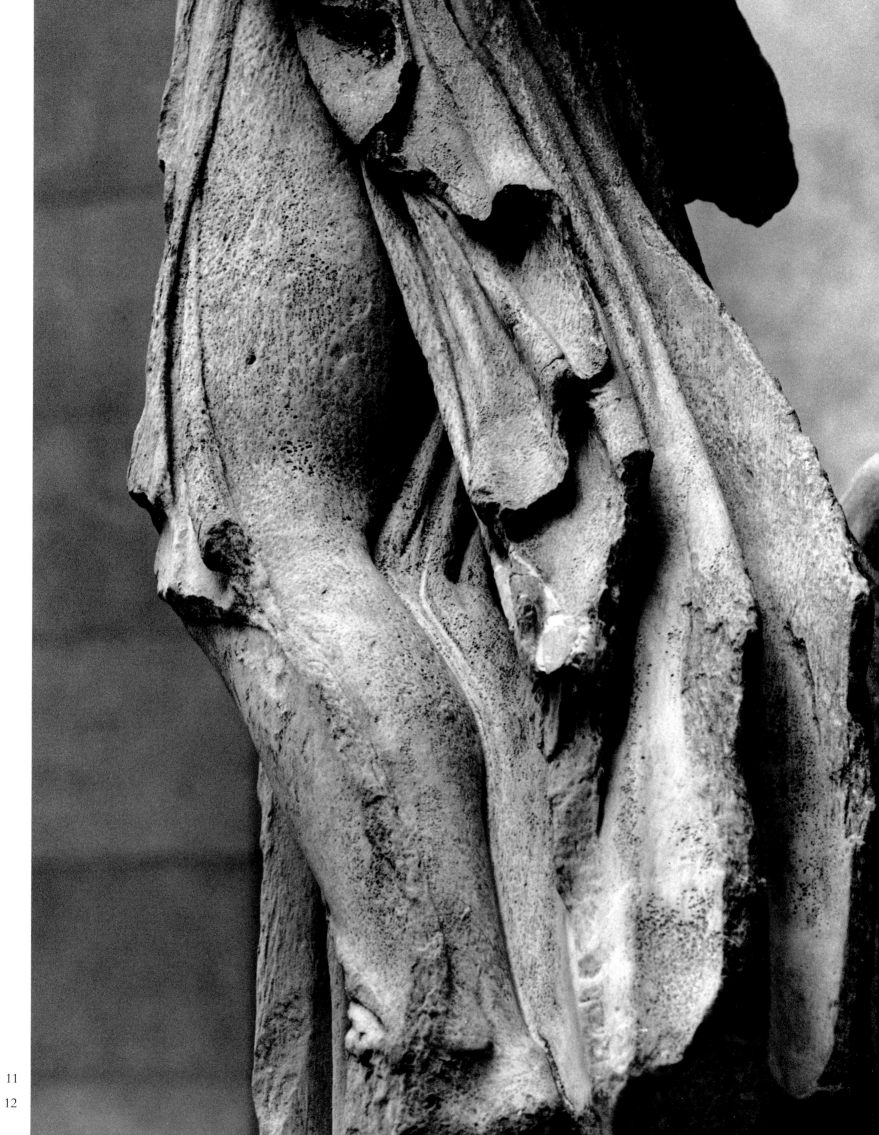

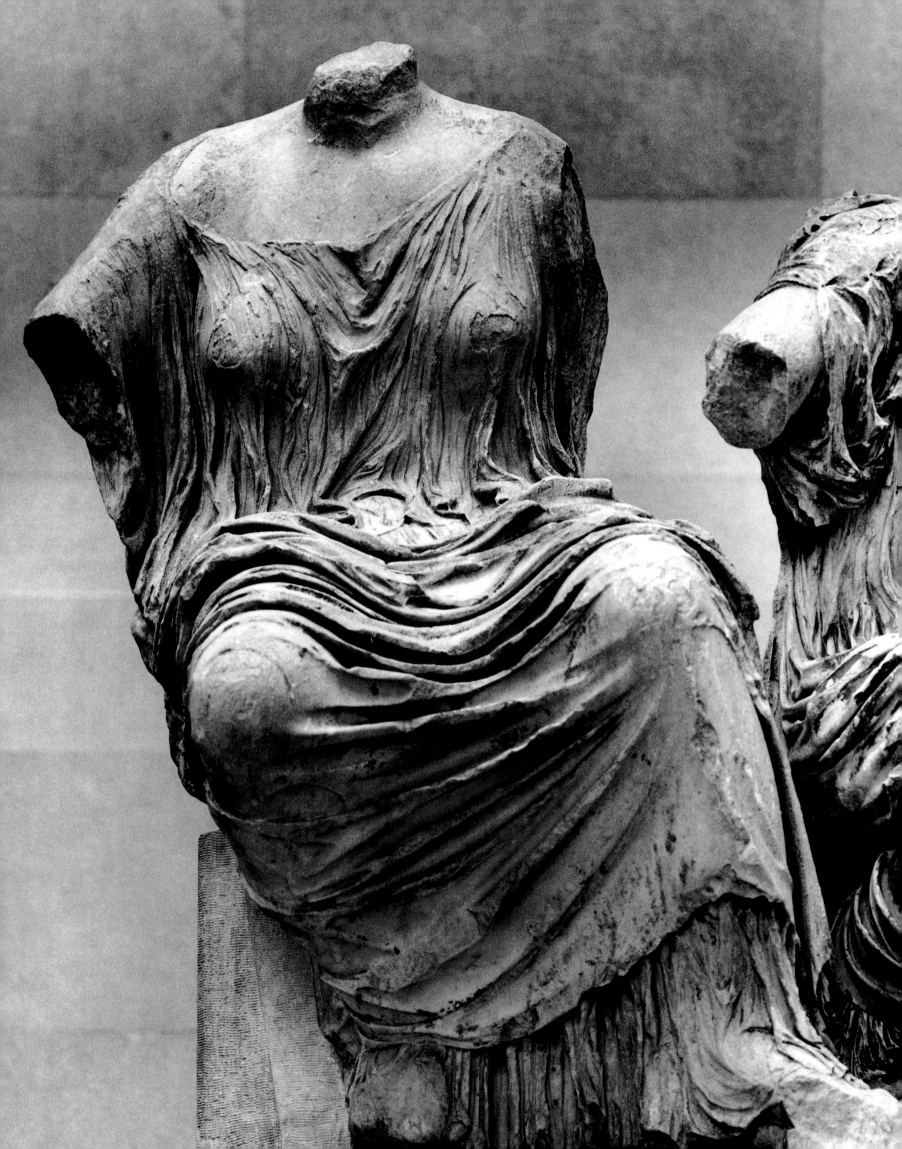

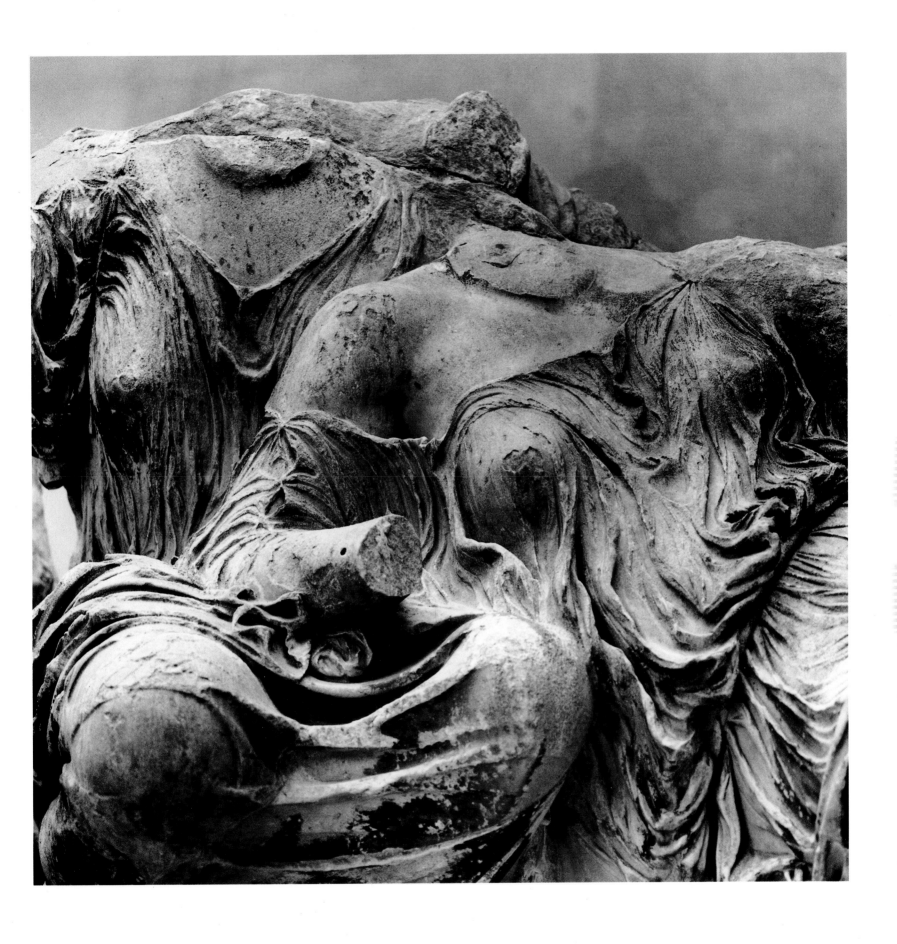

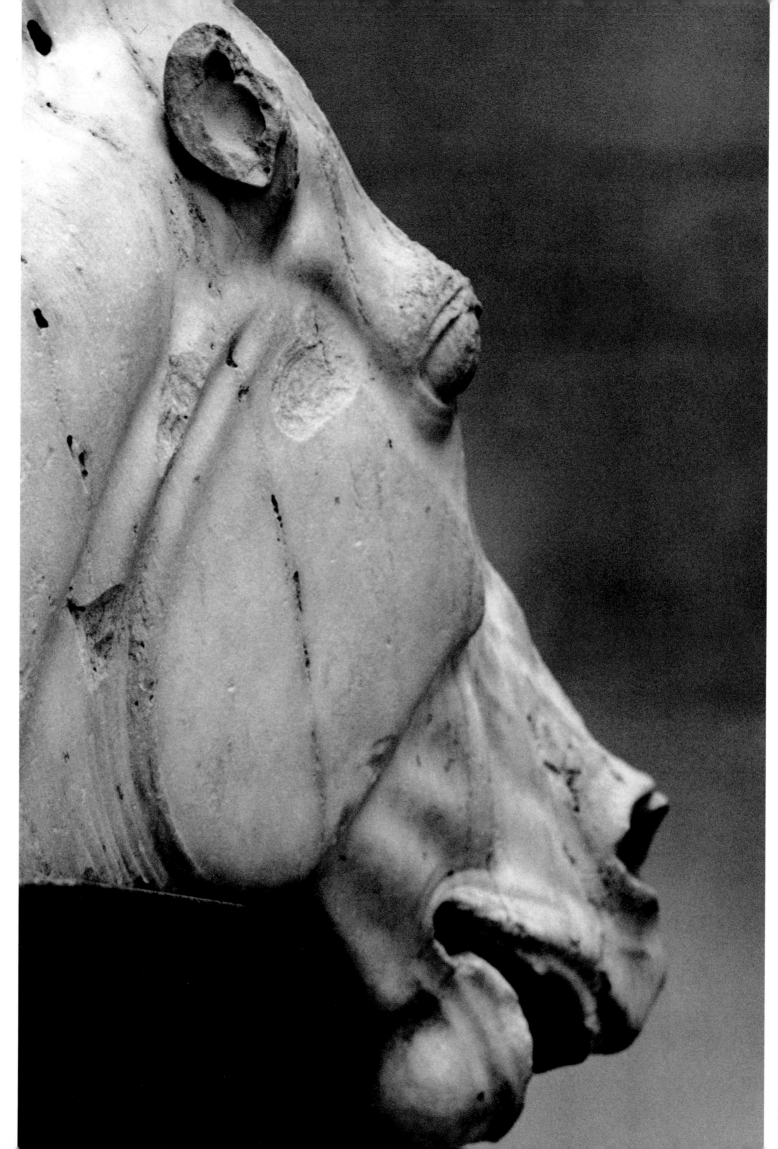

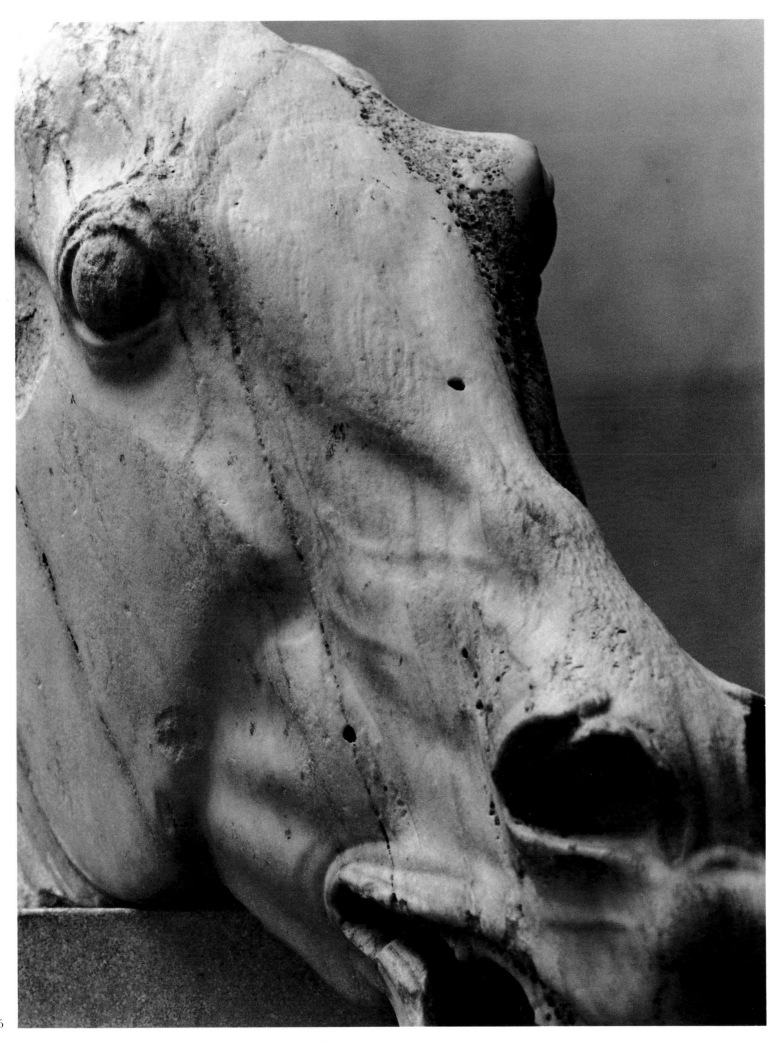

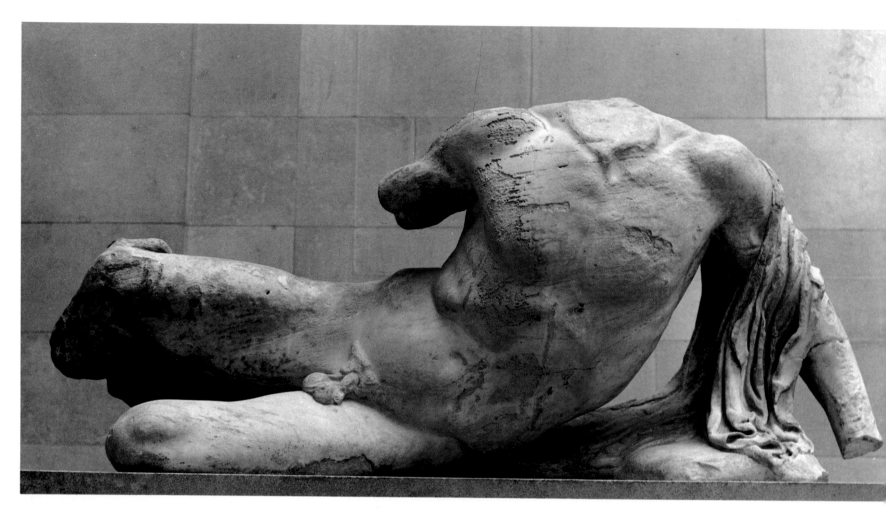

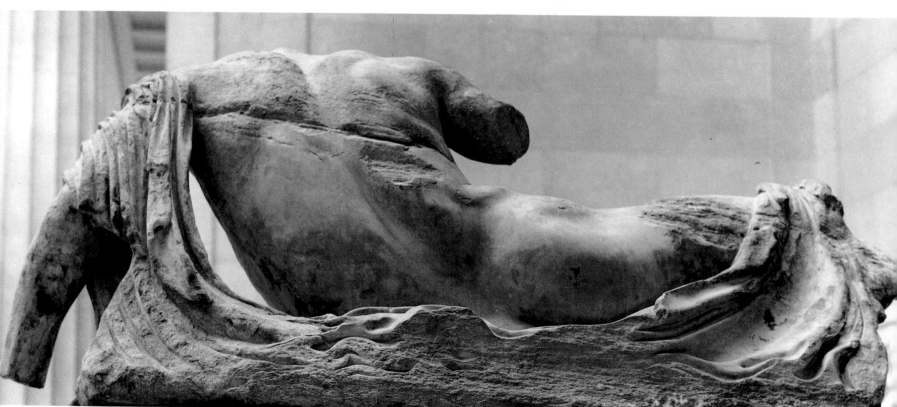

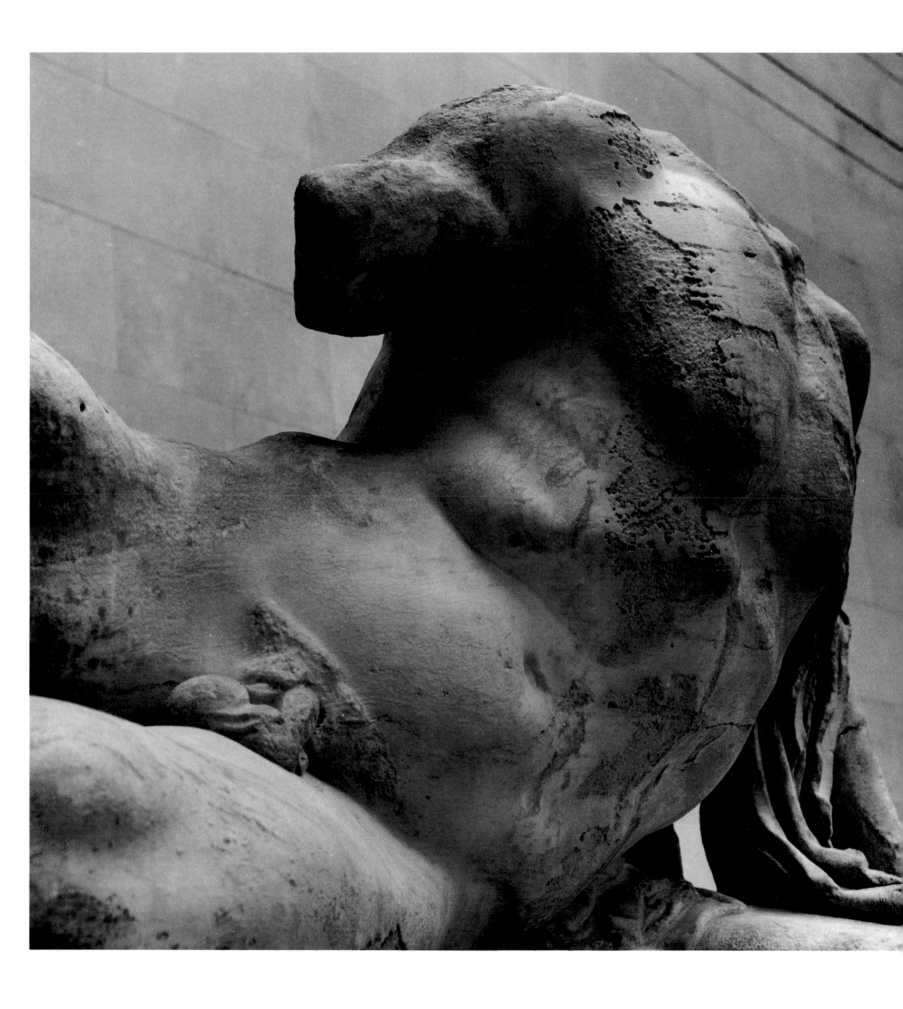

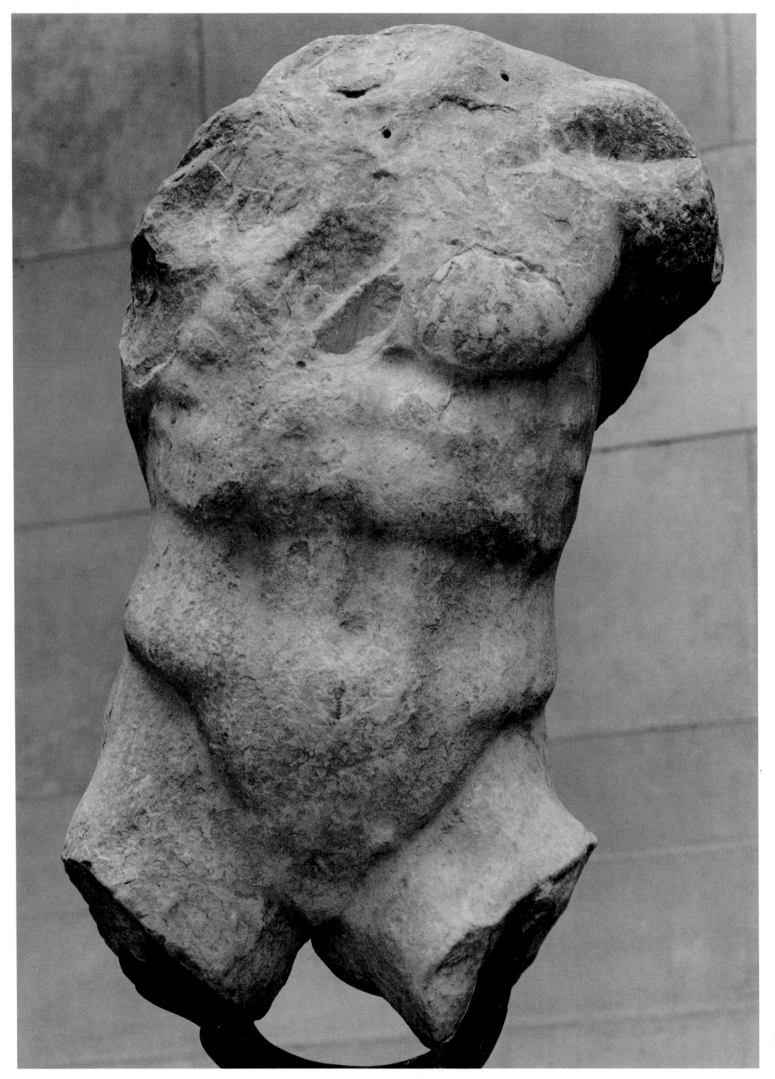

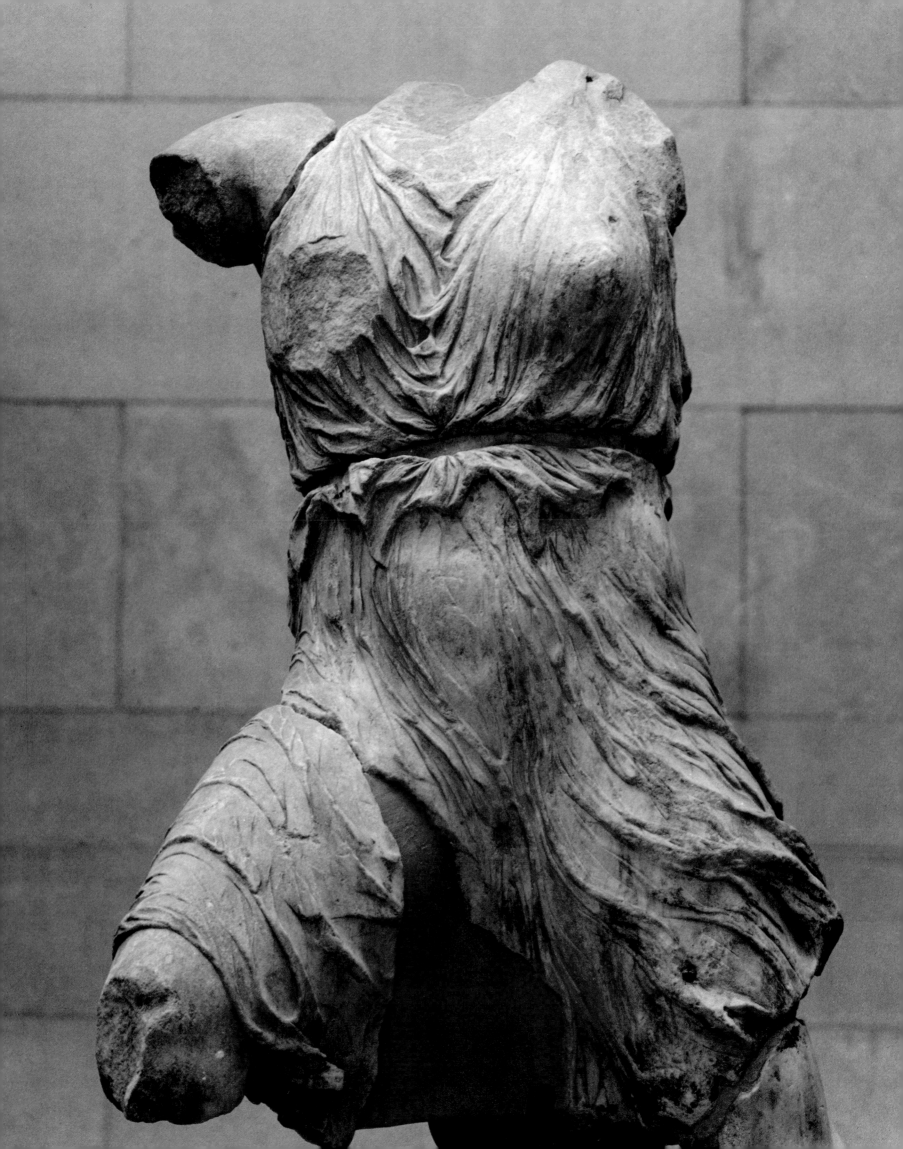

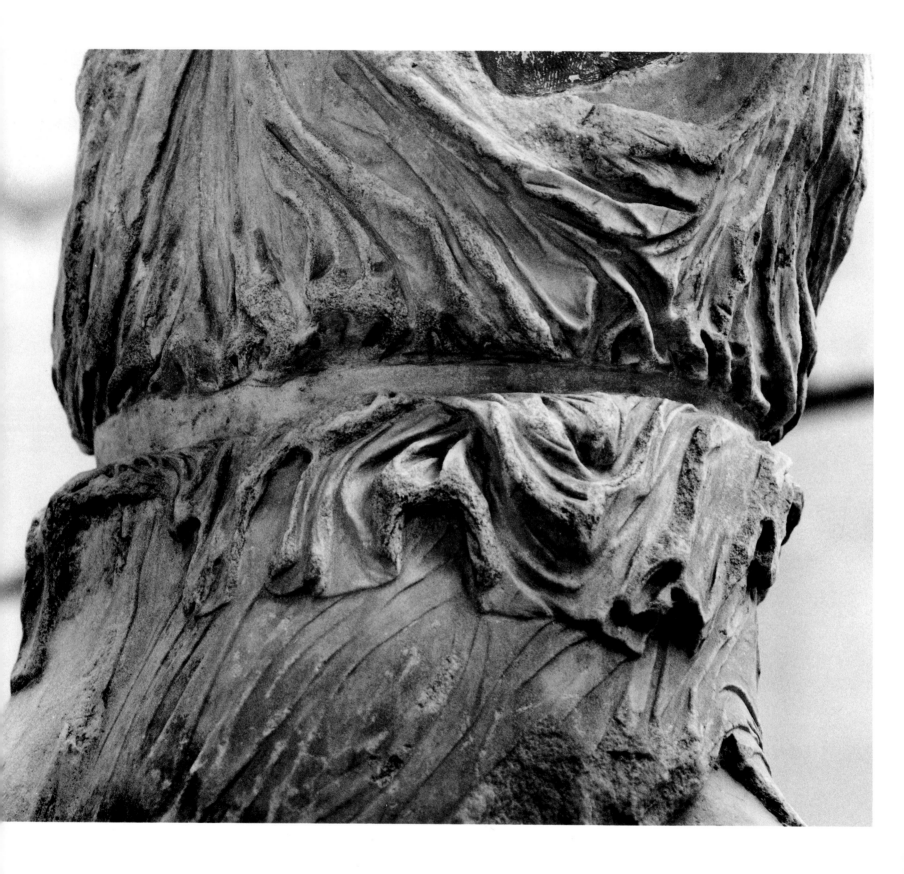

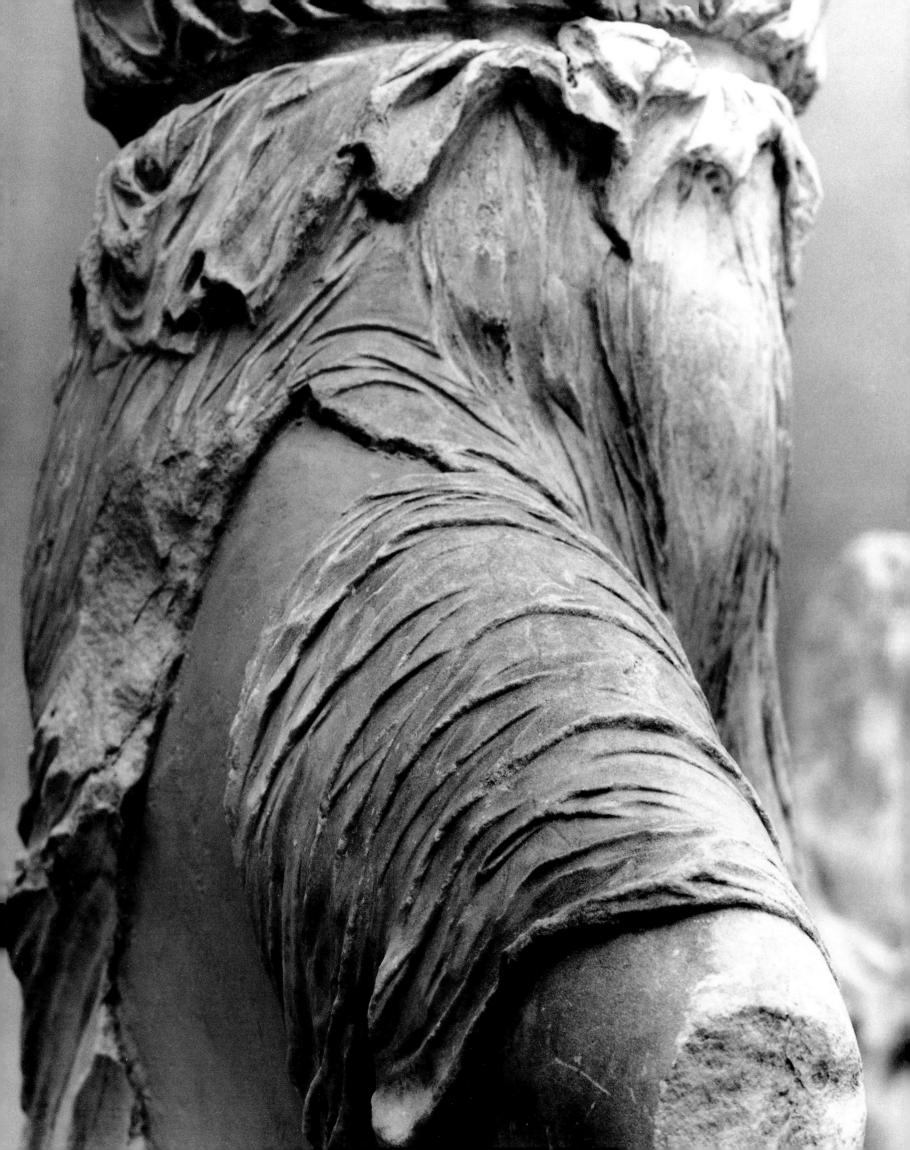

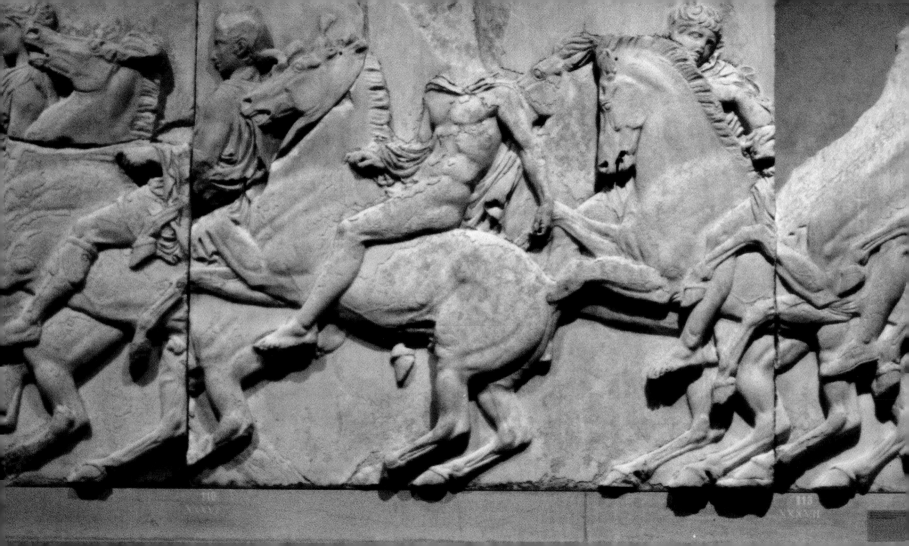

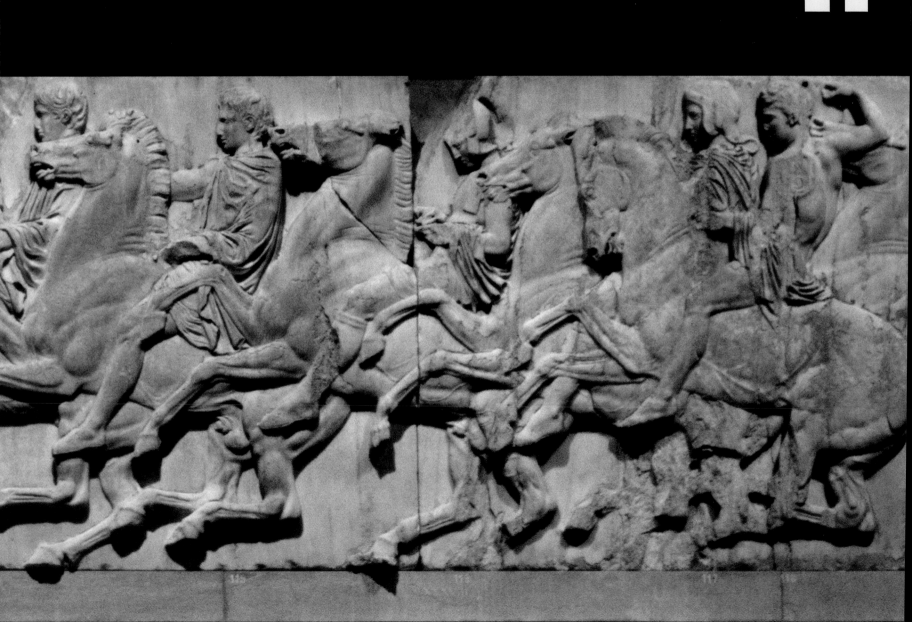

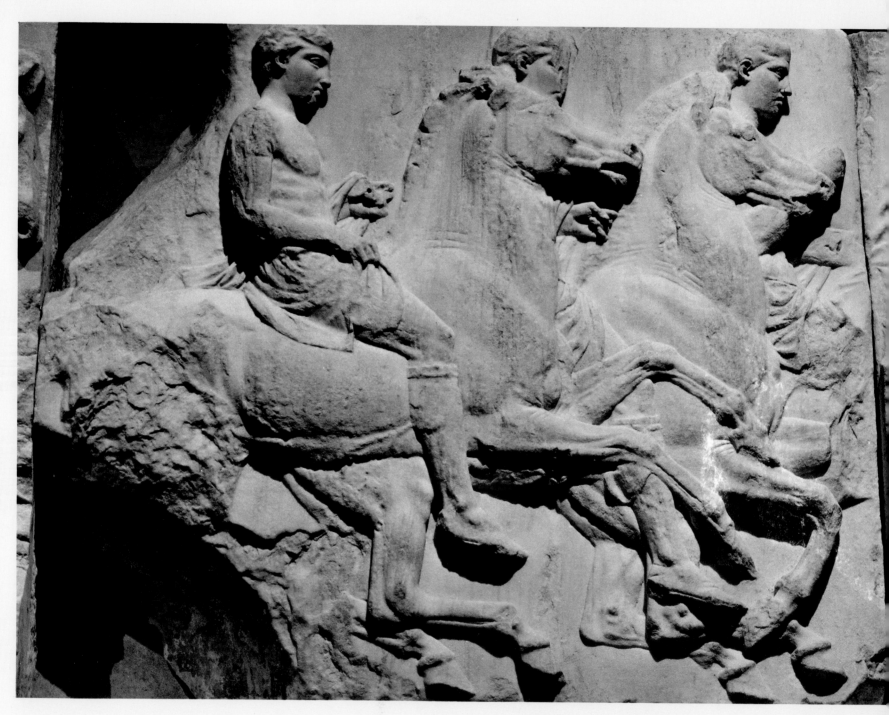

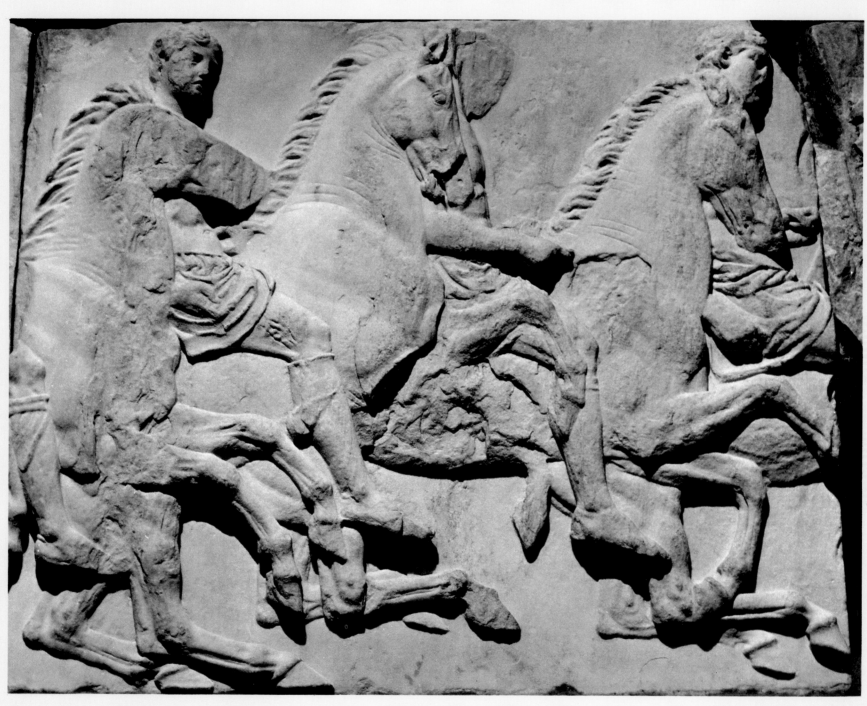

28

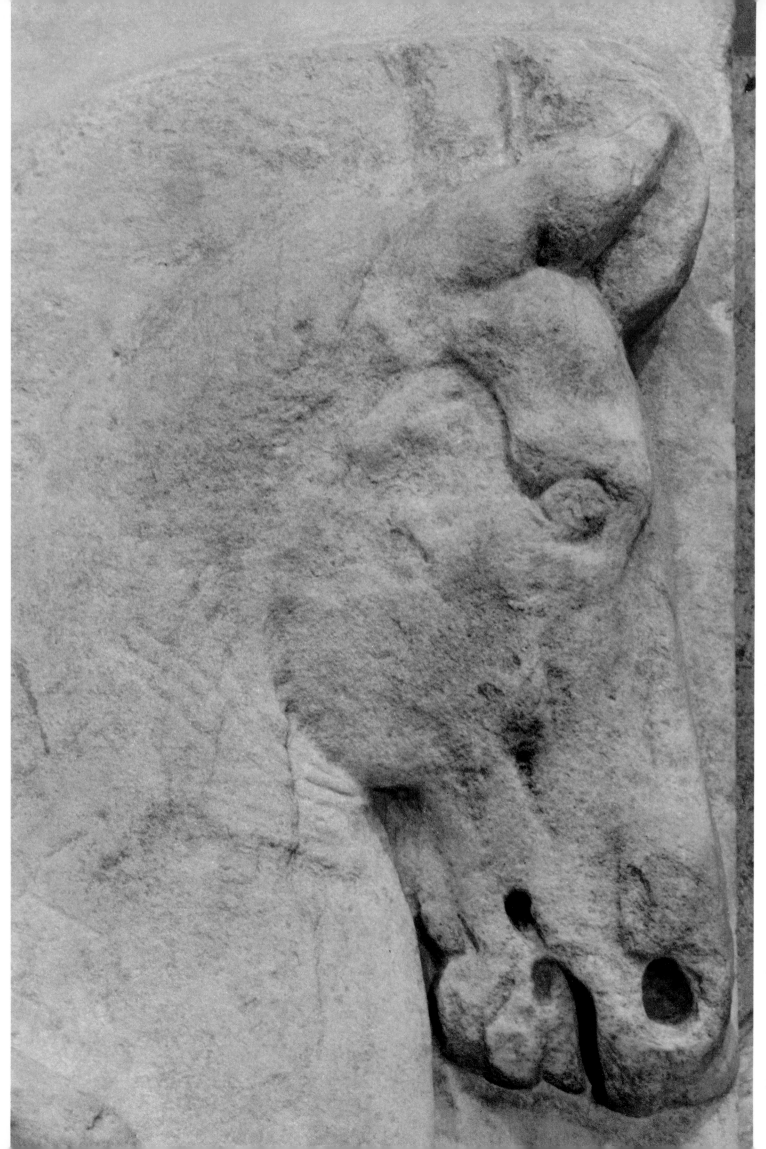

29

30

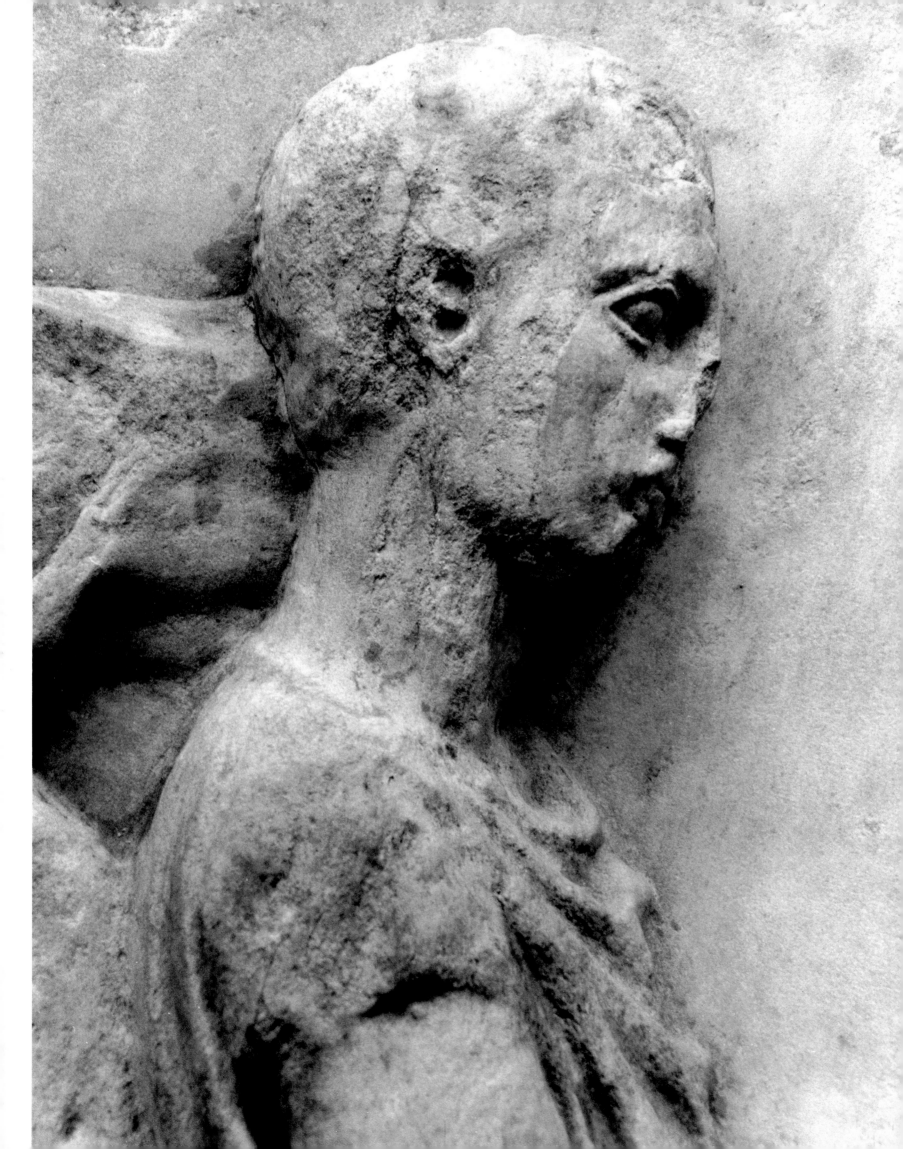

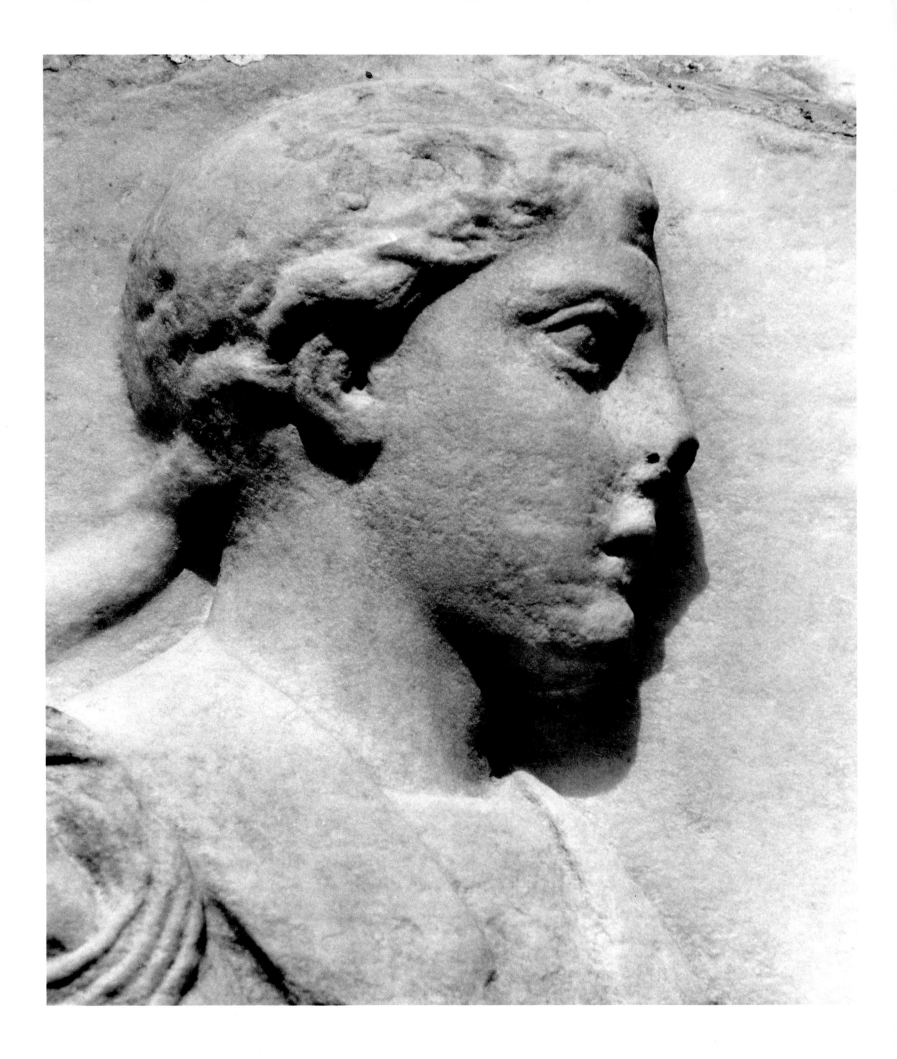

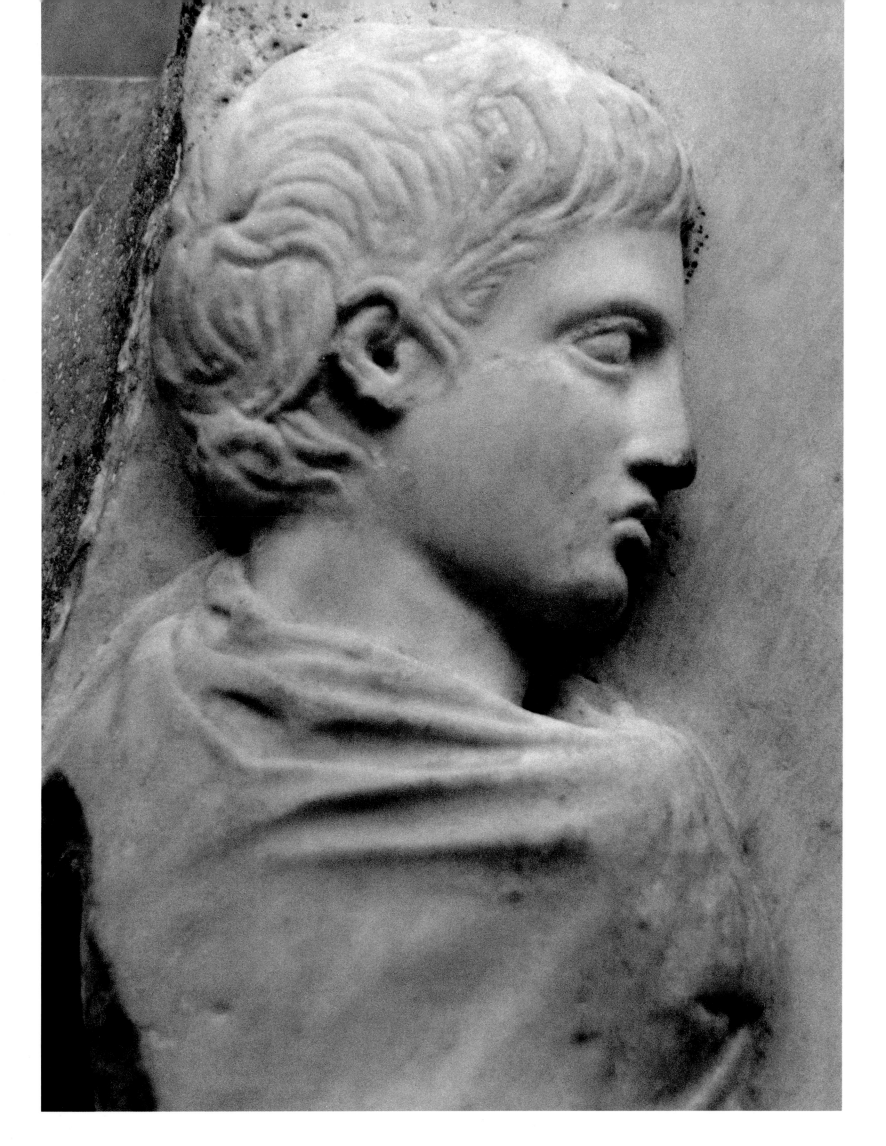

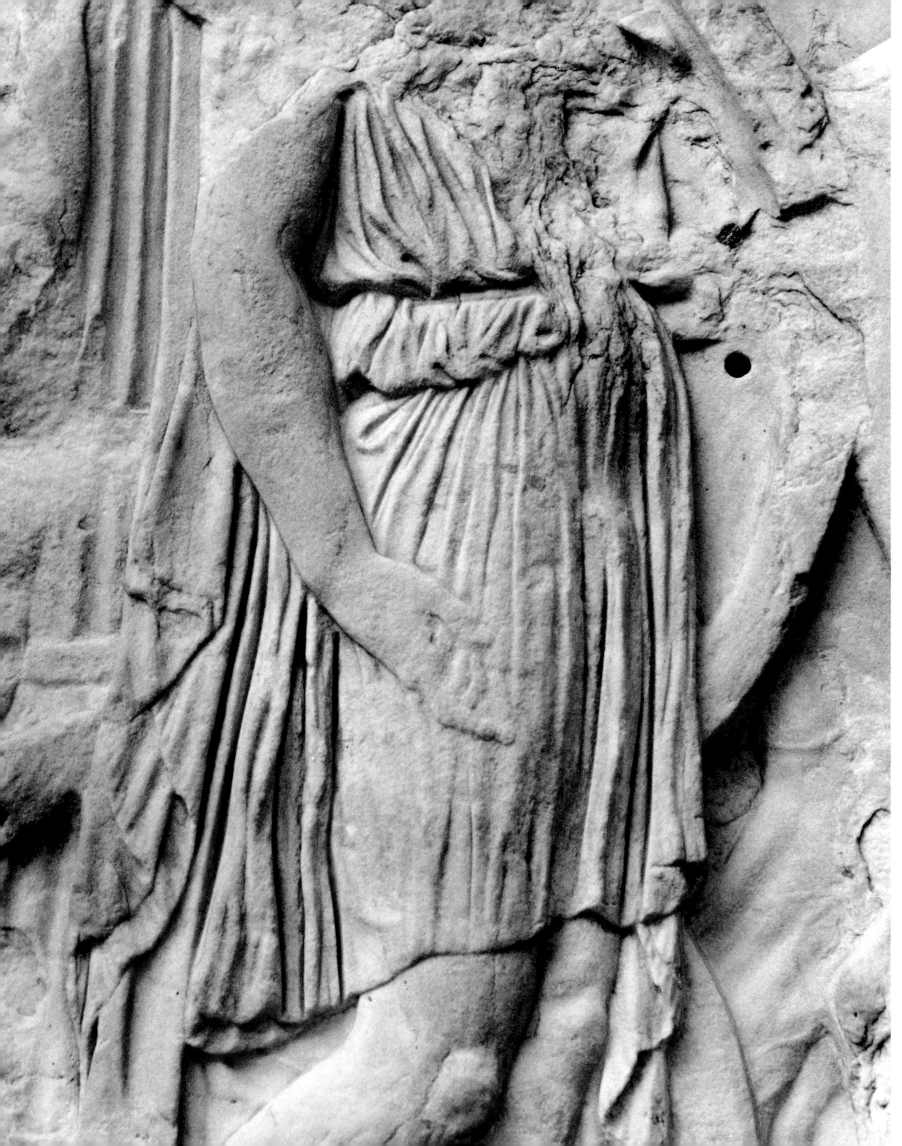

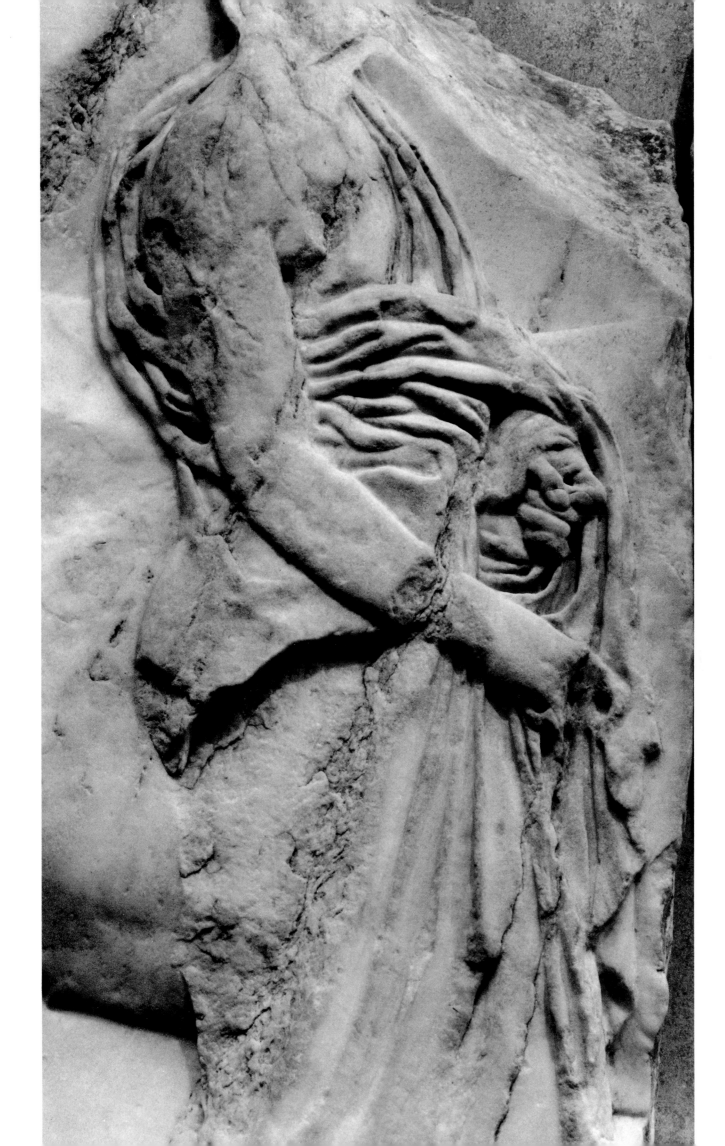

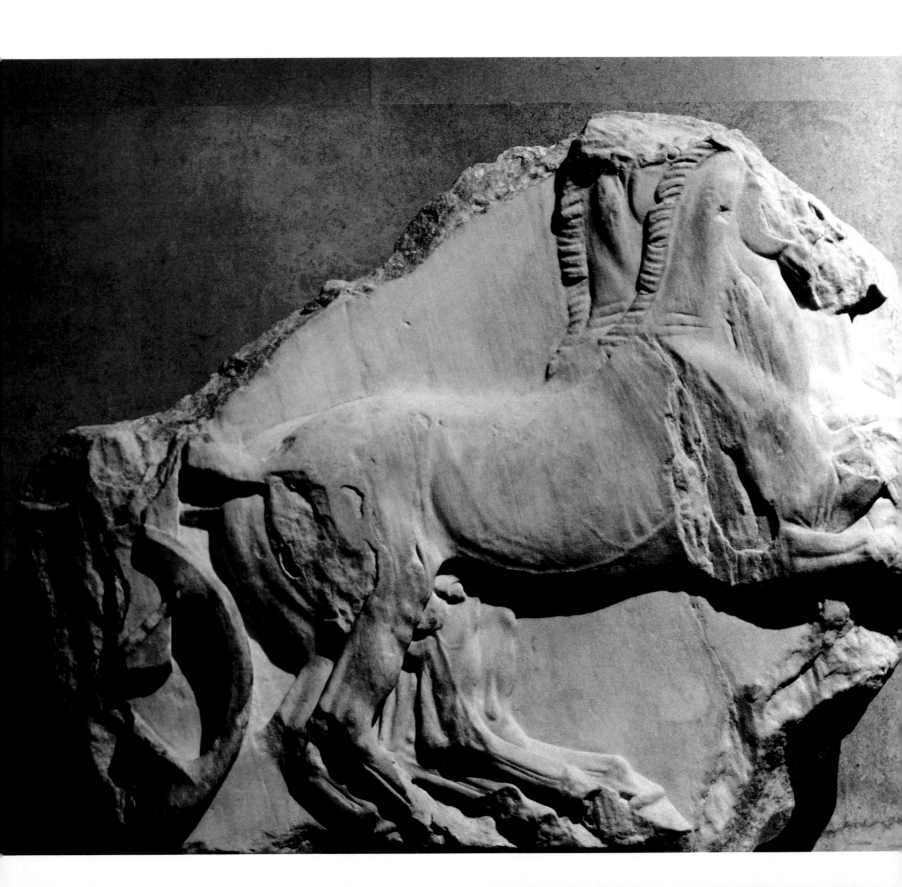

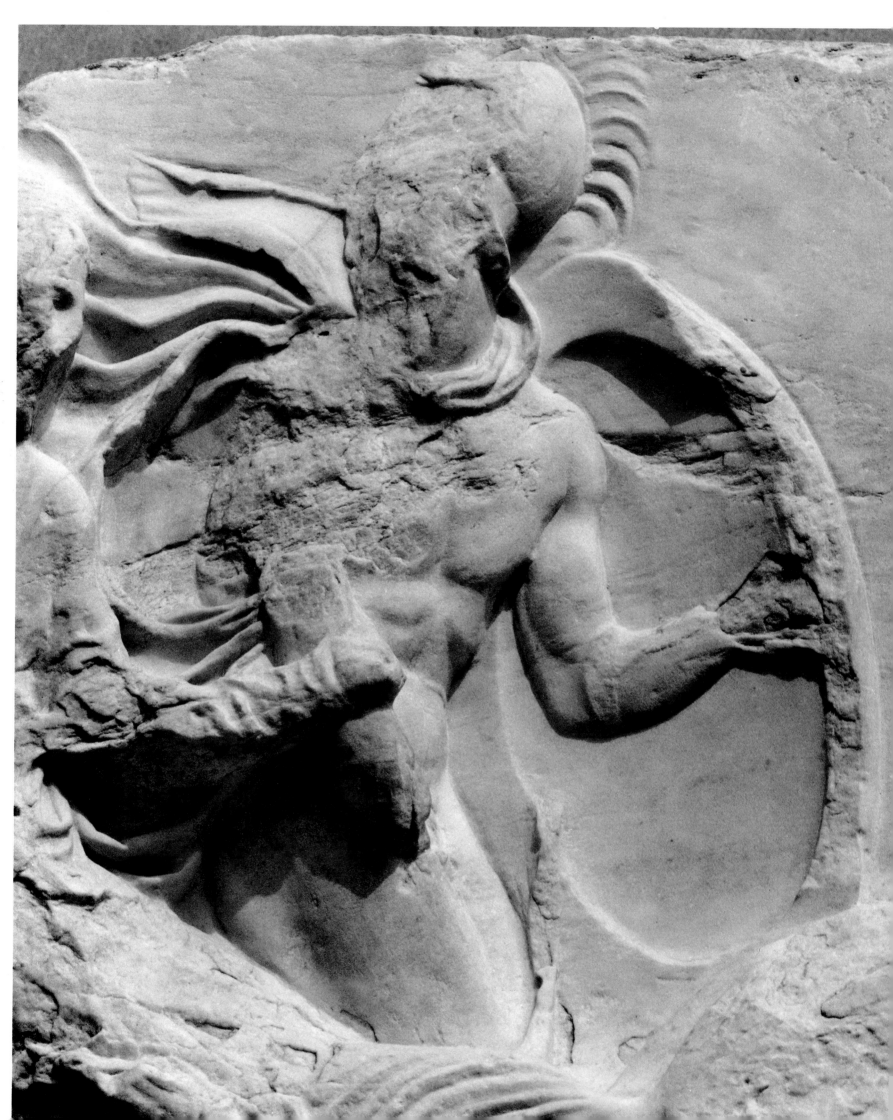

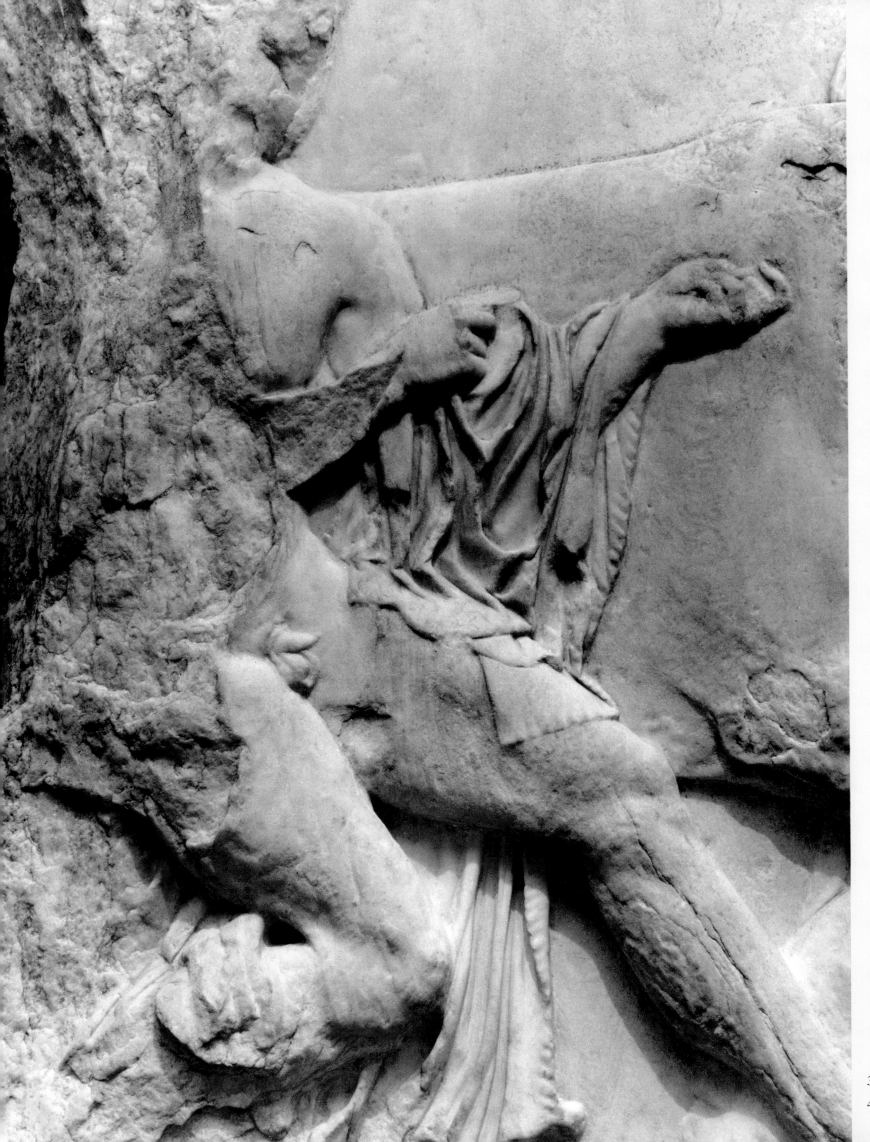

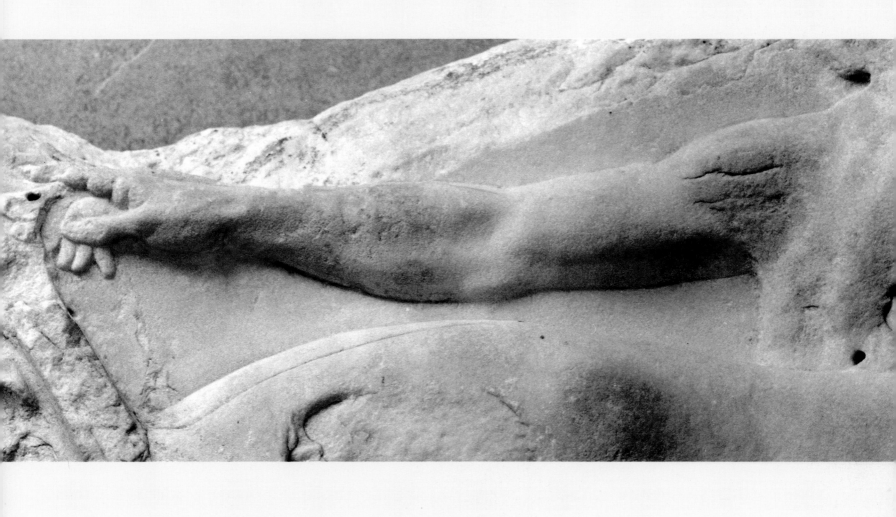

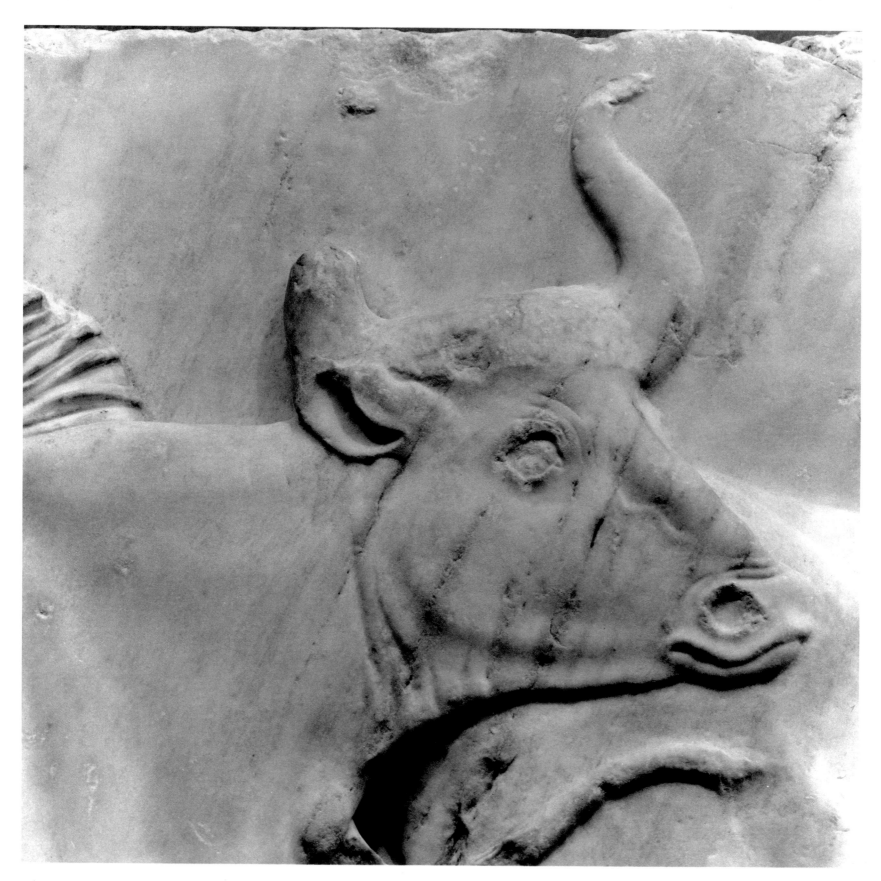

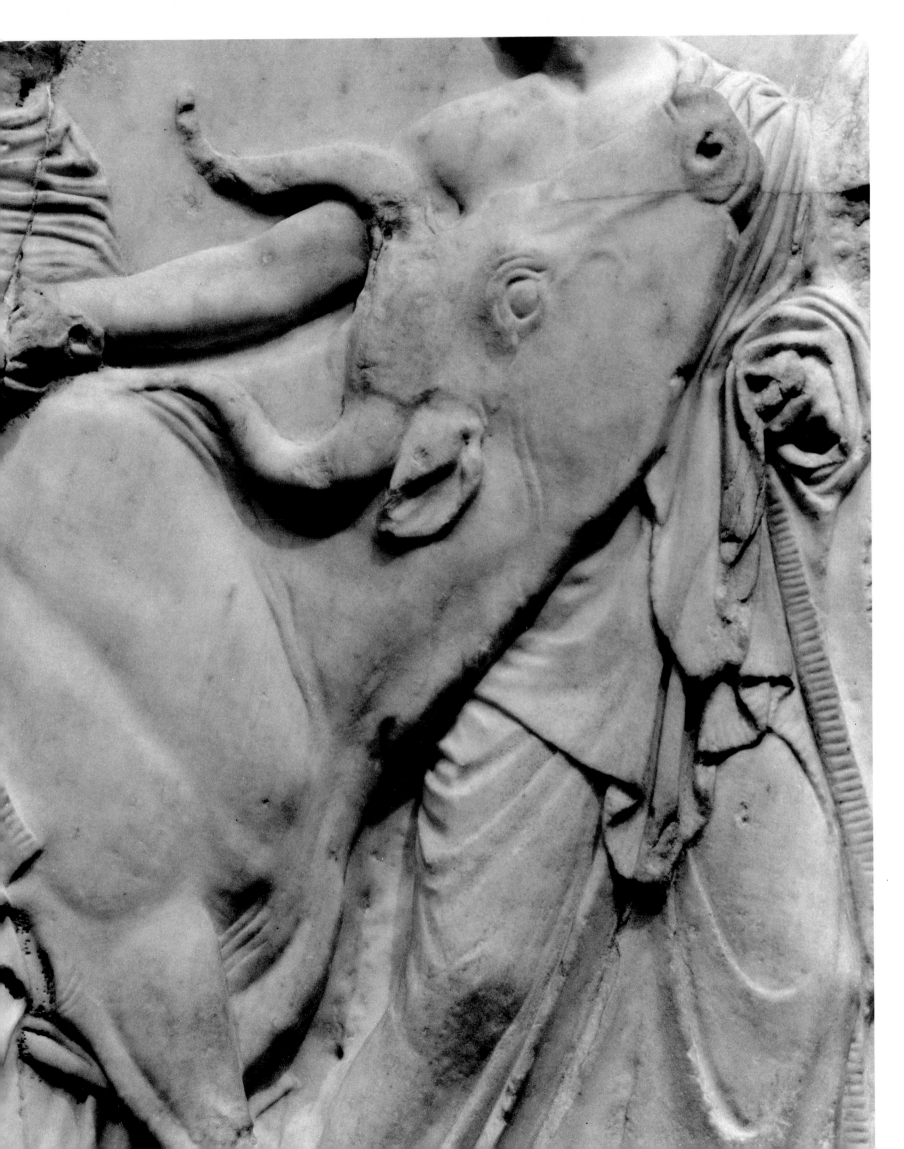

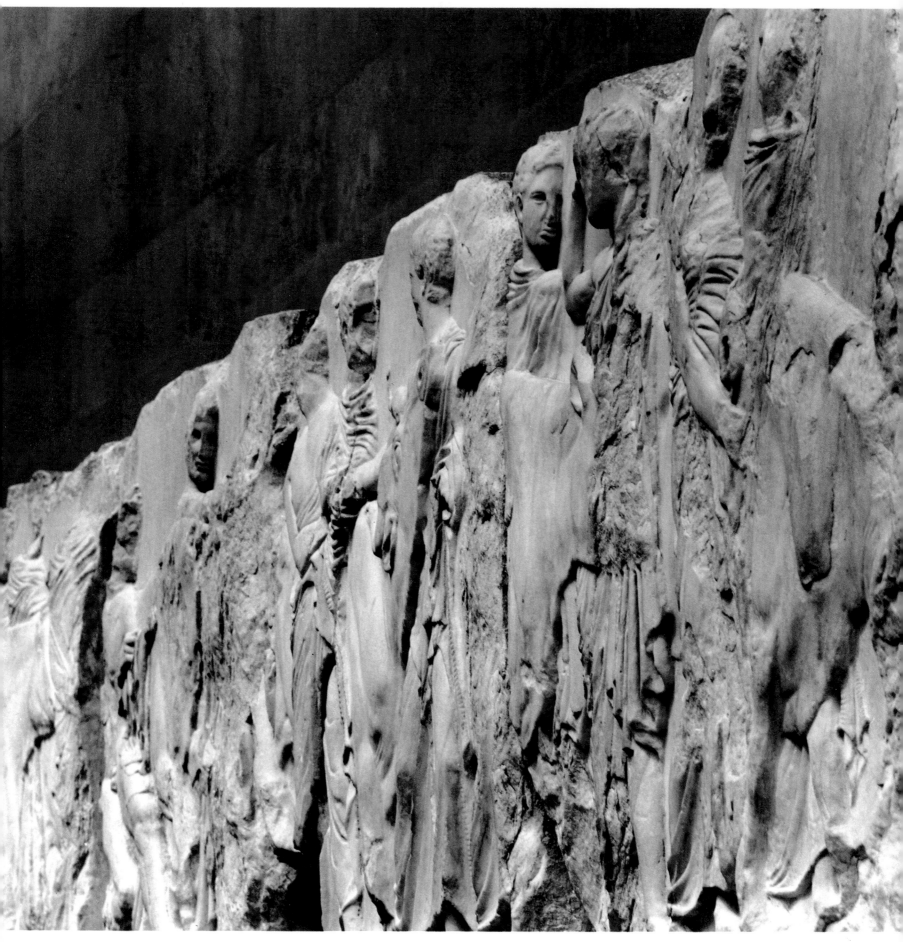

44

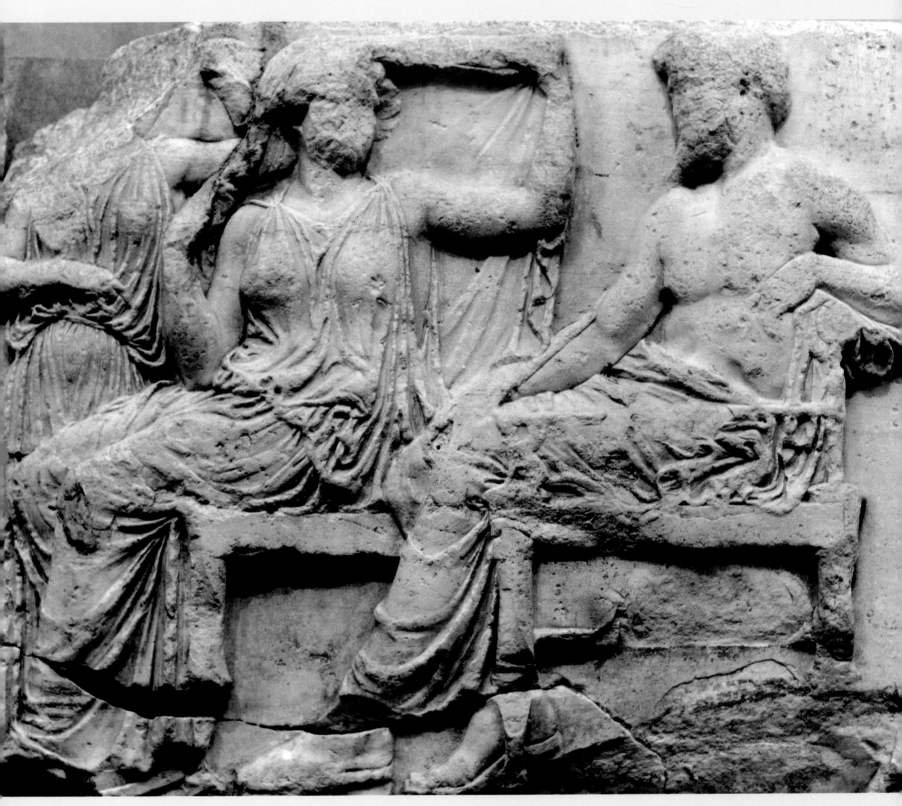

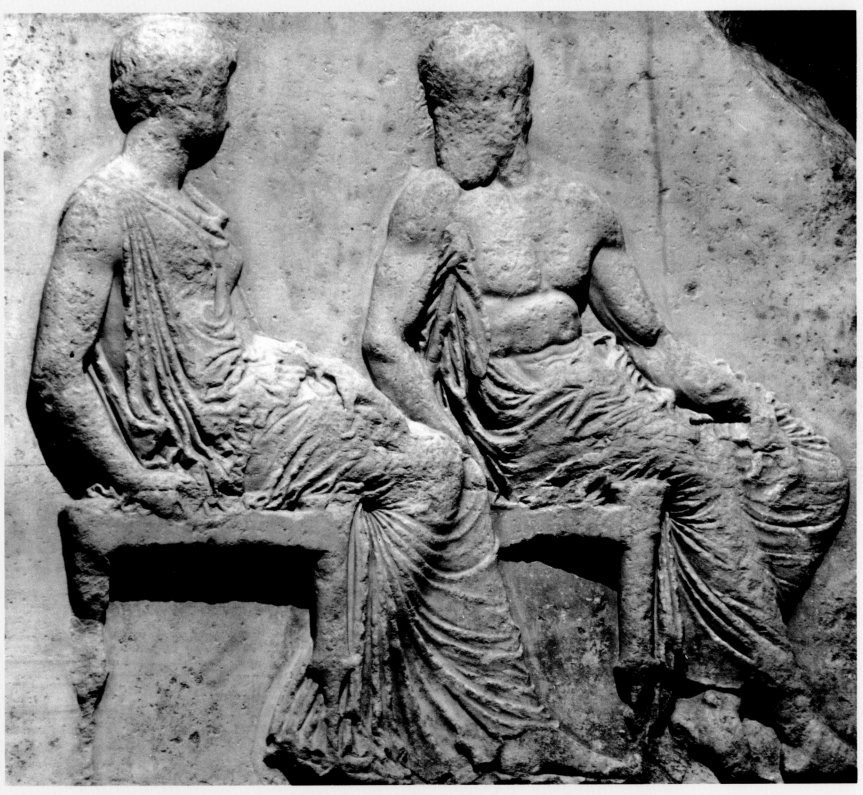

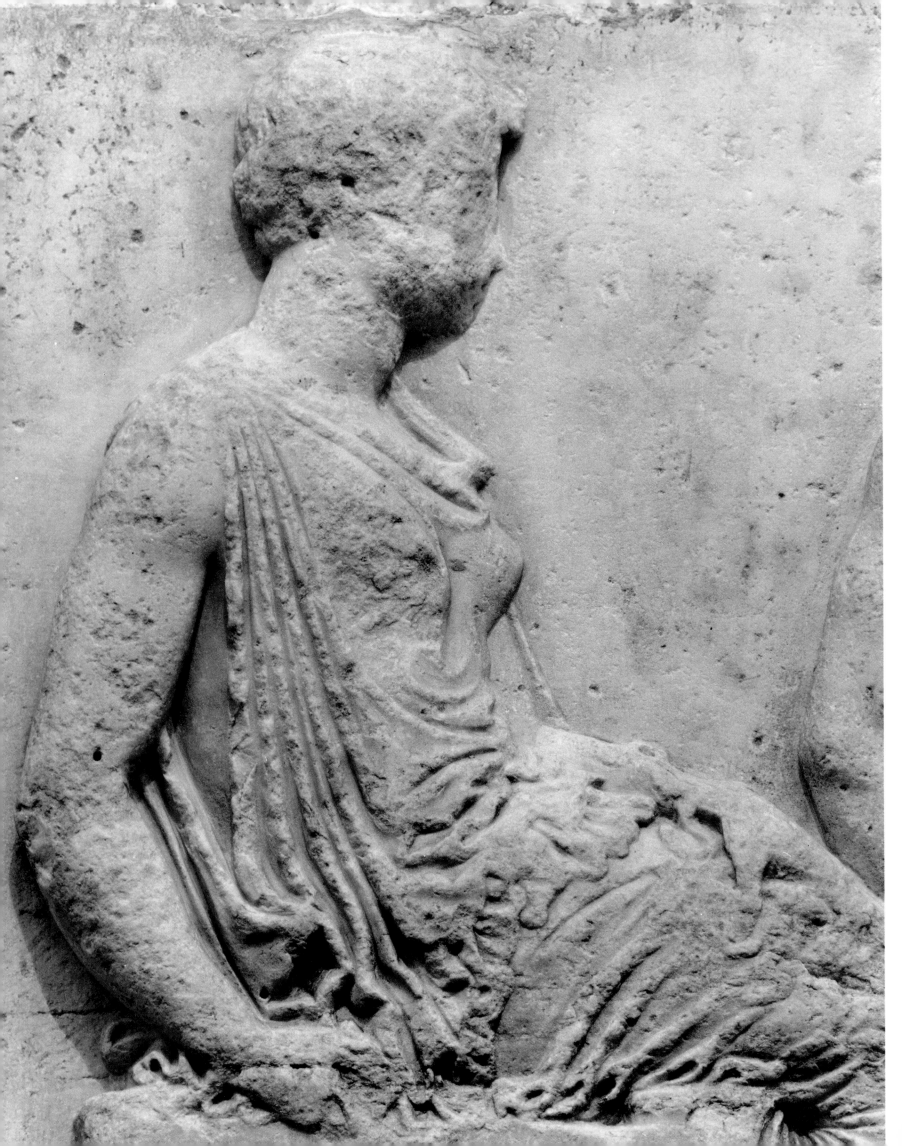

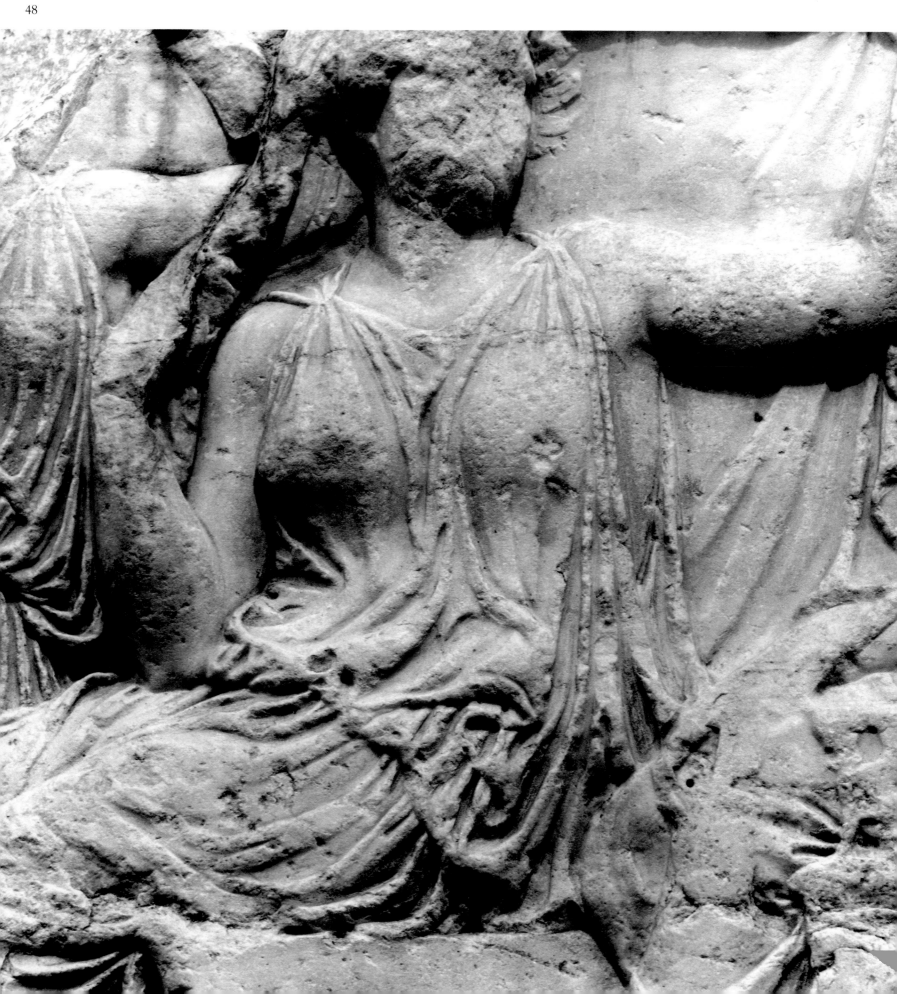

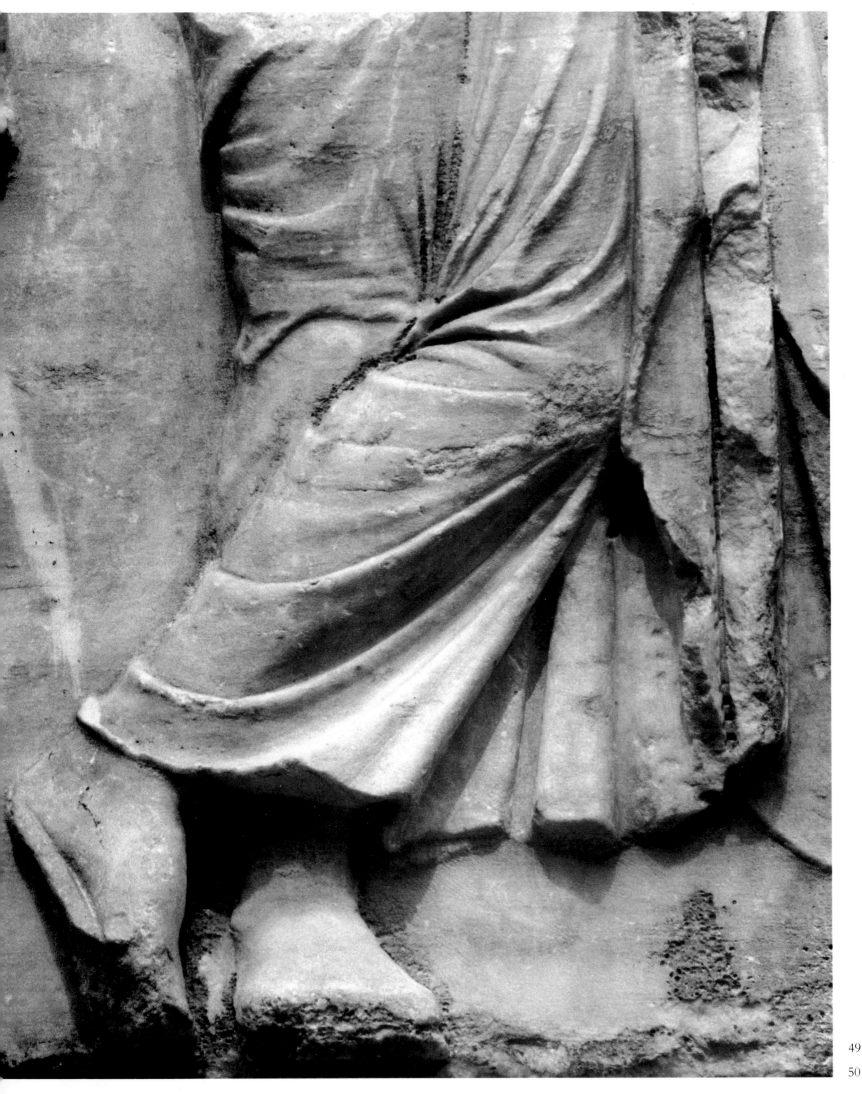

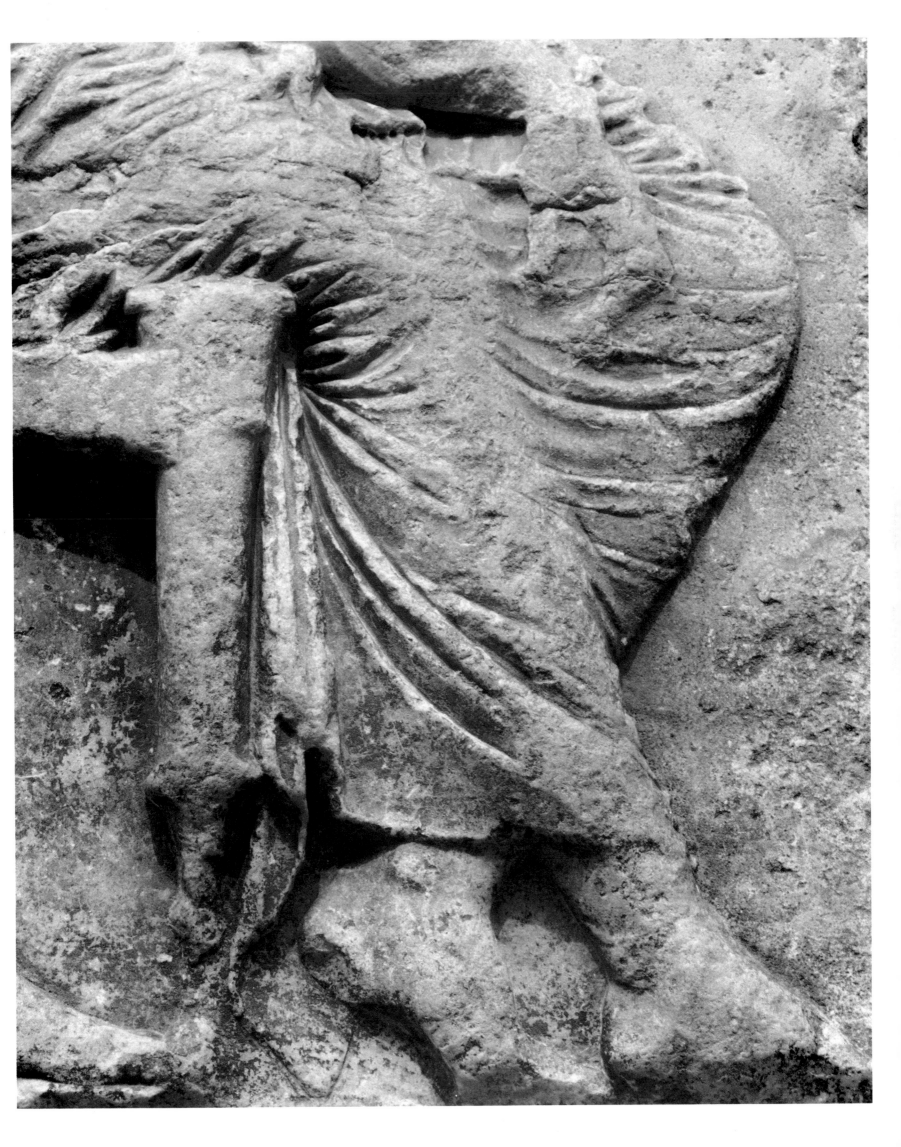

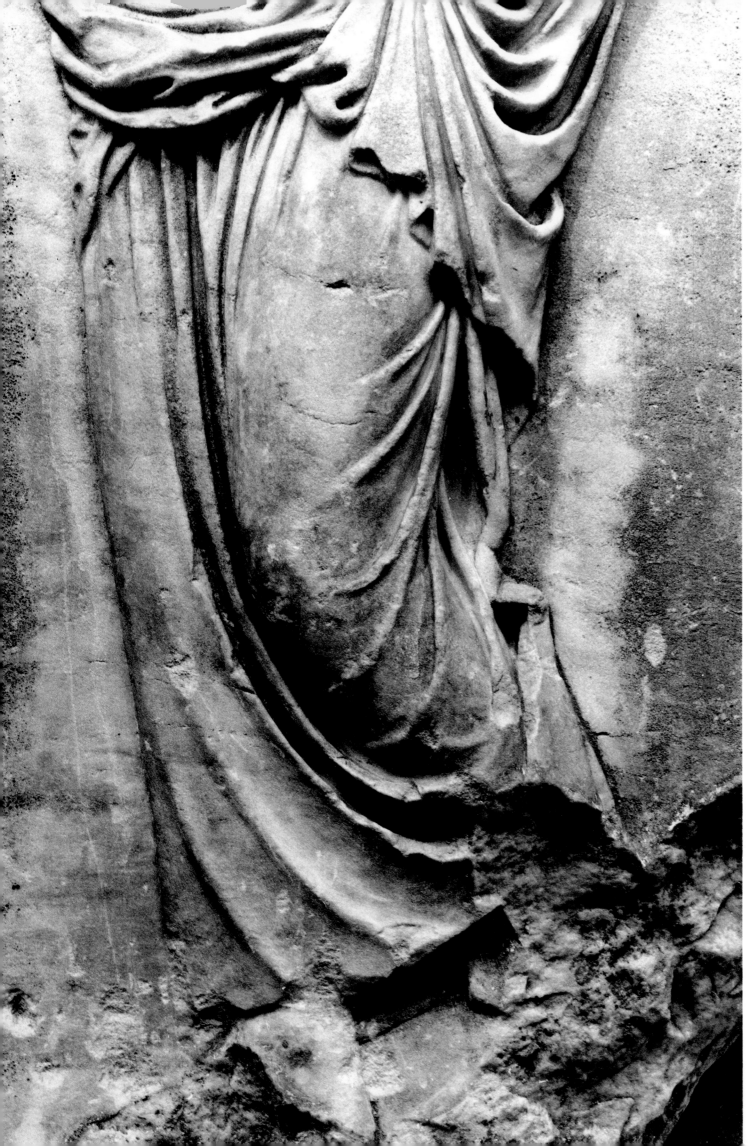

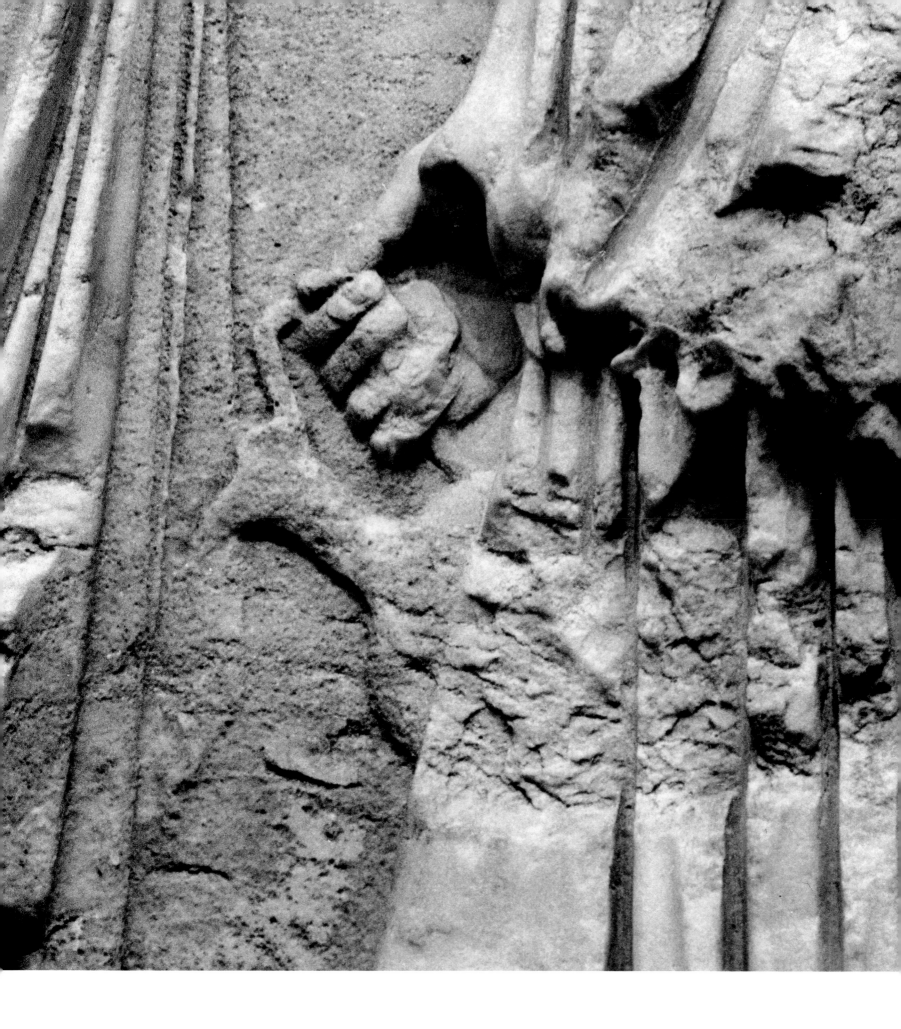

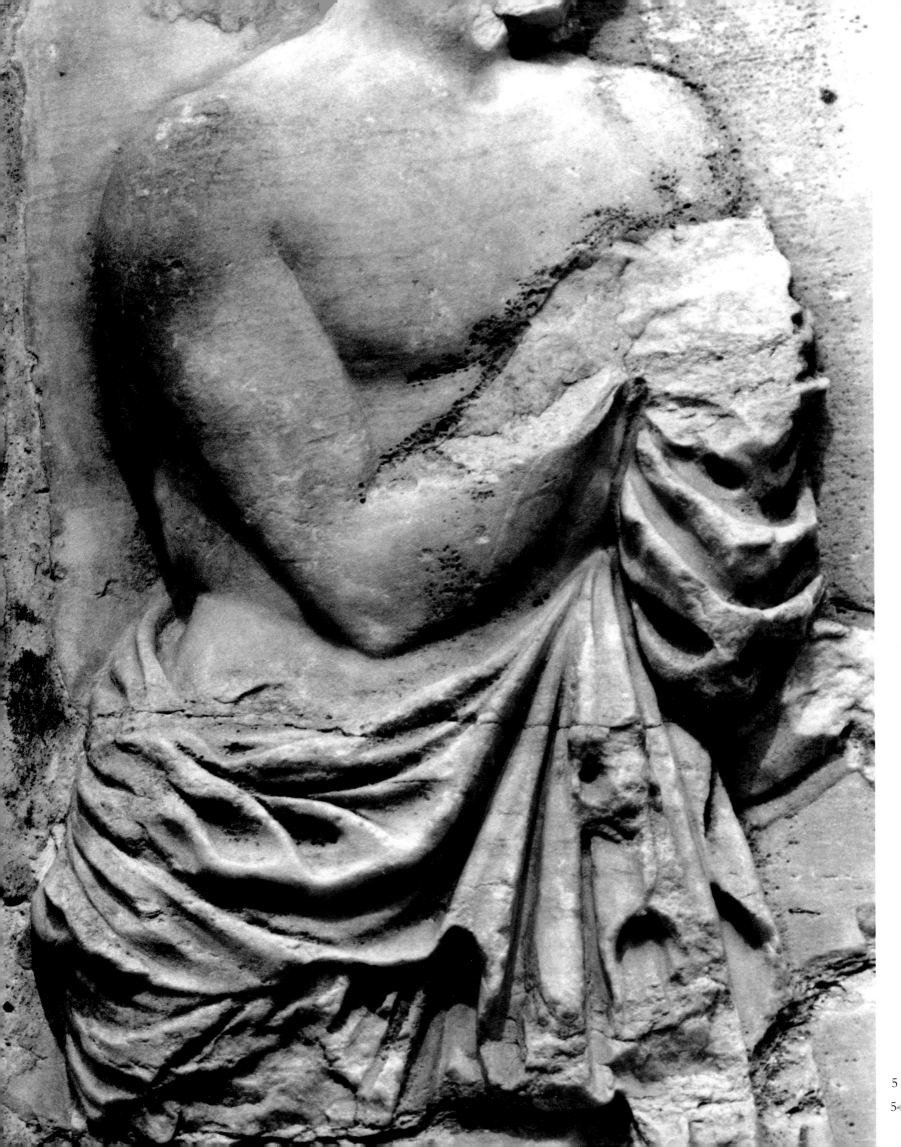

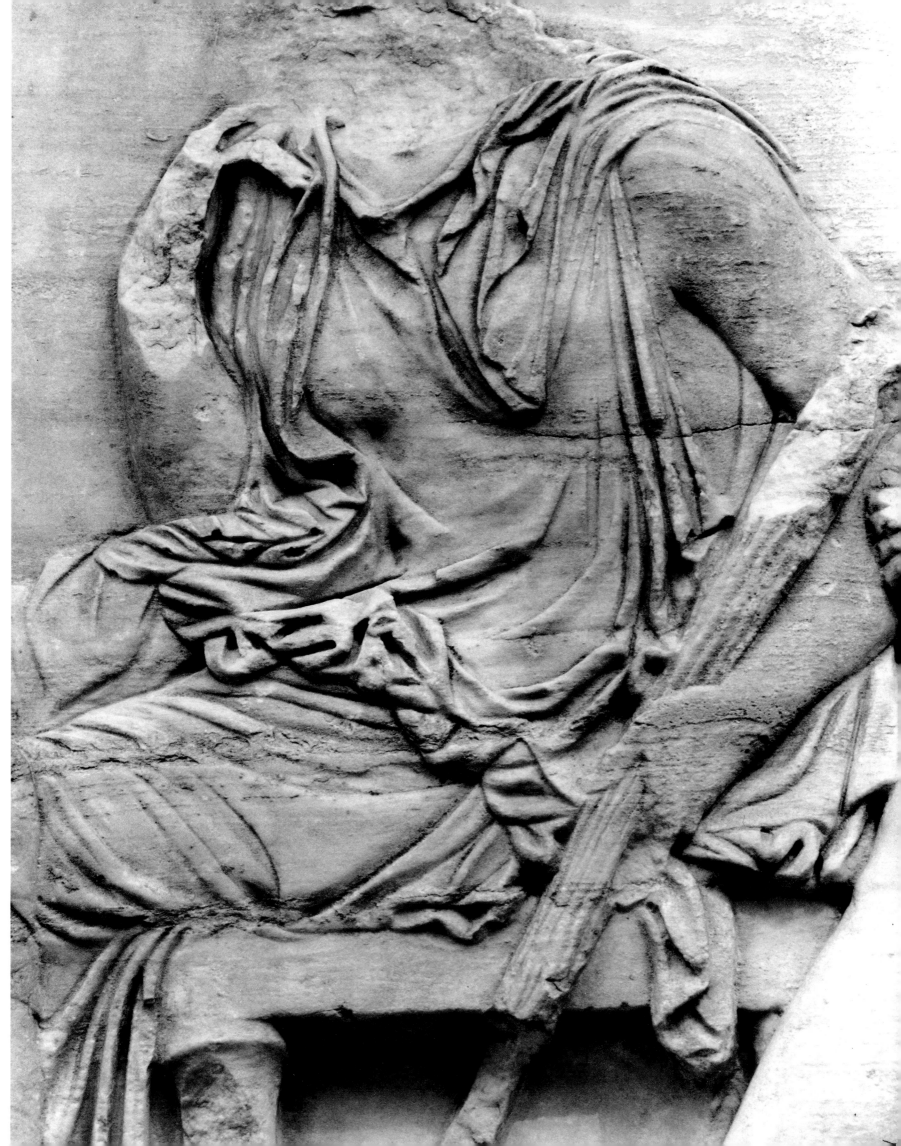

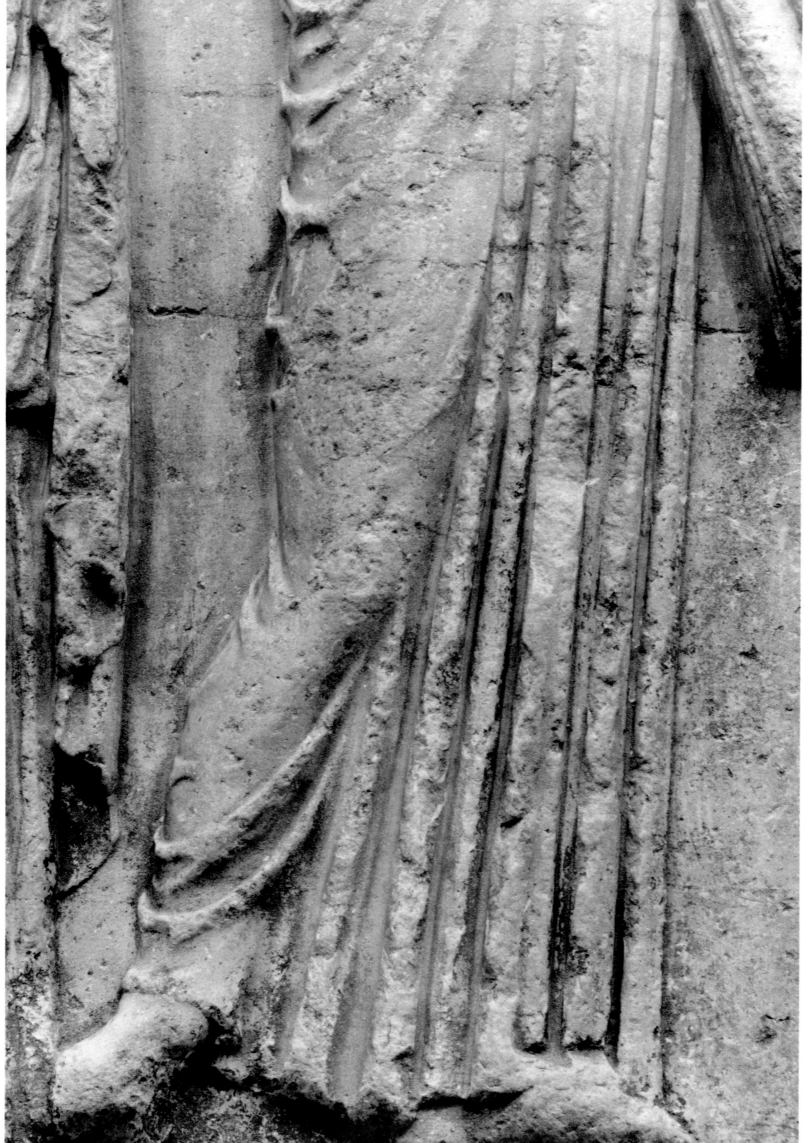

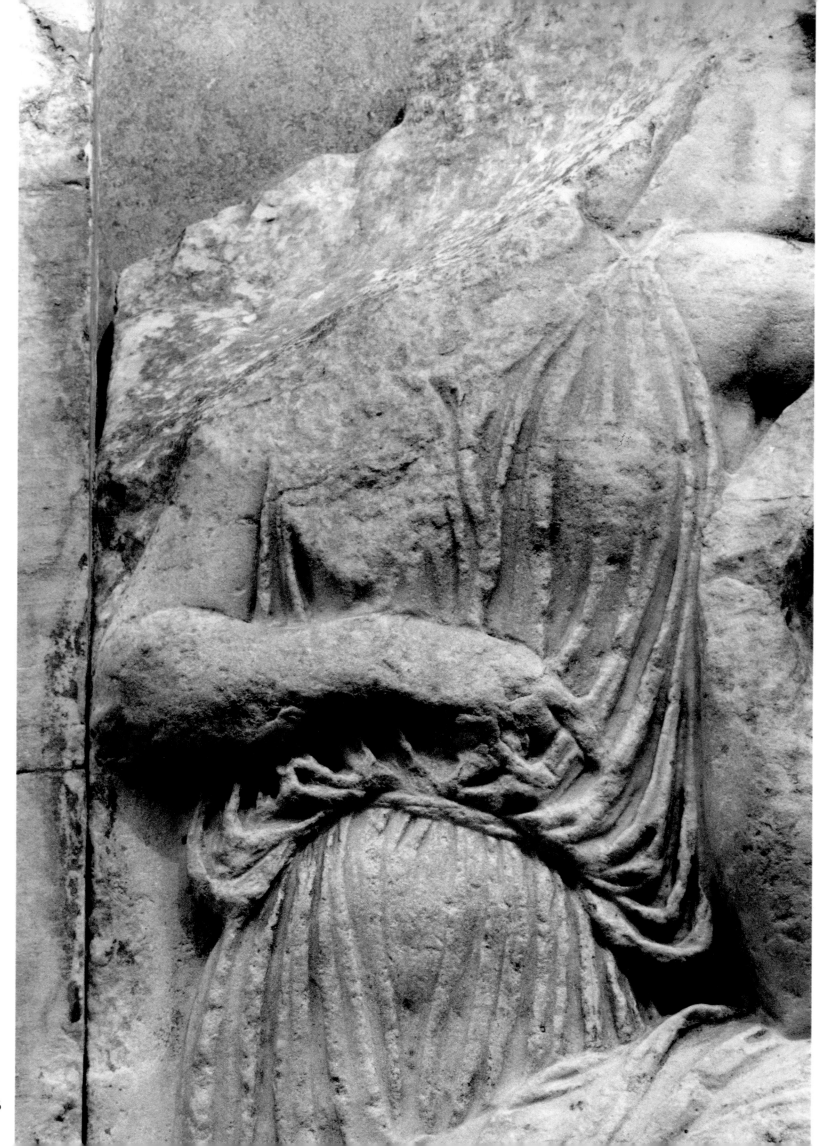

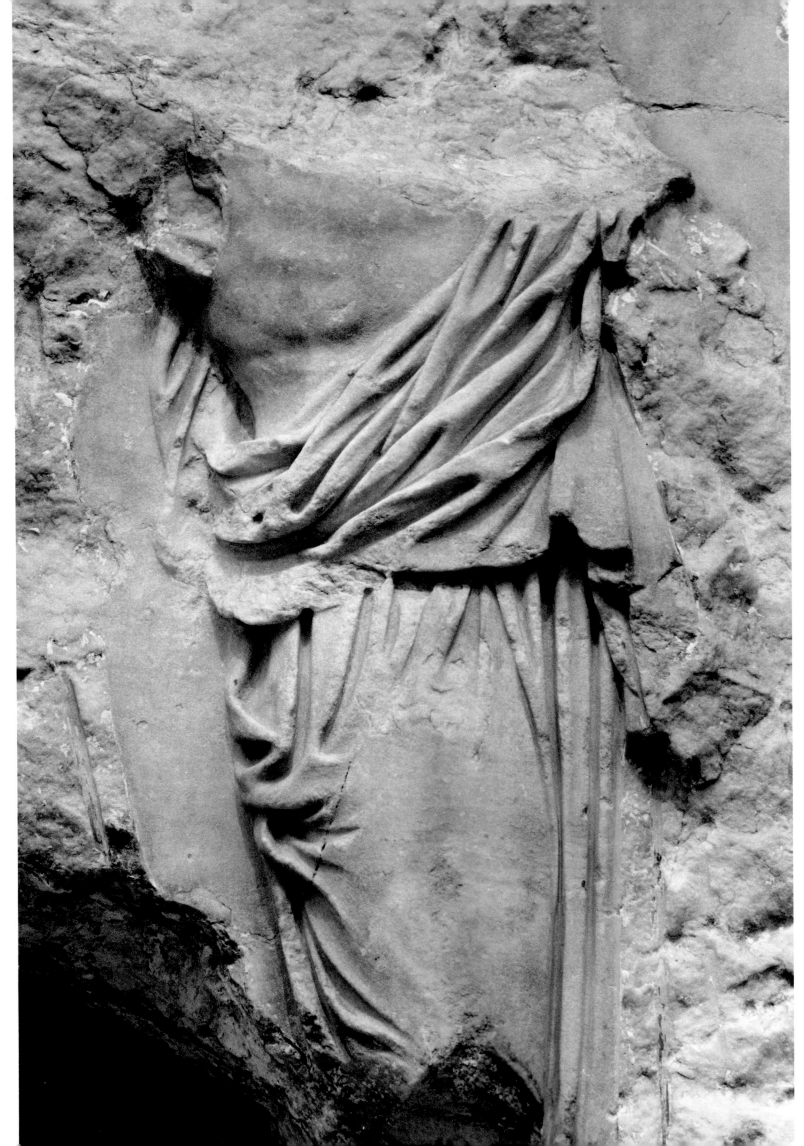

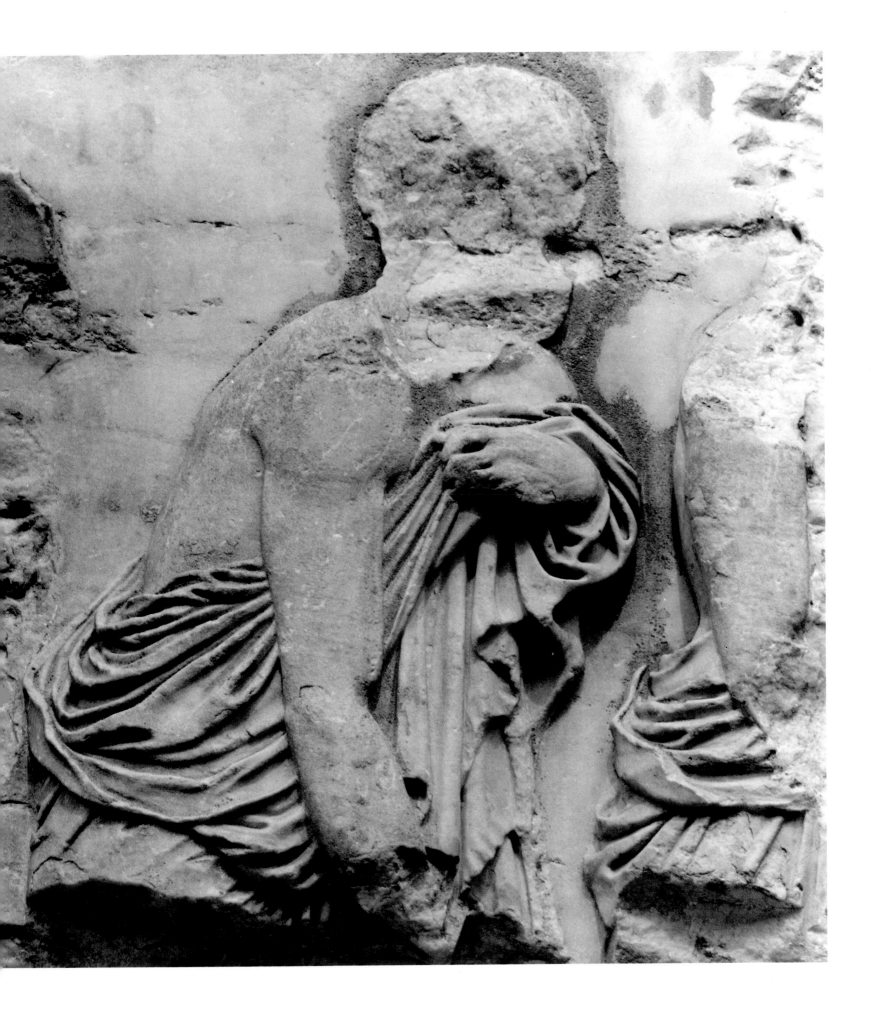

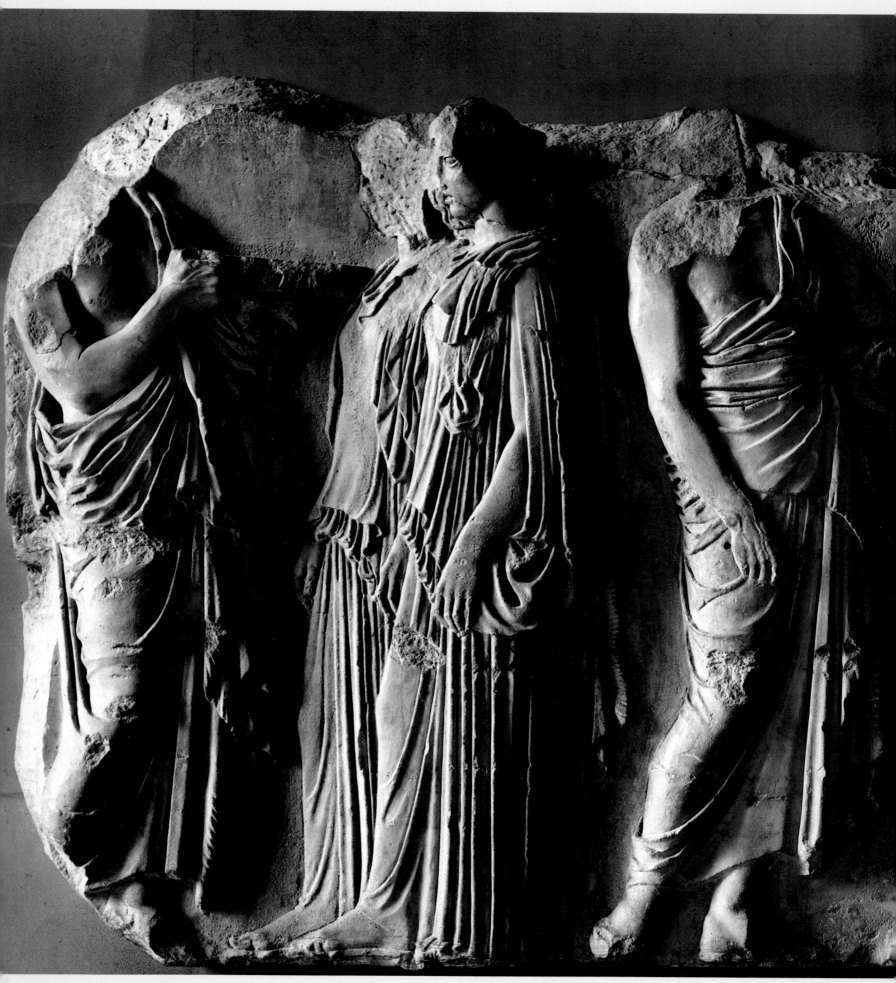

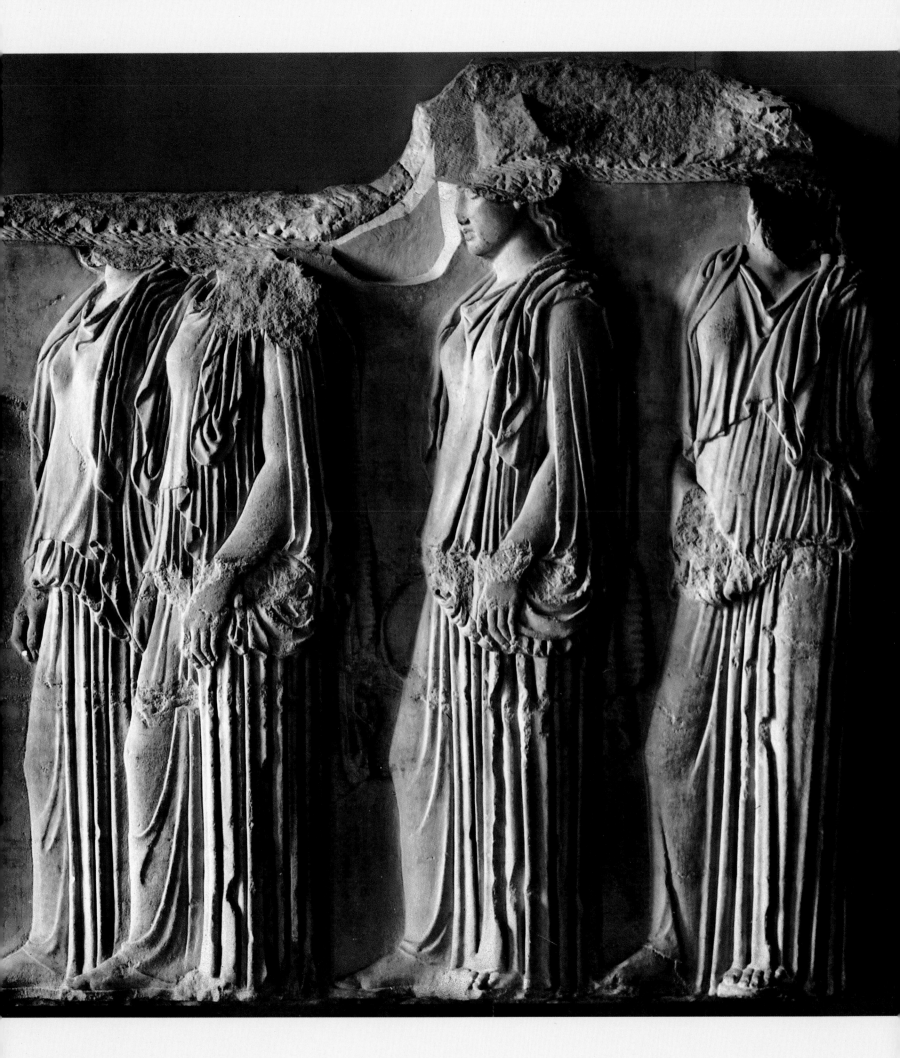

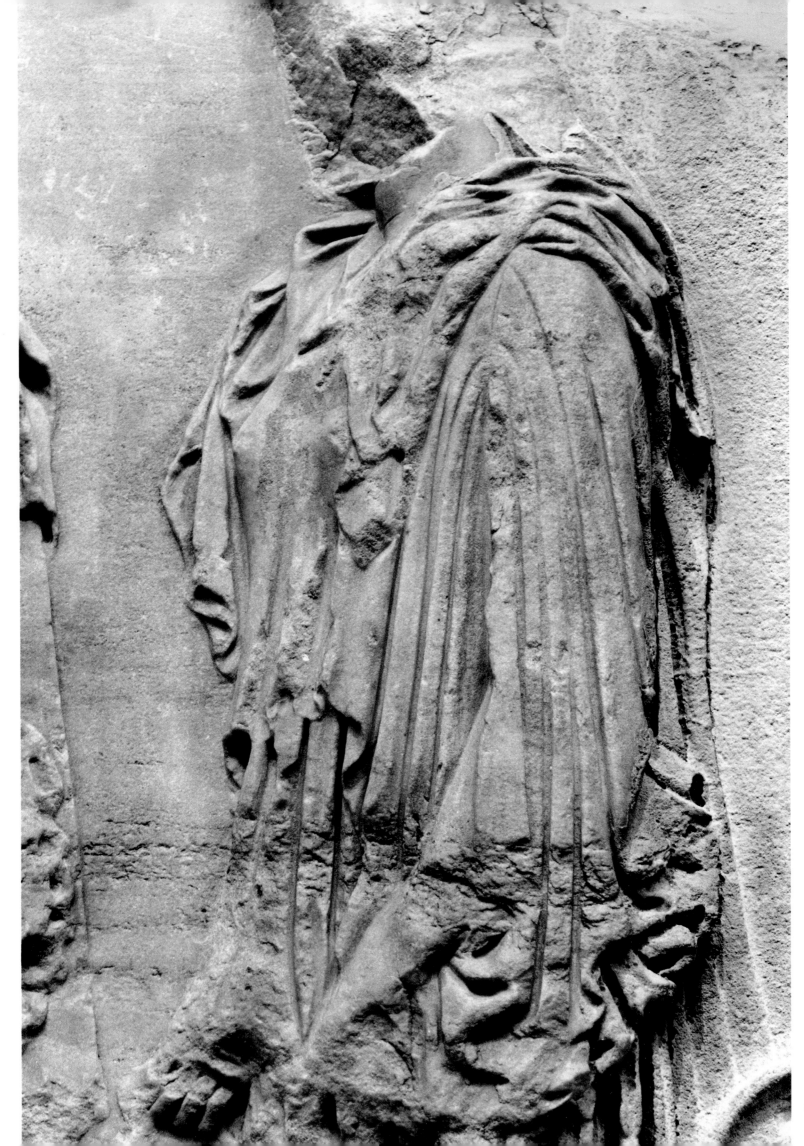

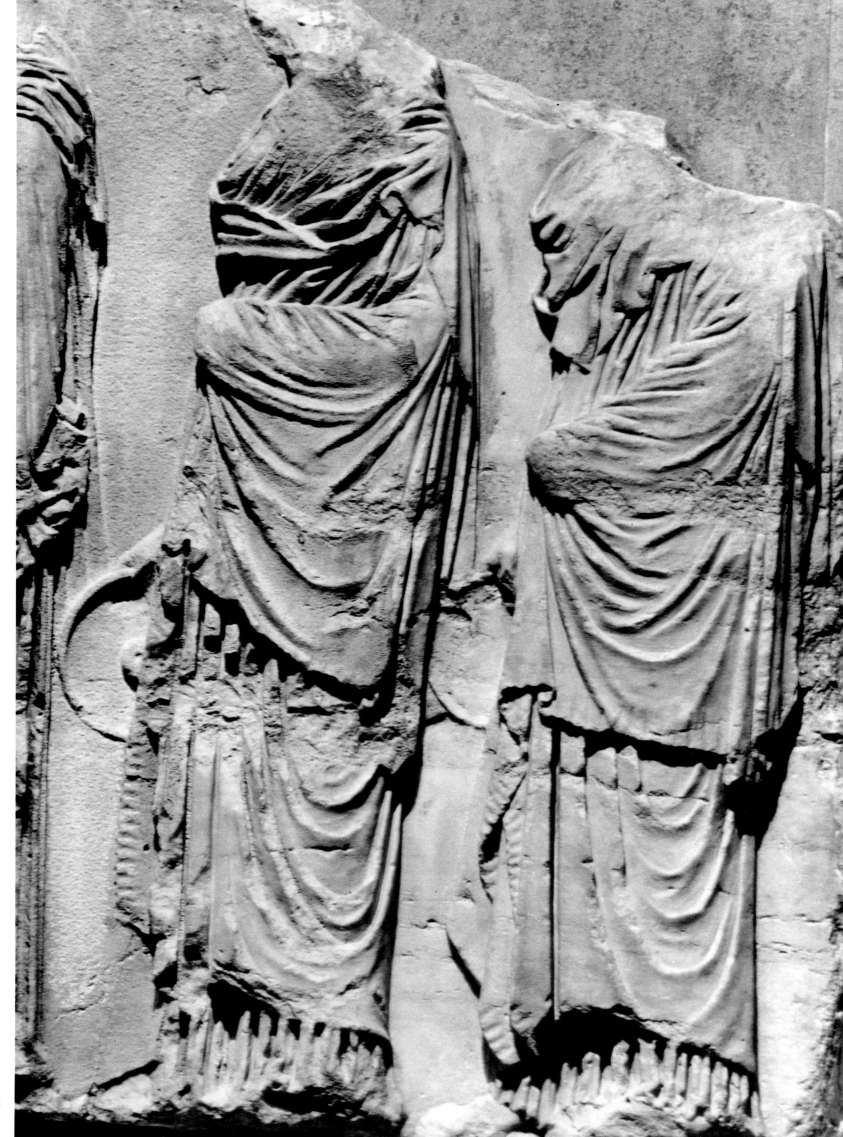

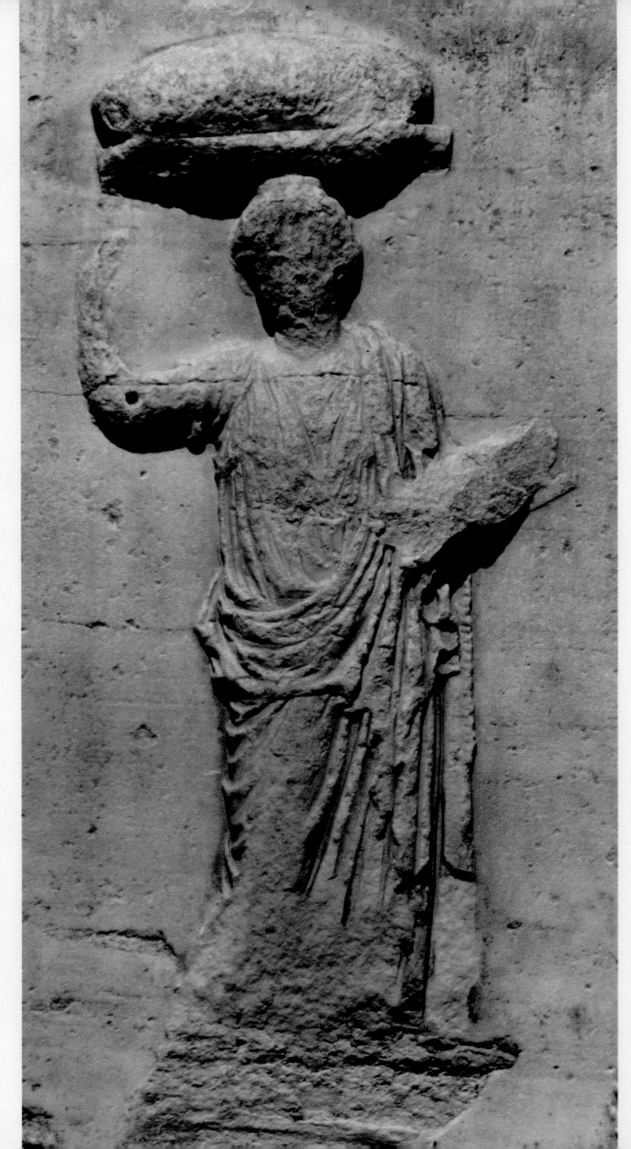

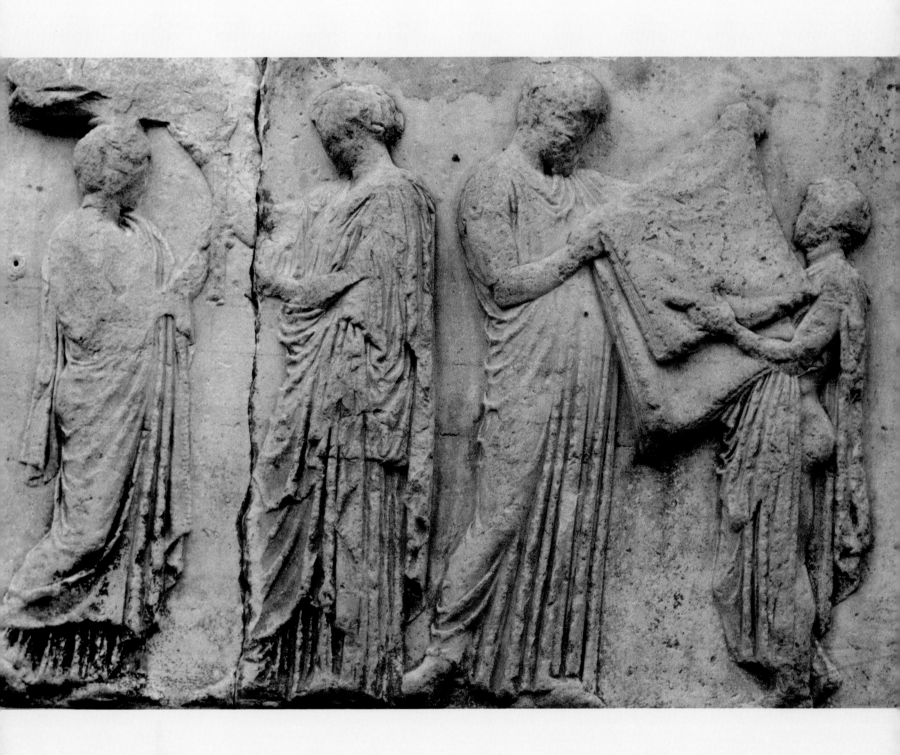

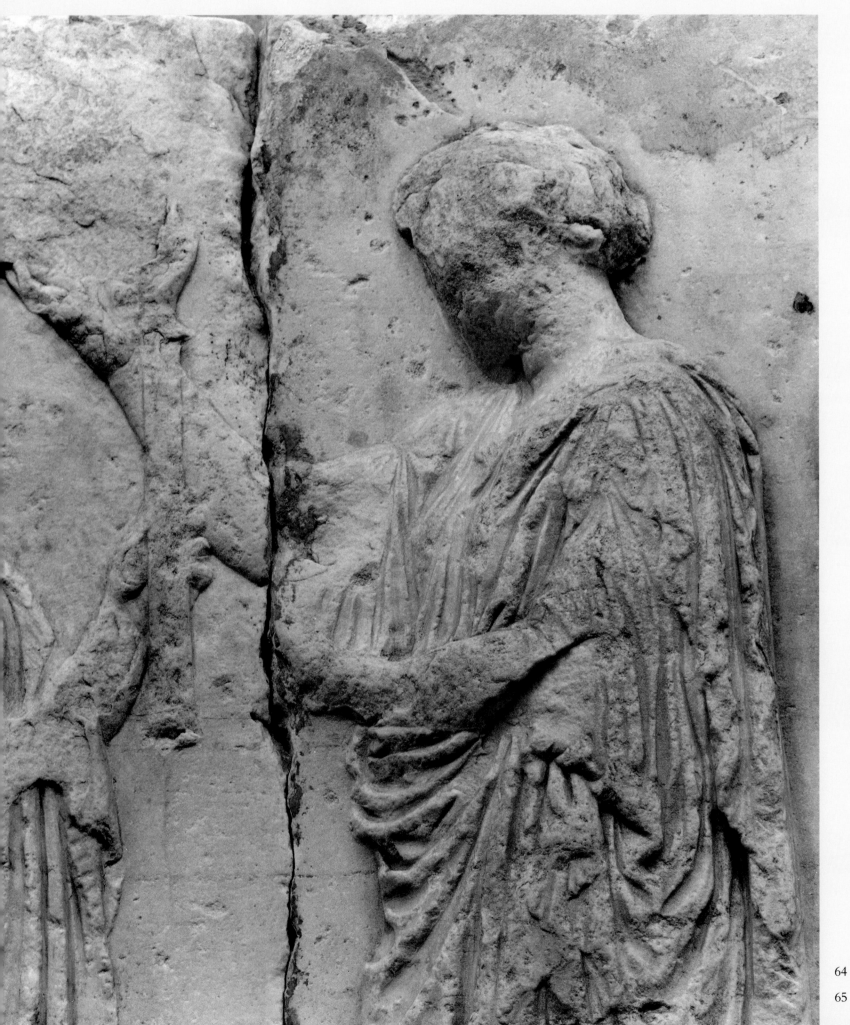

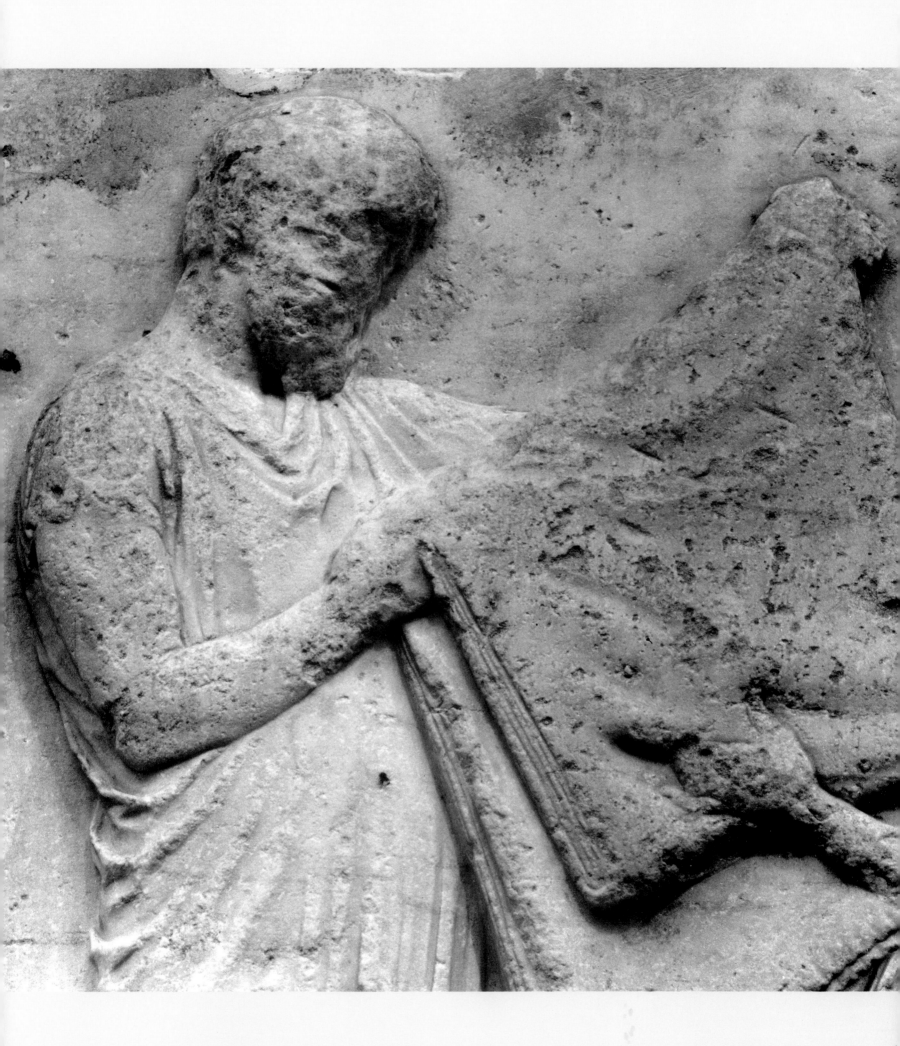

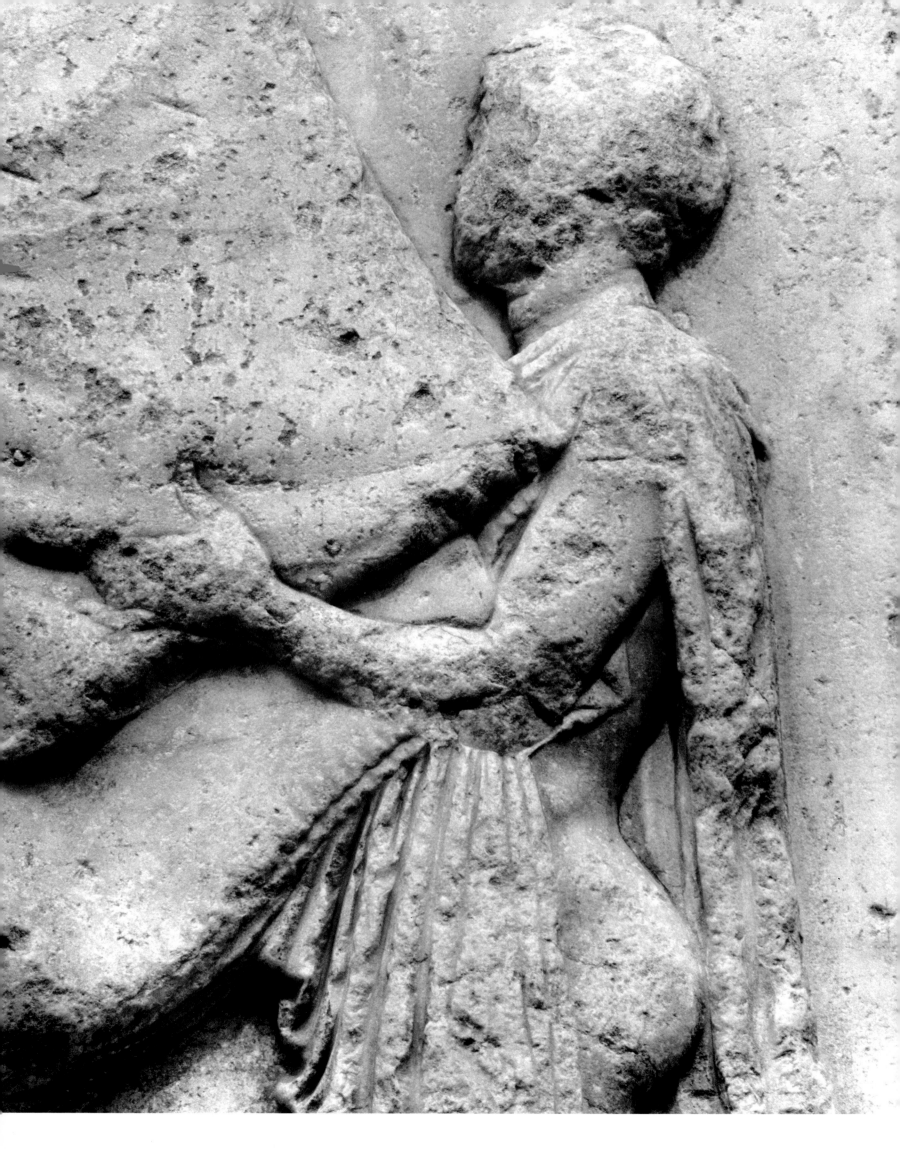

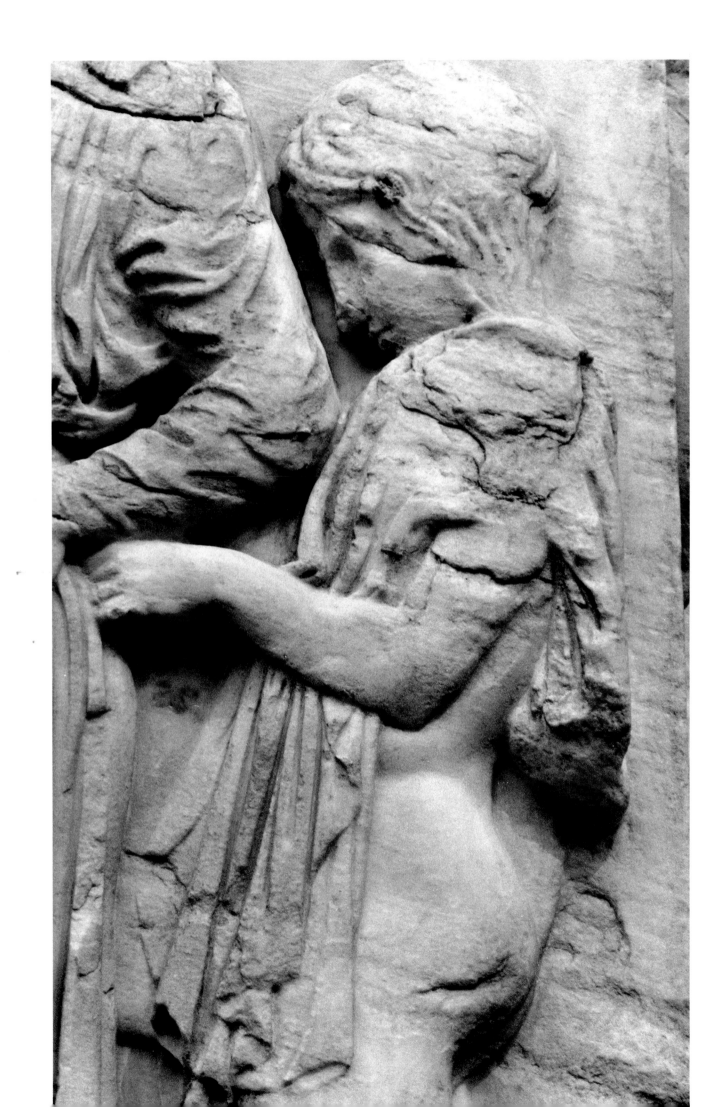

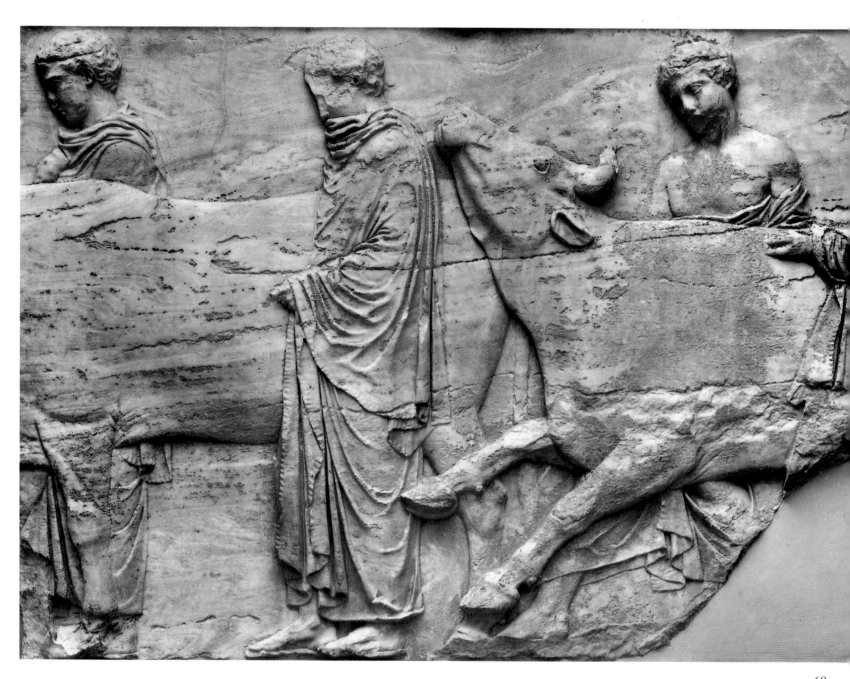

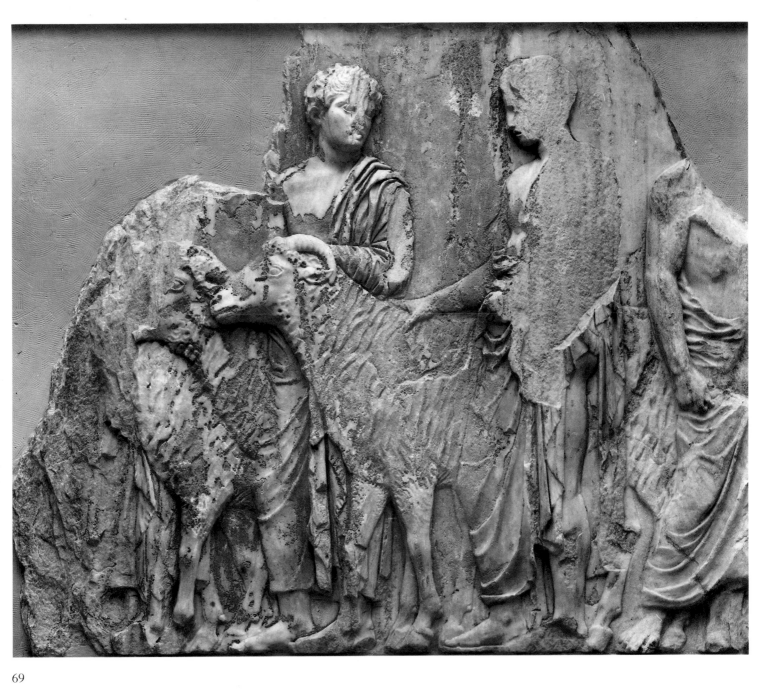

69

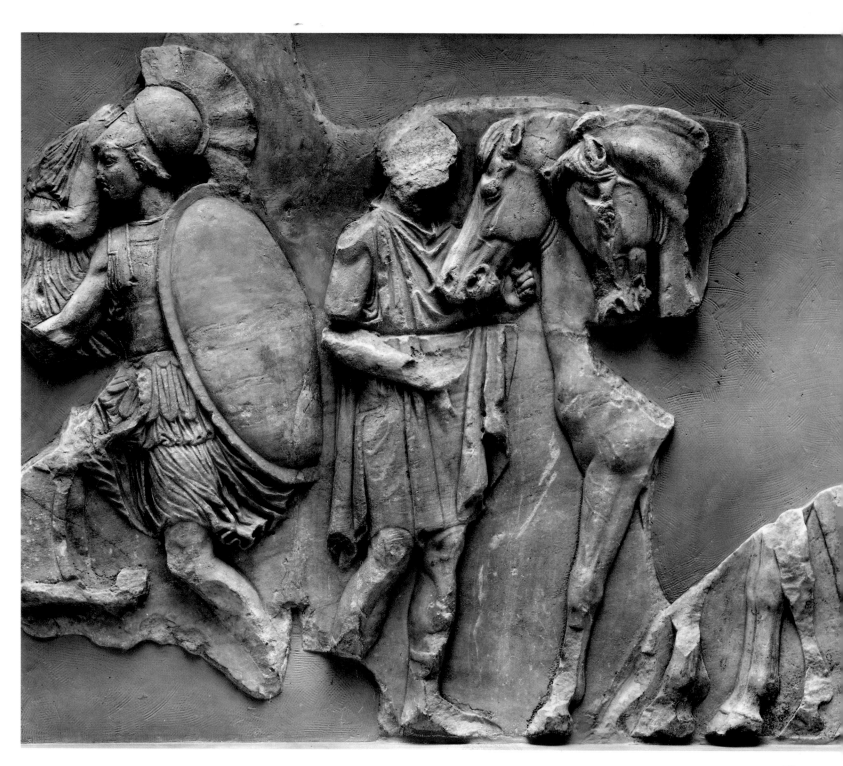

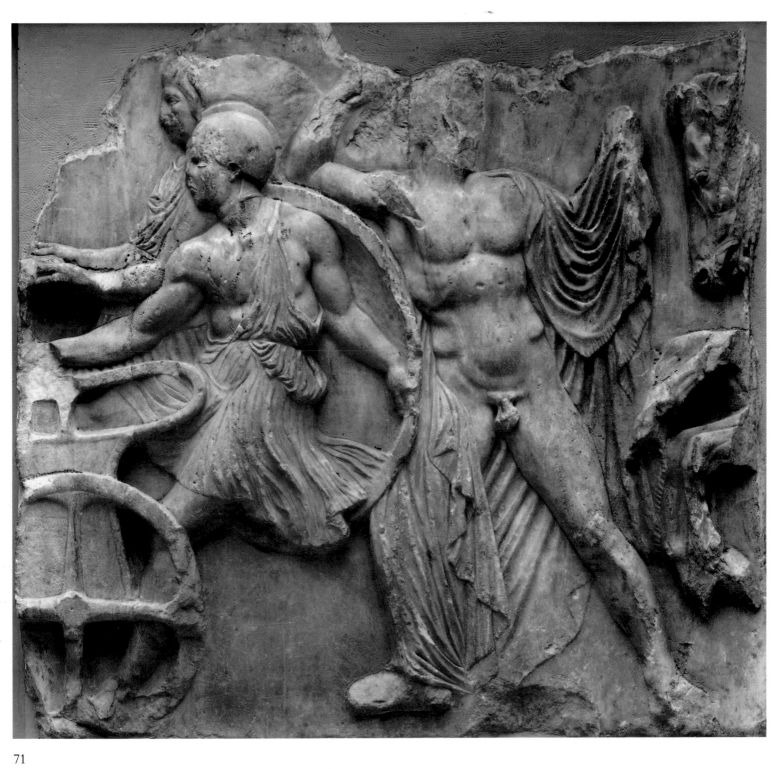

71

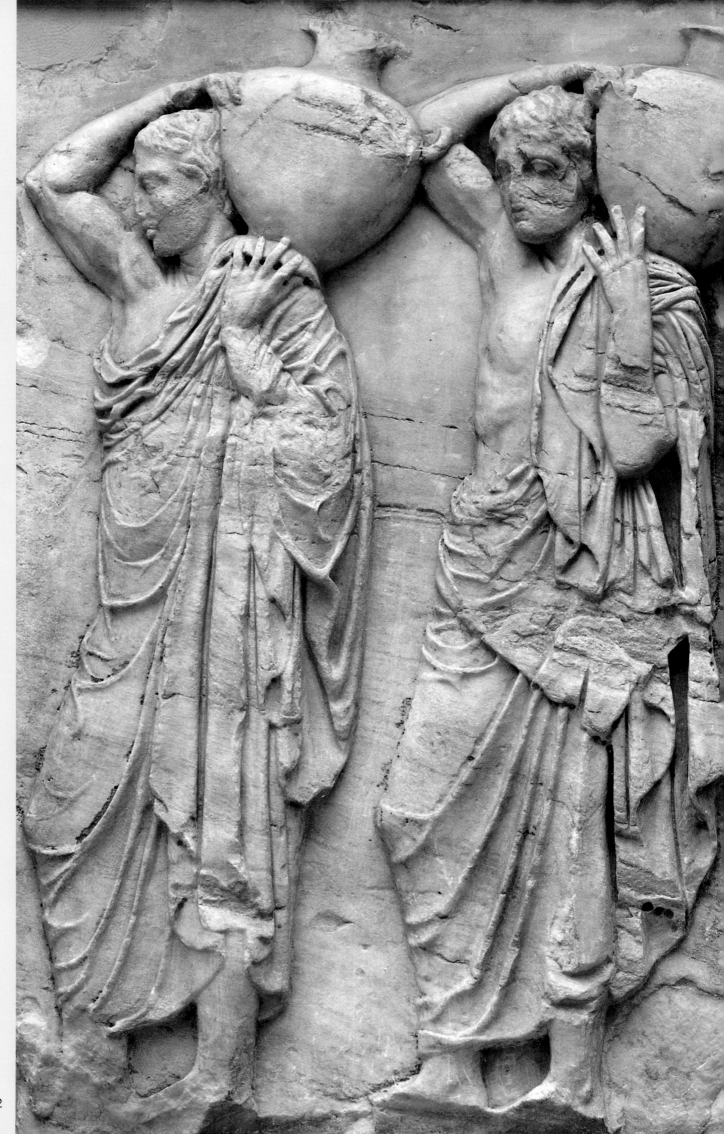

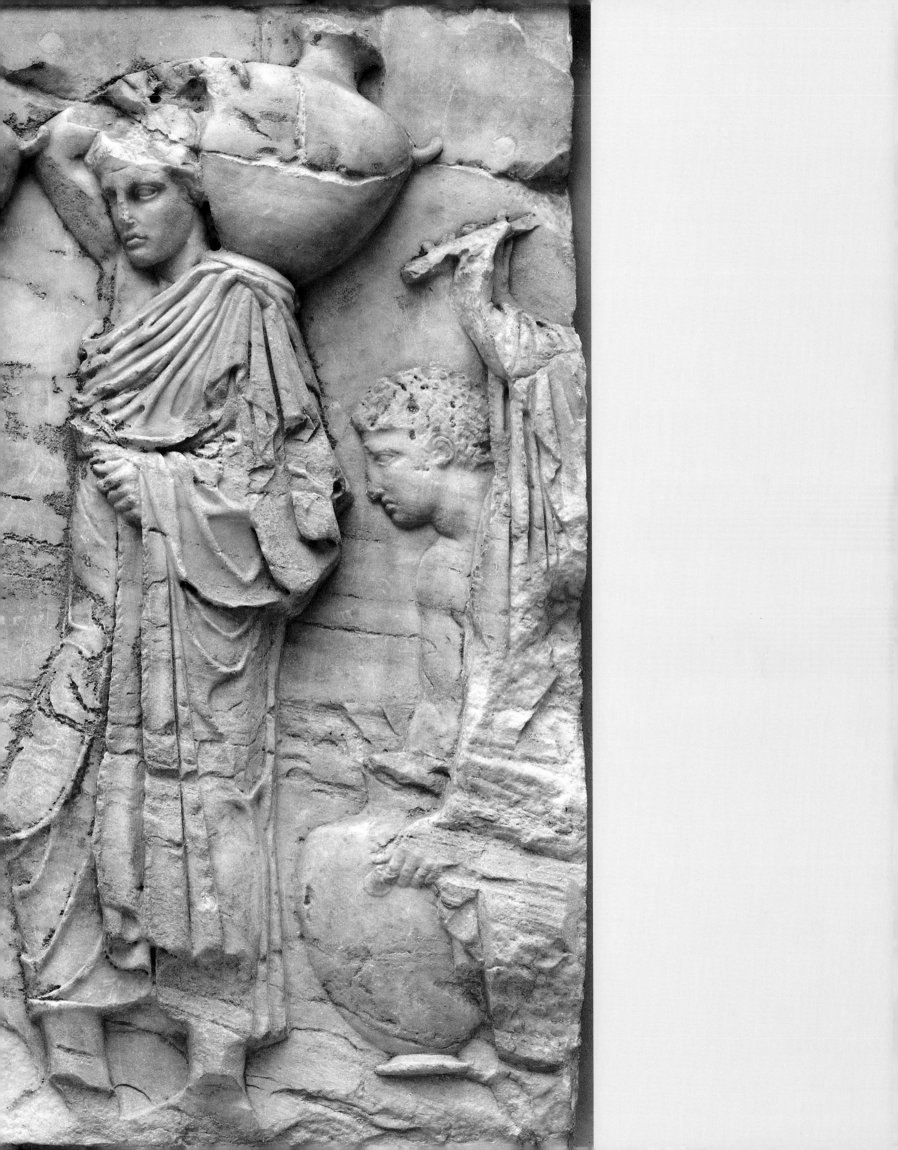

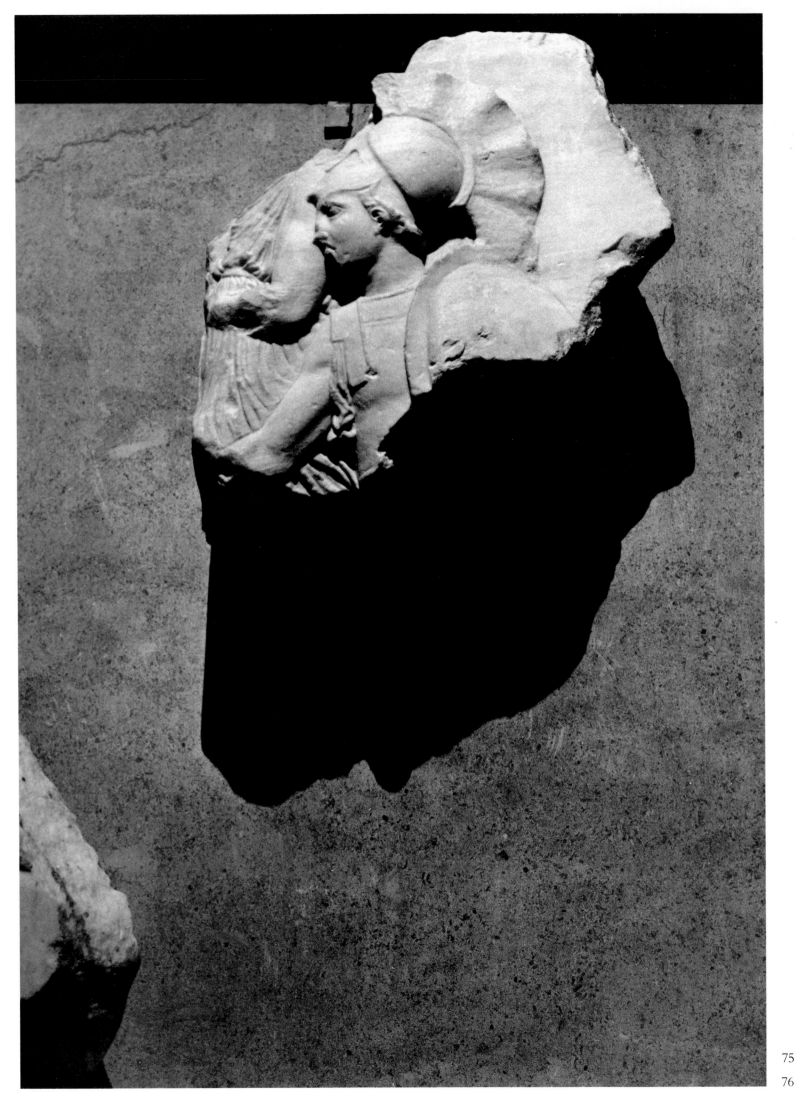

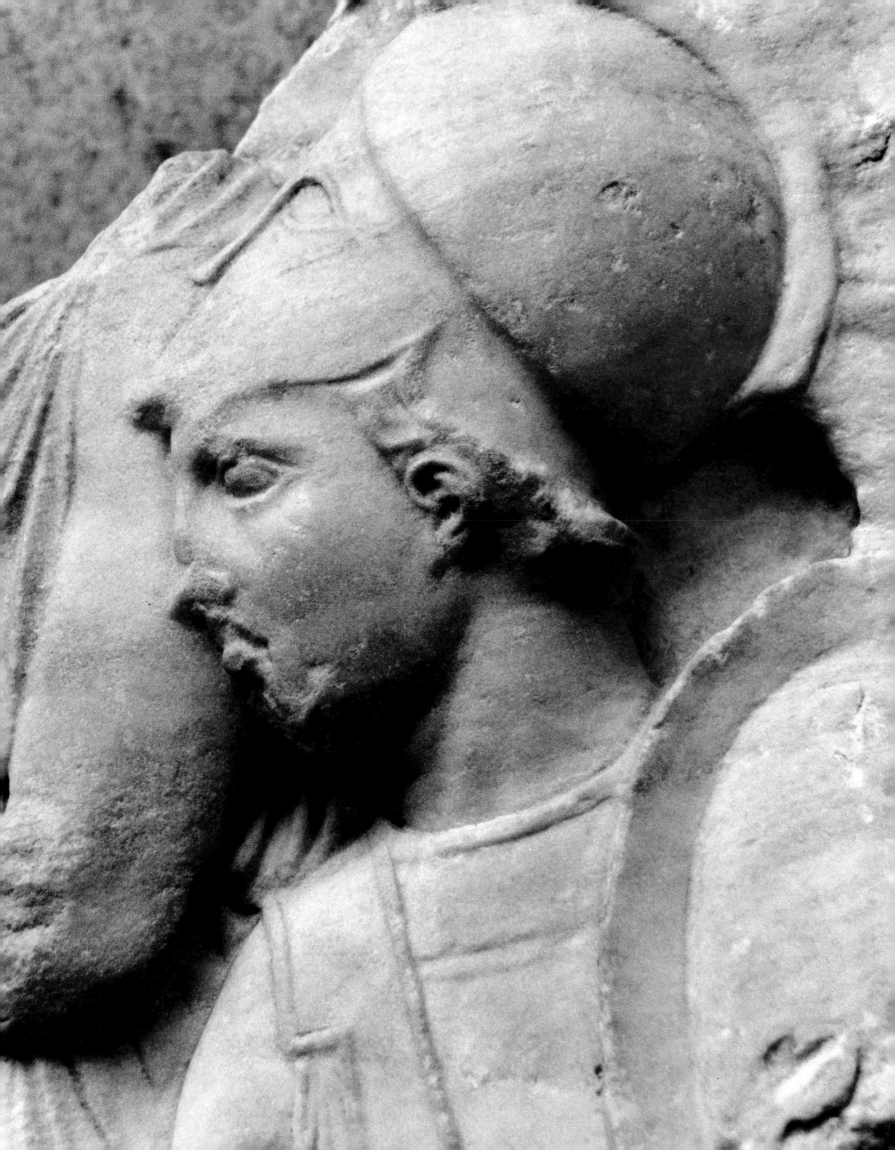

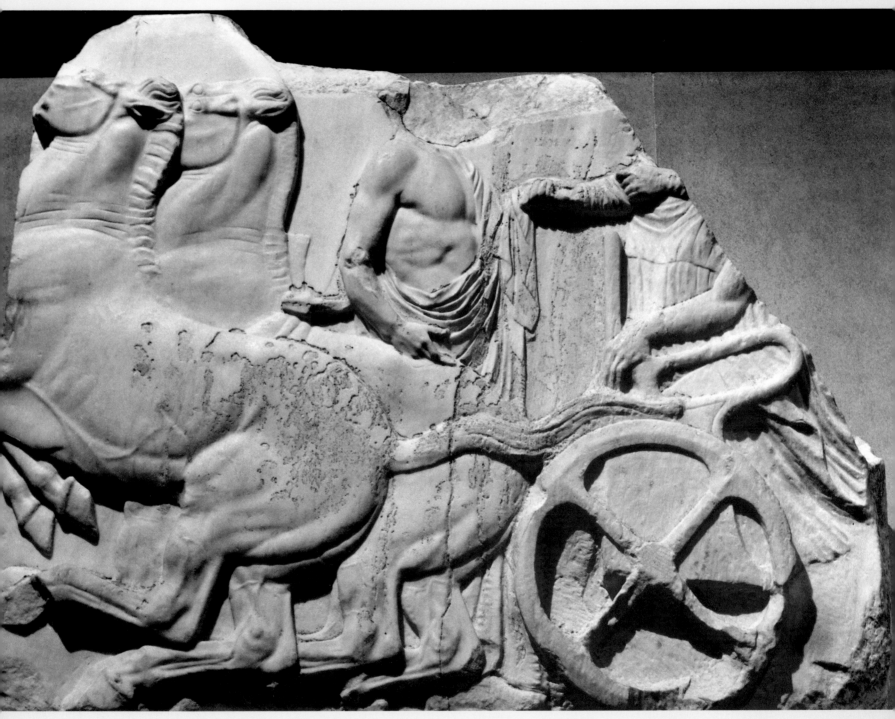

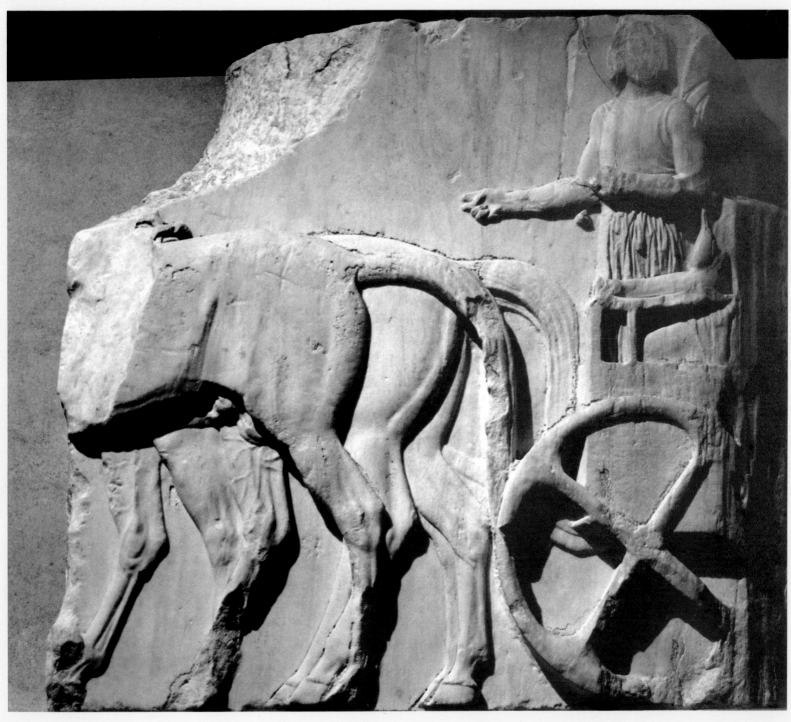

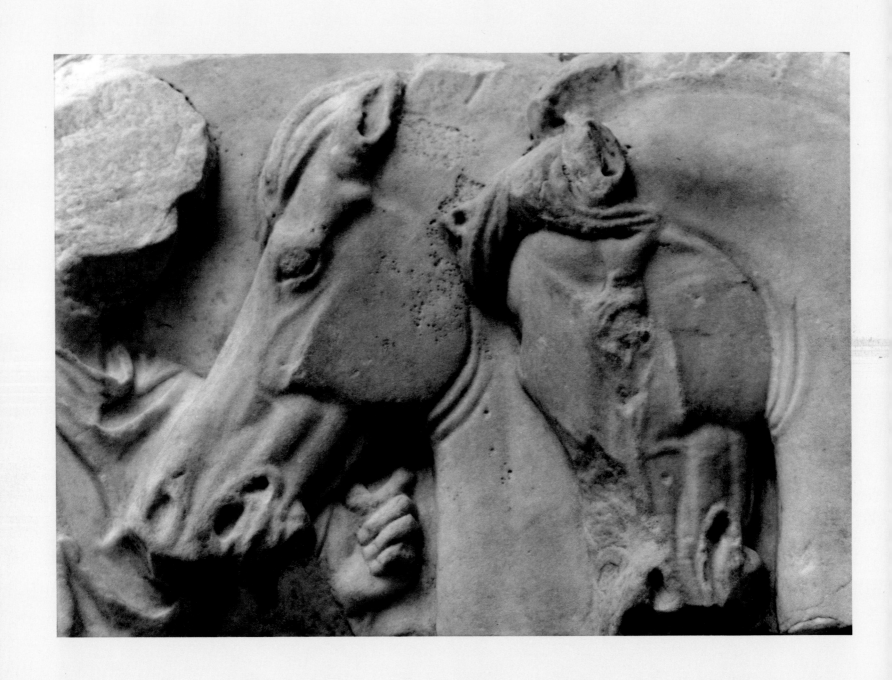

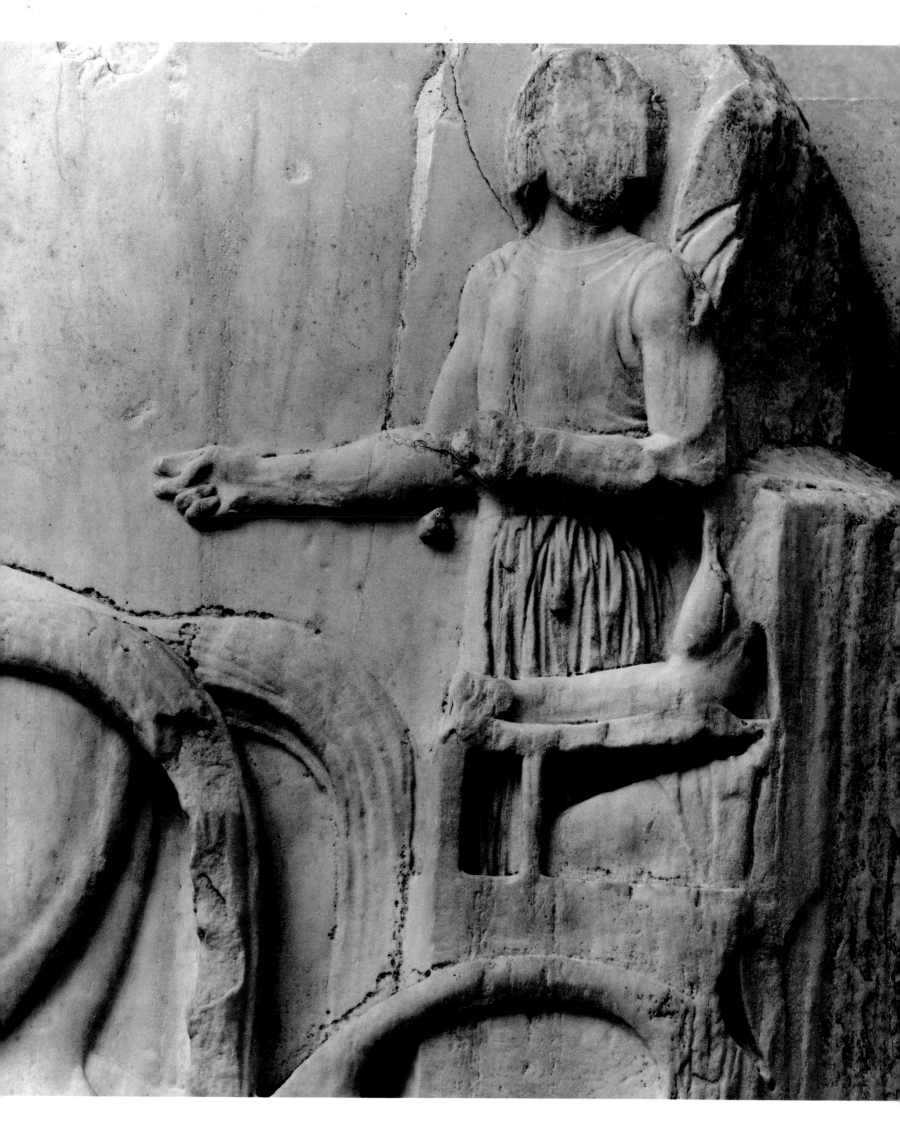

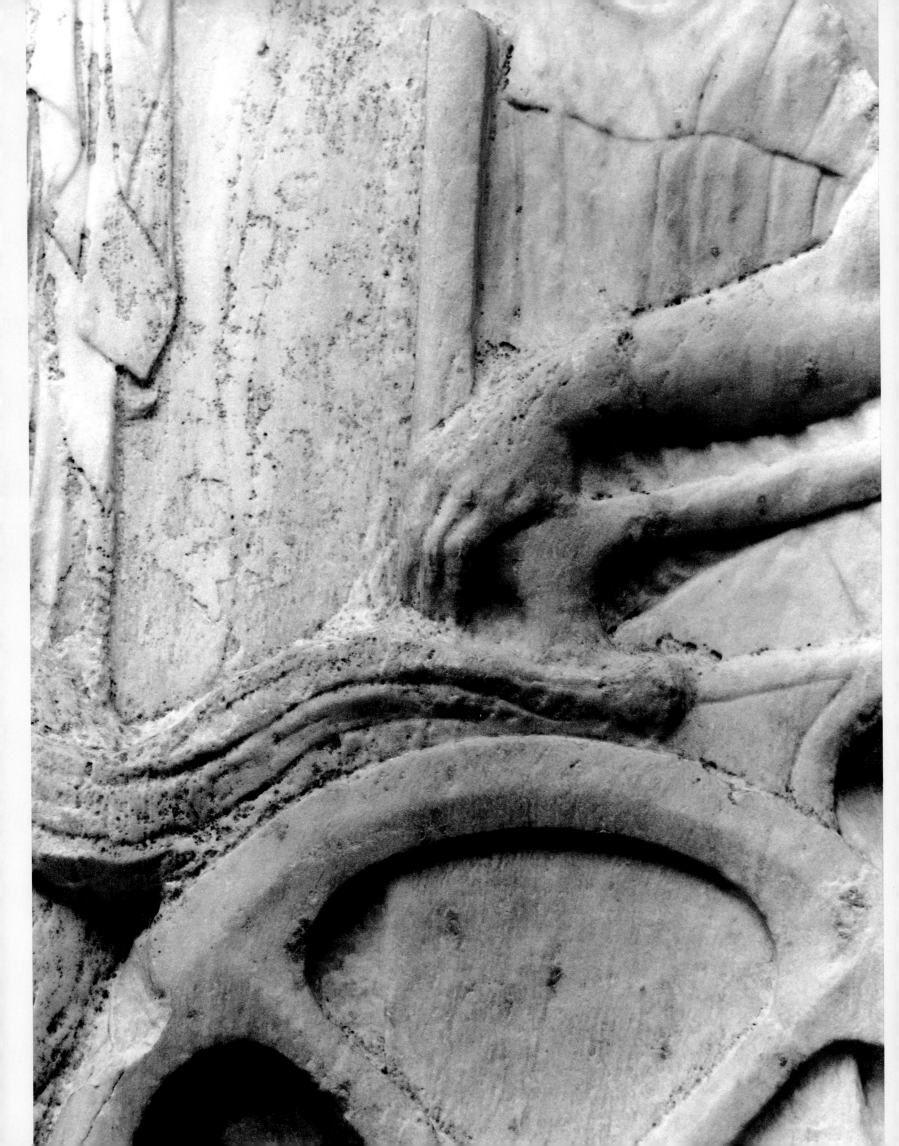

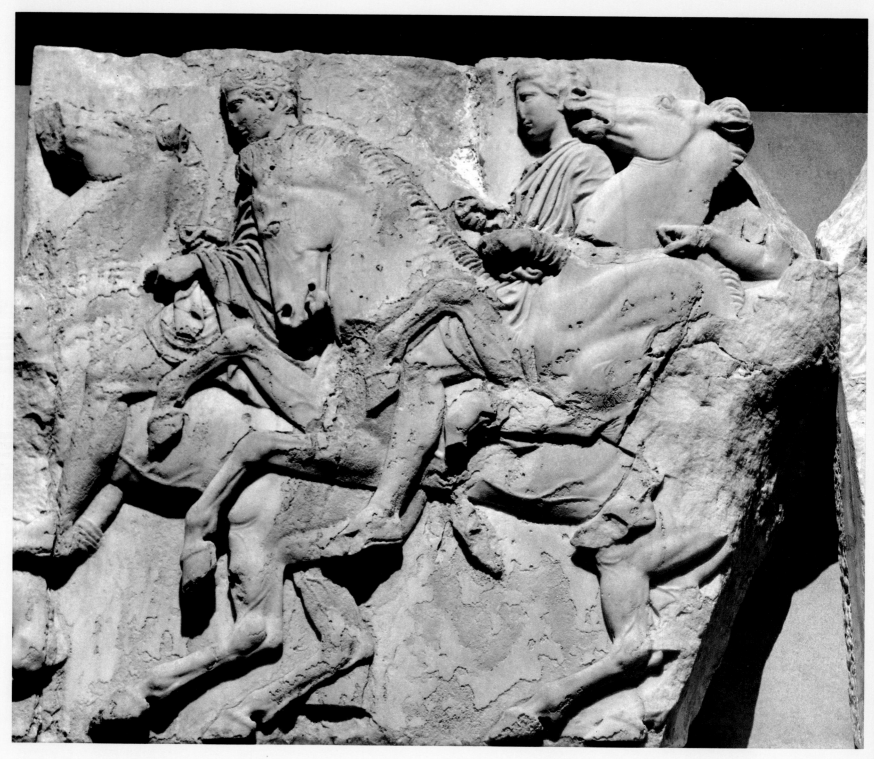

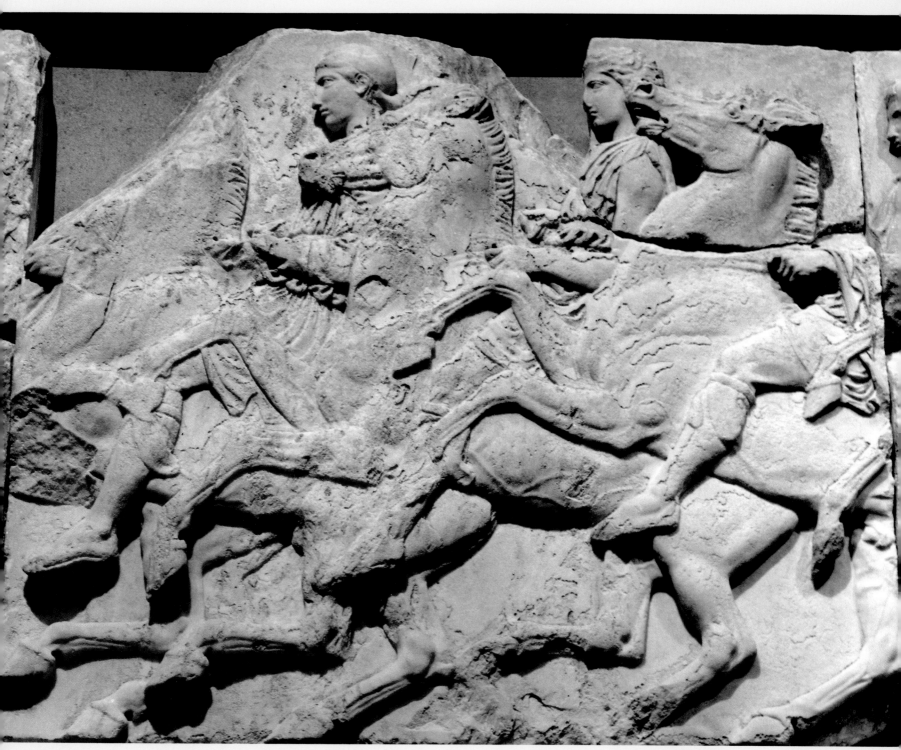

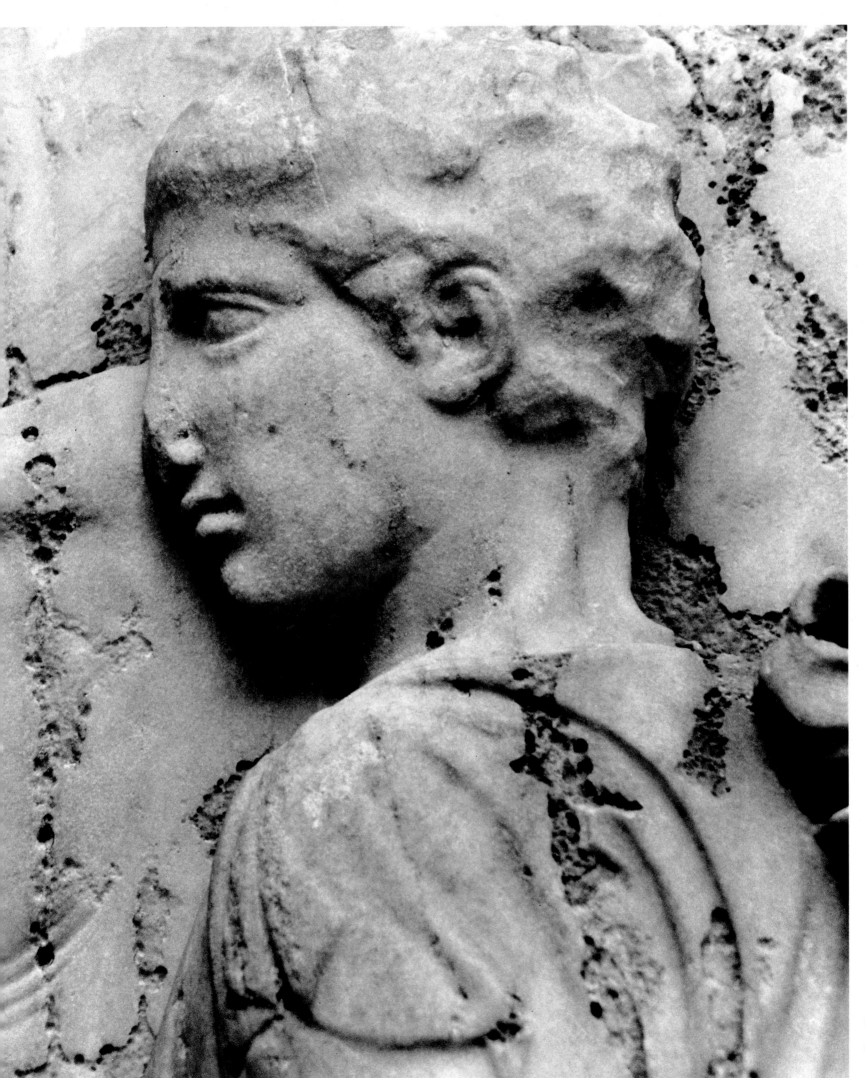

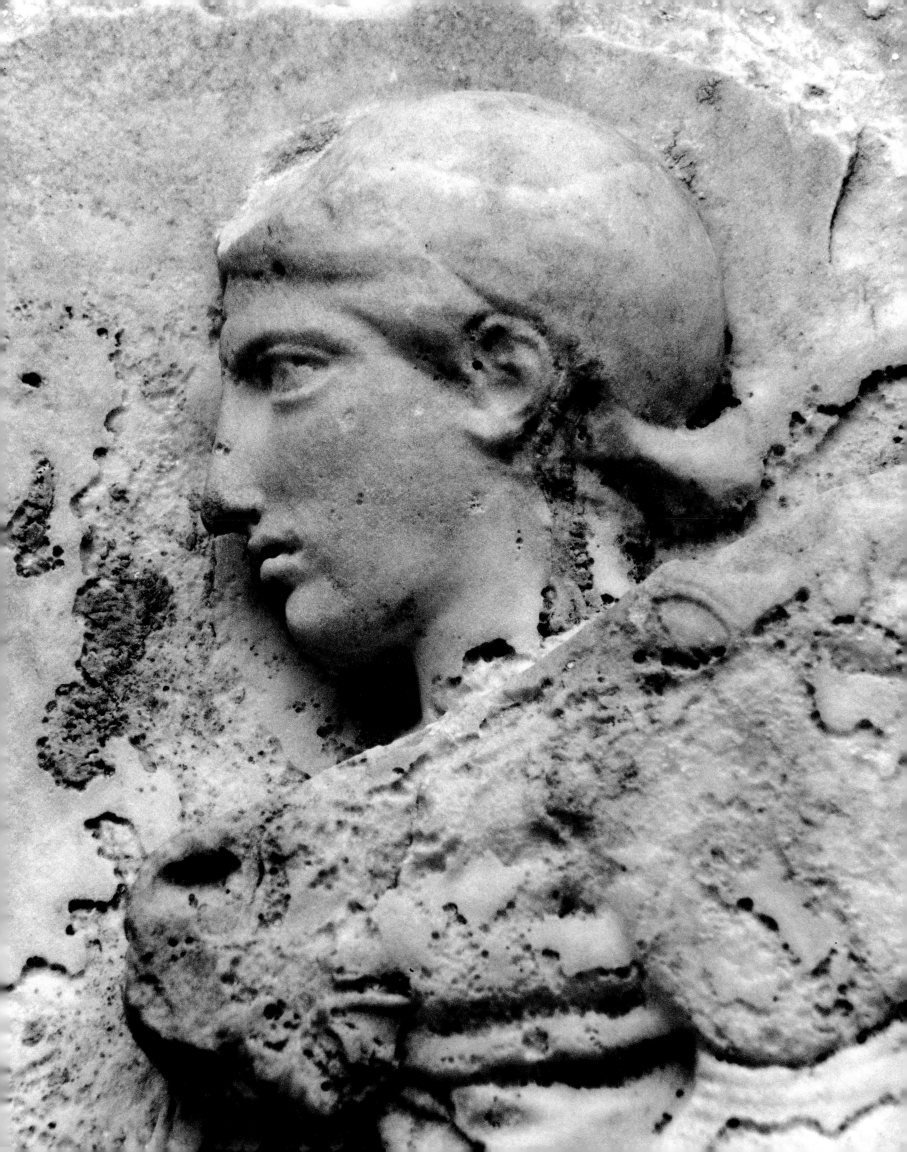

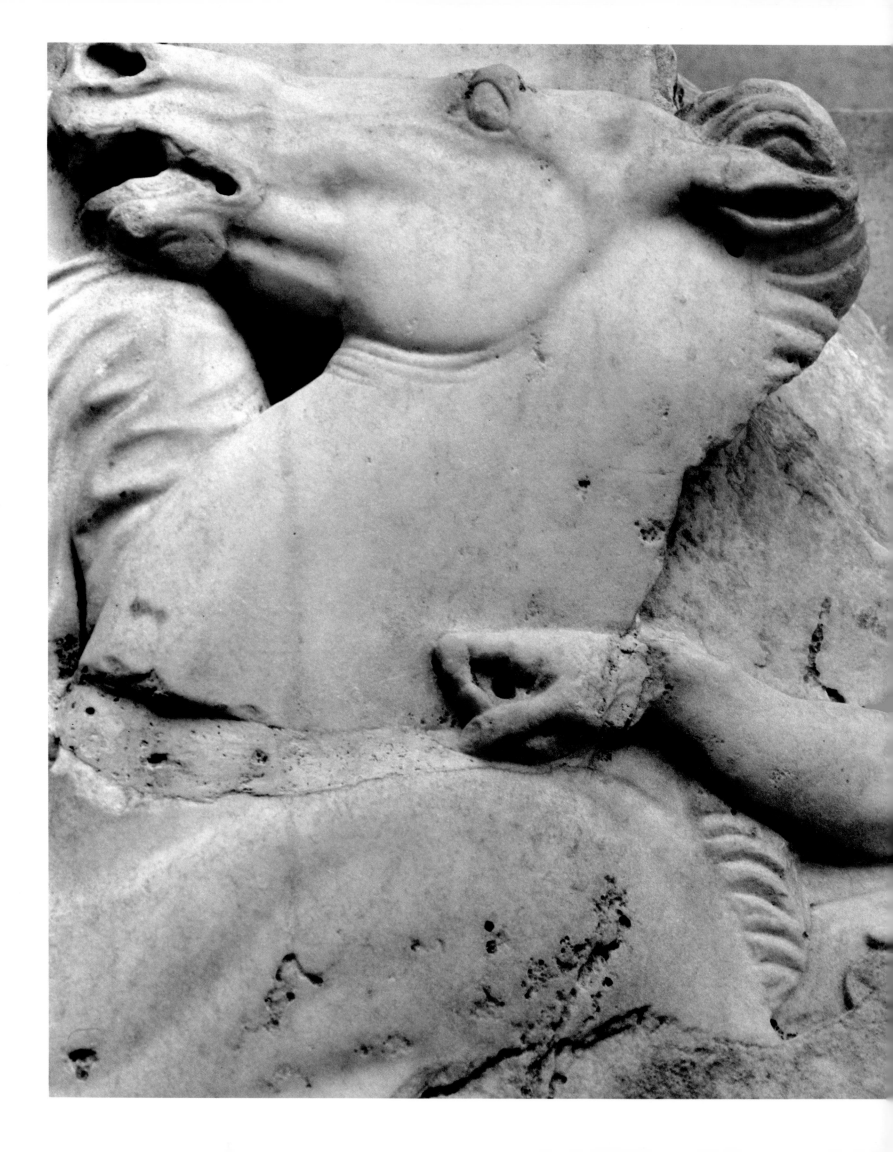

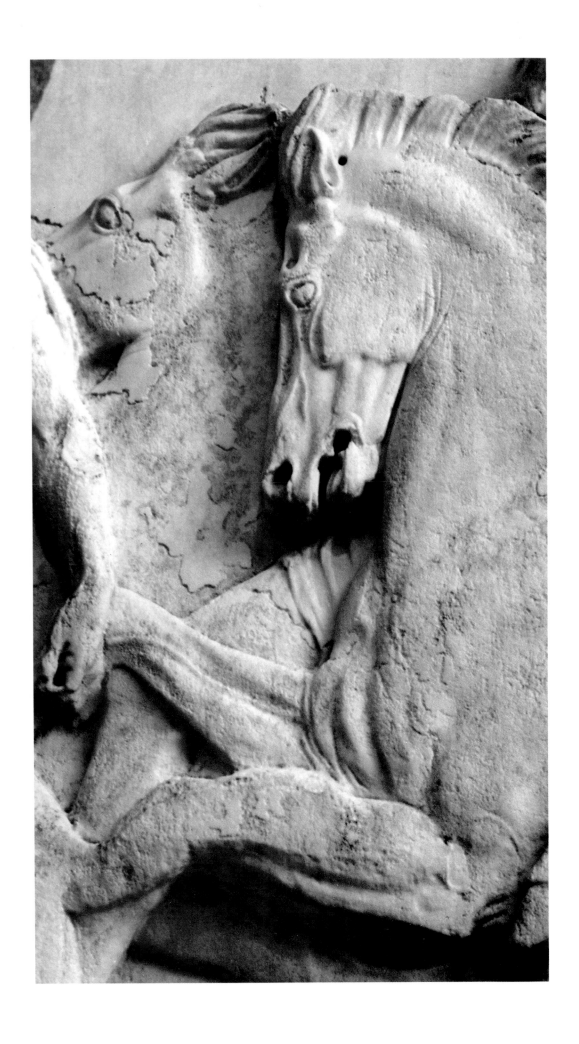

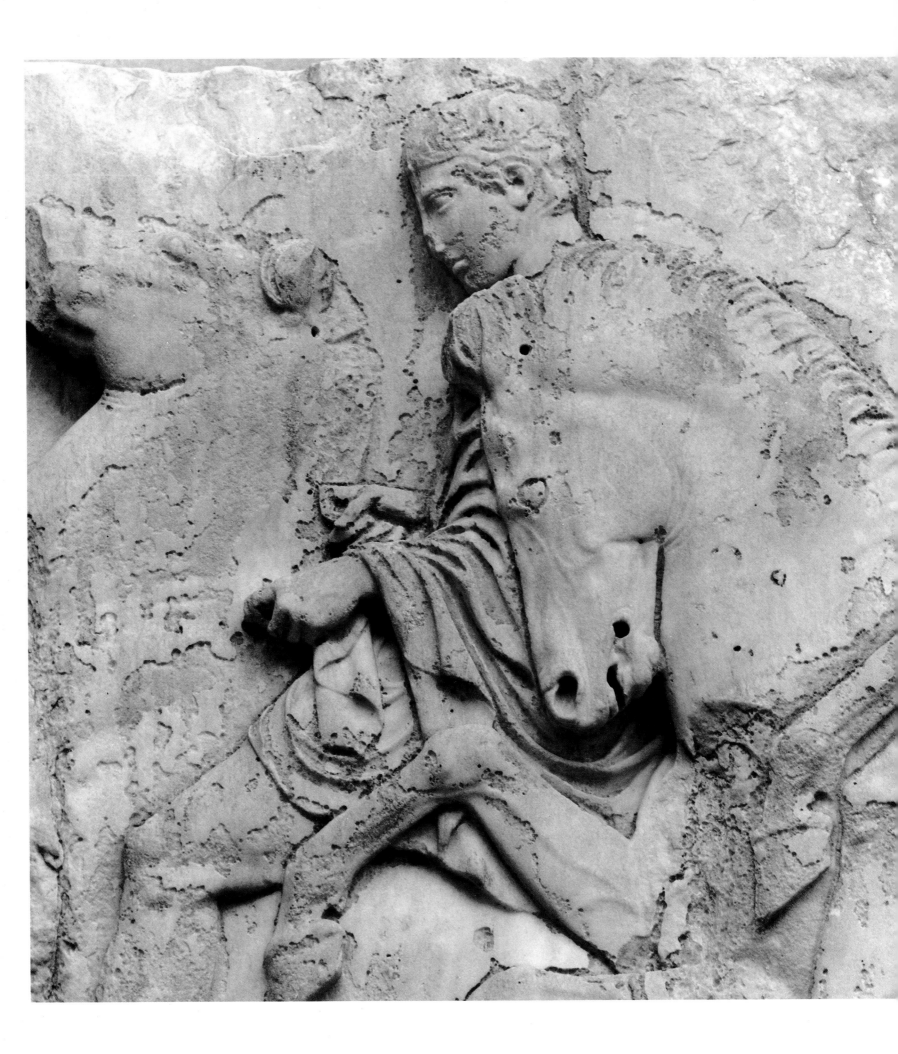

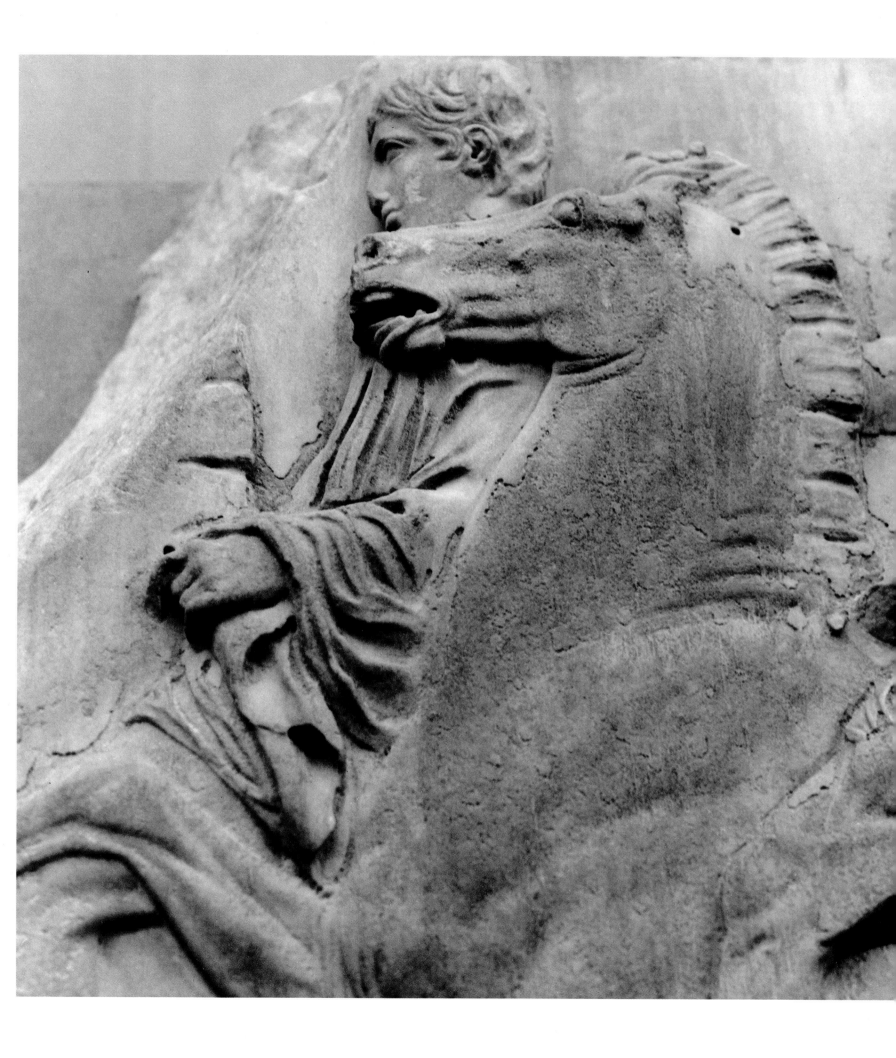

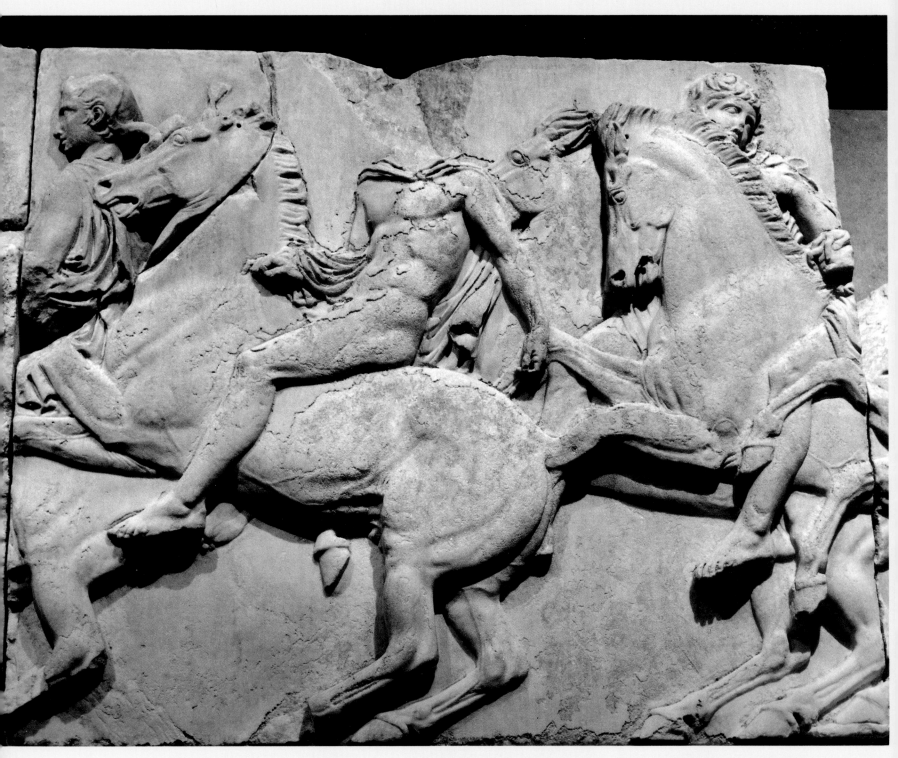

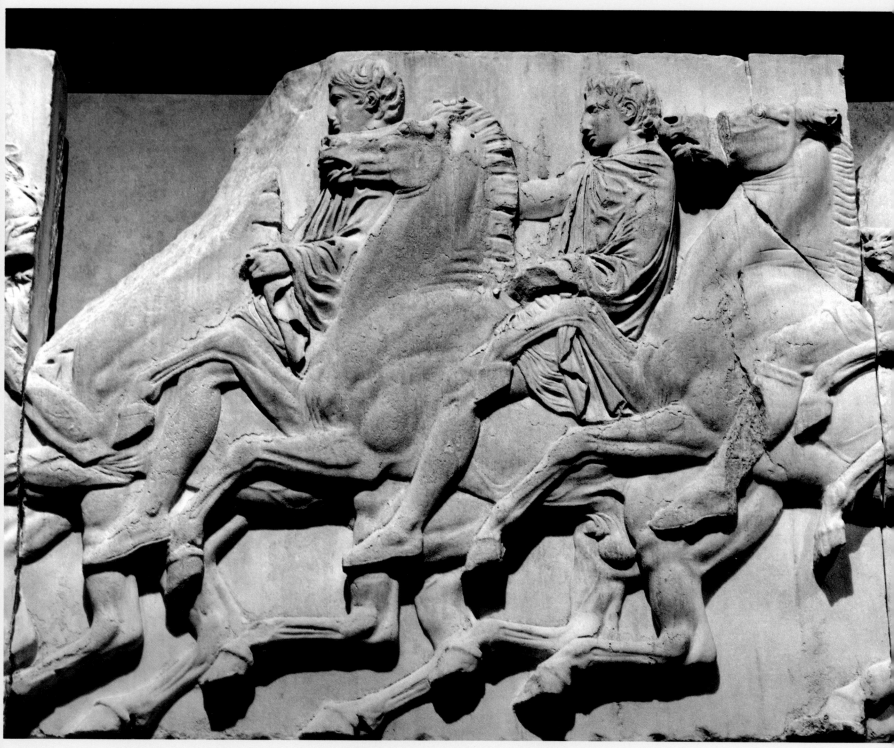

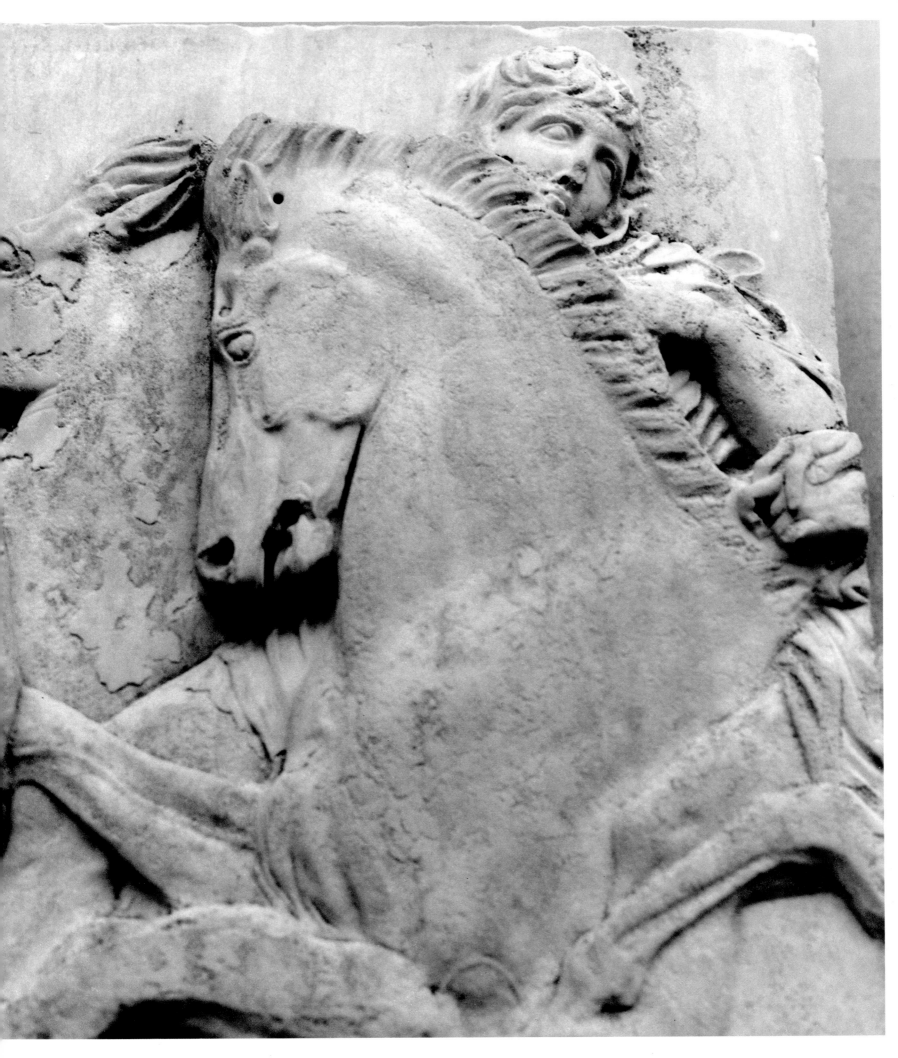

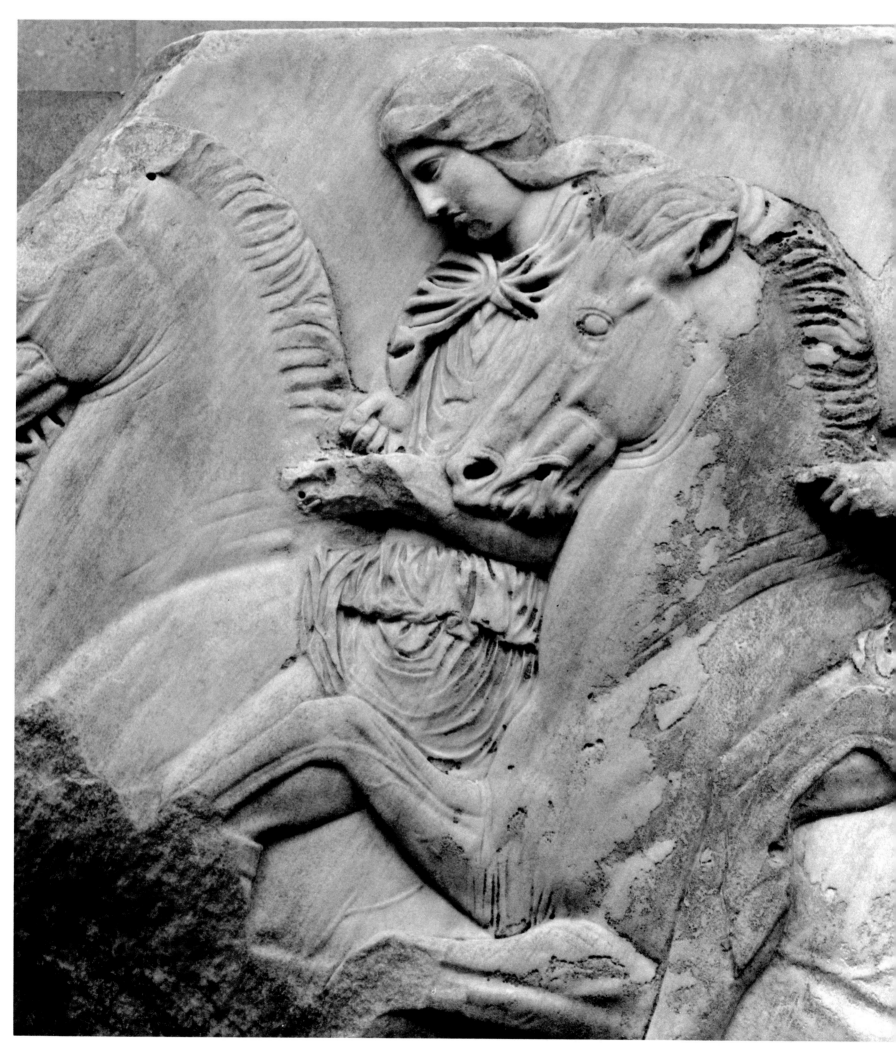

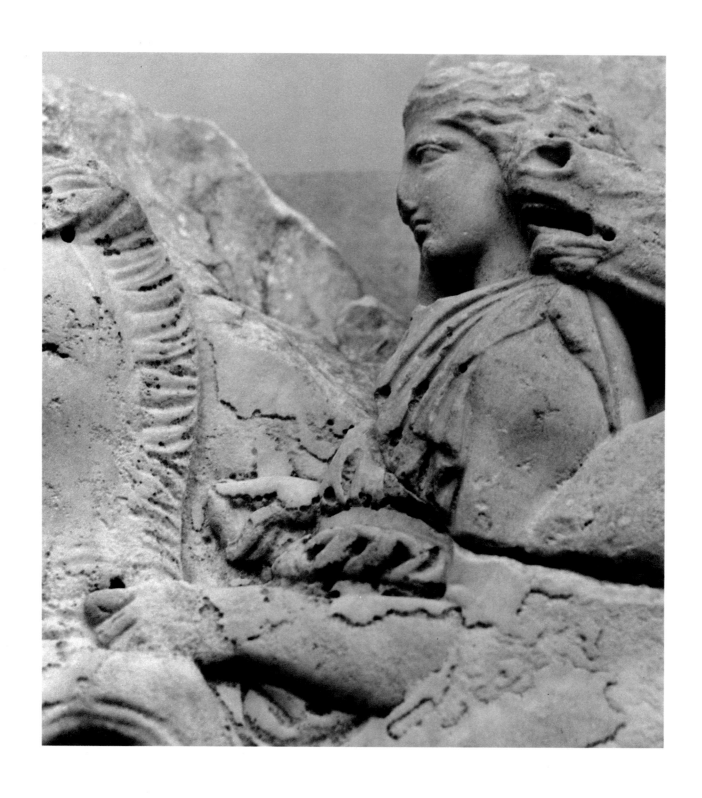

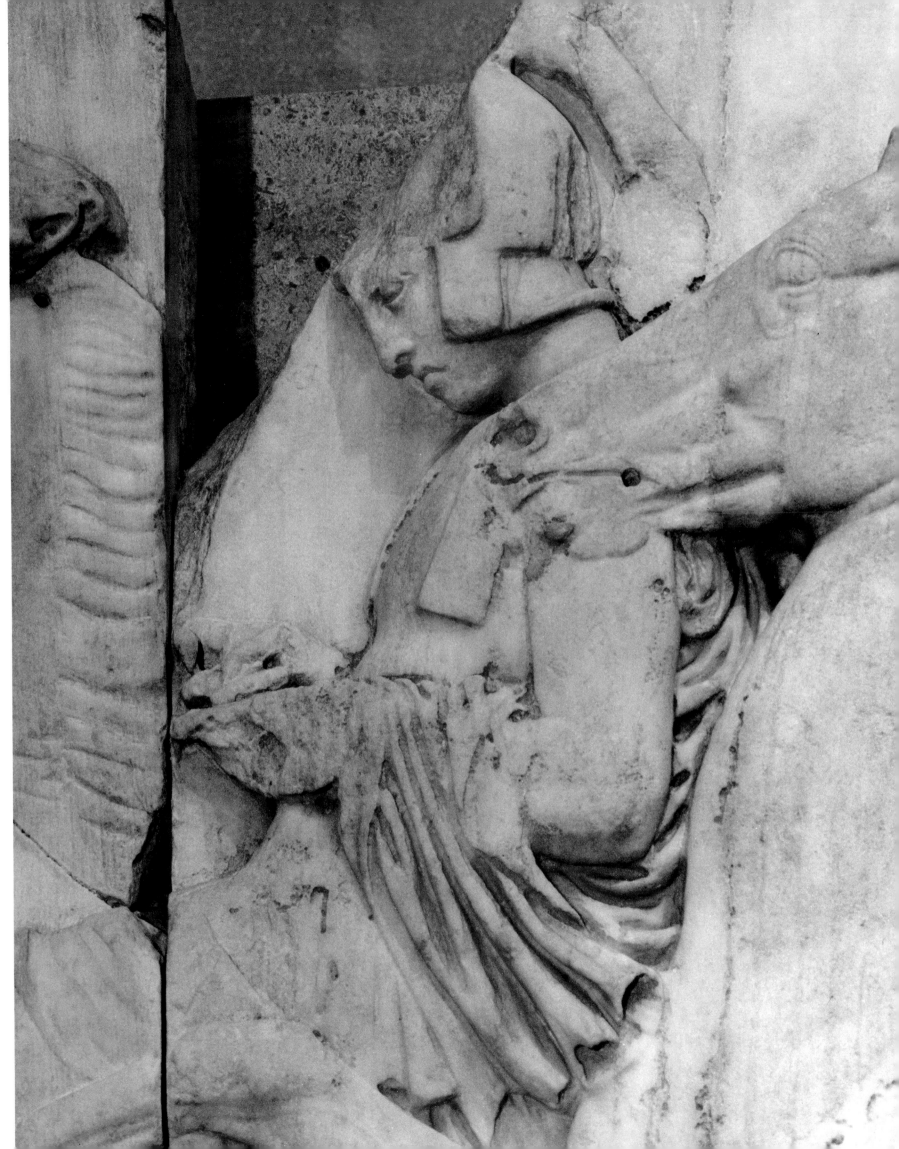

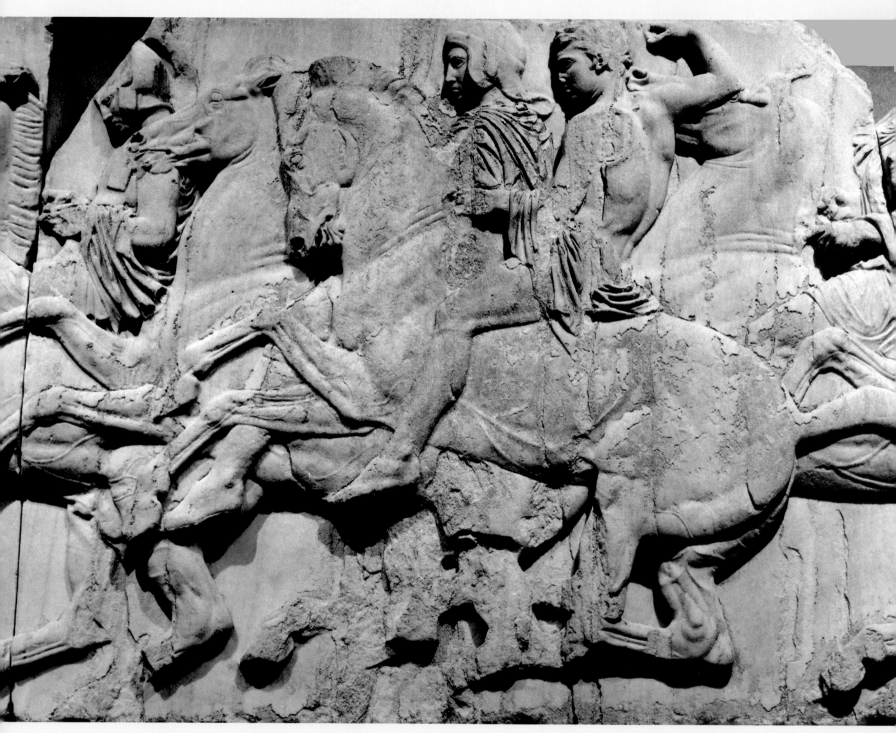

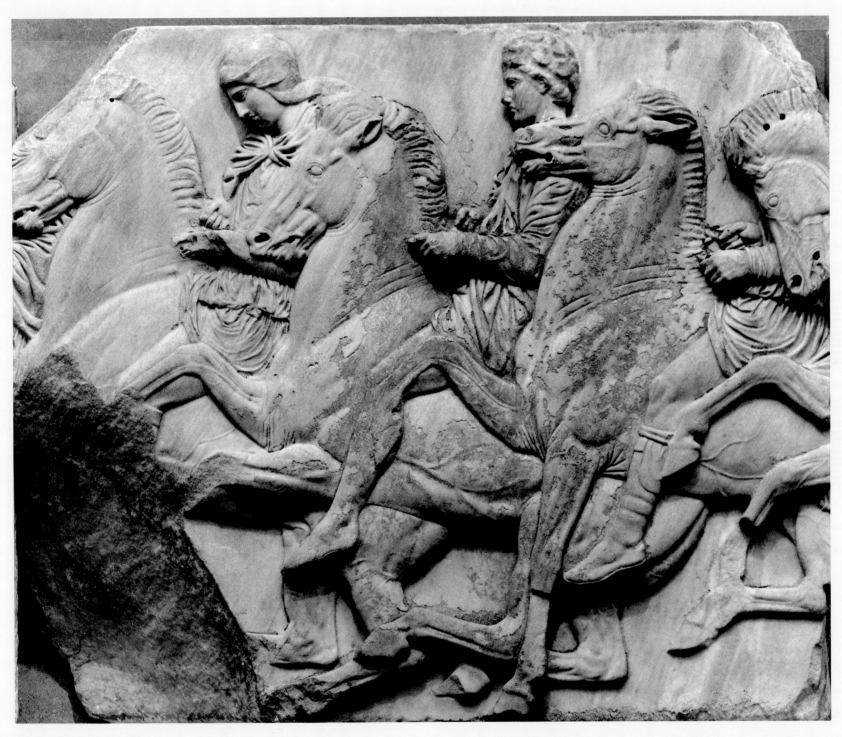

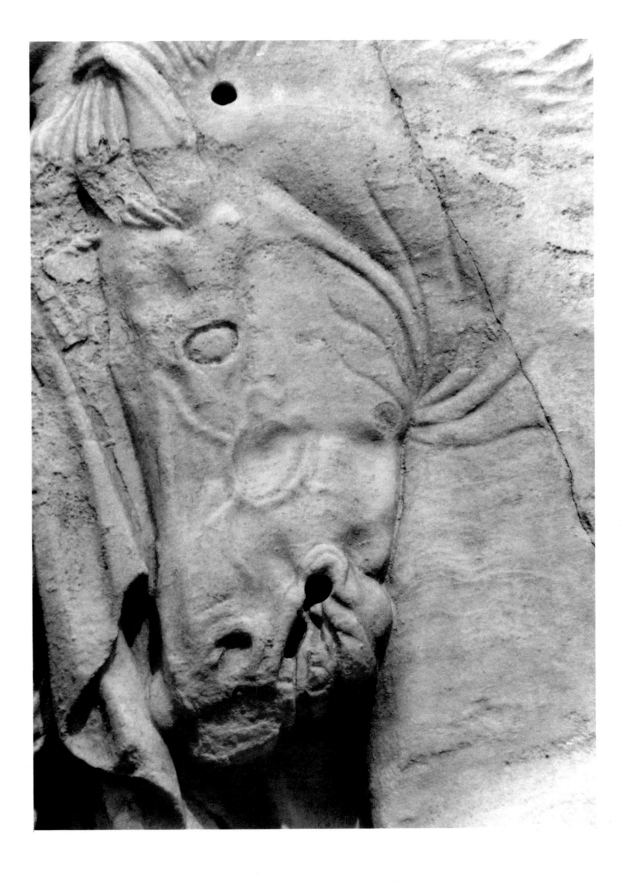

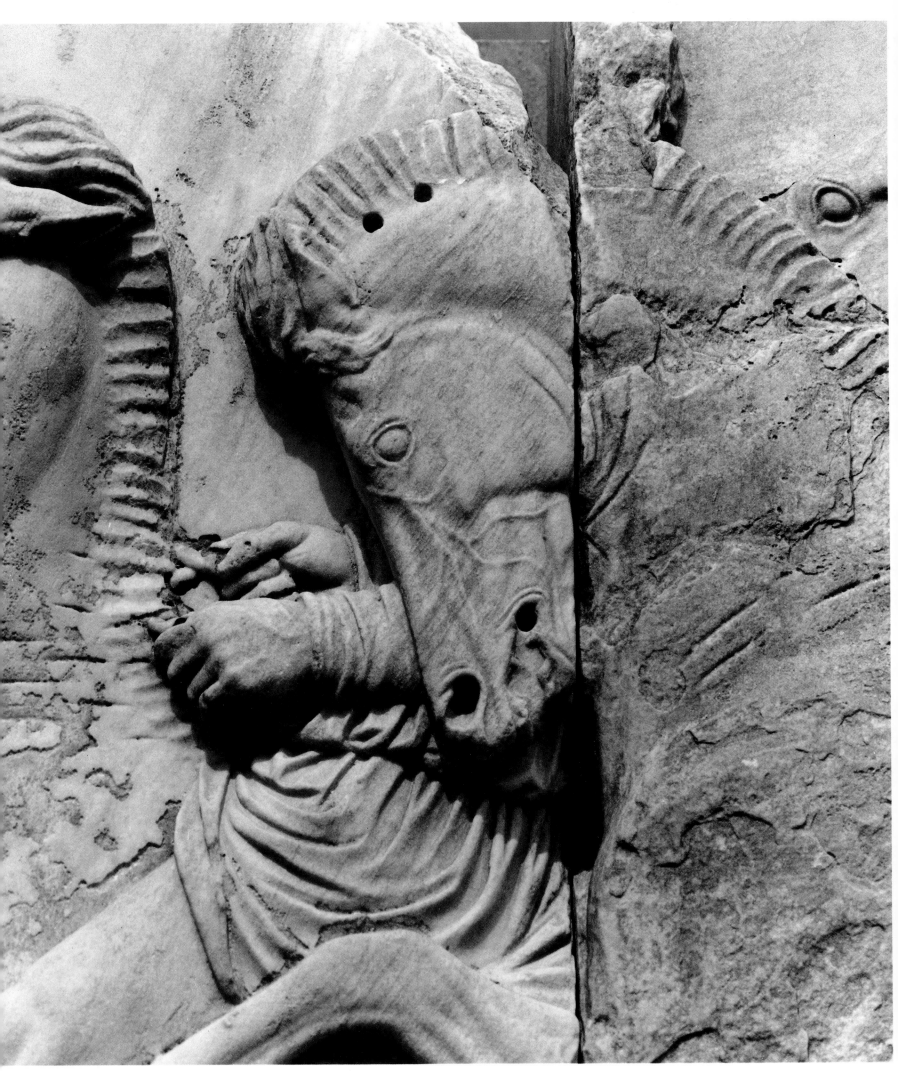

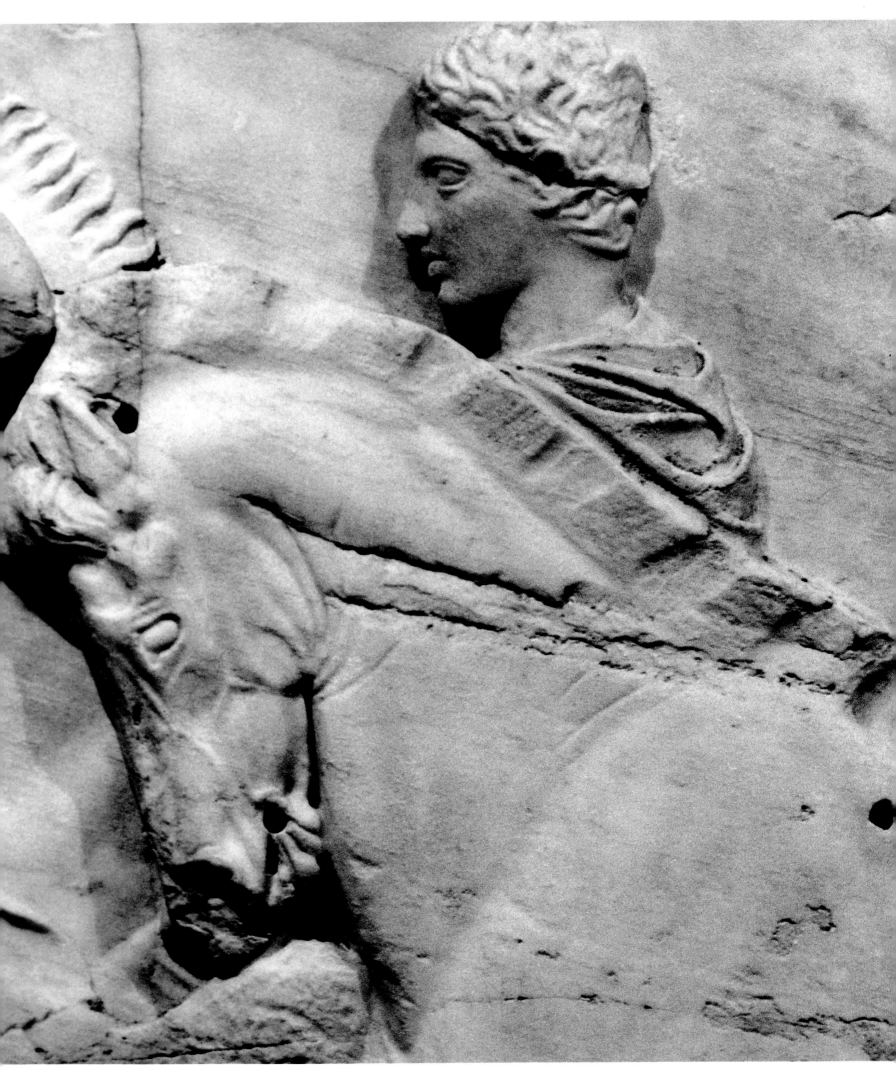

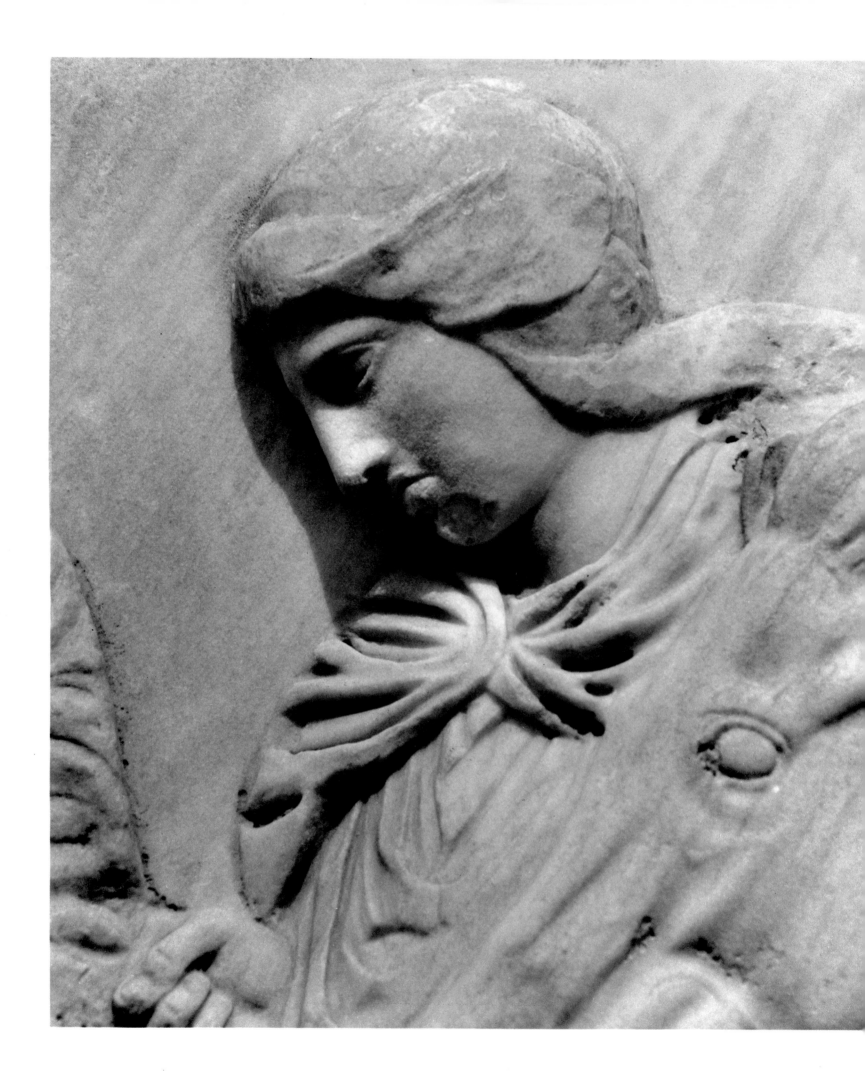

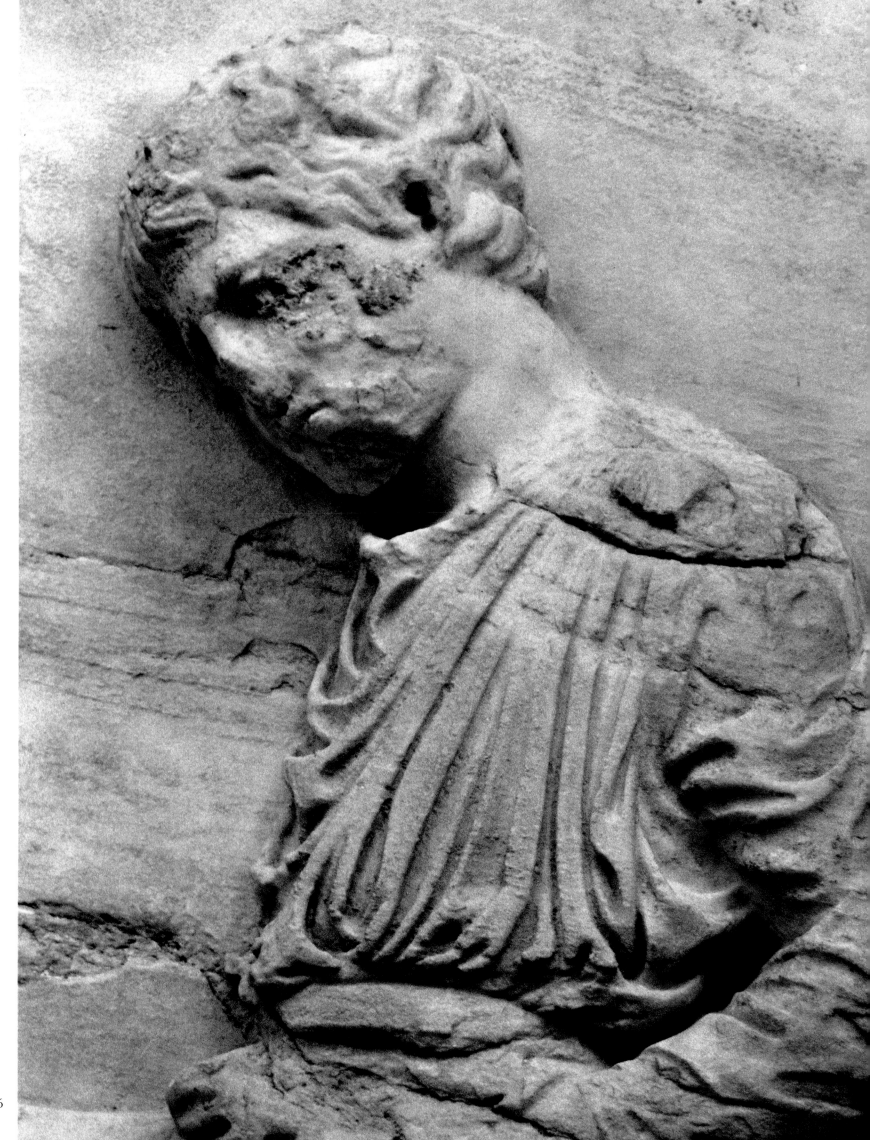

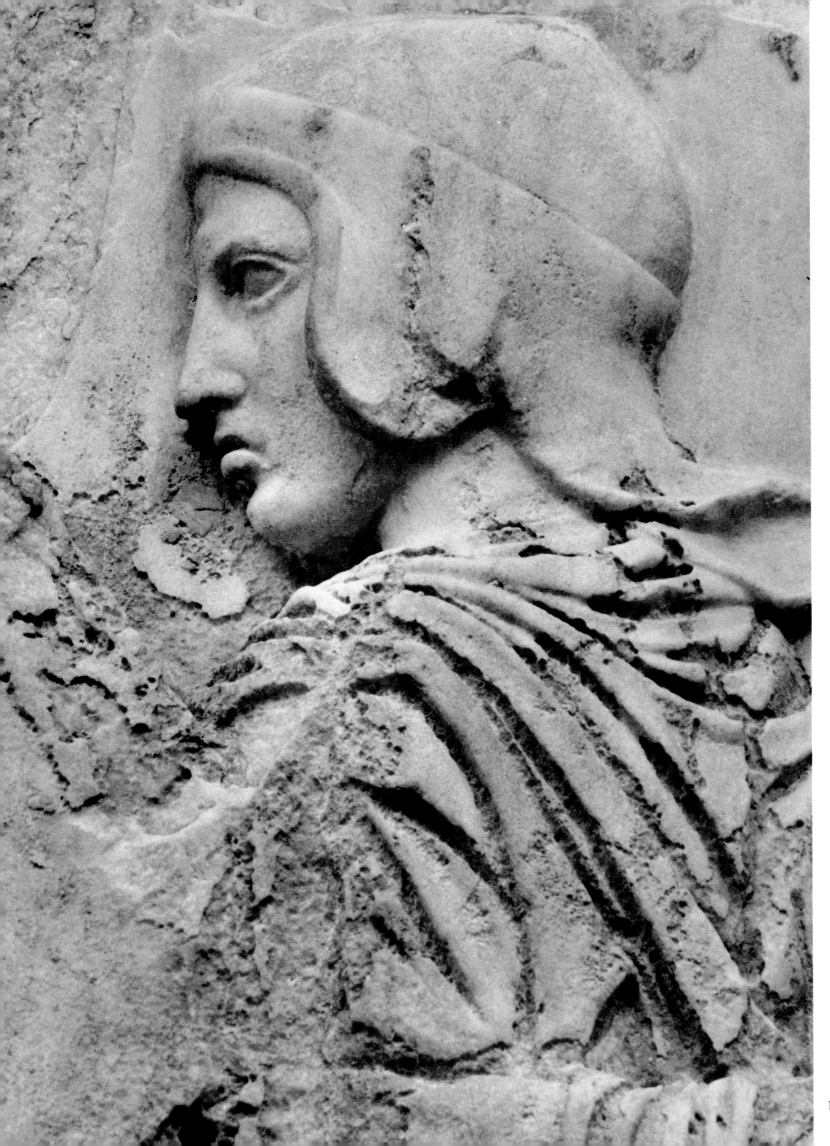

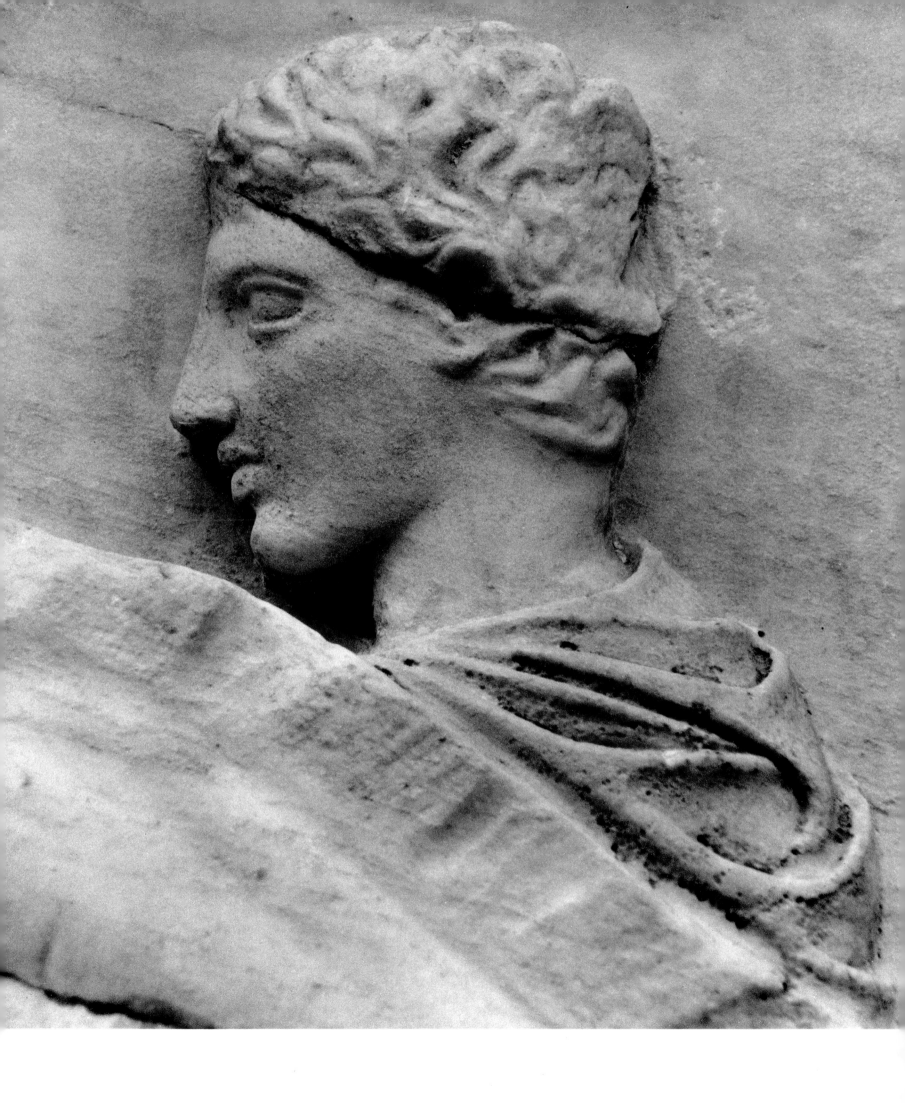

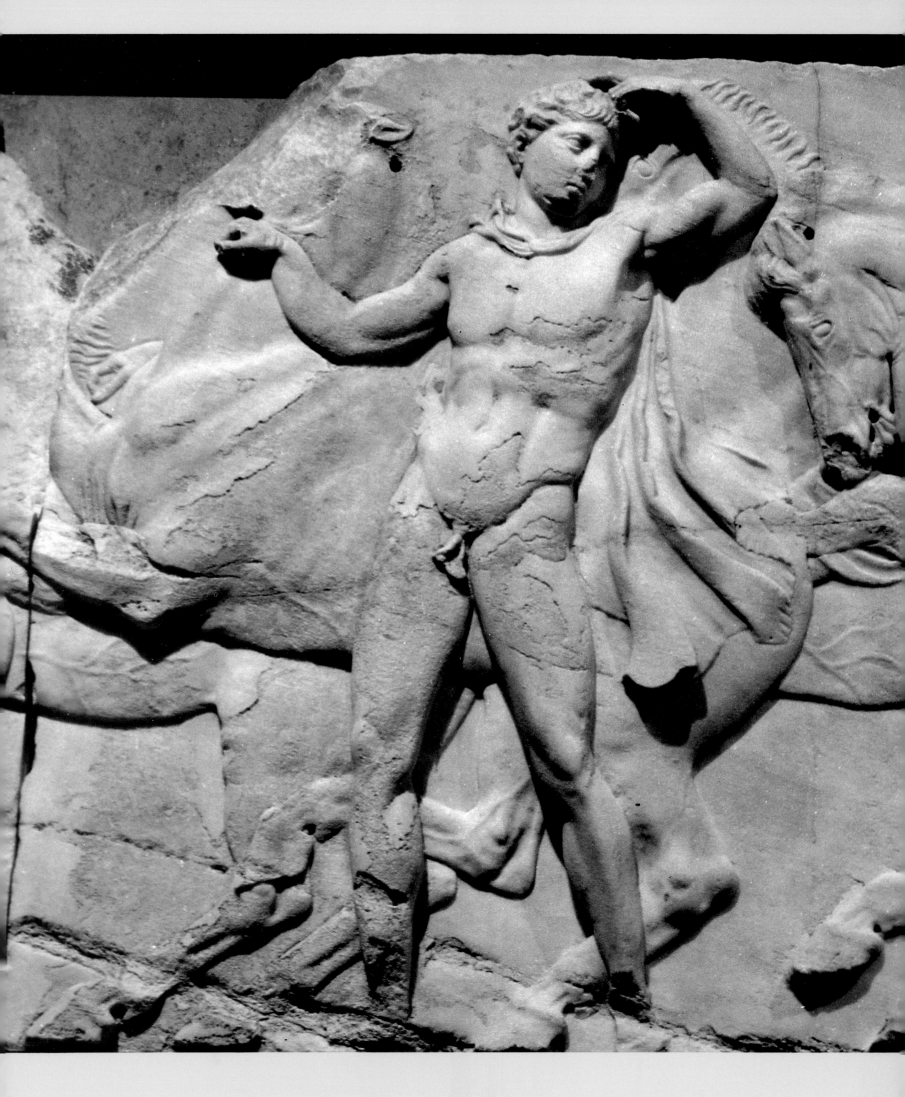

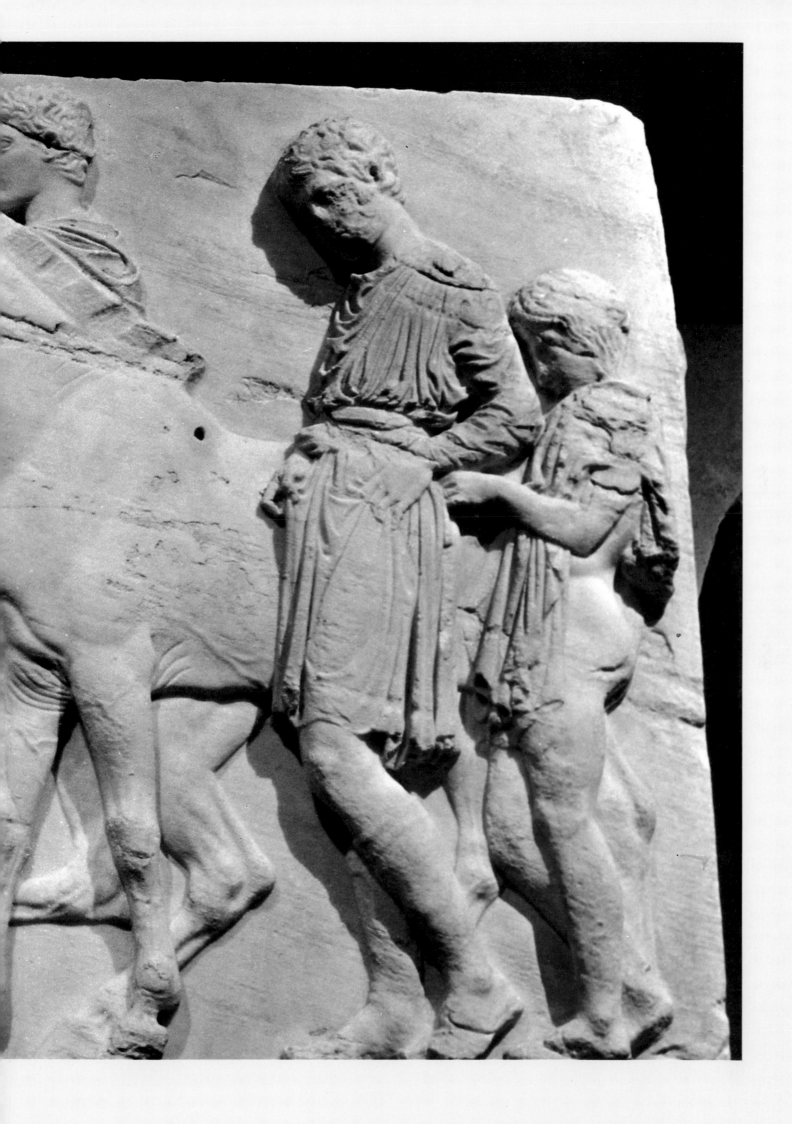

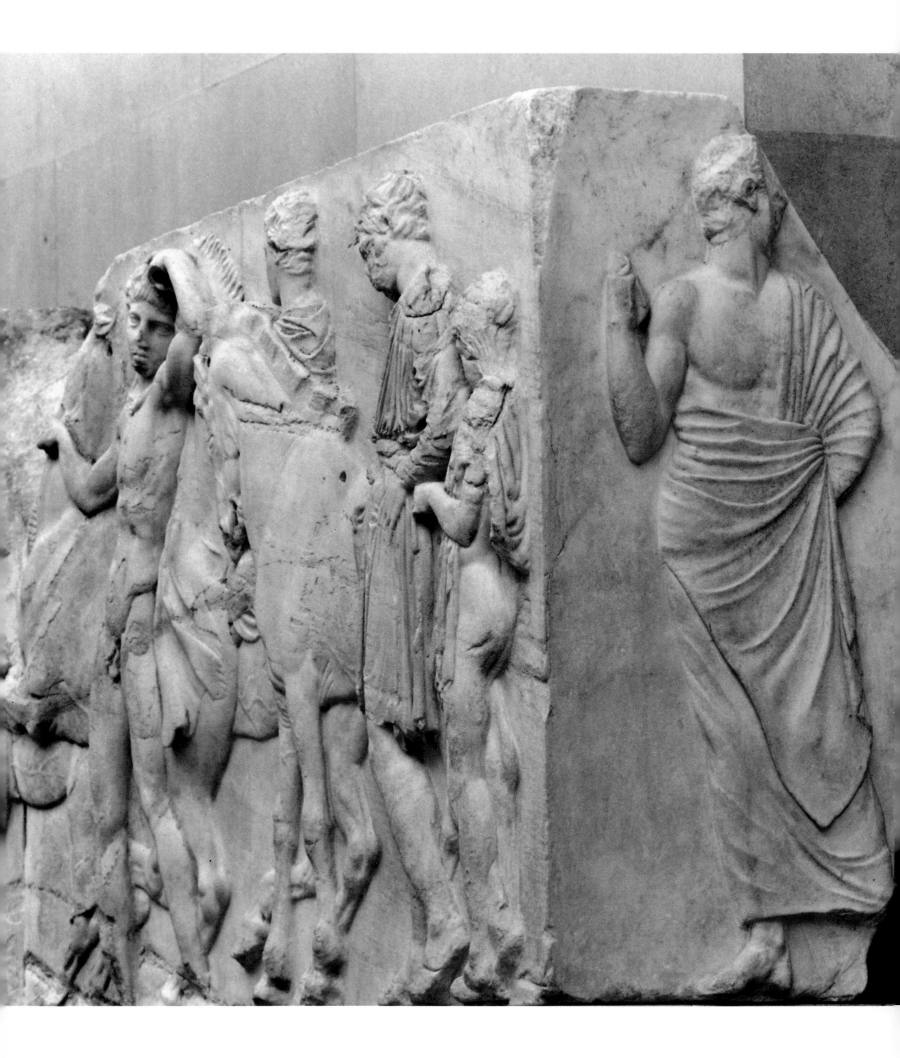

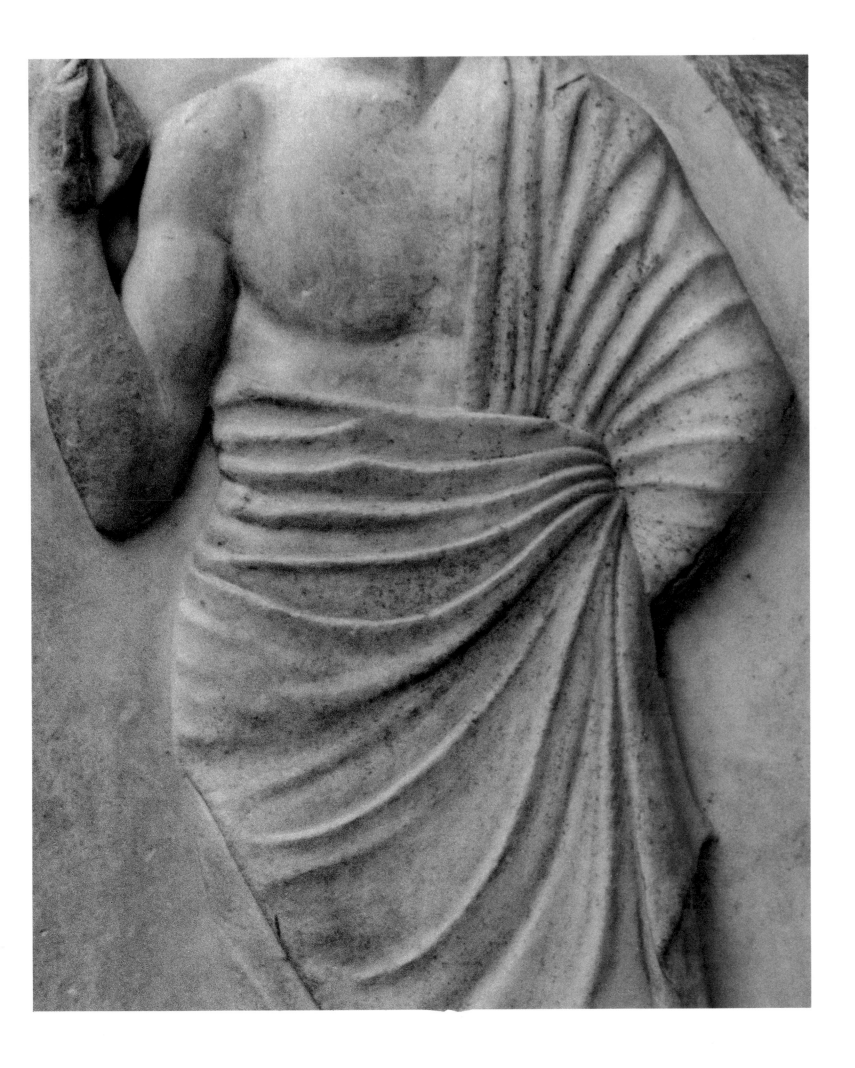

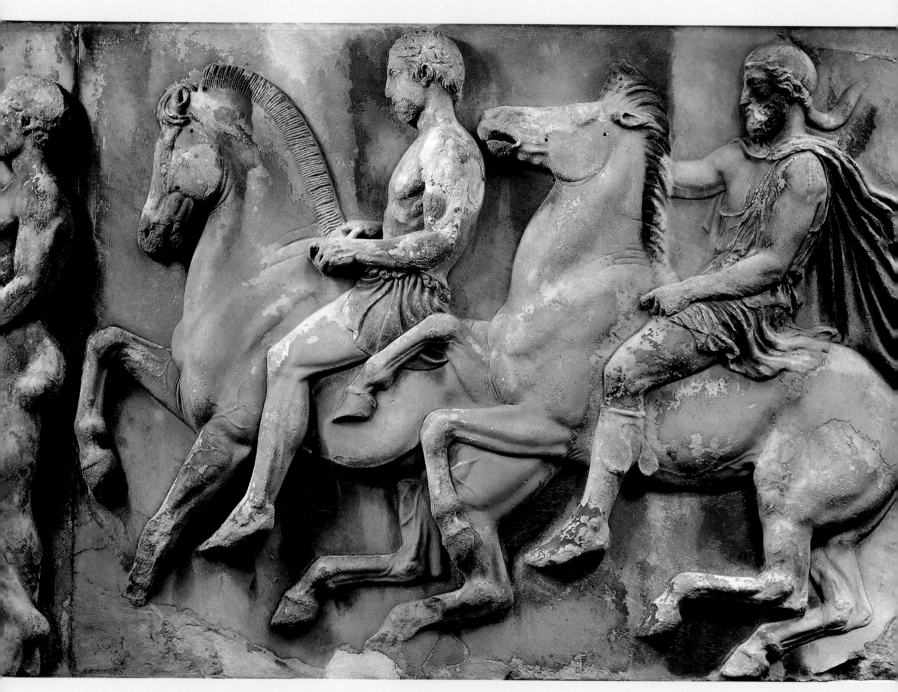

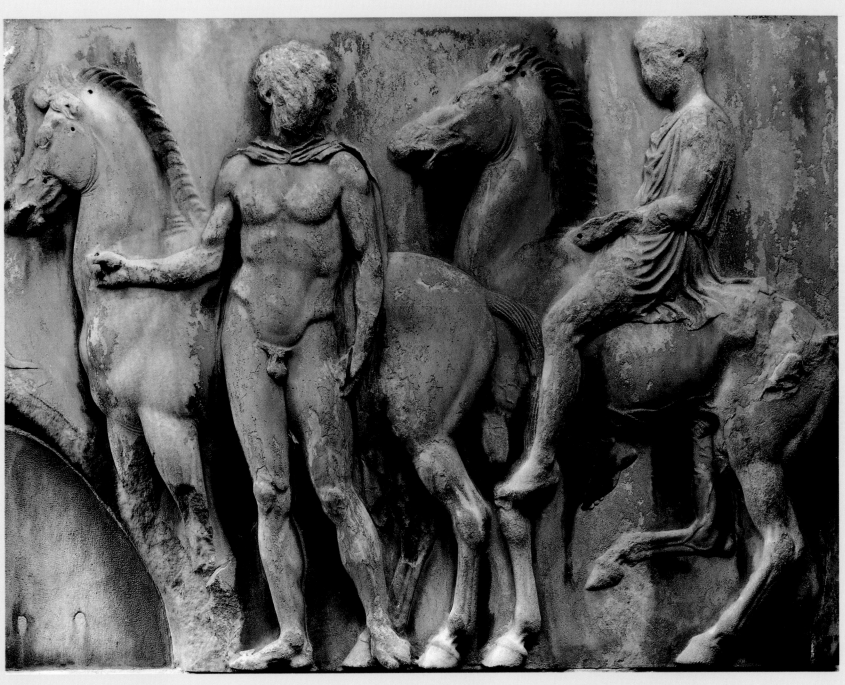

115

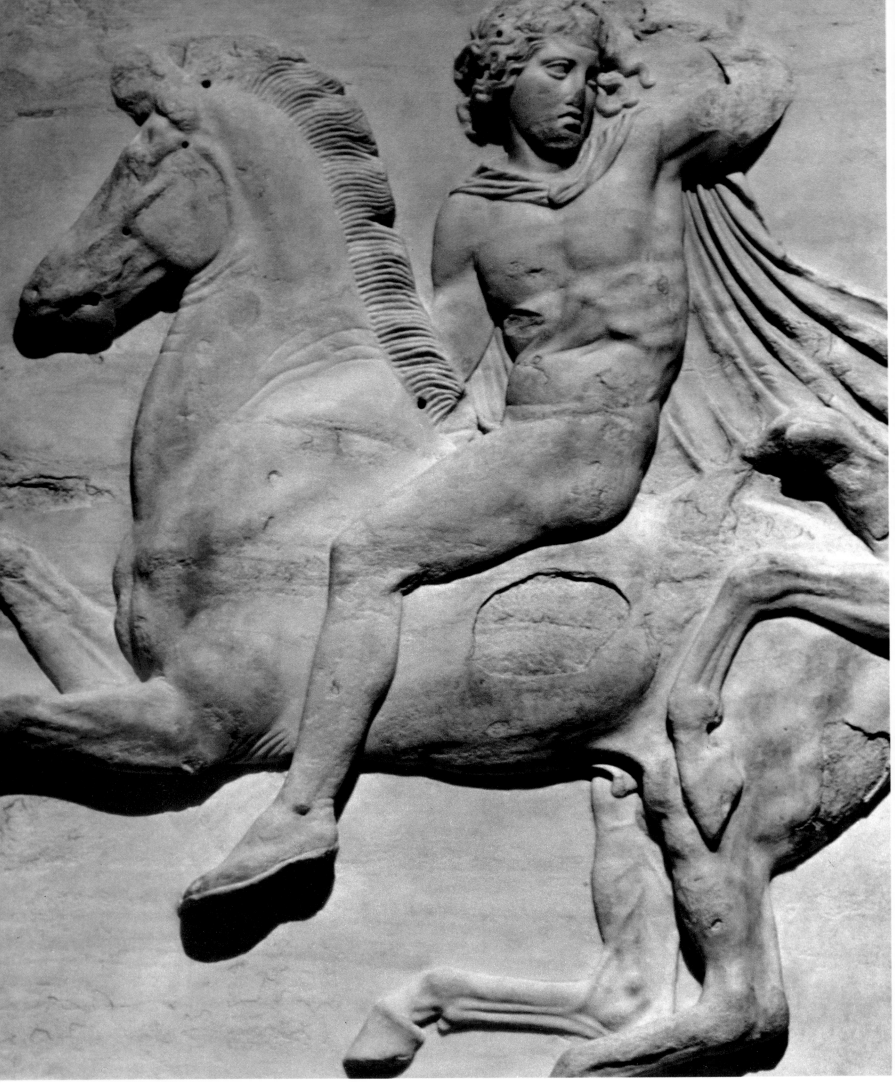

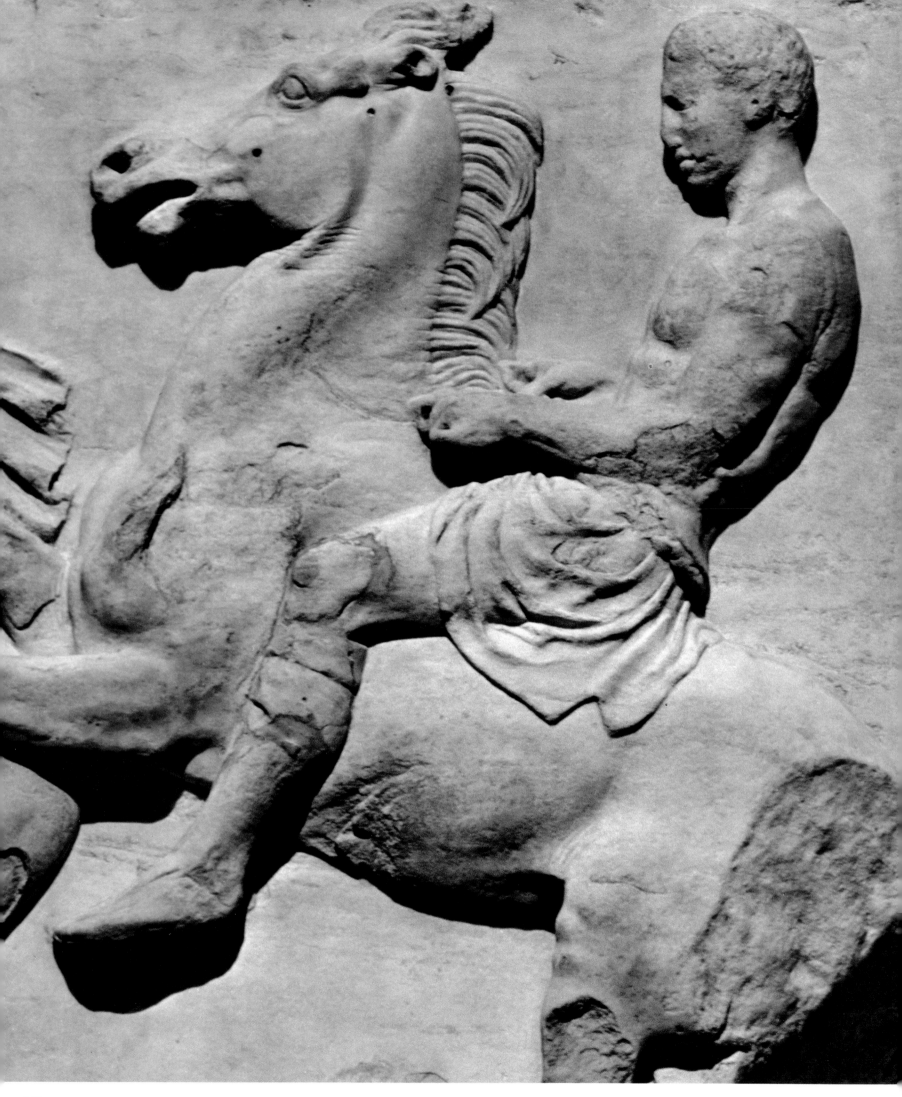

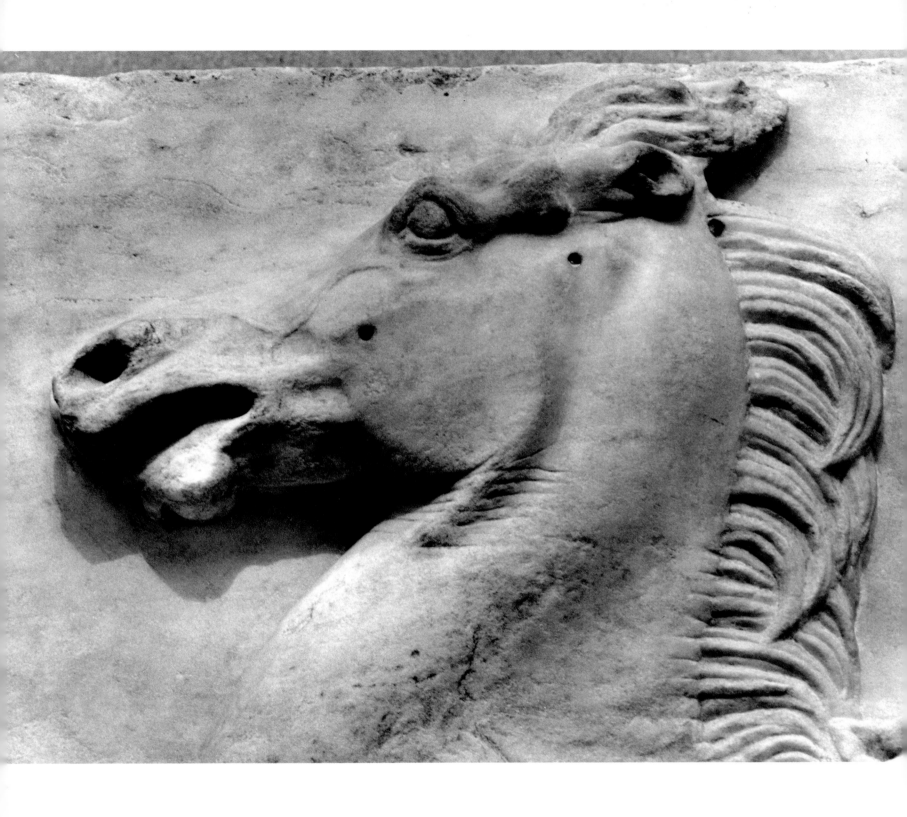

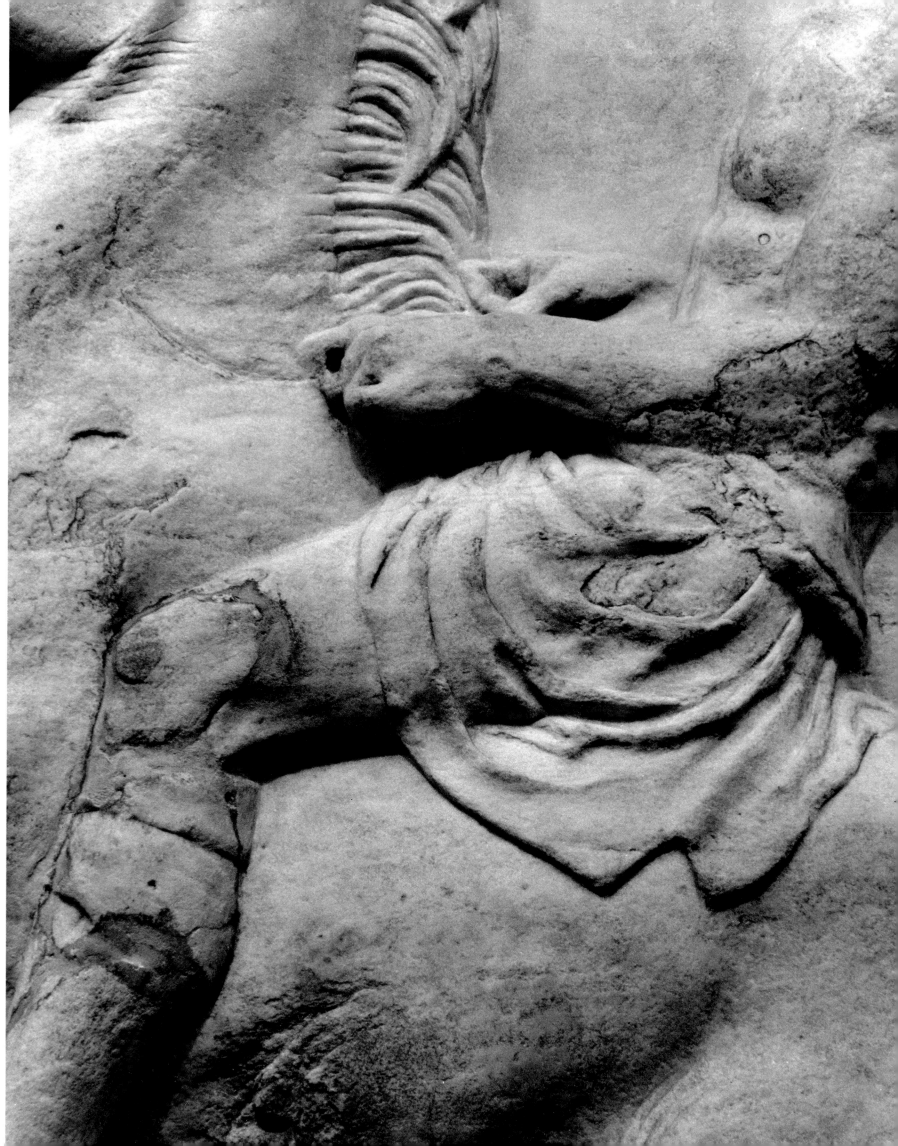

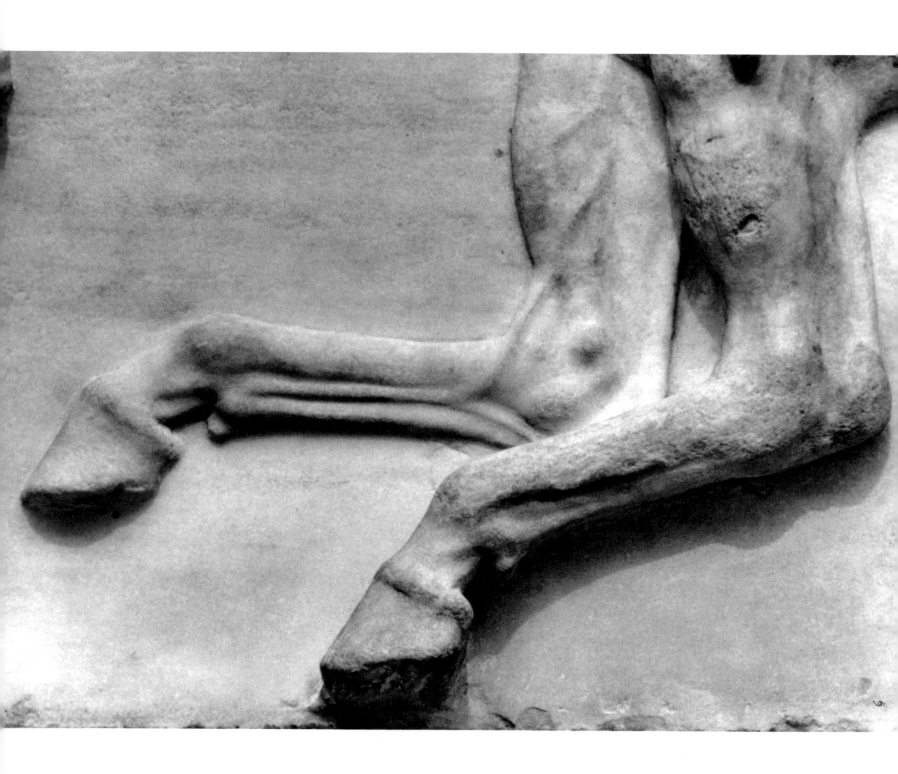

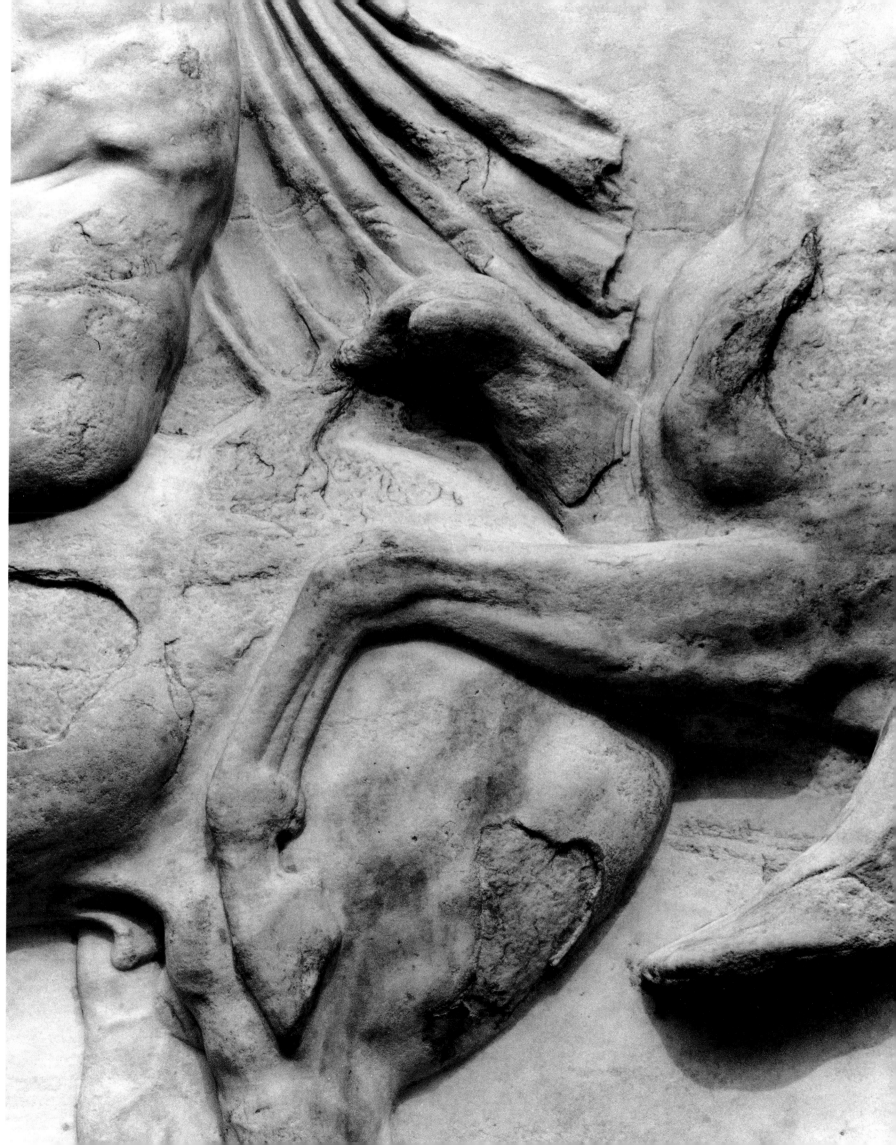

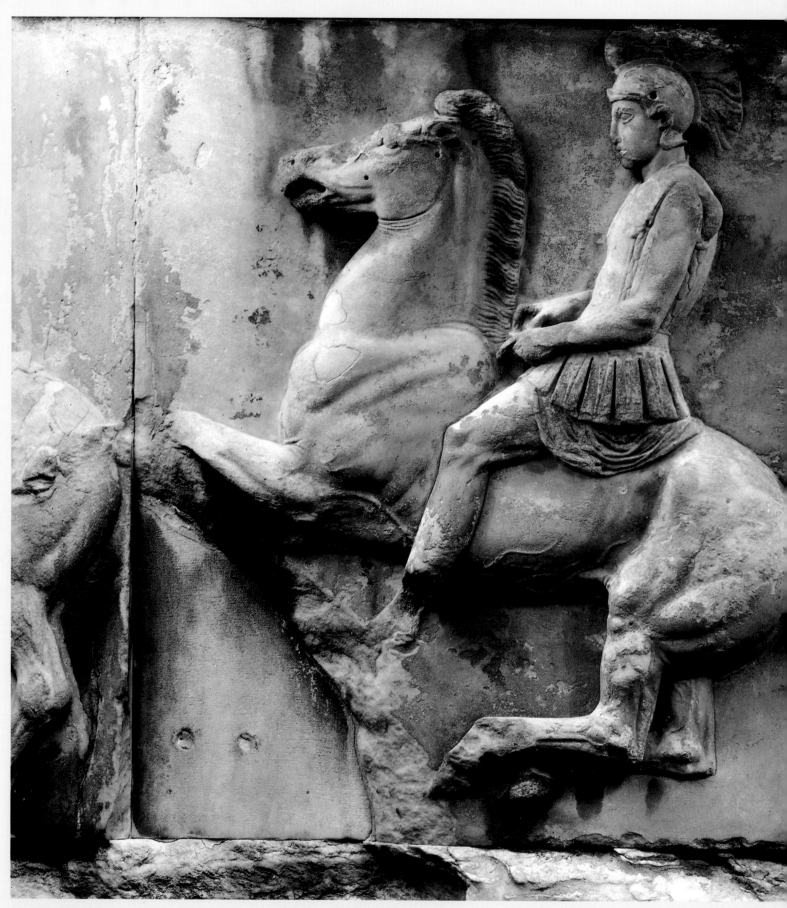

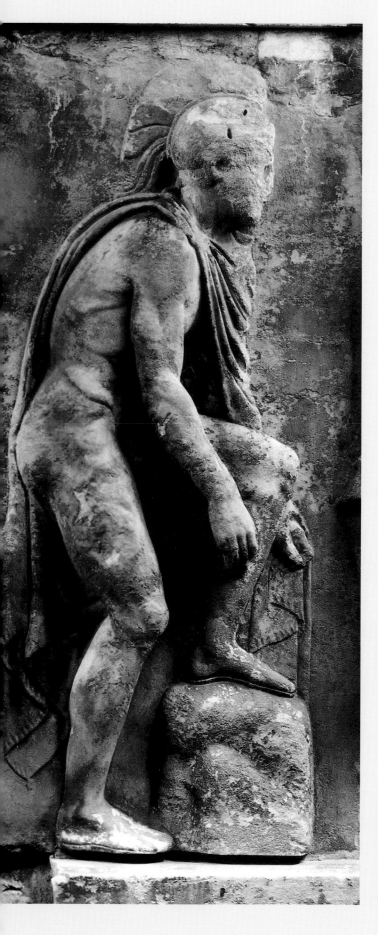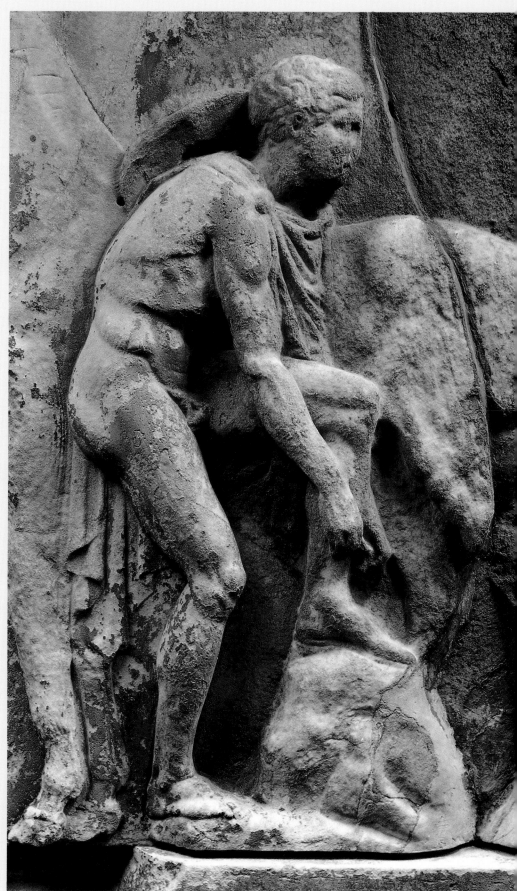

123

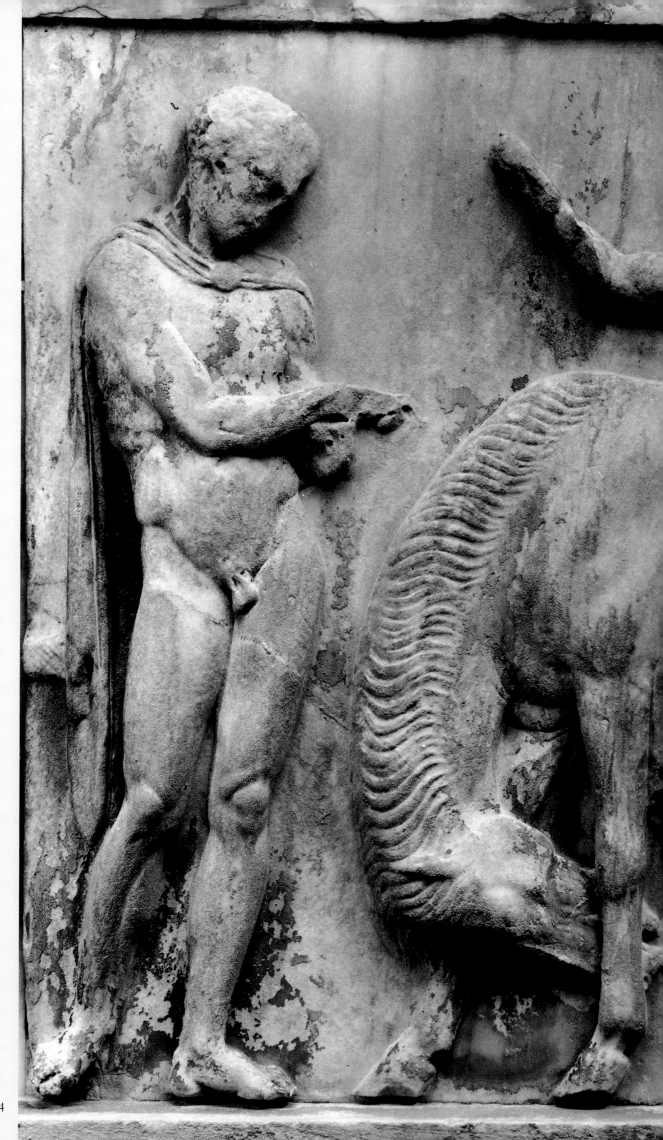

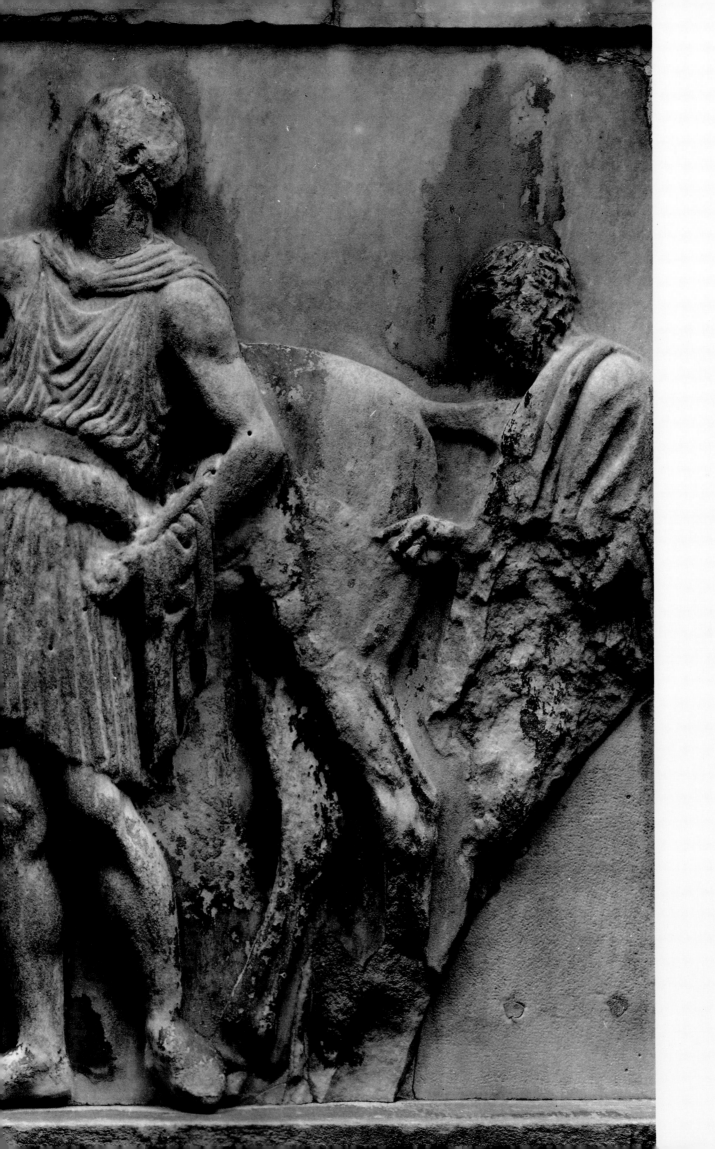

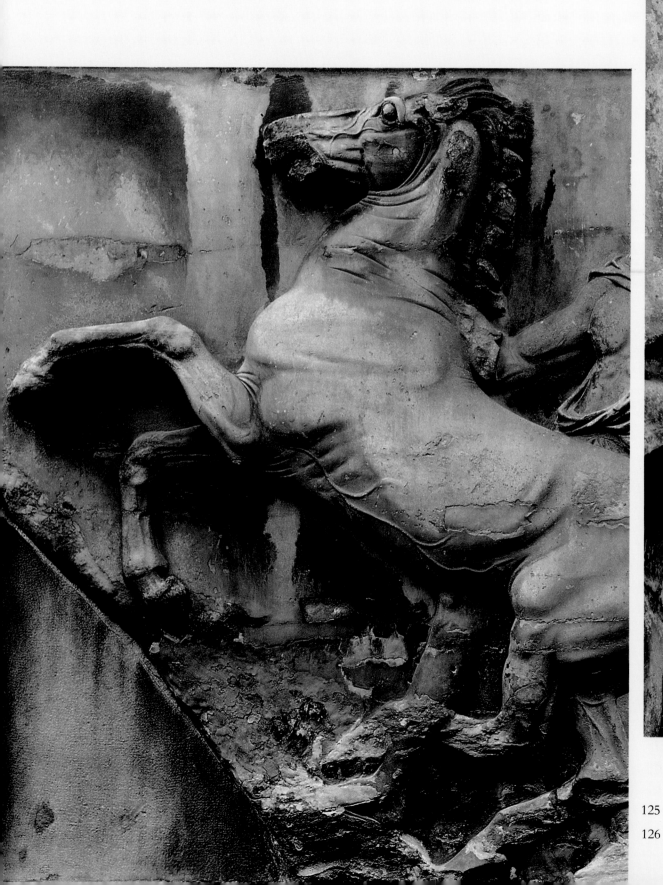

125

126

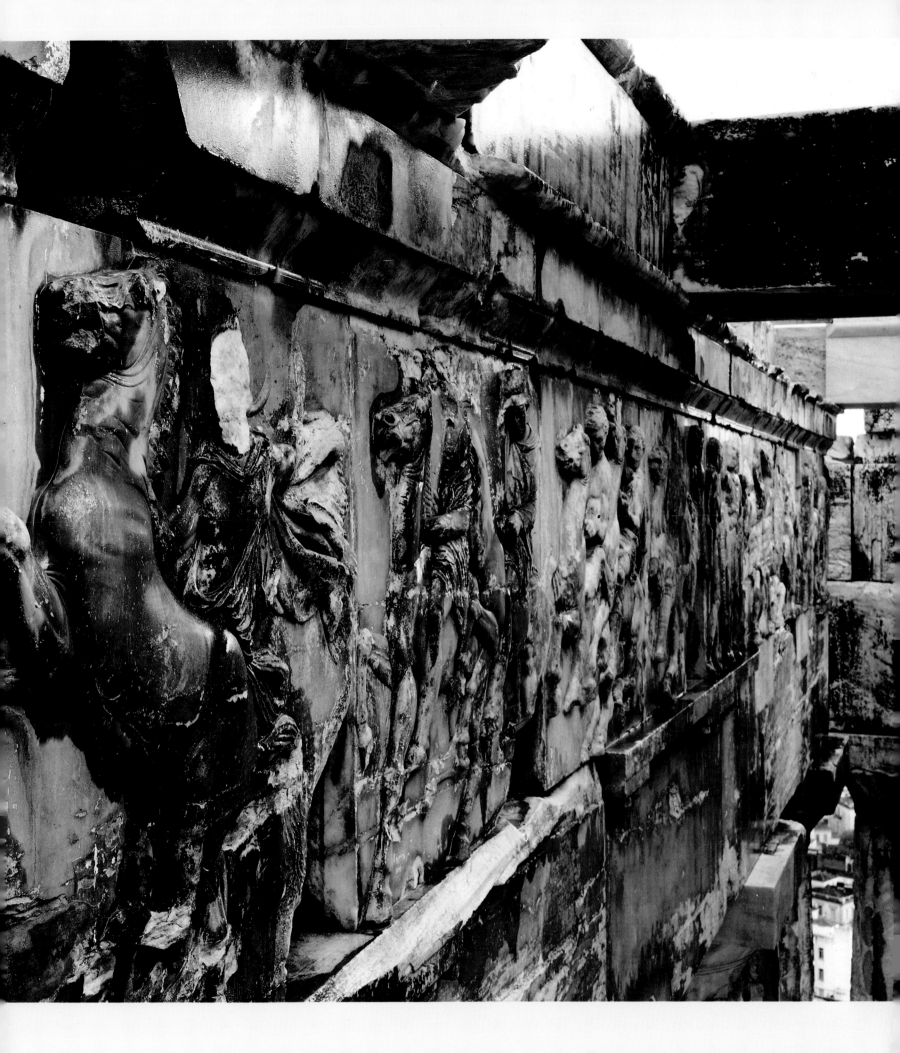

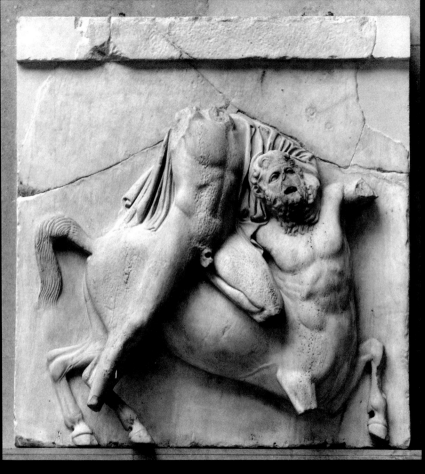

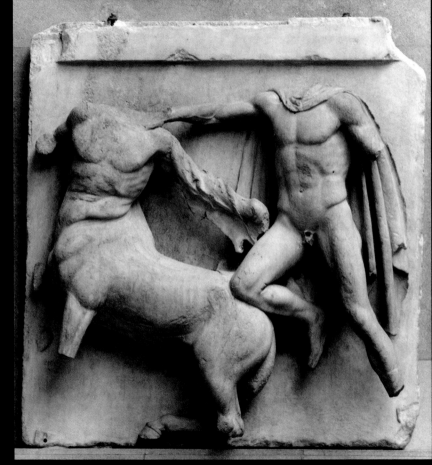

127

128

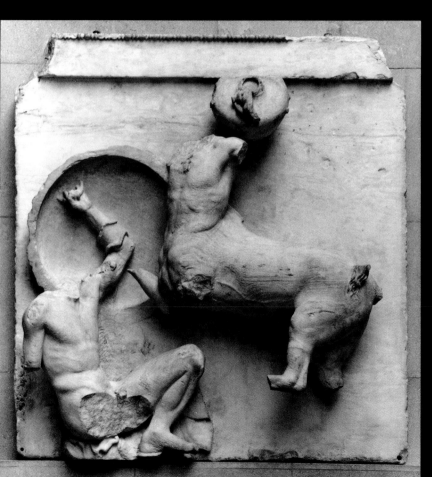

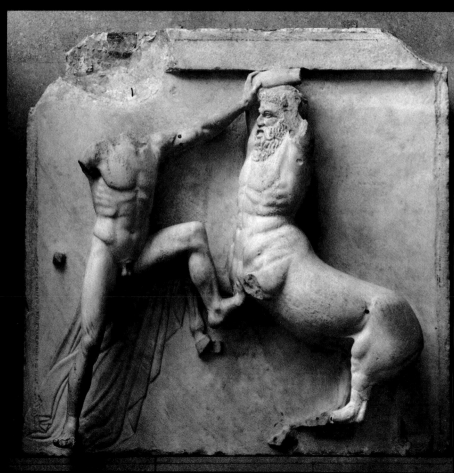

129

130

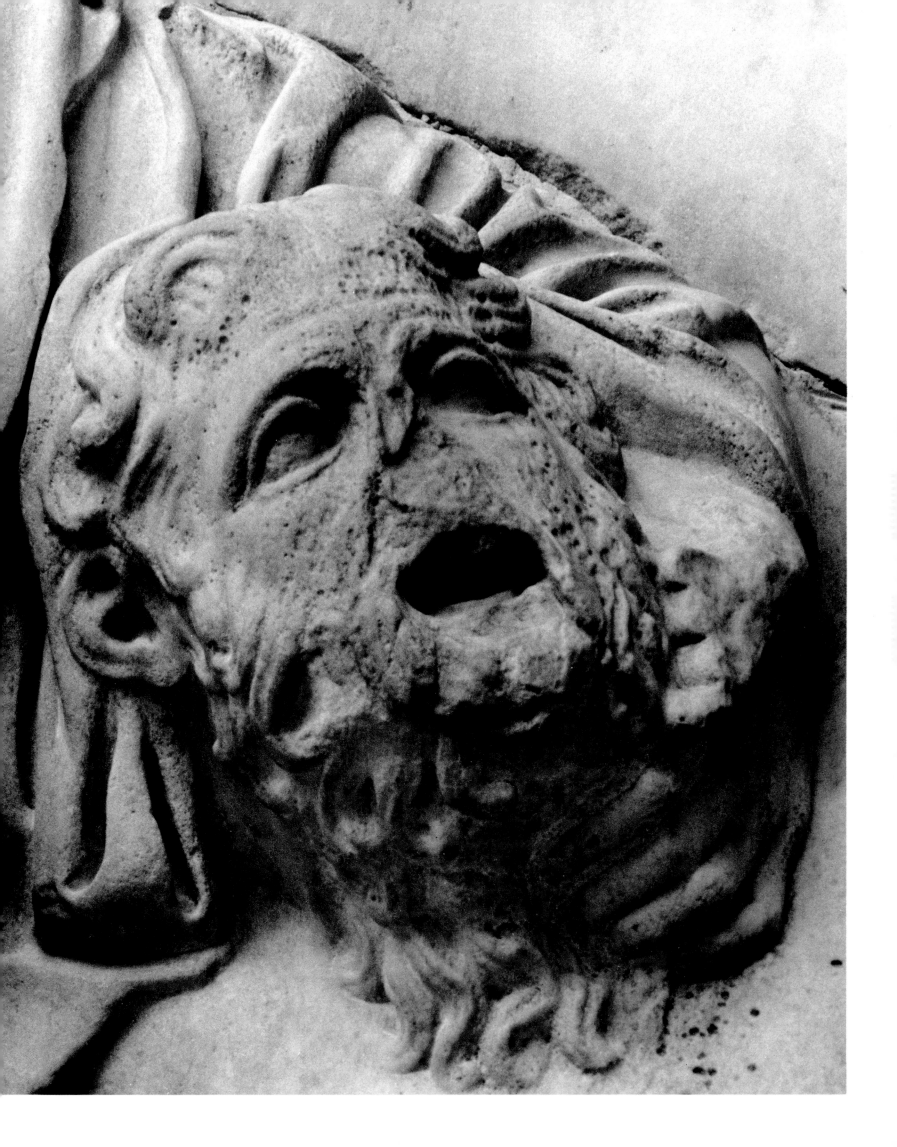

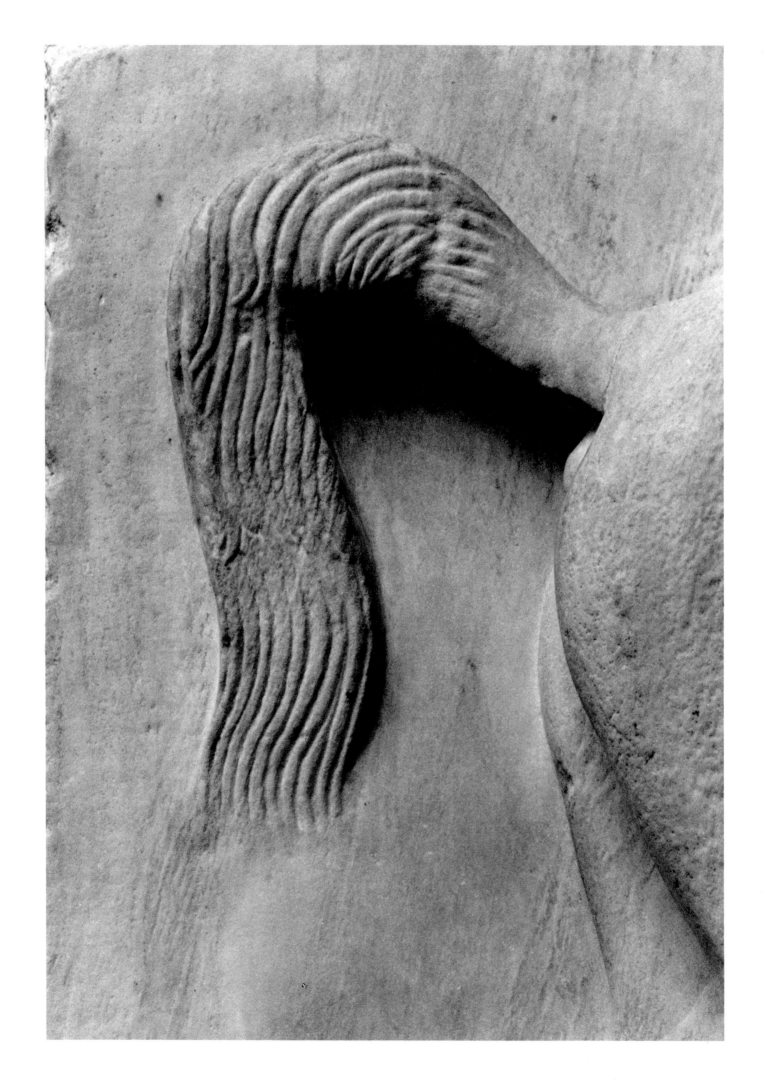

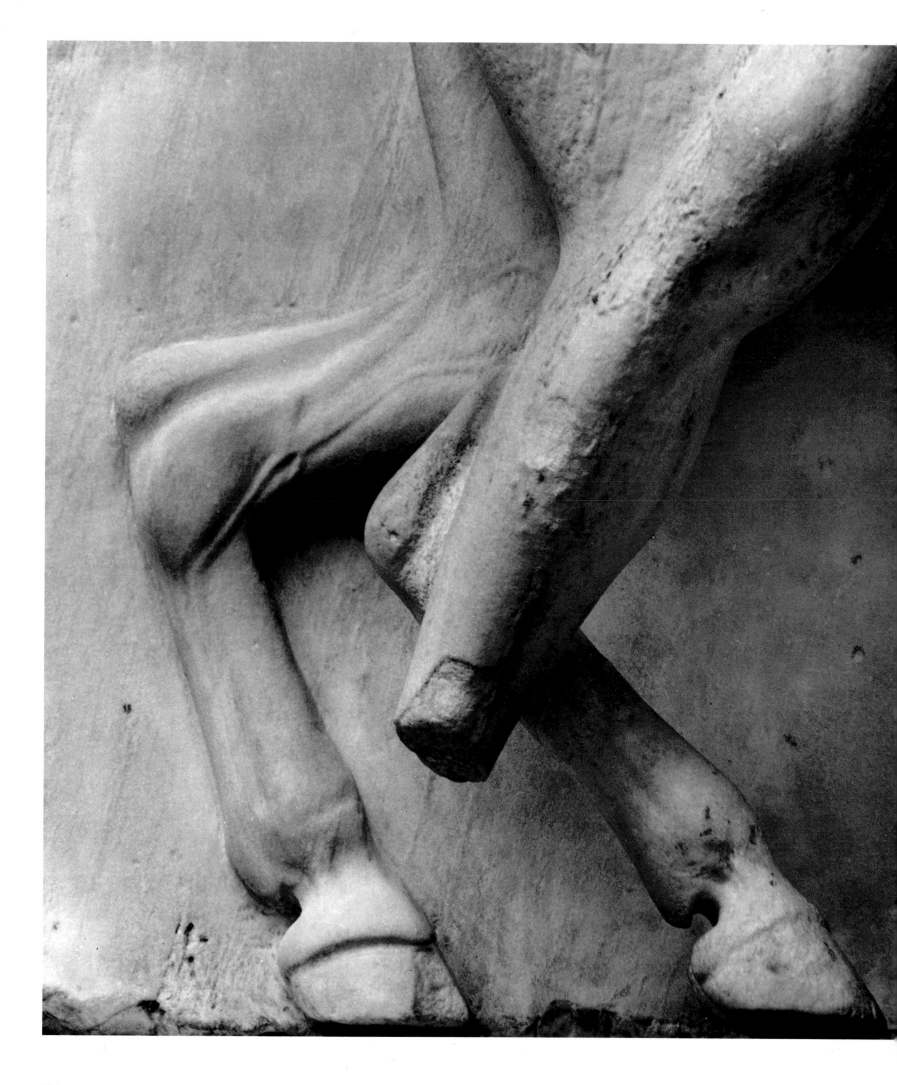

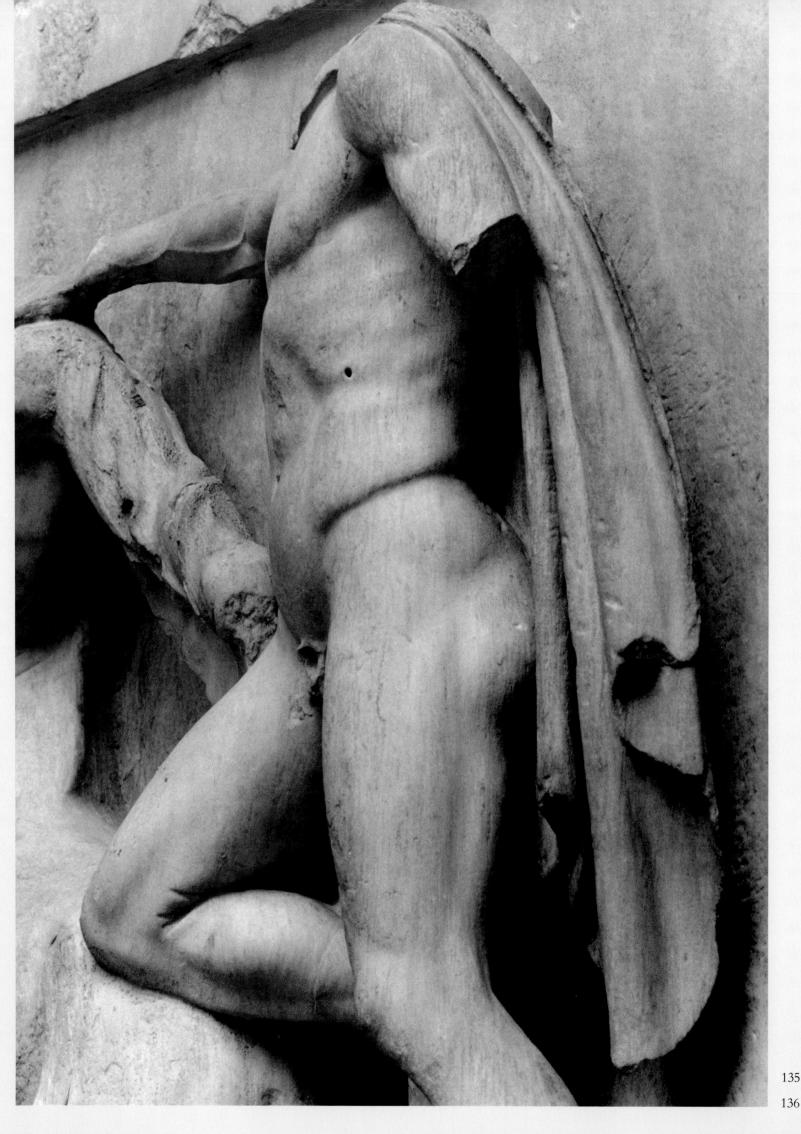

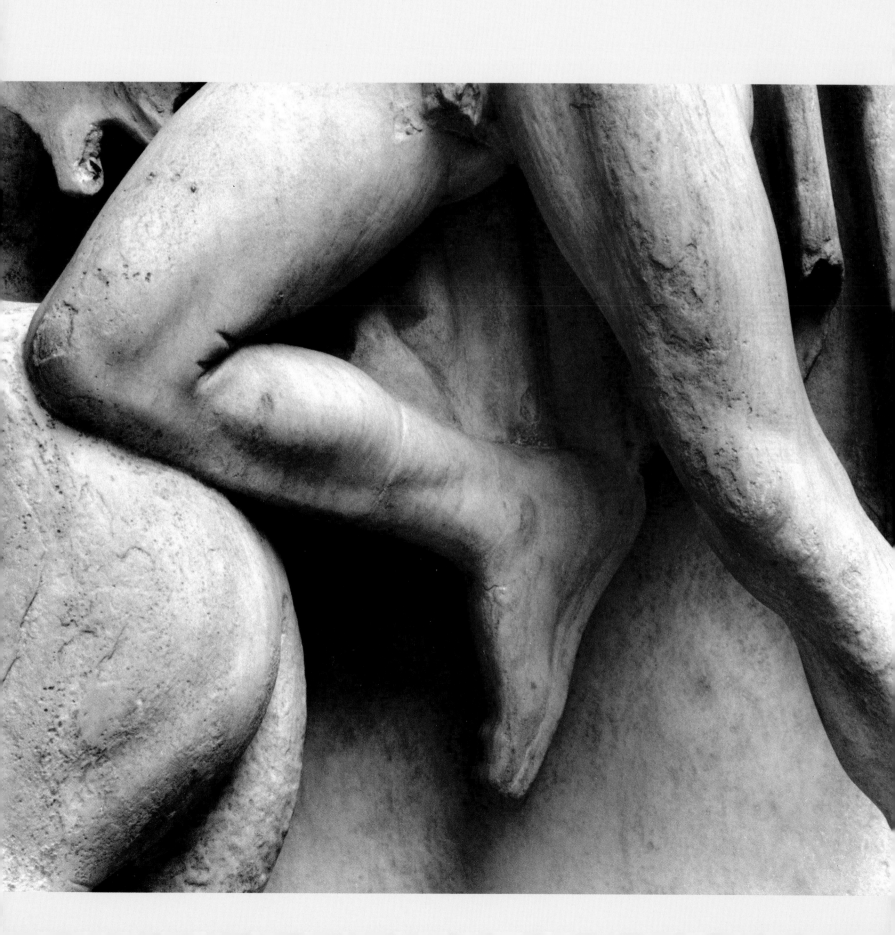

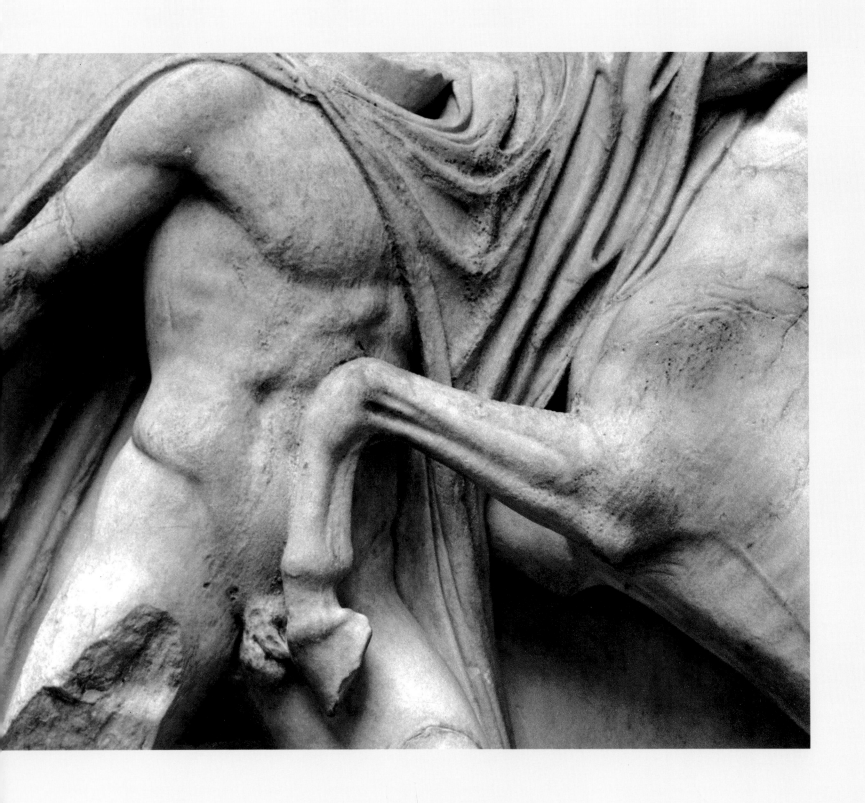

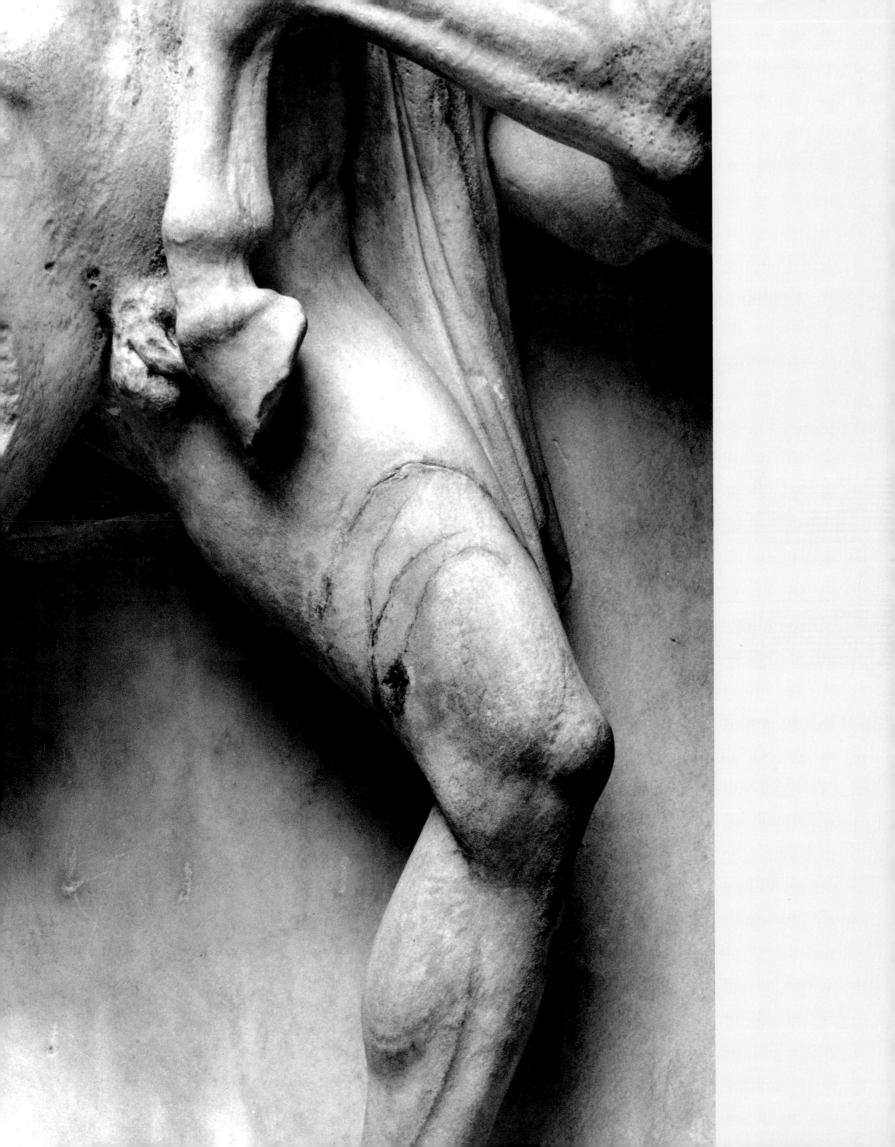

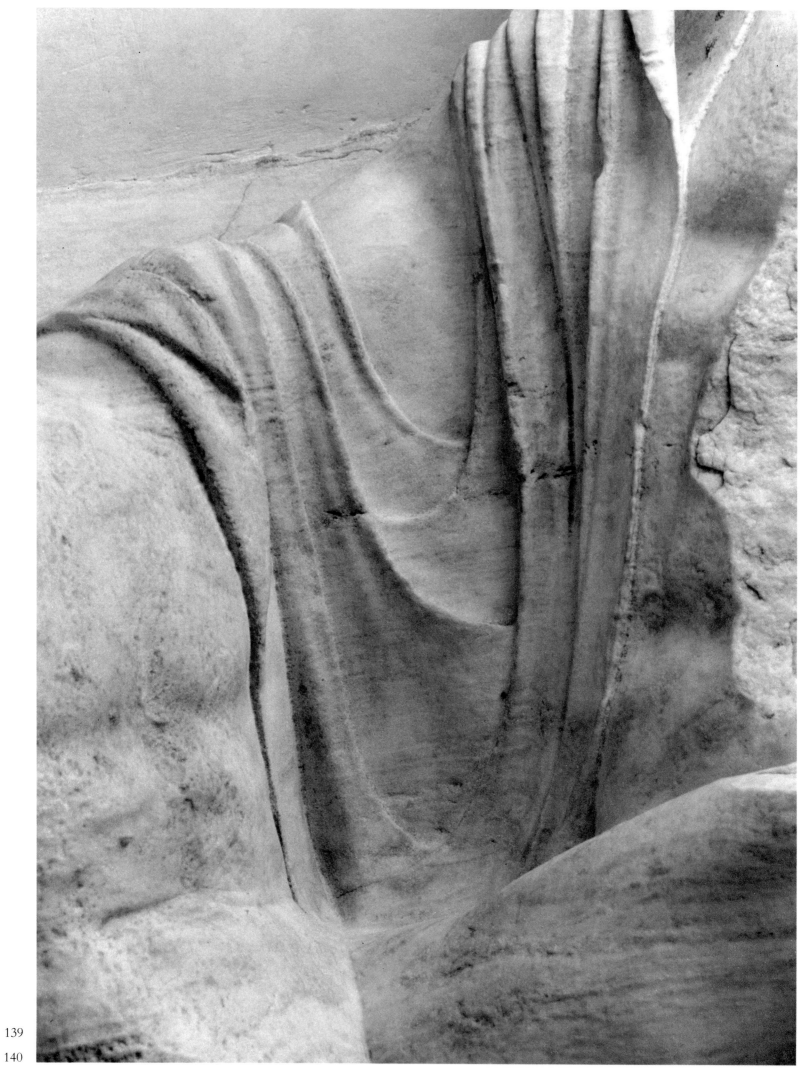

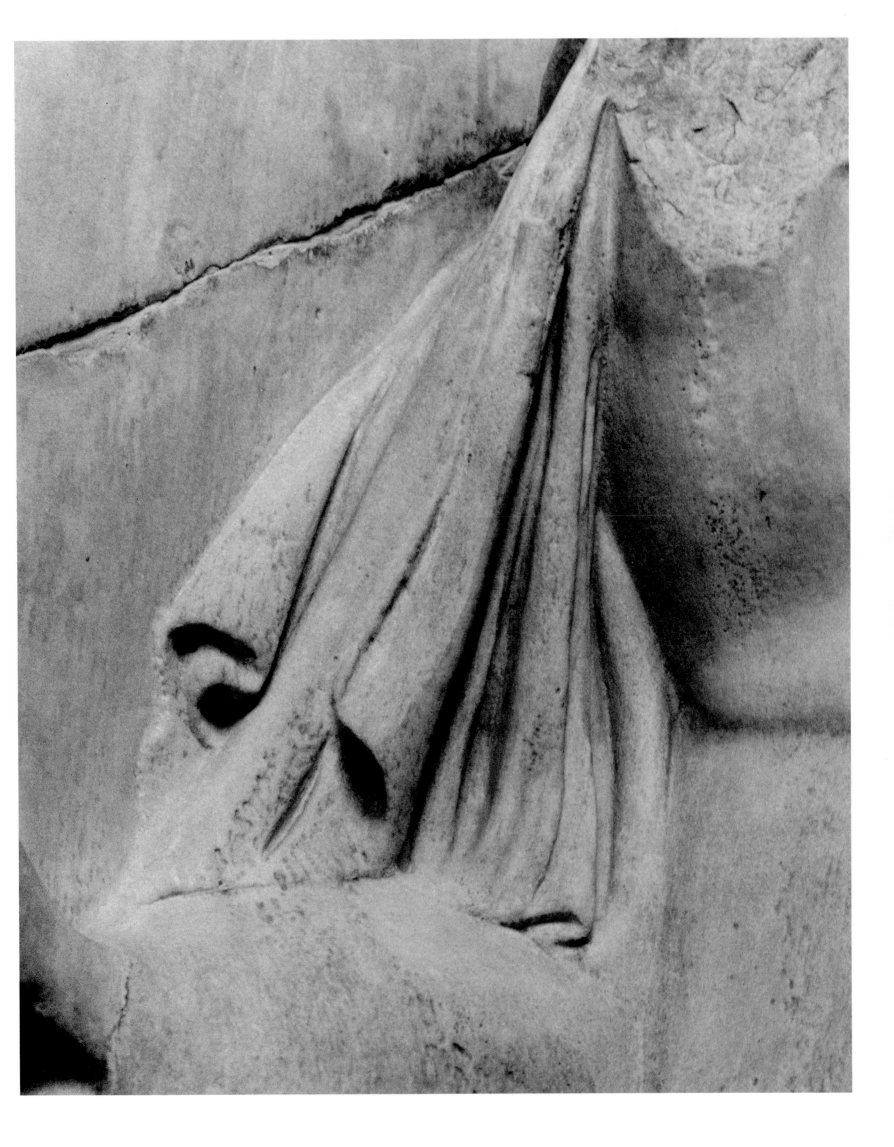

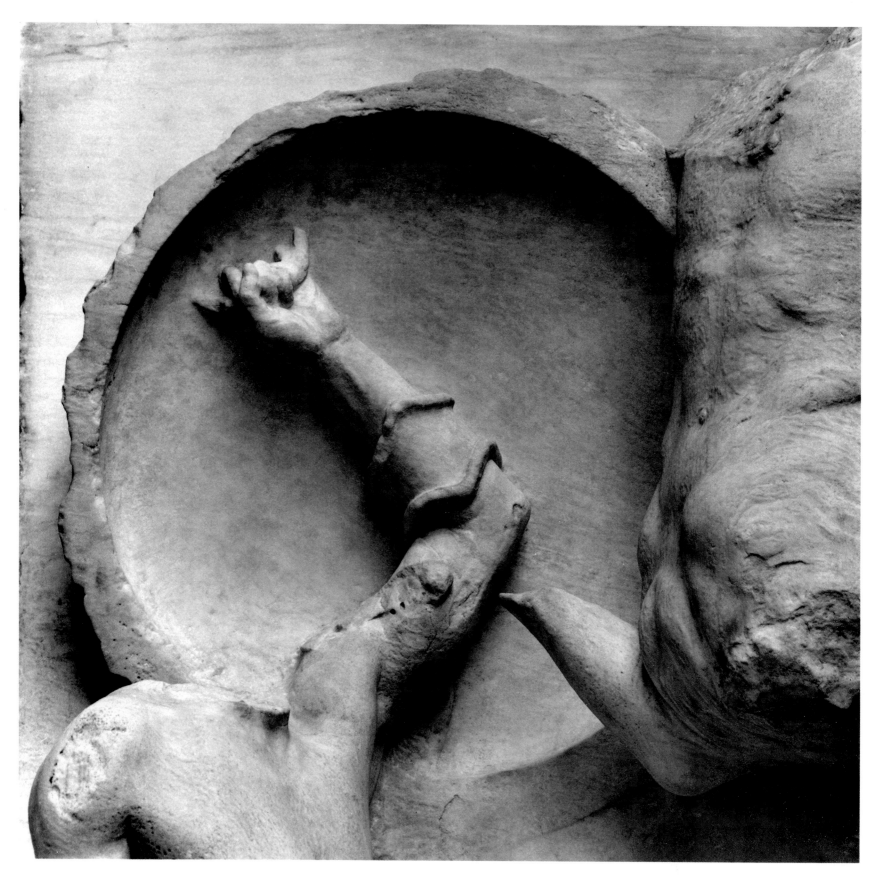

141

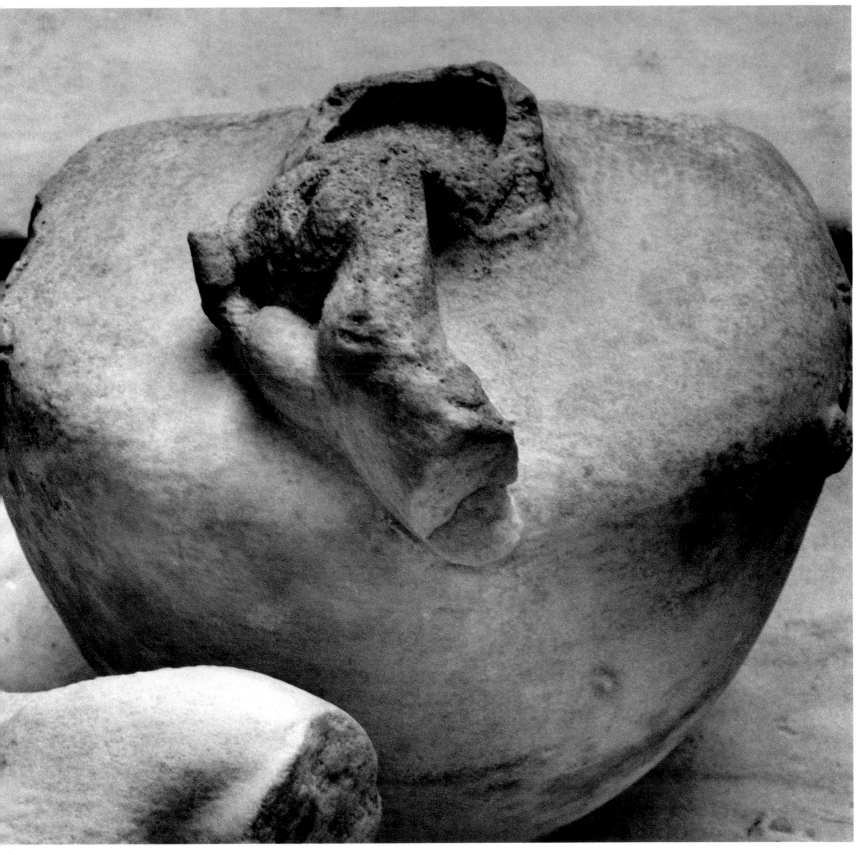

142

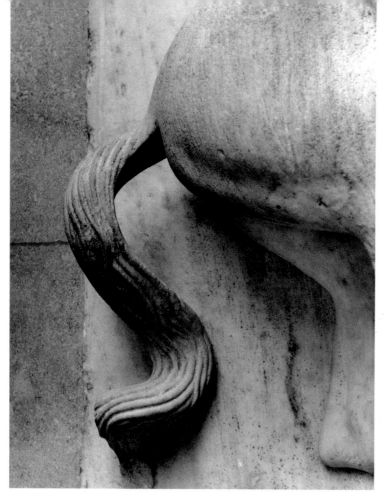

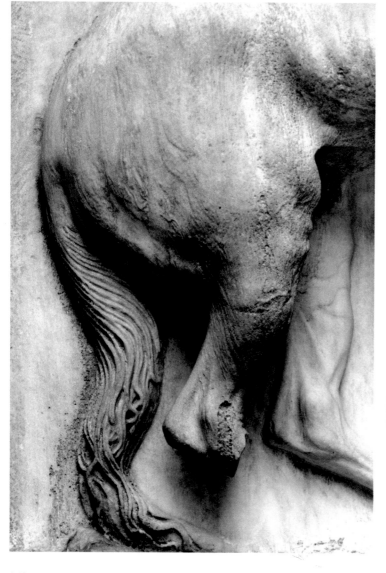

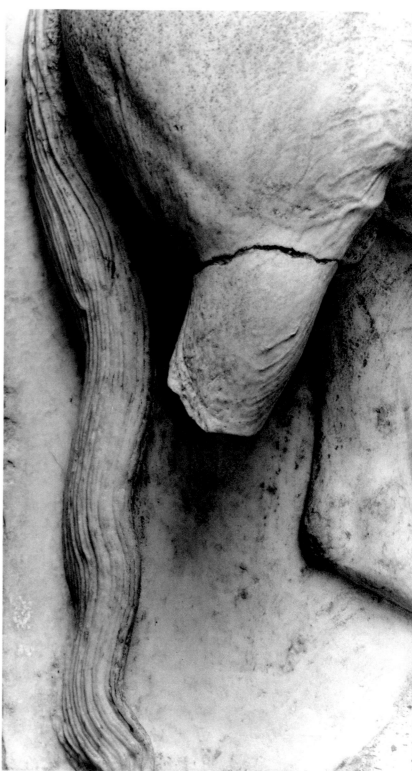

143

144

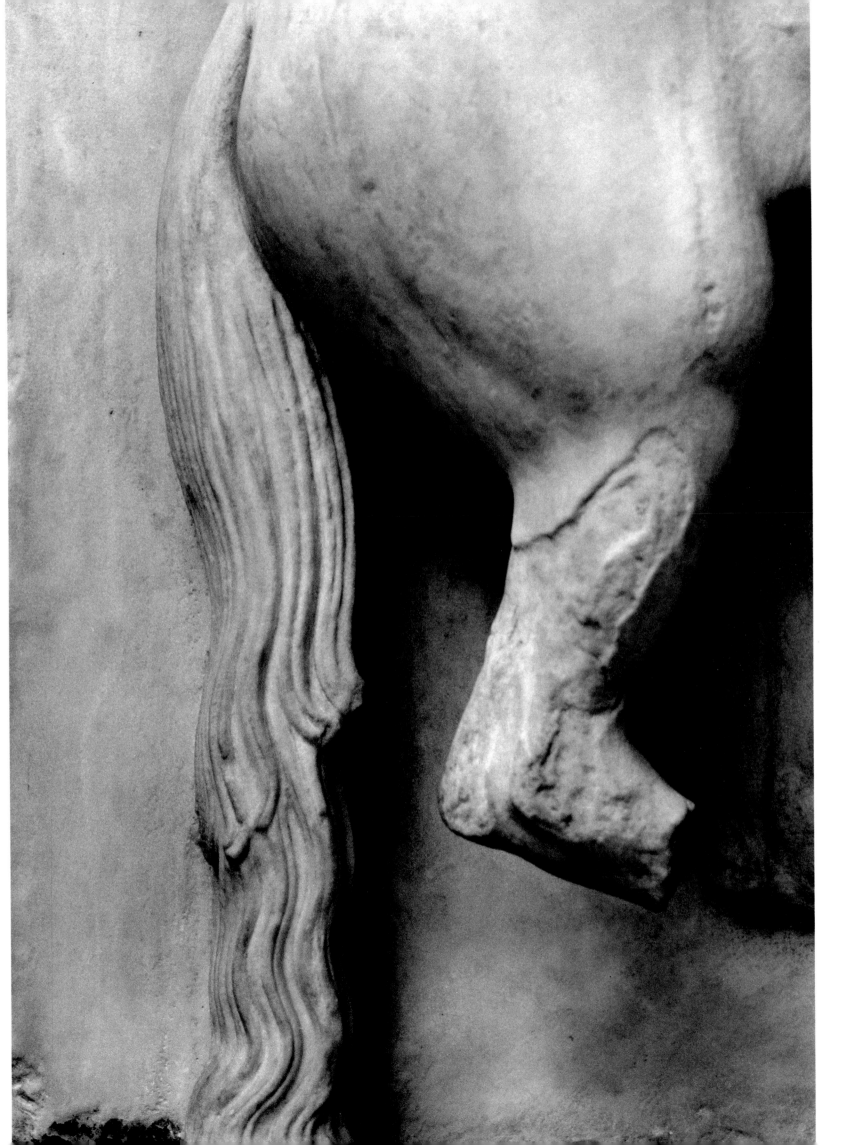

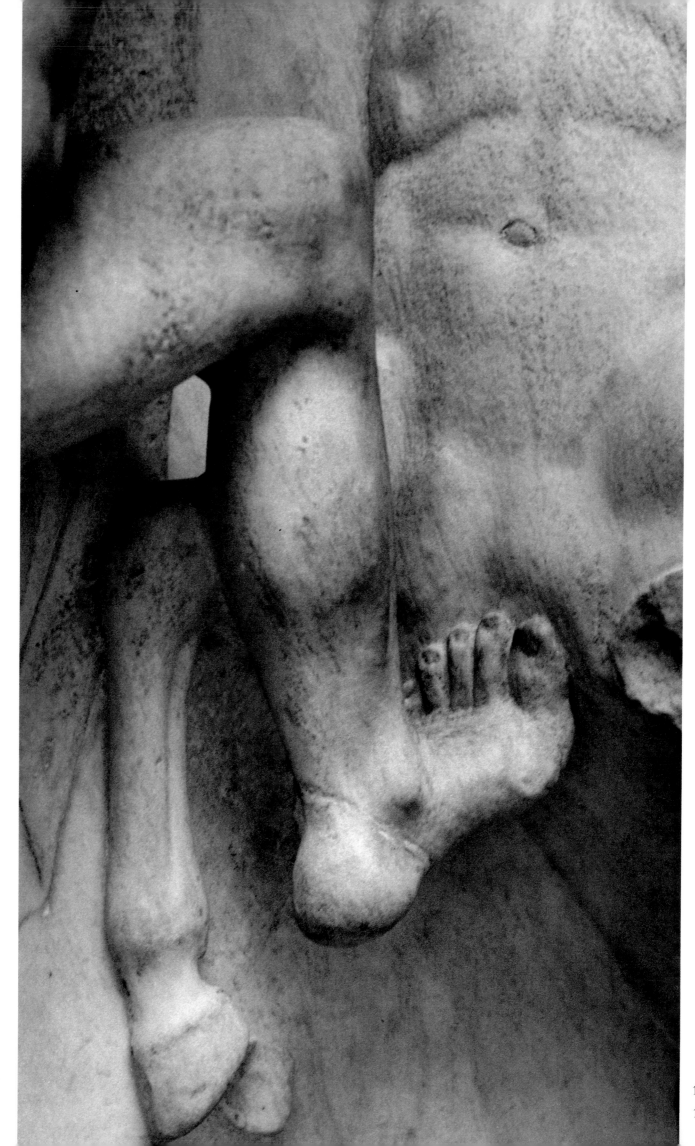

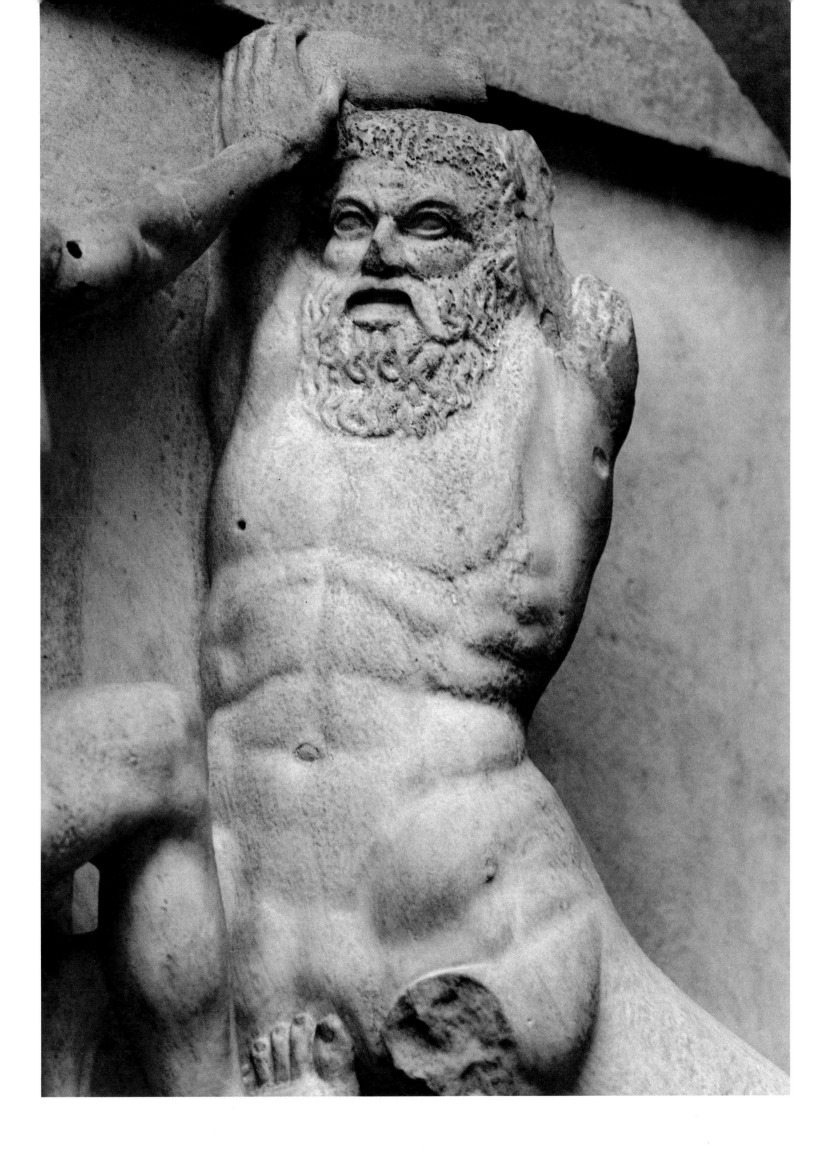

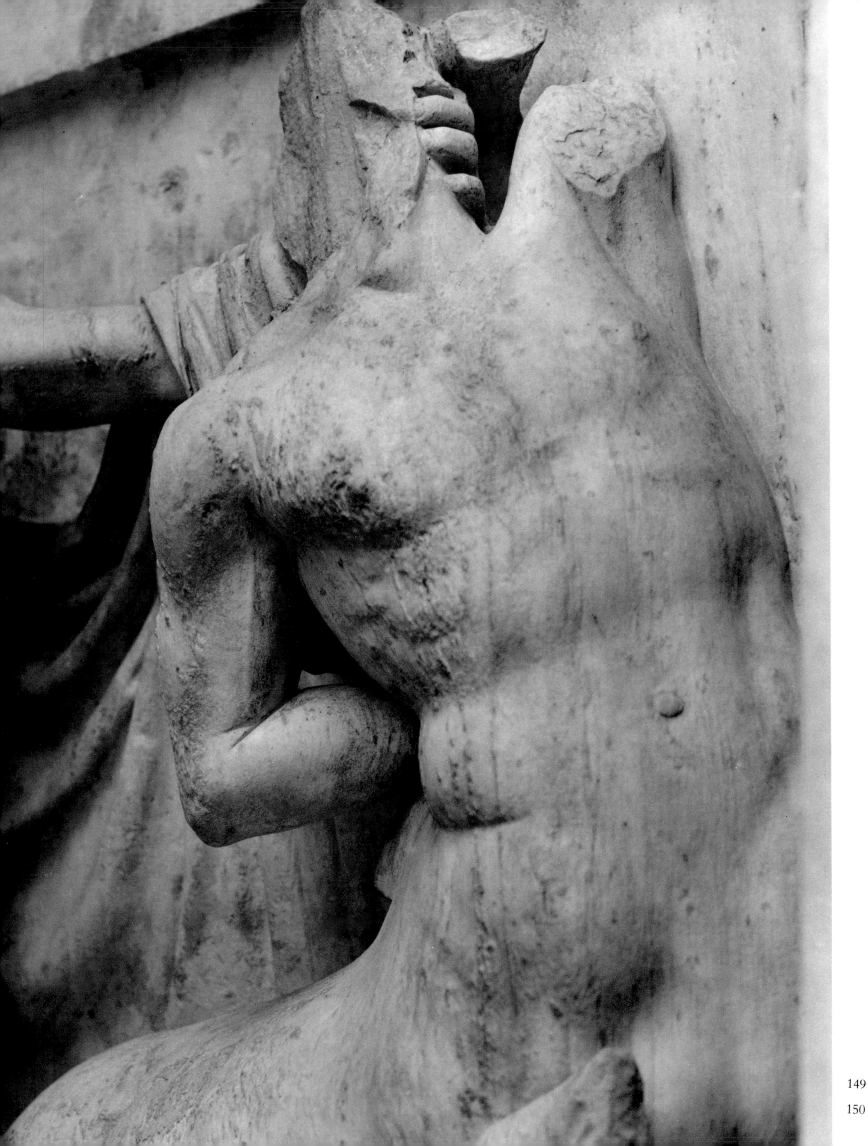

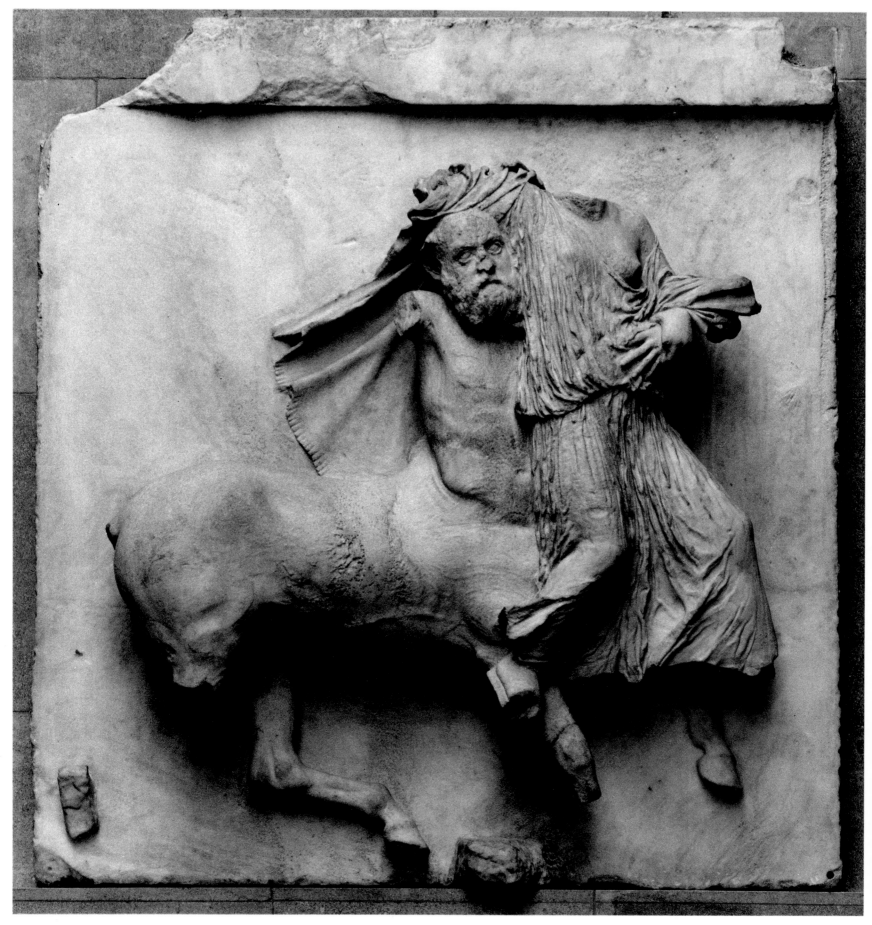

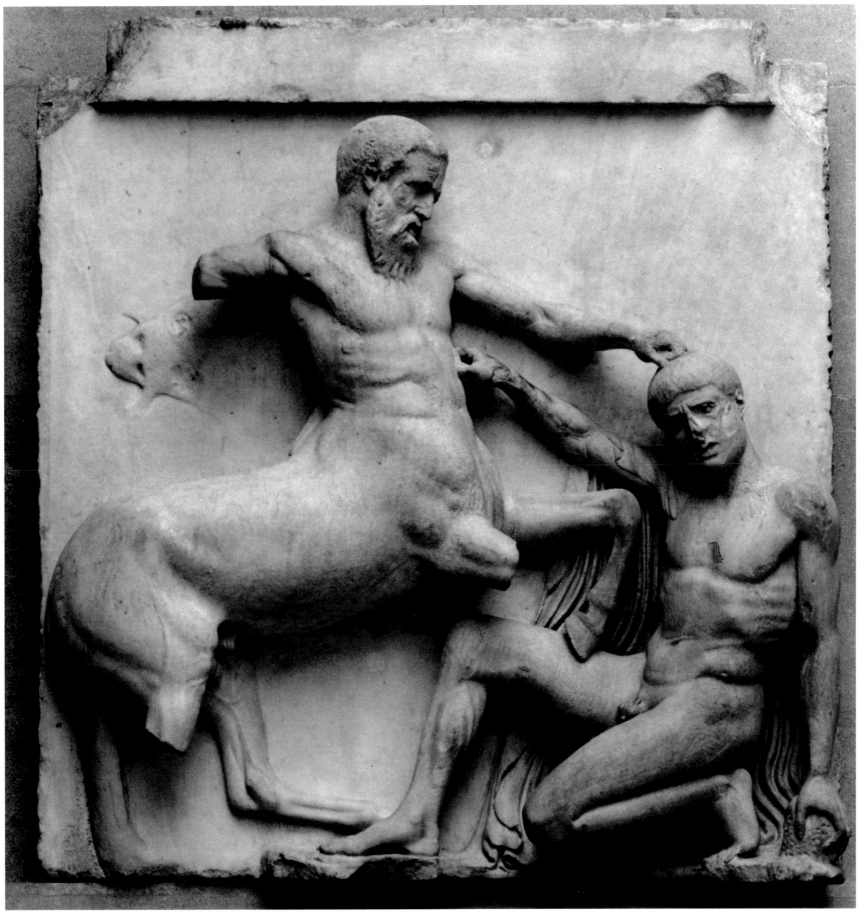

152

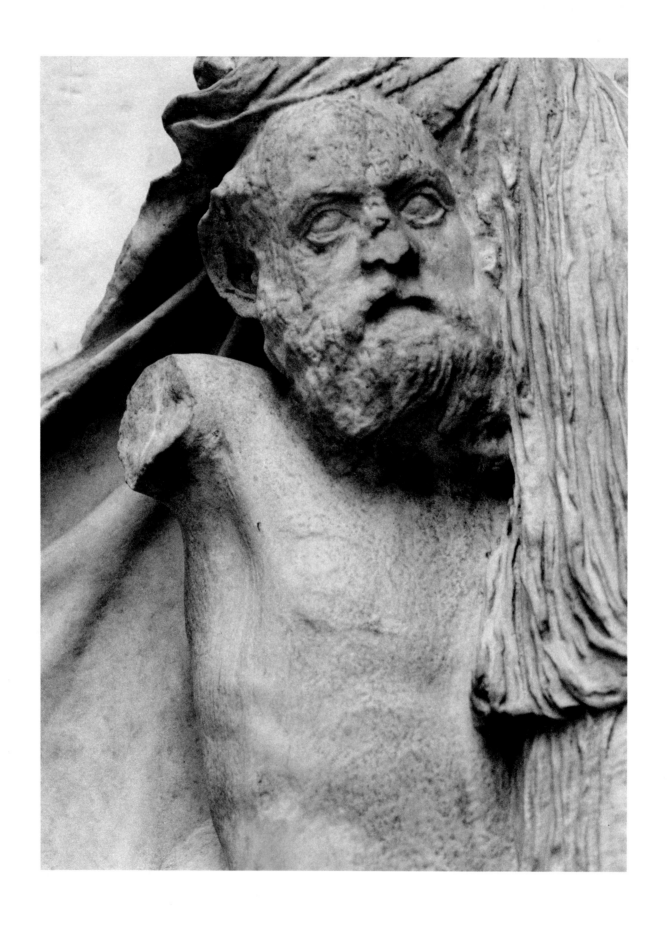

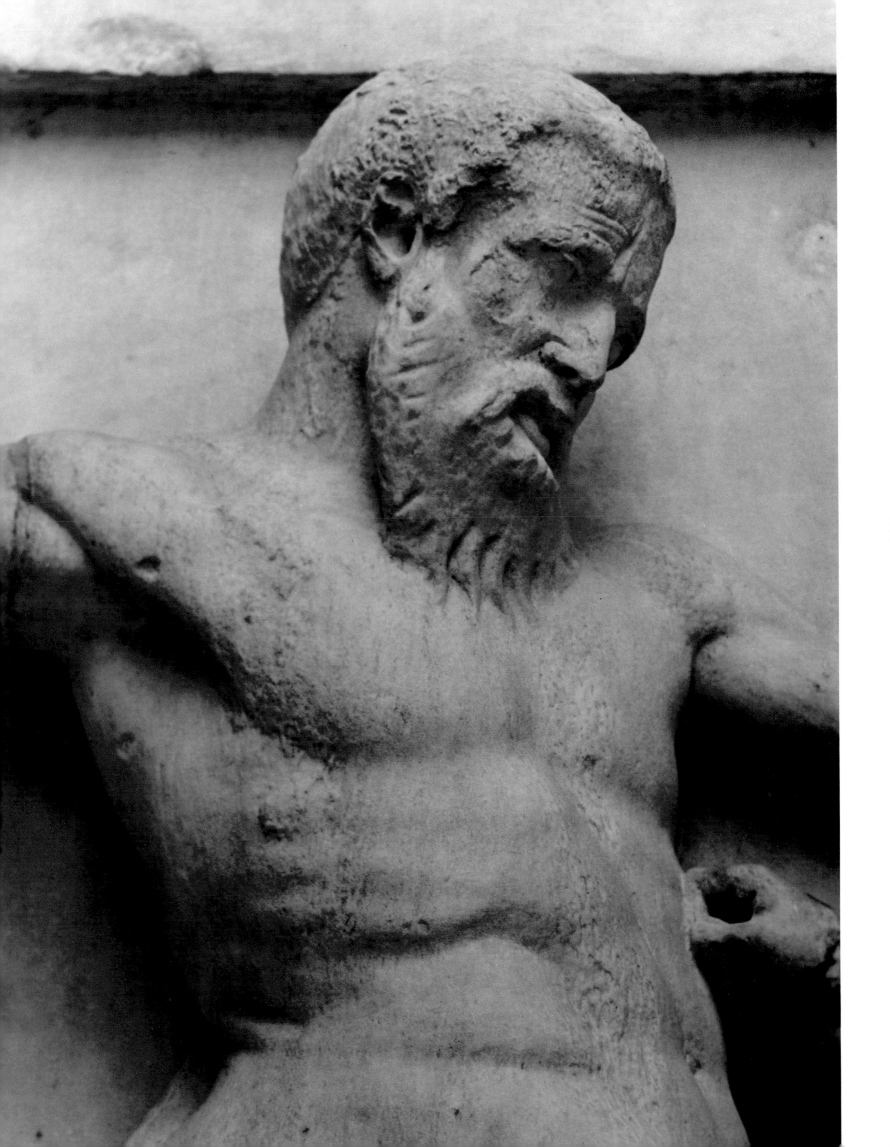

155

156

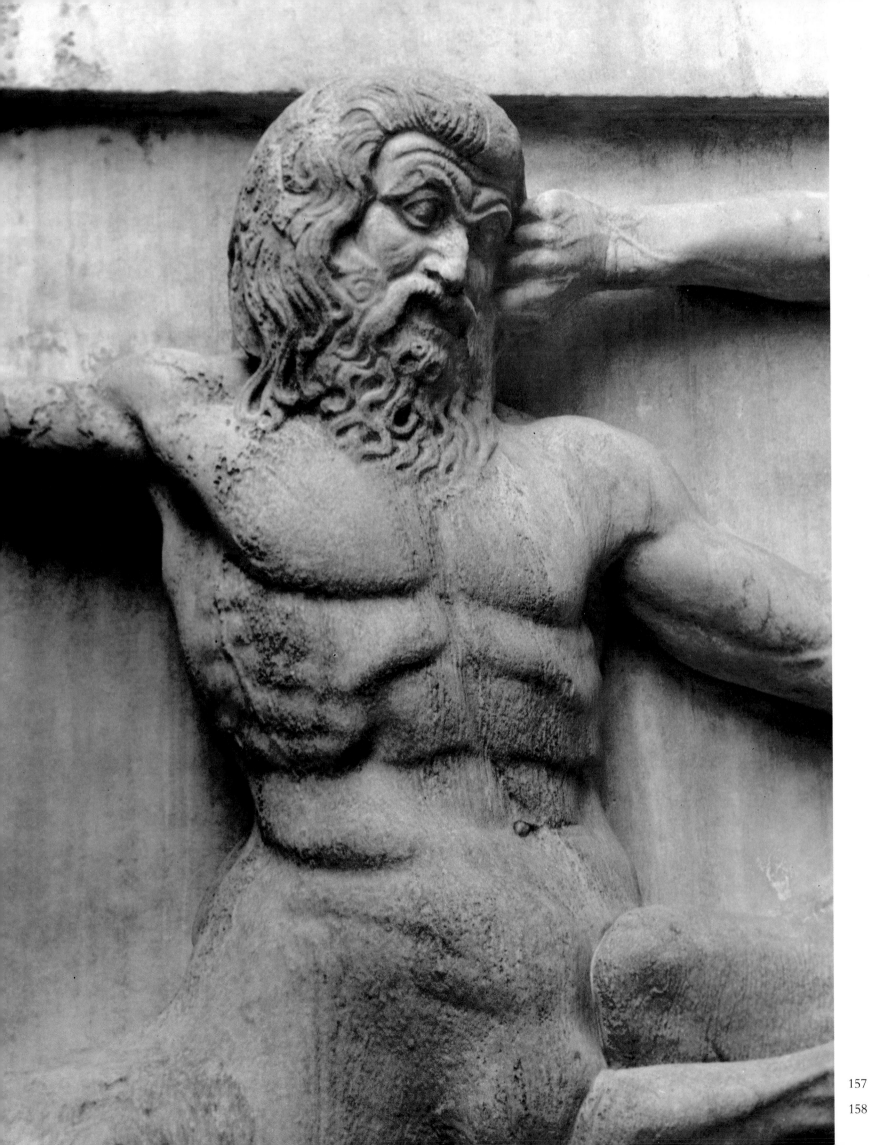

157
158

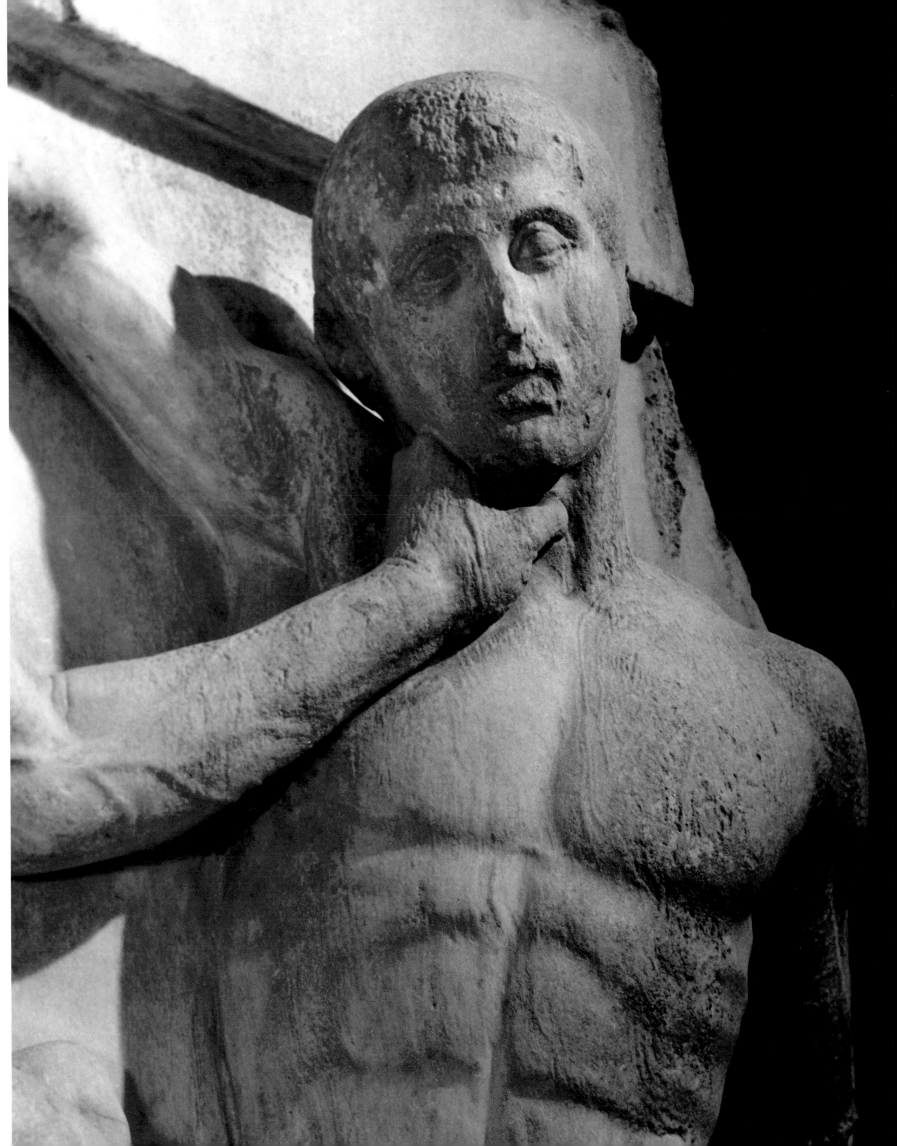

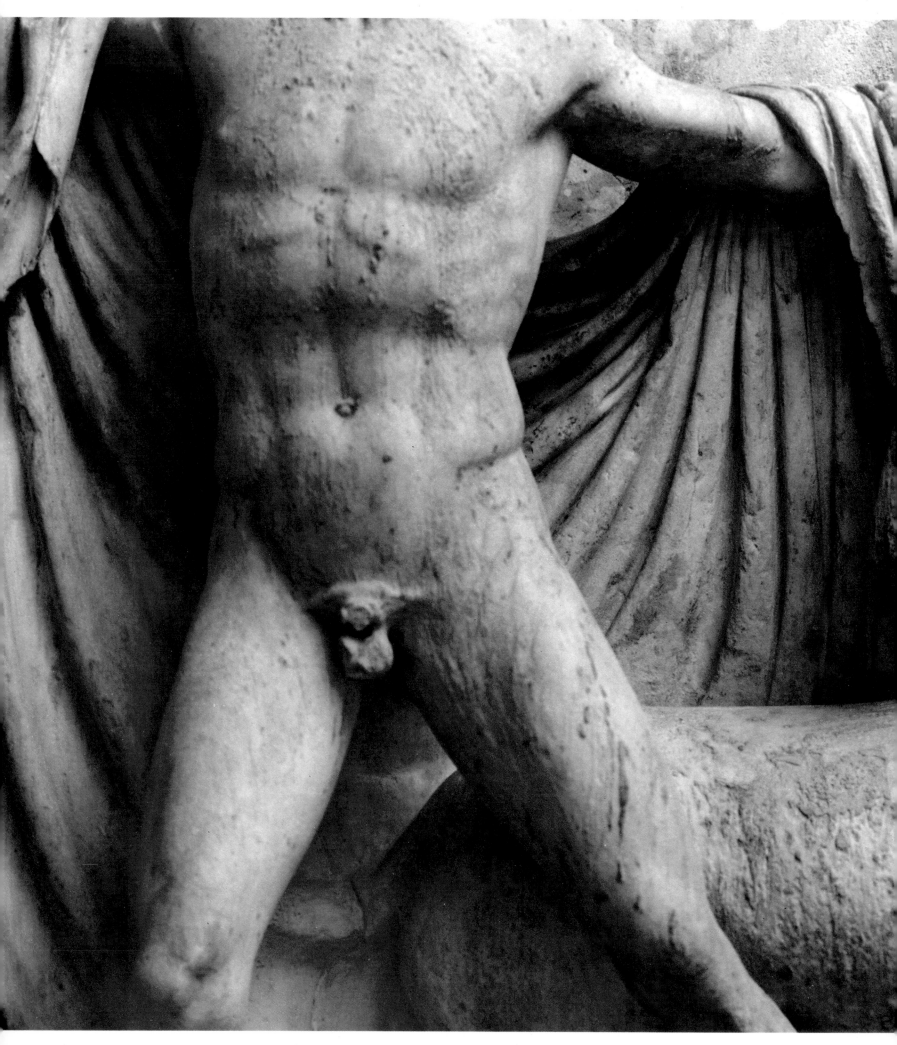

CAPTIONS TO THE PLATES

All the sculptures are in the British Museum with the following exceptions: pl. 59 in the Louvre; pls. 68, 69, 72 in the Acropolis Museum, Athens; pls. 114, 115, 122–126 in position on the Parthenon; and pl. 1 shown on the Parthenon but since removed to the Acropolis Museum.

THE EVIDENCE

1 THE NATURE OF OUR SOURCES

Descriptions of the Parthenon, accounts of the sculptural style of Phidias or the fortunes of Athens, fall readily from the lips of lecturers and flow from scholars' pens. Professional accounts, by archaeologists, epigraphers and iconographers, are heavily documented, not usually because there is so much original evidence, but because there is so little, and gaps have to be filled by analogy with other apparently parallel circumstances, and theories justified by exploring all their implications against the evidence available.

A conference devoted to the Parthenon was held in Basel in 1982. Its results – papers read by some fifty scholars – now fill five hundred pages of the published report, and they deal with only a small selection of the problems, determined by the interests of the scholars invited. The fullest recent publication which describes the marbles is in German and occupies six substantial volumes. Even so, it deals very summarily with opinions and arguments, and concentrates on the physical remains. To the ordinary reader the minutiae of such research may seem otiose (much does also to some scholars) and is certainly incomprehensible in detail, but the search for the truth about such an important building and its sculpture is exciting and challenging. This aspect of the Parthenon has been carefully disguised in the first part of this book, because I wanted to try, for a change, to look at the Parthenon through the eyes of those for whom it was made and not through the eyes of a twentieth-century investigator. It was necessary, therefore, to assume full knowledge of the contemporary scene, and to invent what is not known. In this and the following sections that other aspect of the Parthenon, the puzzle set for the modern world by the accidents of time which have clouded our knowledge of antiquity, is given its due. What do we really know about the building, its planning, its construction, its purpose, its appearance? How much of the semi-fictional account above is true, or plausible, or likely to have proved acceptable to a fifth-century Athenian? Even the most dedicated, impartial scholar tends to take a highly personal view of such an important subject, and is no less than human in the passion with which he or she will defend his or her own solutions. I shall be as impartial about the evidence as I can, but partial about my interpretation of it, and judge that no excuses for such an attitude need be looked for or given.

What stands between us and a full understanding of the Parthenon is not only what has been lost since antiquity of the record in stone or texts, which can be readily defined, but all comprehension of what it must have been like to be a fifth-century Athenian, indeed any Greek. We know their written language and how they conducted their religion, but the writings of poets, philosophers and historians (even retired generals) let us barely approach understanding of the human motives and reactions provoked by, for instance, a military disaster, a threat of slavery, a case of divine intervention. Archaeology can bring us closer to the physical world, although much of the available evidence it offers is irrelevant to the daily life of antiquity. European medieval towns (some in the Greek Islands) may give an idea of the physical appearance of Classical towns, but for the flavour (or aroma) we should probably turn, for example, to the poorer urban quarters of cities in parts of the Indian sub-continent or Central America. And how can we allow for that civic fervour (of the Greek city-state) which could transcend any feeling for national unity, or shattering contrasts in one small society between utter brutality and extreme refinement of taste? The more brilliant of our historical novelists (a Mary Renault) can forge a sense of place and mood which reads plausibly to the professional, but we have to admit that most of the time we can do no better than try to define the outlines of shadows of the real past. Reading ancient texts and looking at the physical remains can take us some way along this path, provided we remember what they cannot ever reveal and what we have to supply by imagination, intuitive human sympathy, or analogy with what is better known or understood about other apparently comparable societies, at other times or places.

The physical evidence for the Parthenon is simply what has survived and what can be understood of it in the light of comparable finds of similar date or character. To describe this evidence we need to know what has happened to the building since it was completed, and this is considered in section 2. We can then go on to discover how complete our knowledge of the architecture and sculpture is, in sections 5 and 6, as well as what we know of how it was planned and executed. The first part of this book dwelt on the historical background to the Parthenon in the belief that this could explain the building. The sources for this are more conventionally historical, and discussed in section 3, and it is similar sources, but far more lacunose and of far more mixed value, that we turn to in section 4 for the account of the Great Panathenaea, which plays such an important role in the building's history. The interpretation of the sculpture, discussed in section 7, is the most elusive of subjects, and depends very much on our views of the use of imagery in Classical Greece. Very different views from that taken here have been held. I do justice to what I can of them but reserve my favours for my own! Finally, in section 8, we look briefly at what the Parthenon, as rediscovered in the nineteenth century, has meant to the western world, as well as what it meant to its creators, though this is really part of a very different subject, of no less fascination.

And before we embark on this survey of evidence let the sorry fact be revealed that Iktinos' book about his building is completely lost, and that, although there are ancient descriptions of the cult statue, the Parthenon marbles are mentioned in antiquity only by the second-century AD traveller Pausanias, and he merely records briefly the subjects of the pediments, without a word about the metopes or frieze. These texts are dumb, but other texts have much to say which can be proved relevant, inscriptions have been unearthed to explain logistic and financial details, and there is the glory of the building itself and what has been preserved of its sculptural decoration.

2 THE LATER HISTORY OF THE PARTHENON

Six years after Pamphilos' visit, in 433/2 BC, the accounts for the pedimental figures on the Parthenon were closed and we may assume that all the marble sculptures were at last in position on the building. Its history thereafter has to be judged from the remains themselves and texts about them. In the following thirty years a new entrance-way to the Acropolis, the Propylaea, was completed and the Temple of Athena as Victory (Athena Nike) beside it, while to the north of the Parthenon the Erechtheion, an irregular and innovatory Ionic building, was erected to house the cults of Erechtheus and Poseidon, and to succeed the old Athena temple as home of the sacred wooden statue of the goddess. But these were dire years for Athens, engaged in the Peloponnesian War, brilliantly described for us by the historian and general Thucydides who had lived through it. By the end of the war Athens had lost her leadership of Greece, and perhaps half her population through war and plague. She had not been occupied or sacked, but had surrendered her wealth to the war effort, even melting down the

gold cladding of statues of Victory kept in the Treasury, though the gold on the Parthenos itself was spared.

Through the fourth century Athens continued to try to play a leading role in Greek affairs, but the increasing involvement of Macedonia, of Philip II and his son Alexander the Great, spelled the end of Athens' and many another Greek city-state's ambitions. Macedon, Alexander's successors, and eventually Rome were now to dictate the flow of Greek politics and life for several centuries.

Inscriptions and the speeches of fourth-century BC Athenian orators throw some light on happenings in the temple – repairs to the cult statue, a fire in the Treasury, thefts. The building was becoming more and more packed with precious offerings as well as the impedimenta of the rites performed on the Acropolis. We have inventories of the treasures and offerings for several years, distinguishing those kept in the porch, in the cella ('Hekatompedon') and in the rear room ('Parthenon').

The new rulers of Greece were to make more impact. Alexander's respect for Athens was shown by his dedication of three hundred captured Persian shields (or panoplies) after the battle of Granicus (near Troy) in 334. His victory liberated the Greeks of Asia and, in the light of what seems the probable role of the Parthenon as commemorative of Athens' similar feat, it was especially appropriate that twenty-six of the captured shields should be fastened on the Parthenon epistyle, with an inscription recording the success of Alexander and the Greeks (except the Spartans) over the barbarians of Asia.

After Alexander Athens had to suffer governors appointed from the successor kingdoms. Demetrius the Besieger (Poliorketes) was invited by sycophantic Athenians to be the guest of the virgin goddess, and to occupy the rear room of the temple, which he desecrated by his libidinous behaviour with the most famous whores of Greece. Even he, however, was outdone by his successor in Athens and rival, Lachares, who in 296/5 BC plundered all the precious objects and gold shields, and removed even the gold from the cult statue. He had to leave Athens in a hurry, and presumably abandoned the gold which could be restored to the Parthenos.

Plan of the western part of the Acropolis at the end of the fifth century BC

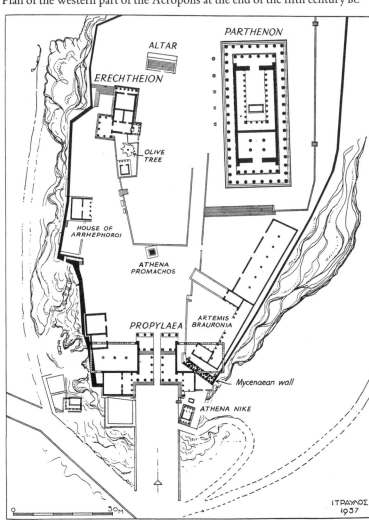

North metope no. 32 (from a cast in Oxford): Athena and Hera. The only metope on this side of the building to be spared by the Christians

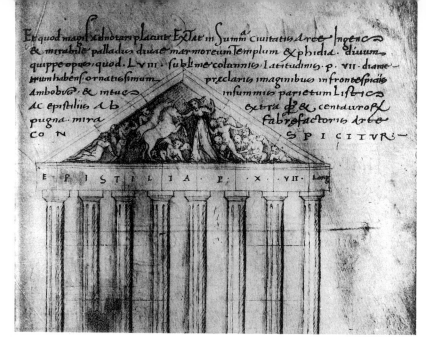

Mid-fifteenth century drawing of the façade of the Parthenon, by or after Cyriac of Ancona

The Hellenistic monarchs of the third century BC were more rewarding. Attalos I of Pergamum paid a compliment to the architectural sculpture of the Parthenon, which in its way reinforces our interpretation of the stories told in the metopes. He dedicated along the south terrace of the Acropolis statue groups depicting the battle of gods and giants, the Athenian defeat of the Amazons, the Athenian defeat of the Persians at Marathon, and his own defeat of the invading Gauls (Celts) in Asia Minor. But the last throes of the Hellenistic rulers of Greece were bloody. Archelaos, lieutenant of the Pontic King Mithridates VI, held Athens and Piraeus against the Roman Sulla in 87/86 BC. Sulla sacked Piraeus, attacked Athens, bloodied the *dromos* of the Panathenaic Way with an appalling massacre, and Archelaos eventually surrendered on the Acropolis.

Although the Acropolis suffered no less than the city of Athens and other cities of Greece from the collecting fervour of the Romans, its splendours and its temple were still long admired. An honorific inscription to Nero was set on the east façade, and can be read from the surviving nail-holes which fastened the bronze letters. Other emperors made their offerings and erected their statues, the philhellene Hadrian even insinuating one of himself into the Parthenon. He was, after all, a 'new Theseus', and considered himself founder of a 'new Athens'.

The third and fourth centuries AD saw Athens again attacked and plundered by barbarians, now the Goths, and the refortification of the Acropolis. It was probably in the fifth century that the temple's inner colonnade had to be replaced but soon thereafter, in an Athens by then largely Christian, the gold and ivory Athena Parthenos was taken from her temple to an unknown fate in Constantinople. The bronze Promachos went the same way, to be destroyed in the Crusaders' sack of Constantinople in 1204.

But Christianity was to be the saving of the Parthenon itself, since the building was converted to a church of Holy Wisdom, Agia Sophia. Greek temples face the east, their altars outside them: Christian churches face west, with an altar within, at the east, so doors were cut through from the rear room of the Parthenon, and its main door was blocked. The apse which took its place may have been responsible for the loss of the centre of the east pediment, with the birth of Athena, but most of the east frieze survived. The metopes were severely battered by Christian hands, especially on the west, north and east, which seemed populated with pagan deities, and were more accessible than the pediments, which appear to have been spared. Heads and torsos were mutilated and cast from the building. The south metopes, with Lapiths and centaurs, were left, perhaps because they seemed to show a proper defeat of monstrous creatures; and the first metope at the west end of the north side, possibly because it resembled an Annunciation. The frieze's figures looked wholly secular and its purpose had been long forgotten.

The Acropolis had become the core of the city of Athens, which had shrunk considerably since antiquity, and the continued use of the Parthenon for various purposes guaranteed that it would not become simply a quarry for building or the lime kilns, although anything that fell from it or could be knocked off it would be so used. With the Crusaders and their Frankish followers the Parthenon changed from being the Greek Orthodox Agia Sophia to a Catholic Notre Dame. But in 1456 the Turks took Athens, and Mahomet replaced the Parthenon's latest Virgin goddess.

Renaissance interests in Classical antiquity, its texts and arts, had already attracted the attention of Italian scholars to Greece. Cyriac of Ancona visited the country three times between 1436 and 1444. In Athens 'what pleased me most of all was the great and marvellous marble temple of the goddess Pallas on the topmost citadel of the city, a divine work by Phidias . . . splendidly adorned with the noblest images on all sides which you see superbly carved on both fronts, on the friezes, on the walls, and on the epistyles.' He recognized the Lapiths and centaurs of the south metopes and took the frieze to show 'the victories of Athens in the time of Pericles'. His drawing transforms the west pediment into a composition of an angelic Athena, horses and putti.

The Turks, understandably, turned the Parthenon into a mosque and built a minaret at the western end of the cella. The rest of the Acropolis surface took on the appearance of a Levantine town with clustered houses sheltering beside and within the ruins of the Classical buildings. Athens was still often visited by Western scholars and there are occasional descriptions of the great temple. In the lower town lived Franciscans and other Westerners who took account mainly of the architectural remains of Athens, but in the seventeenth century life on the Acropolis became decidedly more dangerous. In 1656 lightning exploded a magazine in the Propylaea, destroying part of the building. For the Parthenon itself, however, and our knowledge of it, events of salvation and destruction were imminent. The Marquis de Nointel, French Ambassador to the court at Istanbul, took an interest in Athens' antiquities and commissioned drawings, now in Paris, generally attributed to the hand of Jacques Carrey. He gave a good account of what remained of the pediments, the south metopes and much of the frieze, the main shortcomings for our purposes being due to the distance and angle at which he had to work and his ignorance of what was plausible. Fortunately, he was a comparatively poor artist, with no very distinctive personal style or imagination to come between what he saw and what he drew.

Carrey's record is invaluable, for within a few years, in 1687, the Acropolis found itself under siege by the Venetians, led by Count Königsmark, General Morosini's lieutenant. The Turks had stored gunpowder in the Parthenon, which therefore came under fire. In

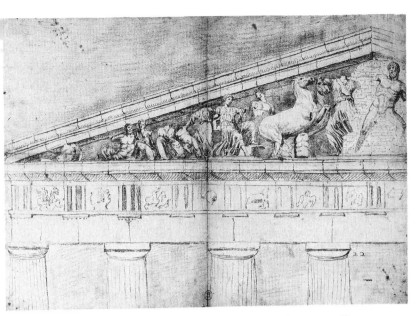

Drawing of the west pediment of the Parthenon, by Jacques Carrey, about 1675

The Acropolis in 1670 with the Parthenon as a mosque

VEDUTA DEL CAST: D'ACROPOLIS DALLA PARTE DI TRAMONTANA

The explosion in the Parthenon, 1687

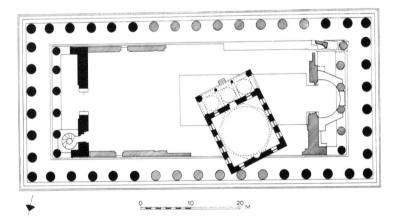

Plan of the Parthenon after the explosion of 1687, showing the outline of the earlier Christian apse, the minaret stair at the south-west, and the small mosque built in the ruins

Drawing of the Parthenon by Julien-David le Roy, from his *Les ruines des plus beaux monuments de la Grèce* (Paris 1770)

the words of an eye witness, one of Morosini's aides, Cristoforo Ivanovich, 'one of [the mortar bombs], striking the side of the temple, finally succeeded in breaking it. There followed a terrible explosion in the fire of powder and grenades that were inside, and the firing and the reverberations of the above munitions made tremble all the houses of the Borgo, which seemed a great city, and put a tremendous fear in the besieged. In this way that famous temple of Minerva, which so many centuries and so many wars had not been able to destroy, was ruined.' The explosion shattered the centre part of the temple, virtually pulverizing the centre metopes and the central slabs of the frieze on the long north and south sides. It must also have dislodged many pieces of sculpture from other parts of the building.

Morosini, the inveterate collector who acquired marble lions in Greece for the Arsenal in Venice, coveted the chariot horses of the west pediment and tried to bring them down, but his engineers misjudged their weight, they fell and shattered. Thereafter the lime kilns were busy and even a century later a British visitor could observe the 'heap of ruins' in the cella: 'the whole of these materials, to our great regret, were promiscuously consumed in the furnace, with their ornaments of sculpture and architecture, for the purpose of making lime to patch up the ruinous walls of the Acropolis.' Directly or indirectly the new liberation of Athens had cost the Parthenon a quarter of its surviving marbles. The walls of the temple itself were no longer deemed worthy to be themselves a holy structure, and a small mosque, with its own walls, roof and minaret, was built on the rubble of the temple cella.

In the eighteenth century travellers and artists took more careful note of what survived of the great building, and desultory collecting began to distribute heads and slabs from the building to Western homes. The French Vice-Consul Fauvel collected fragments but also made casts of surviving figures and reliefs, a practice of the greatest value in the light of what the marbles were yet to suffer. At the turn of the century Lord Elgin's artists were busy drawing and casting on the Acropolis, and in 1801 he secured permission from the Turkish authorities also to remove 'any pieces of stone with inscriptions or figures'. This was a difficult and dangerous exercise (as Morosini had discovered) and it was achieved with no little damage to the architectural appearance of the temple, although the sculptures were carefully tended and

The Parthenon and Erechtheion (at the left); from John Cam Hobhouse, *Travels in Albania and other provinces of Turkey in 1809 and 1810* (London 1855)

Nineteenth-century photograph of the Acropolis. The Frankish tower in the Propylaea was demolished in 1874 at Schliemann's expense

The Temporary Elgin Room in the British Museum, 1819. Painting by A. Archer

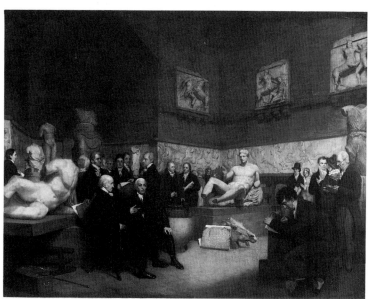

survived their removal to Britain virtually unscathed. Elgin took almost all the substantial pedimental figures that survived, much of the remaining north, south and east frieze (leaving the west, which had been virtually undamaged by explosion or reconstruction), and the best metopes from the south side. In 1816 the marbles were purchased from Elgin by the government, for the British Museum.

The legality and propriety of this whole operation has aroused heated controversy from that day to this, and need not be judged here. For our present purposes it suffices to observe that architecturally the Parthenon suffered, but probably with no loss of information about its structure, while the sculptures which reached London are in virtually as good condition now as they were when they were removed, which is more than can be said for what was left behind.

At the end of the nineteenth century comprehensive excavations on the Acropolis by Greek archaeologists recovered many more substantial sculptural fragments from the building, now exhibited in the museum on the site, and among the sculptural crumbs it is still possible for the diligent and observant to find pieces which belong to and even join the Parthenon sculptures. These can sometimes make a profound difference to our understanding of the ensemble. Restoration of the building itself has not, perhaps, so much enhanced our knowledge of its structure as altered its aesthetic appeal as a ruin, and the use of the bare iron clamps here, as in other Acropolis buildings, has proved more destructive than preservative. Worse, though, has been the effect of the corrosive atmosphere of modern industrial Athens. The building carried until recent years a few battered figures in the pediments (now removed), and still carries almost all the west frieze, and the ruinous metopes on the west, north and east. Comparison of the present state of these with casts taken two hundred years ago show how they have suffered from time (e.g. the Eros of the east frieze) and exposure. Nevertheless, time and man have dealt more gently with the Parthenon than with many monuments of Classical antiquity, and we shall see that the incompleteness of the physical remains is probably the least of the problems that a twentieth-century investigator of the meaning of the Parthenon has to face.

East frieze, slab VI, figures 41, 42 (Aphrodite, Eros). Cast from a late eighteenth-century mould. The slab was not taken by Elgin and these figures are now virtually destroyed

216

3 ATHENS AND HISTORY

In this section we consider the evidence for those elements in Athenian history of the first half of the fifth century BC that seem relevant to the planning and building of the Parthenon, and the evidence of other monuments that have been mentioned.

Herodotus, the father of history, was born a little before the Persian Wars at Halicarnassus, on the coast of Asia Minor, south of Ionia. His city had been liberated and paid tribute to Athens as a member of her League. In the mid-fifth century he was writing his history of the Persian Wars, which is our prime source, but he also dealt with earlier events, including the Ionian Revolt in 499 and the expedition of the Athenians to Ephesus and Sardis, for which he is virtually our only source. Being moderately anti-Ionian he plays down this remarkable exploit of arms, and dwells rather on the confusion that followed. The fact remains that the Athenians reached the Persian satrapy capital at Sardis with their Ionian allies, burnt it and returned home. Casualties are not recorded but we have no reason to believe them heavy, and Athens must have been proud of their achievement. What they thought had happened counted for more than what, with hindsight, we can judge as the true significance of the event. The Persian reaction, the delayed punitive expedition, is a better commentary on the importance of the Athenian intervention than Herodotus.

Thucydides described the Peloponnesian War, which broke out a year after the Parthenon accounts were closed, and which saw Athens humbled and her walls cast down before the end of the century. His opening chapters give an account of the development of Athens' empire and the funeral speech devised for Pericles is an excellent expression of Athens' view of her own greatness and her role in Greek affairs. Thucydides had himself lived through the war.

Diodorus, a historian of the first century BC, is our source for the oath taken by the Greeks before the battle of Plataea. 'I will not rebuild any temple that has been burnt and destroyed, but I will let them be and leave them as a memorial of the sacrilege of the barbarians.' His information is from the fourth-century BC historian Ephorus, and the main elements of the oath are repeated by a fourth-century Athenian orator and in an inscription found at Acharnae in Attica. But, already in the fourth century, another historian, Theopompus, had dismissed it as Athenian propaganda. However, in Attica, Eretria and elsewhere, ruins attributed to the Persian attack were still being shown in the second century AD. It is hard to understand why, if there had been no oath, the Athenians, flush with gold and silver from booty and tribute, so long delayed their rebuilding; and easy to understand why they revoked the oath, when they did, once the Persians had retired finally from the Aegean world and the Greeks had been freed.

This revocation is alluded to by Plutarch, a first- to second-century AD historian and raconteur, in his *Life of Pericles*. Around or just after the mid-fifth century BC Pericles is said to have proposed a congress of the Greeks to discuss, inter alia, the sanctuaries which

Map of the southern Aegean and its coasts

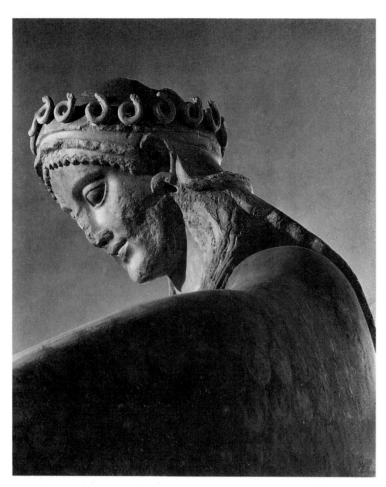

Athena from the pediment of the Archaic Temple of Athena on the Acropolis, late sixth century BC

outraged,' they cried. 'They must consider this an act of bare-faced tyranny, when they see that with their own contributions, extorted from them by force for the war against the Persians, we are gilding and beautifying our city, as if it were some vain woman decking herself out with costly stones and statues and temples worth millions of money.'

Pericles' answer to the people was that the Athenians were not obliged to give the allies any account of how their money was spent, provided that they carried on the war for them and kept the Persians away. 'They do not give us a single horse, nor a soldier, nor a ship. All they supply is money,' he told the Athenians, 'and this belongs not to the people who give it, but to those who receive it, so long as they provide the services they are paid for. It is no more than fair that after Athens has been equipped with all she needs to carry on the war, she should apply the surplus to public works, which once completed, will bring her glory for all time, and while they are being built will convert that surplus to immediate use. In this way all kinds of enterprise and demands will be created which will provide inspiration for every art, find employment for every hand, and transform the whole people into wage-earners, so that the city will decorate and maintain herself at the same time from her own resources.'

Certainly it was true that those who were of military age and physically in their prime could always earn their pay from the public funds by serving on Pericles' various campaigns. But he was also anxious that the unskilled masses, who had no military training, should not be debarred from benefiting from the national income, and yet should not be paid for sitting about and doing nothing. So he boldly laid before the people proposals for immense public works and plans for buildings, which would involve many different arts and industries and require long periods to complete, his object being that those who stayed at home no less than those serving in the fleet or the army or on garrison duty, should be enabled to enjoy a share of the national wealth. The materials to be used were stone, bronze, ivory, gold, ebony and cypress-wood, while the arts or trades which wrought or fashioned them were those of carpenter, modeller, copper-smith, stone-mason, dyer, worker in gold and ivory, painter, embroid-erer, and engraver, and beside these the carriers and suppliers of the materials, such as merchants, sailors, and pilots for the sea-borne traffic, and waggon-makers, trainers of draught animals, and drivers for every-thing that came by land. There were also rope-makers, weavers, leather-workers, roadbuilders and miners. Each individual craft, like a general with an army under his separate command, had its own corps of unskilled labourers at its disposal, and these worked in a subordinate capacity, as an instrument obeys the hand, or the body the soul, and so through these various demands the city's prosperity was extended far and wide and shared among every age and condition in Athens.

So the buildings arose, as imposing in their sheer size as they were inimitable in the grace of their outlines, since the artists strove to excel themselves in the beauty of their workmanship. And yet the most wonderful thing about them was the speed with which they were completed. Each of them, men supposed, would take many generations to build, but in fact the entire project was carried through in the high summer of one man's administration.

After the transfer of the League Treasury from Delos to Athens in 454 the accounting was done in Athens, by the Hellenotamiai, and a *stele* was erected recording that one-sixtieth of the tribute of each city which was reserved for Athena. Substantial fragments of the colossal *stele* covering the years 454/3-440/39 have been found on the Acropolis and they give a consistent picture of Athens' growing wealth. Each Great Panathenaea was the occasion for a new assessment. We have no evidence for the manner in which the rebuilding was planned, except that Pericles was the prime mover and Phidias the director and supervisor of the whole enterprise (not

had been burnt down by the Persians. (In the narrative above I have placed the decision to rebuild in or before 450. Formal peace with Persia was not 'signed' until 449 – the Peace of Callias.) Nothing became of the congress but it is reasonable to assume that something of the sort was planned, something at which Athens could explain why she had decided to start rebuilding. Plutarch also gives an account of Pericles' plans for Athens and reactions to them, which is worth quoting at length:

But there was one measure above all which at once gave the greatest pleasure to the Athenians, adorned their city and created amazement among the rest of mankind, and which is today the sole testimony that the tales of the ancient power and glory of Greece are no mere fables. By this I mean his construction of temples and public buildings; and yet it was this, more than any other action of his, which his enemies slandered and misrepresented. They cried out in the Assembly that Athens had lost her good name and disgraced herself by transferring from Delos into her own keeping the funds that had been contributed by the rest of Greece, and that now the most plausible excuse for this action, namely, that the money had been removed for fear of the barbarians and was being guarded in a safe place, had been demolished by Pericles himself. 'The Greeks must be

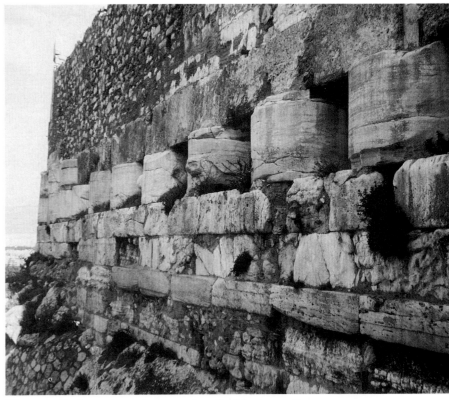

the Parthenon alone, to judge from Plutarch). The monuments themselves suggest that there was an overall strategy. Rebuilding in the Attic countryside brought local prosperity just as the work in Athens did to the metropolis. Coincidence in styles, themes and architecture suggest a master plan.

We turn now to the mainly archaeological evidence for other monuments that have been mentioned. The temple standing on the Acropolis at the time of Marathon seems to have been one that was built before the mid-sixth century, and which had been decorated with limestone sculptures in its pediment. The compositions were dominated by animal fights, but in the corners of the pediments (if one follows an attractive recent reconstruction) appeared mythological vignettes – a Birth of Athena (?), Heracles introduced to

The Acropolis from the north-west, with the re-used column drums visible in the north wall

The re-used column drums in the north wall of the Acropolis

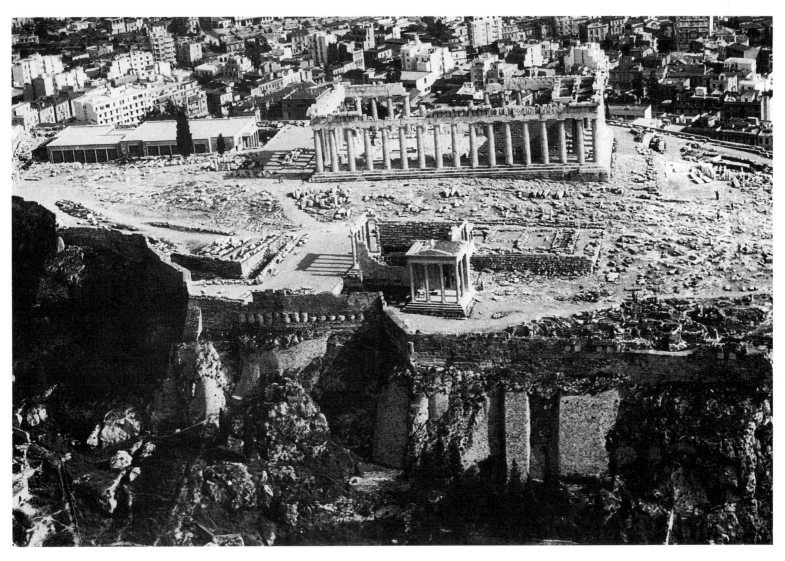

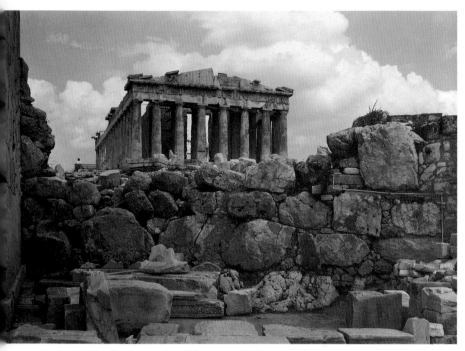

The Parthenon from the west, with part of the Mycenaean fortification wall in the foreground

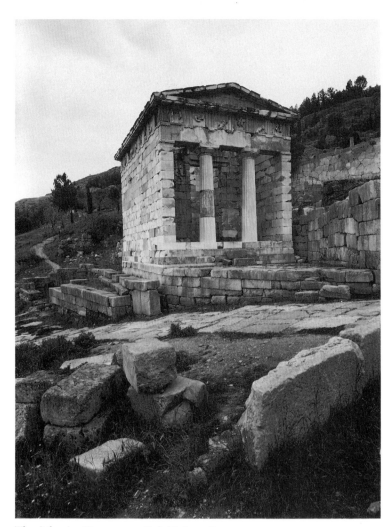

The Athenian Treasury at Delphi, just after 490 BC

Olympus by Athena, Heracles fighting the sea monster Triton, and a strange triple-bodied snaky monster. Heracles is prominent also in other, smaller Acropolis buildings and is overwhelmingly popular in the lesser arts of Athens in the sixth century. The fortunes of Heracles, as Athena's favourite hero, could be used as parables for Athens' fortunes, and the city's tyrant family seems to have adopted him.

The tyrants were evicted from Athens in 510 through the machinations of the Athenian Alkmaionid family, which had retired to Delphi, and with the help of Spartan arms. At Delphi the Alkmaionids had rewarded the god Apollo by paying for marble to be used on the façade of his new temple. Back in Athens, they may have promoted the replacement of the limestone pediments on Athena's temple with marble. In one pediment were animal fights in the old manner; in the other a gigantomachy – an important theme for Athena, and one in which Heracles was usually also prominent, but so far no pieces of a Heracles have been identified from this composition. These new pediments have generally been attributed to the last years of the tyrants, the 510s, closer in date to the Delphi temple, and, as it were, an answer to it. The slightly later date, after 510, makes at least as good sense. Fragments of the sculpture were recovered with other debris of the Persian sack in excavation on the Acropolis at the end of the last century. They had been packed into the fill of terraces designed to support the new buildings, together with other statuary and votives overthrown by the Persians.

The old entrance-way to the Acropolis lay at an angle to the later, Periclean Propylaea, but in the same place. It was of brick and marble with a colonnade of two or four columns at each side of the gates. It may have been built as late as the 490s or even after Marathon; it was damaged in 480/79 and restored. Much of the Acropolis wall must still have been the 'Cyclopean' structure of Mycenaean date, part of which is still visible beside the Propylaea and on the north-east side of the Acropolis. Unfinished column drums and blocks built into the north wall of the Acropolis attest to the hurried refortification after 479, and are from the aborted first Parthenon.

At Marathon the dead were cremated on the battlefield and a tumulus erected. This was mauled by Schliemann and better excavated in the 1890s to reveal offering trenches and scraps of pottery. A Hellenistic inscription records the laying of wreaths at the tomb by Athenian youths (ephebes) and in the second century AD Pausanias observed that the dead were still worshipped by the Marathonians as heroes. Herodotus says that *stelai* naming the dead by their tribes were erected at Marathon.

After Marathon, according to Pausanias, the Athenians celebrated their victory with various dedications. At Delphi they erected a Treasury, which is readily identified on the site, where it is restored, and from which much of the sculpture survives. Scholarly opinion has tended to date the Treasury before Marathon on stylistic grounds, dismissing Pausanias (who does often make mistakes) who was thought to have misinterpreted an adjacent inscription as referring to it. The post-Marathonian date is, however, becoming more acceptable. The metopes divide the honours between Heracles, Athens' old hero, and Theseus, her new hero, who on one metope is shown in conversation with Athena in

220

a manner previously reserved for Heracles. Across the front of the temple and perhaps in the pediment was an Amazonomachy, apparently linking the two heroes (see below, section 7).

Another dedication at Delphi was a bronze group by Phidias showing Athena and Apollo, Athenian heroes and kings, and the Athenian general at Marathon, Miltiades (who had died soon after the battle). Some scholars believe that the two bronze statues of warriors recovered from the sea off Riace in south Italy in 1972 were from this group. Yet another bronze dedication celebrating Marathon and made by Phidias was the colossal Athena Promachos which was erected on the Acropolis just within the entrance-way. Its appearance can be judged only from representations on coins of later date and it seems to have borne a superficial resemblance to its successor, the Parthenos. Pausanias says that the shield was decorated with a centauromachy designed by the painter Parrhasios and executed by Mys, who was a bronze-worker. The statue was appreciably older than the careers of these artists, but appliqué figures could easily have been added to the shield, perhaps on the model of the Parthenos shield.

Between the Persian Wars and the start of work on the Parthenon there were several public buildings erected in Athens, around the market-place. Some are associated with the statesman Cimon, son of Miltiades the victor of Marathon, and a leading figure in the

military operations of the Athenian League. He had recovered the bones of the Athenian hero Theseus from Skyros and installed them in the Theseion, east of the Agora: we have no trace of the building. He is also associated with the Painted Stoa (Stoa Poikile) off the north-east corner of the Agora, elements of which have recently been identified. Here, Pausanias tells us, were the famous paintings of Polygnotos and Mikon, depicting events which seem symbolically important to fifth-century Athens – the battle of Marathon itself, an Amazonomachy, a Sack of Troy.

Finally, a word about Plataea, the home of Pamphilos' friend. It lay in the neighbouring state of Boeotia, some fifty miles from Athens. The city had been helped by Athens against her old enemy Thebes in 519, which is why she promptly sent a contingent to Marathon. After the defeat of the Persians at the battle of Plataea in 479 the Greeks awarded the city eighty talents and swore to guarantee its independence, but ten years after the events narrated here she was again attacked by Thebes and destroyed after a long siege (429–7). The building of the Temple of Athena Areia might seem to contradict the controversial Oath of Plataea not to rebuild temples overthrown by the Persians, but this seems to have been a new foundation, largely inspired by Athens. The cult statue was likened to Phidias' bronze Promachos in Athens, but a bit shorter, comparable in size to the Parthenos. The temple was built long before the Parthenon, because the painter Polygnotos (who had worked in Athens for Cimon) decorated its walls. It is not known when the cult statue was made, but if it too was early it might have served Phidias as a trial piece for his Parthenos, though in different materials.

In the account in the first part of this book dates are given by reference to the Great Panathenaea, or to Olympiads – the four-year intervals between celebrations of the Games at Olympia, which were numbered. Great Panathenaea happened in the third year of Olympiads. Individual years in Athens were characterized also by the name of the principal magistrate. Hekatombaion was the first month of the Athenian year, starting with the new moon before the summer solstice. Dating events 'BC', with neat but unrealistic century compartments, can give an odd perspective to the flow of events. Talking about a 'fifth-century style' is of course meaningless in terms of antiquity. In the same way, viewing a map 'upside-down' can sometimes reveal unsuspected territorial relationships. All single viewpoints, of events or objects, tend to distort them.

Bronze statue found in the sea off Riace in south Italy. Plundered from a Greek sanctuary in antiquity

Roman coin showing the Acropolis with the Athena Promachos

Model of the Acropolis

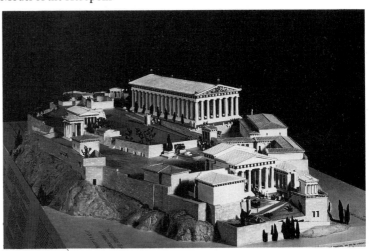

4 THE GREAT PANATHENAIC FESTIVAL

Much of our evidence for the conduct of the festival comes from written sources far later than the fifth century BC. We cannot always be sure that all elements were present and practised so early, and much of what is written about its fifth-century form may be found to be based on rather subjective interpretation of the Parthenon frieze itself.

The festival had been reorganized in the 560s, with the addition of the special four-yearly celebration. The main day was the 28th Hekatombaion (early August). We do not know the exact day of the procession, nor for how many days (probably three or more) the festival lasted. But the procession was probably one of the first events, after songs and dances on the Acropolis by young men and women. There were athletic contests, with prizes of oil collected from special groves at the Academy, and presented in oil vases specially decorated for the purpose, with Athena shown on one side in the stance of an Archaic fighting image (Promachos) between columns surmounted by cocks (symbols of competition?), and on the other side a depiction of the games. The example shown here is of the years near Marathon, and by a leading artist of the day (called by modern scholars the Kleophrades Painter) whose main work was in the red-figure technique, but who had to practise the older black-figure technique for these vases – an anachronism maintained on them for centuries. Musical contests were an early feature of the festival and Homeric recitals were introduced before the end of the sixth century.

The Royal Archon (Archon Basileus) was the magistrate responsible for the religious events of the city, in this case with the priestess of Athena. Responsibility for the making of the *peplos* lay with two of the *arrhephoroi*, girls of eight to eleven years old, who lived on the Acropolis and performed various cult functions, including the 'carrying of the unspoken things' (*arrheta*). Work was started some nine months before the Panathenaea, at the Chalkeia, a festival in honour of the smith-god Hephaistos, who was Athena's colleague as patron of crafts in Athens. The weaving was entrusted to chosen workers (*ergastinai*). The clothing of the image was the duty of the family of Praxiergidai, who had also to keep it and the *peplos* clean at the washing festival, Plynteria, in early summer.

Of participants in the procession the branch-carriers (*thallophoroi*) were elderly men. Girls served as basket-carriers (*kanephoroi*), as many as a hundred of them in the fourth century BC, and chair-carriers (*diphrophoroi*). Resident non-Athenians (*metoikoi*) sent their daughters as water-jar carriers (*hydriaphoroi*) and their sons as tray-carriers (*skaphephoroi*). After the Persian Wars Athenian colonies and League states each sent a cow and a panoply. Foot soldiers (hoplites) formed part of the procession too. Full equipment for these would have been bronze helmet, corselet and greaves, with a large round shield, thrusting spear and sword. But they were often, and increasingly in the Classical period, more lightly armed. Cavalry was an irregular force in the early Classical period, and

Prize vase for the Panathenaic Games,

chariots were used only for racing and processions, though they may still have had some minor military function.

The *peplos*, as worn by Athenian women, was a rectangular cloth wrapped around the body, belted and pinned at the shoulders, so that the arms were bare and one side left open. The top was folded down to make an overfall to waist level, or sometimes longer and also belted in (as for the statue of Athena Parthenos). What evidence there is for the decoration of Athena's *peplos* mentions the

early fifth century BC, by the Kleophrades Painter

battle of gods and giants, and this was perhaps a regular feature (see also below, section 7). The sacred wooden image was perhaps a creation of the seventh century BC, detailed enough to have jewellery attached. The statue had been kept in the Archaic Athena temple (see above, section 3), and after the sack of 480/79 presumably in some smaller structure on its ruins. It was no doubt less than life-size and had its robe simply wrapped around it. It is possible that the original intention was that it should be kept in the Parthenon, despite the presence there of the new, chryselephantine statue, but it seems that it was installed in the Erechtheion, which was completed in 406 BC. This building more closely matched the varied functions of the Archaic Athena temple, and overlapped its foundations. A life-size *peplos* would have needed no special provision for its carriage to the Acropolis, but by the end of the fifth century there is evidence that the robe was carried as a sail on a ship-car (a type of float for religious processions first used in Athens in festivals of Dionysos). This has provoked the thought that it might have been intended for the larger statue, in the Parthenon, but there would have been no easy or plausible way of attaching it, and even a life-size *peplos*, unfolded, could measure two metres square, large enough to make a show as a sail on a wheeled ship. The device presumably answered the need to display its decoration rather than its size.

It is difficult to imagine the problems posed by the sacrifice of a hundred cows, and with the other sacrificial animals provided by colonies and allies the logistics of the exercise are unfathomable. (In third-century BC Syracuse Hiero built an altar two hundred metres long to accommodate the annual sacrifice of four hundred and fifty cattle.) In the Panathenaea we know that one beast was sacrificed to Athena Nike (Victory) at her altar on the south side of the Acropolis entrance. Pandrosos, another Acropolis deity who seems to have shared some of Athena's sacrifices, was offered ewes, also perhaps at the Panathenaea. Perhaps not all the beasts were sacrificed on one day, and the altars kept burning throughout the festival.

Exploration of the lower city of Athens since the late nineteenth century has done much to elucidate its topography, but the greatest contribution has been the American excavations in and around the old market-place (Agora) which have revealed identifiable buildings that relate to our quest. The line of the Panathenaic Way is clear, and the paved stretch of the race-course (*dromos*) is visible today before the reconstructed stoa of Attalos (a second-century BC building). It ran from the Dipylon gate, which led on to the road to the Academy and lay beside the Sacred Gate. Between them, from the fifth century on, there was a building, the Pompeion, which served as store for the trappings of the processions. The road ran on through the potter's quarter (Kerameikos), with the Classical temple of Hephaistos up on the right. Close to the road on the right was the Royal Stoa (Stoa Basileios), the office of the Royal Archon. We do not know that the *peplos* was handed over to him here, and the evidence that the *peplos* workshop lay north of the market-place is circumstantial, but the associations suggested are plausible. On the left lay the area of the herms, pillar images of Hermes. It has been suggested that the Eponymous Heroes of the ten tribes were worshipped here in the early fifth century, though later in the century they were given a long base with statues in the south-west

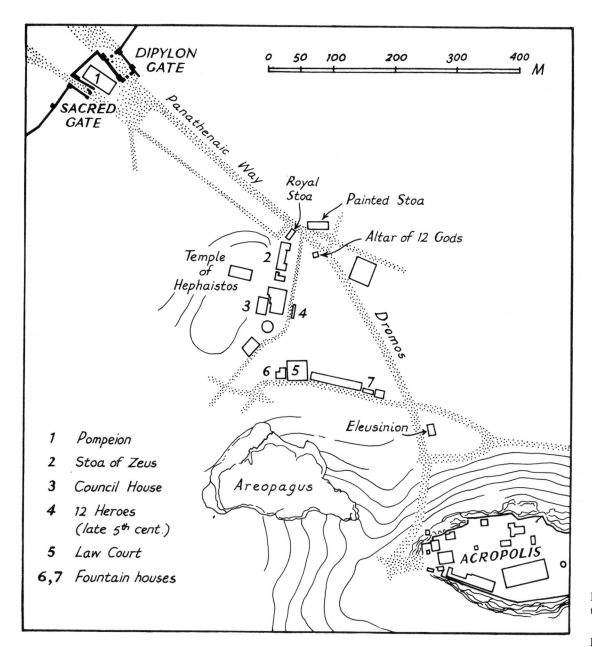

1 Pompeion
2 Stoa of Zeus
3 Council House
4 12 Heroes
 (late 5ᵗʰ cent.)
5 Law Court
6,7 Fountain houses

Plan of the Athenian Agora at the end of the fifth century BC

Fourth-century BC relief from a victor monument, showing an *apobates* chariot-jumper, found south-east of the Agora near the end of the *dromos*

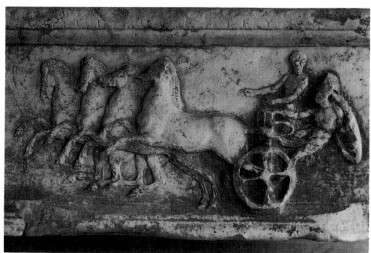

area of the Agora. Opposite them, on the right of the road, lay the Altar of the Twelve Gods, founded in 522/1 BC and marking the start of the race-course (*dromos*) stretch of the Panathenaic Way. We are not told that the procession visited the heroes or the altar, but this would be the normal procedure for such a procession in Greece, and in the fourth century BC Xenophon, presenting an ideal cavalier procession in Athens, says that it 'would be pleasing to the gods and spectators if they made a circuit of those with shrines and statues in the Agora, starting from the herms, honouring the gods,' ending with a cavalry charge by tribes across the Agora to the Eleusinion. This building marked the end of the *dromos*, where the going got too steep and rocky for horses and chariots, and where the ship-car with the *peplos*-sail was also garaged.

That the exercise of jumping on and off chariots, by the *apobatai*, also took place here is suggested by the discovery of a votive relief showing the activity near the Panathenaic Way at the south-east corner of the Agora. There are three or four deposits of offerings in the Agora marking cult at old graves, one of them close beside the Panathenaic Way and not far from the Altar of the Twelve Gods, where the offerings included clay chariot groups. The excavator (Professor Thompson) suggested that these hero cults explain the equestrian exercises in the Agora during the Panathenaea.

224

5 THE ARCHITECTURE

Our knowledge of the architecture of the Parthenon only really falters when we try to envisage details of its interior. Much of the outer colonnades and walls still stand and the rest can be confidently restored, but the requirements of its Orthodox, Catholic and Moslem occupiers have stripped its interior of all but pavement traces of what once stood there. Nevertheless, we have more of this than of most Classical buildings, and before we survey what problems there are about the remains there is also the epigraphical evidence to consider, since this takes us, in a summary way, through the building stages. A marble *stele* measuring 1.6 × 1.8 × 0.2 m and inscribed in columns on all four sides, was set on the Acropolis and recorded receipts and expenditure on the Parthenon. From the fragments that survive we can determine much of the year-by-year progress, of which I here give a summary, with comment:

447/6 BC – for the cutting, carriage and dragging of stone (to the Acropolis); a recurrent expenditure each year.

444/3 BC – for pine-wood (scaffolding, or to be seasoned for roof timbers).

442/1 BC – mention of columns and timbering (by now, the roof).

440/39 BC – mention of doorways (there is a separate account of 438 for cypress wood for doors).

439/8 BC – for purchase of ivory and payment to workers in gold and silver (not for the Parthenos, separately accounted, but for other fittings, perhaps on doors or possibly the statue base); mention of column fluting(?).

438/7 BC – first mention of stone for pediments (the cult statue was dedicated in this year).

437–2 BC – quarrying continues throughout but surplus gear is sold and surplus gold and ivory (presumably from the cult statue), to be credited to the account.

The last account is for 433/2 BC.

The total cost of the building (except the cult statue) is thought to have been over 500 talents. This is 30,000,000 drachmae, one drachma being roughly a day's wage. Most of the materials were free – the marble certainly – but wood had to be purchased and perhaps some metals. If the main expenditure was labour it averages out at a regular work force of at least six hundred, at quarries and on the Acropolis, with many fewer after 438 when the only major operation was the completion of the pedimental sculpture and its installation. Over 11,000 cubic metres (some 30,000 tons) of marble were used in the building.

The foundations of the 'first Parthenon', whose unfinished walls and columns were overthrown by the Persians in 480, served for the new building. This was to be slightly shorter but wider, and displaced a little to the north so that the old foundations are visible

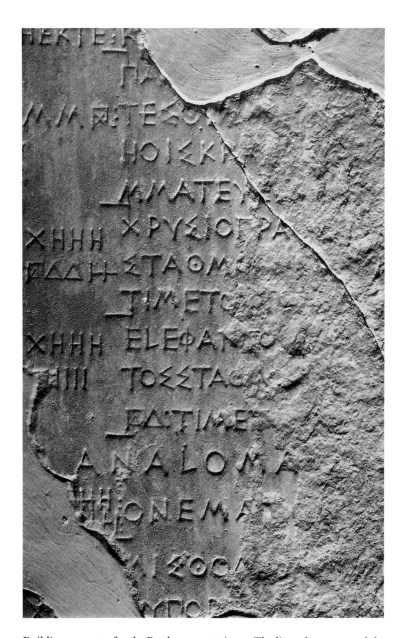

Building accounts for the Parthenon, 434/3 BC. The lines shown record the receipt of 25,000 drachmae from the treasurers, of 1,372 and 1,354 drachmae from the sale of gold and ivory (surplus from the cult statue), and the beginning of the account of expenditure

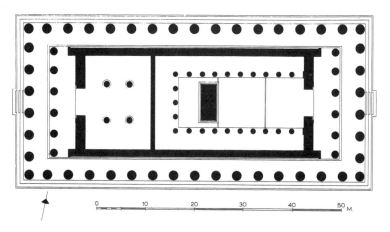

Plan of the Parthenon

intrusion of Ionic features in a Doric building was not in itself novel, though anything so ostentatious had only been seen hitherto in western Greek temples. On the Parthenon there were other, minor Ionic mouldings and, notably, the frieze. Down by the Agora the Temple of Hephaistos had been planned before the Parthenon and had allowed for a frieze across the ends of the temple porches within the colonnade. Although its sculptured friezes were only later installed, it looks like a trial run for the placing of a frieze in this position on a Doric building, where before only metopes and triglyphs stood (at Olympia, decorated with relief sculpture). The Parthenon seems to have been designed for metopes in this position too, and the frieze adopted in the course of construction, but the architectural evidence is not decisive.

It is not easy to judge how the planning and instructions for masons were managed. The conventions of construction in the Doric order were such that much could be conveyed by a written specification without large-scale, drawn plans. Thus, we can reconstruct well enough on paper a large arsenal designed for the Piraeus in the fourth century simply from the specifications preserved in an inscription. Details of mouldings and capitals would require models to follow, such as we find for the Temple of Asklepios at Epidauros in the fourth century. The observation of basic or conventional proportions at all levels of execution made

to the east and south. Many of the old column drums could be re-used, as in the six west porch columns (those at the east were new, and a little slimmer), while other undamaged drums and blocks were built into the repaired north wall of the Acropolis in a deliberately conspicuous position. Some scholars have argued that this 'first Parthenon' is post-Persian War, or that there was an intermediate plan, inspired by Cimon (with Callicrates as architect) and superseded by the Periclean plan (with Phidias and Iktinos). The answer depends on disputed interpretation of inscriptions, on the stratigraphy of the excavations of the last century (which, though excellent for their day, do not match modern standards) and on architectural and sculptural detail. I have followed the orthodox view but some aspects of the other theory cannot be altogether discounted.

The building was called the Hekatompedon, hundred-footer, borrowing the nomenclature of the old Athena temple rather than reflecting on its exact size. It measures 30.88 × 69.50 m, a proportion of exactly 4:9 which was observed for other elements in the structure. The eight columns (instead of six) on the façades were novel, and the six-column porches were set so close to the doors behind them that they were more like screens and did not define a deep, open porch as in most Doric temples. Evidence for windows in the front porch walls has only recently been identified. There had been two-tier colonnades in other temples but the Parthenon was the first to carry them round the back of the cult statue. Scraps of the Classical double colonnade survive and there are fragments from the closer-set replacement for it. The arrangements for a shallow water pool before the statue are just detectable and were alluded to by Pausanias in his description of the similar scheme introduced by Phidias in the Temple of Zeus at Olympia, for which he made the gold and ivory cult statue after the completion of the Parthenos.

The square back room of the temple occupied space which in other temples was given to a deep open porch. It was the room of the virgin goddess, the Parthenon, the name eventually given to the whole building. The interior supports for its roof required columns higher than those of porch or façade, and the more slender proportions of Ionic columns met this need. The only real evidence for them is the size of the slabs supporting their bases. This

A sectional view of the east end of the Parthenon showing the construction and placing of pediments, metopes and frieze

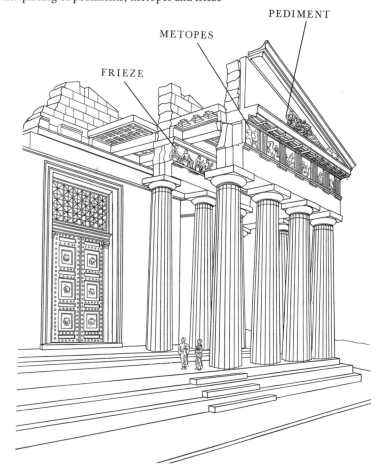

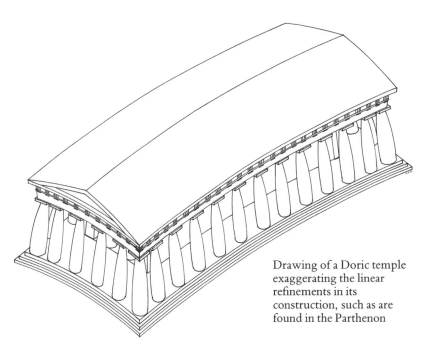

Drawing of a Doric temple exaggerating the linear refinements in its construction, such as are found in the Parthenon

ings, but the largest areas of a single colour were probably the triglyphs which, with the painted relief metopes between them, would have provided a strongly coloured band just below the painted gutter and white roof. Ceiling coffers were also highly coloured, best judged in surviving examples from the Propylaea.

The Parthenon façade was relatively broad and squat by comparison with other Classical temples, but there were very few viewpoints from which this might have been judged. From just inside the Propylaea the lower part of the building was screened by a wall limiting the area to the west of the temple and the Sanctuary of Artemis Brauronia. The first view of the whole west façade was at a distance of about forty metres from its centre and considerably

predictions of size relatively simple and much could be adjusted as work proceeded. There are many minor inconsistencies or asymmetries but overall dimensions and even refinements could be accurately foreseen and executed. The optical refinements seem to have been devised for effects which they may not necessarily have achieved. J. Coulton's drawing (above) gives an idea of the deviations from the rectilinear or perpendicular which were sought. Corner columns were made slightly plumper and the distances between columns at the corners somewhat shorter for aesthetic reasons. A corner column viewed against the sky looks different from one of the same size but with architectural backing, and a need was felt to compromise with the mathematical rhythm of the triglyphs and metopes in the upperworks, which becomes awkward at the corners where a triglyph could not be centred over the column. This may seem a more dire problem to us than it did to ancient architects.

The ancient quarries on Pentelikon can still be detected as a white scar on the mountainside, and the grooves worn by sleds and carts which brought the marble down from the quarries can be traced on the lower slopes. There is ample evidence from many temple sites for the stages of preparation of the marble blocks, in the shape of unfinished or rejected pieces. They carry evidence too to show how they were raised (lifting bosses, cuttings for pincers, etc.), while the construction of the clamps can be studied on the buildings themselves. Accounts for later buildings record the architect's duty to inspect the marble provided for construction. The Parthenon accounts mention expenditure on wood: cypress, elm and pine. Crete was famous for its cypress trees. The eleven-metre span across the inner colonnades in the temple would have called for substantial beams at least seventy centimetres square, probably of cypress rather than pine. The sockets for the longitudinal roof beams (purlins) were nearly a metre square. The ceiling coffers, like the roof tiles, were of marble.

The lowest element of colour on the building (apart from doorframes) was in the annulets cut just below the capitals. There was more paint above, and patterns on the smaller horizontal mould-

Slip-way from the quarries on the lower slopes of Mount Pentelikon

below its pavement. The altar of Athena was at the highest point on the Acropolis rock, aligned with the old temple (or rather the temple was aligned with it), and so to the north of and behind the line of the east façade of the Parthenon. We know nothing of its form in the Classical period.

Iktinos, the architect of the Parthenon, is said to have worked also at Eleusis on Demeter's Hall of Mysteries, and on the Temple of Apollo at Bassae at Arcadia, where there was another odd use of a frieze, around the interior of the cella, as well as interior Ionic columns of novel design and the earliest example of a Corinthian capital. Plutarch couples with his name that of Callicrates, for the Parthenon, but I have left the honours with Iktinos; and one Karpion is said to have collaborated with him on a book about the building. We know nothing of Iktinos' origins, but his name, like that of many artists working in Athens, seems a nickname (it is never met again) and he is unlikely to be Athenian by birth.

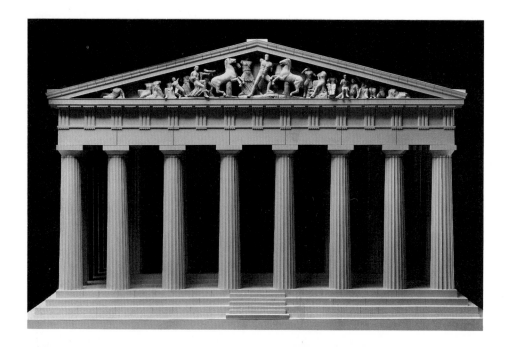

The west façade of the Parthenon with sculptures restored on the model in the Cast Gallery, Basel

A reconstruction of the first view of the Parthenon from within the Propylaea

6 THE SCULPTURES AND CULT STATUE

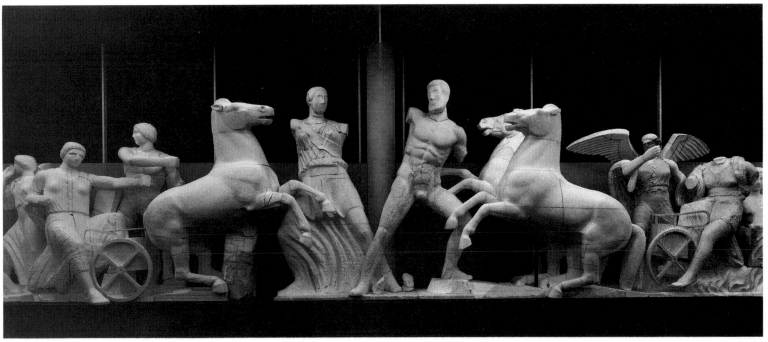

Part of the restored west pediment in the Cast Gallery, Basel, using plaster casts of original pieces, and restoring the remainder in light plastic

Despite the Parthenon's dramatic history (section 2) time has dealt relatively kindly with its marble sculptures. Yet there is still a great deal to learn about missing or fragmentary figures, and the exercise of reconciling old drawings with surviving pieces and with the evidence drawn from other arts and monuments continues apace. It has received considerable impetus in recent years from an interesting experiment conducted in the Cast Gallery of the University of Basel under the direction of Ernst Berger. Casts of all likely and certain Parthenon marbles have been assembled and carefully studied, and where possible the fragmentary figures of the pediments have been completed in a light plastic so that their poses and proportions can be properly judged. This has resolved some problems of composition and restoration, but notable difficulties remain and it is, for instance, still possible to be uncertain whether chariot teams flanked the central group of the east pediment. In this section I survey what is known or guessed about the figures and their identity (though not their broader significance, for which see the next section), and how they were made.

THE PEDIMENTS

There were probably some twenty-two major figures (or horse teams) in each of the pediments. From drawings made before the explosion of 1687 we know the general appearance of almost all at the west, of about nine at the east. From the west we have quite

large pieces of some ten figures surviving and many fragments attributable to others, and from the east a little more than the drawings show. The main figures are conveniently identified by letter. The drawings here show the reconstructions proposed in Basel (still the subject of discussion), and I have given lower-case letters to additional figures at the east for ease of reference.

In the narrative I assumed that some figures were already in place when the temple was dedicated in 438. This is probably untrue since the accounts only mention work on the pediments after 438; but the models for them could have been made earlier, and the content and probably the appearance of the pediments was surely known by 438. A life-size marble sculpture is said to take one man-year to carve 'from scratch'. The pediments might have required about seventy-five man-years, with relatively less of the work delegated to apprentices. The carving of the pediments seems to have taken six years.

West Pediment. The central group is clear, with substantial pieces of Athena with helmet and aegis (L) and Poseidon (M), no doubt armed with spear and trident respectively. Their bodies lunge away from the centre, but they are linked by their gaze and thrust. It is not certain whether an olive tree stood between them. A thunderbolt, indicating Zeus' intervention, has been suggested, and is supported by a vase scene of the dispute (in other respects unlike

The drawings are those of the reconstruction in Basel by Ernst Berger, combining extant fragments with Carrey's drawings (left plain in the West Pediment)

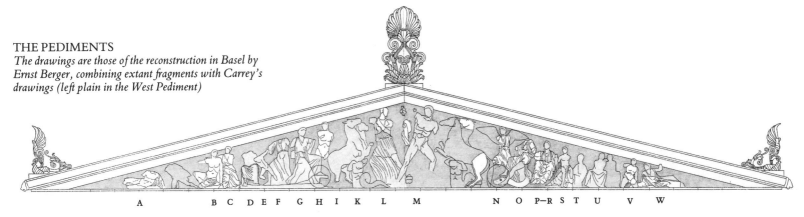

WEST

A – hero 'Ilissos'. B–F – Kekrops, his daughters and son (?). G – Nike. H – Hermes. I,K – Triton (?) supporting horses. L – Athena. M – Poseidon. N – Iris. O – Amphitrite. P,Q,R – woman with two children, Oreithyia (?). S–W – other Attic royalty or heroes.

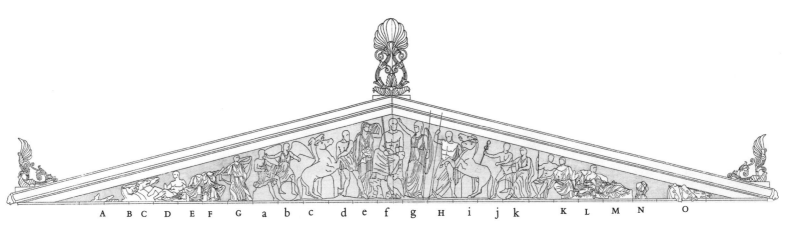

EAST

A–C – Helios (Sun) and chariot. D – Dionysos. E,F – Demeter and Kore. G – Artemis. a–c, i–k – conjectural chariot groups (Ares and Iris; Hermes and Amphitrite ?). d – Hephaistos. e – Hera. f – Zeus. g – Athena. H – Poseidon. K,L,M – Hestia, Dione, Aphrodite (?). N,O – Selene (Moon) or Nyx (Night) and chariot

the pediment, however). Poseidon's torso was copied in the Roman period for figures on the façade of a Music Hall in the Agora, and a surviving head gives some idea of the original.

Athena's charioteer is likely to be Nike/Victory (G) with Hermes (H) (pl. 22) beyond, and Poseidon's charioteer should be his consort Amphitrite (O), with Iris (pls. 23–25) beyond. Beside Amphitrite is her familiar, a sea-monster (*ketos*) whose head has recently been recognized from fragments. Drawings suggest that the horses' bellies may have been supported by Tritons. The other figures should be members of Athens' old royal family. The snake beside (B) suggests that this is Kekrops, with his daughter, then, to his left (pl. 1). The woman with two children (P, Q, R) could be the princess Oreithyia with Kalais and Zetes. (A) (pls. 19–21) is taken for a personification of the River Ilissos on the analogy of Pausanias' identification of river deities in the pediment of the Temple of Zeus at Olympia: but he may have been wrong. A small pediment of the Roman period at Eleusis copies some of the subsidiary figures (though for a different main subject) and is of some help in reconstructing figures on the Parthenon pediment.

East Pediment. The personnel of the central group can be restored from other works showing the birth of Athena, but their poses cannot, and we shall have to rely on the identification and attribution of fragments. Zeus (f) is restored here frontal, but may

have been in profile, with the fully-grown armed Athena (g) before him. A piece of the presumed Hera (e) is preserved. Hephaistos, starting away with his axe which cleft Zeus' head, is here (d), but the torso (H) (here taken for Poseidon) has been given to Hephaistos hitherto. A Roman well-head relief in Madrid may copy a work influenced by the Parthenon pediment, though its other figures (the Three Fates) are irrelevant. The inclusion of the chariot groups (a–c, i–k) remains uncertain, but there are scraps from figures and horses which may go here. Other figures should be attendant deities. (D) (pls. 3, 5–8), seated on an animal skin, should be Dionysos rather than Heracles. The goddesses seated on chests (E, F) are usually taken for Demeter and Kore, and the startled (G), Artemis (pls. 2, 9–12). The fine group (K, L, M) is often taken for Hestia, Dione and her child Aphrodite in her lap (pls. 13, 14). The last is certainly a remarkably sensuous figure, especially for this date. Almost the only secure identifications are the chariot of the rising Sun Helios (A–C) and the setting Moon (Selene) or Night (Nyx) in (N, O) (pls. 4, 15–18).

The temple acroteria, decorating the corners of the roof and the gable crowns, were elaborate florals. The pediment field is 3.5 m high at the centre where the figures are twice life-size. This scale is roughly maintained for the gods at the east, down to about one and a half times life, but many of the heroes or royal figures at the west are smaller.

West pediment, figure L, Athena (British Museum and cast of joining fragment of head in the Acropolis Museum)

Head of the *ketos* sea-monster accompanying Amphitrite (west pediment, figure O)

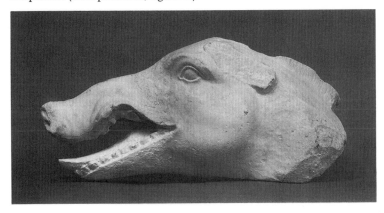

Head of a Triton from a second-century AD Music Hall in the Agora, copying the head of Poseidon (figure M) in the west pediment

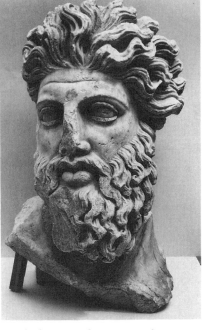

Group from a small second-century AD pediment at Eleusis copying Kekrops and daughter (figures B, C) in the west pediment (pl. 1) Height 41 cm

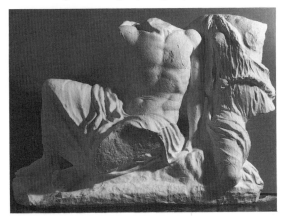

The 'Laborde' head in the Louvre. Probably an original head from one of the pedimental figures

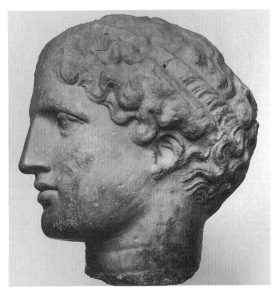

East pediment, figure N: torso of Selene/Nyx driving her chariot

Drawing on the relief of a second-century AD well-head, probably copying a fourth-century BC original, showing the Three Fates and the Birth of Athena

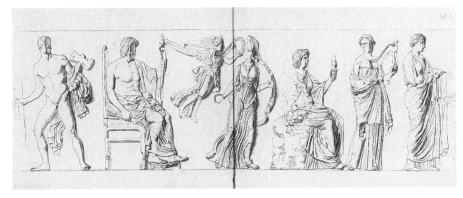

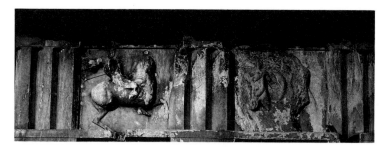

West metopes nos. 1, 2, in situ on the Parthenon

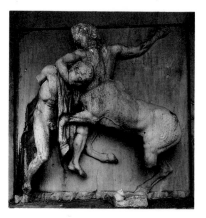

South metope no. 1, in situ on the Parthenon (youth and centaur)

THE METOPES

West Metopes. In their sadly battered state, still on the building, we recognize a mounted Amazon on 1, and then duels of Greeks and Amazons, alternately with a mounted Amazon. The honours seem roughly even. The Amazons wear Persian dress. All metopes are 1.20 m high.

North Metopes. The metopes on the building are incomplete, and there are two loose (A, D), but 32 was not damaged by the Christians. The subject is the Sack of Troy, but only a few scenes can be securely identified: 1 is probably Helios' chariot, and 29, the woman rider sinking into the waves, Selene or Nyx; these frame the action as they do in the east pediment. Men disembark on 2. (D) may show the rescue of the elderly Aithra from Troy (she was Theseus' mother, taken to Troy with Helen). On 24 Menelaos moves to attack Helen on 25, but Aphrodite, with Eros at her shoulder, intervenes to save her. On 28 Aeneas escapes from Troy with his son and father, Anchises. 30–32 are gods, presumably the pro-Greek at Troy. On 32 Athena stands before Hera or Themis.

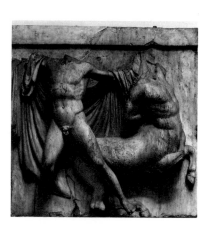

South metope no. 27 (youth and centaur)

East Metopes. These are in as bad a state as the west and north, and although the general subject of gods fighting giants is clear, identities are confused. The chariots probably go with deities, but 14, rising from the sea, may be Helios. Some of the more secure identifications are: 1, Hermes; 2, Dionysos helped by a lion and snake; 3, Ares; 4, Athena with Nike; 6, Poseidon crushing a giant with a rock; 8, Zeus; 9, Heracles; 11, Eros with Apollo; 13, Hephaistos with fire brands. With most of the surface of the figures broken away we are not helped by attributes or dress which would have made identities clear.

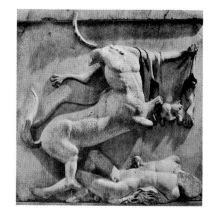

South metope no. 28 (centaur and youth)

South Metopes. The explosion which destroyed 11 and 13–25, here did more damage than the Christians. 1 is on the building, 10 in Paris, 12 in Athens, the rest in London (pls. 127–159). Luckily Carrey drew them all. 1–12 and 22–32 show Greeks fighting centaurs, or centaurs carrying off women with two other women taking refuge at an image on 21. The occasion is the wedding of Peirithoos, which the centaurs drunkenly disrupted. Some Greeks have weapons but the water jars show the domestic setting.

It is difficult to find any coherent theme in 13–20. The collapsing figure on 16 might be Icarus, with Daedalus, but several other explanations have been offered, none totally convincing. Episodes from the lives of early Attic kings and heroes (including Daedalus) are possible. There is some architectural evidence that metopes were intended over the Parthenon porches before the frieze was planned. If so, some may have been carved and eventually installed on the exterior in the least conspicuous position, here at the centre south. The porches would have accommodated ten metopes at each end of the temple, so what we have is incomplete and not necessarily in the right order, if this explanation is accepted. This may seem an easy way out of the impasse, but could be correct.

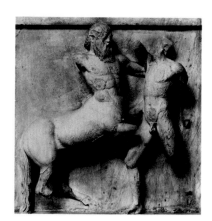

South metope no. 32 (centaur and youth)

THE WEST METOPES

GREEKS FIGHTING AMAZONS
(mounted on alternate metopes)
6–8 are unintelligible in detail.

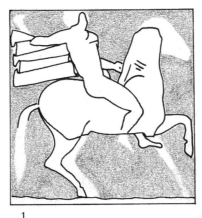

1

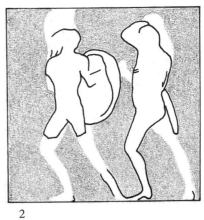

2

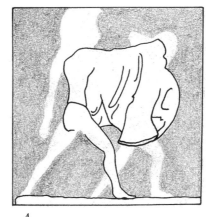

3

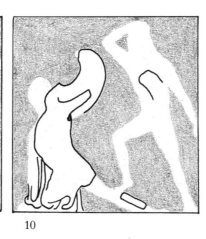

4

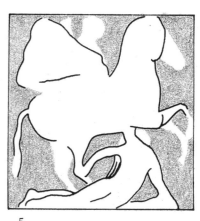

5

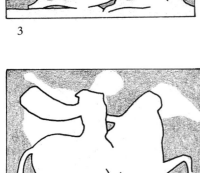

9

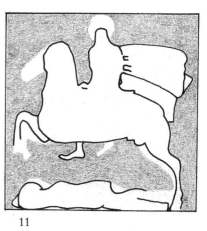

10

11

12

13

14

1

2

3

A

D

24

25

27

28

29

31

32

THE NORTH METOPES

THE SACK OF TROY

1 Helios and chariot.
2 Greeks disembark before the final attack.
3 warrior stringing bow and another.
A – man with horse.
D – Aithra rescued.
24 a Greek and Menelaos threaten.
25 Helen taking refuge at a statue
of Athena with Aphrodite before her.
27 woman and man.
28 a woman, Aeneas, Anchises and
his son escape.
29 Selene or Nyx.
31 Zeus and Iris.
32 Athena and Hera or Themis.
The other metopes are unintelligible in detail.

1

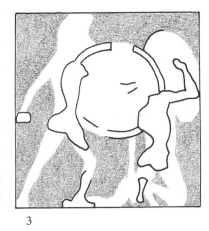

2

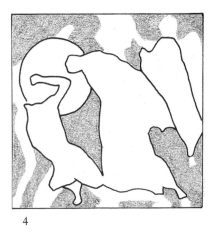

3

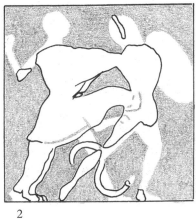

4

5

6

7

8

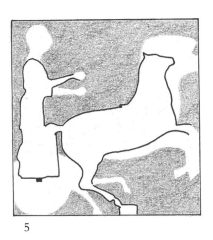

9

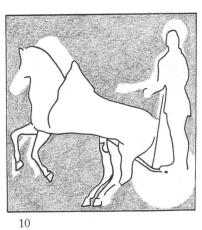

10

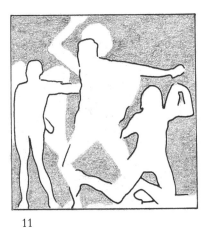

11

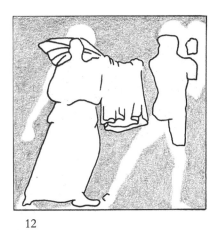

12

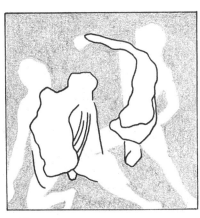

13

14

THE EAST METOPES

GODS FIGHTING GIANTS
Most identifications are highly conjectural.
1 Hermes. 2 Dionysos. 3 Ares. 4 Athena and Nike.
5 Amphitrite (?) and chariot. 6 Poseidon. 7 Hera (?) and chariot. 8 Zeus.
9 Heracles. 10 chariot. 11 Eros and Apollo.
12 Artemis (?). 13 Hephaistos. 14 Helios and chariot.

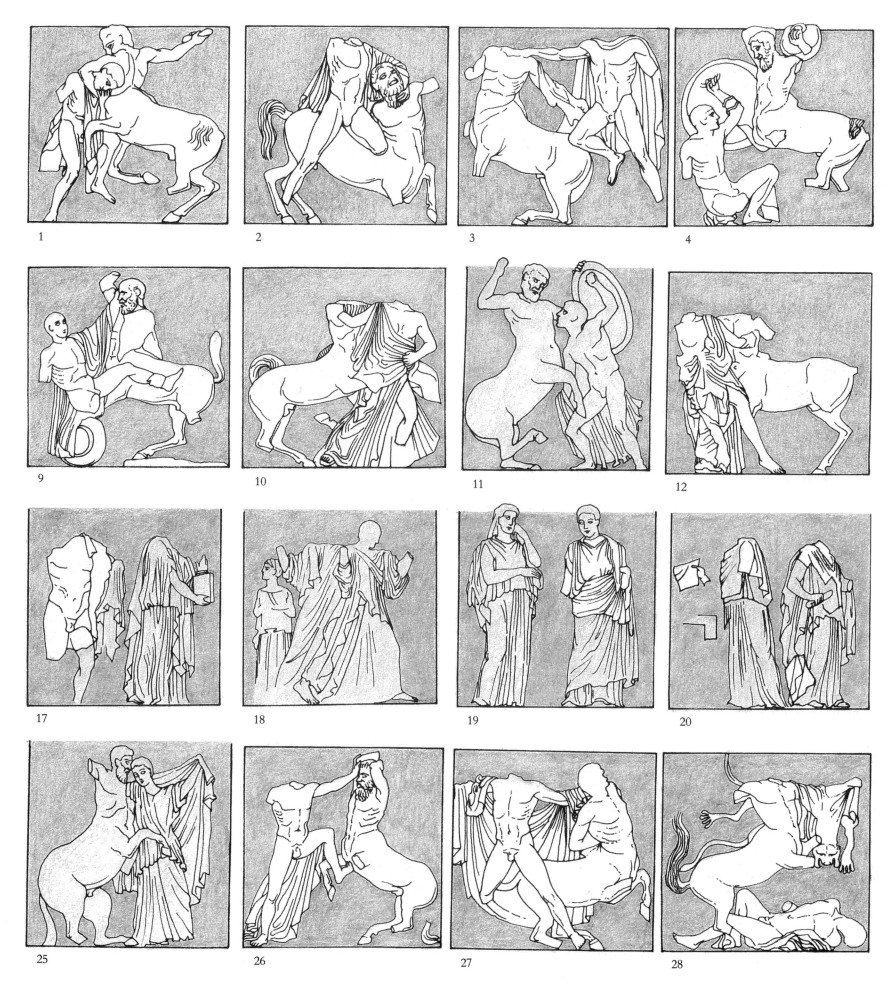

THE SOUTH METOPES GREEKS FIGHTING CENTAURS: 1–12, 21–32. The centaurs steal the Lapith girls on 10, 12, 22, 25, 29, two of whom seek sanctuary on 21.

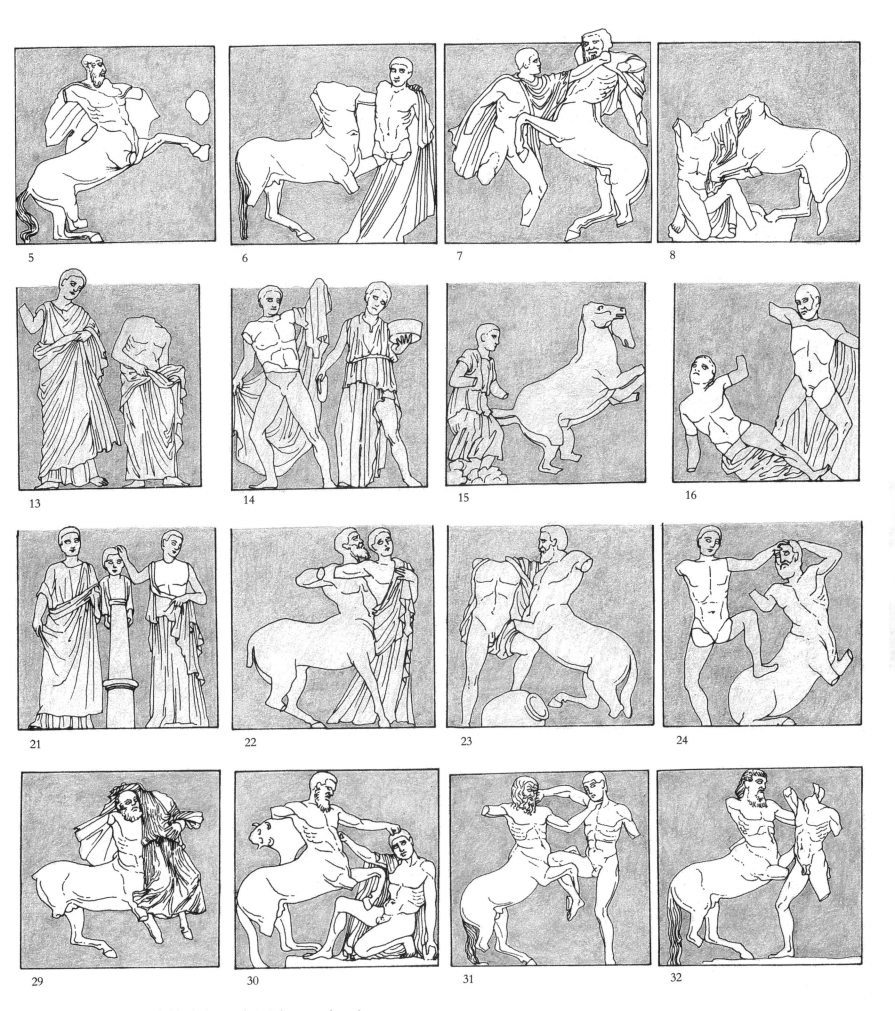

13–20 unexplained scenes, probably dealing with Attic heroes and royalty.

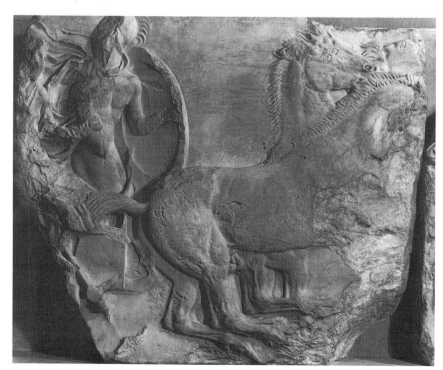

South frieze, slab XXX, figures 73, 74 (charioteer and warrior)

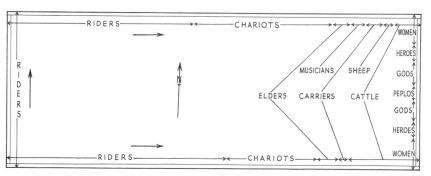

Plan of the frieze

West frieze, slab VIII, figure 15, from a cast in the Cast Gallery, Oxford. The head is now mainly destroyed

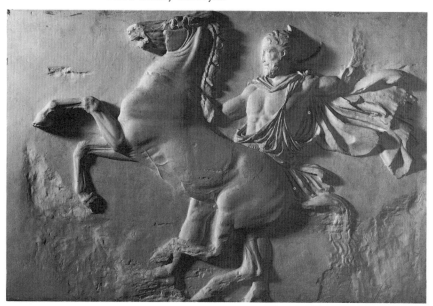

THE FRIEZE

The frieze is 160 m long, and 1 m high. The west frieze is in position on the building (pls. 114, 115, 122–126) (but for a slab at the north). Most of the rest that survives is in London, but for important parts of the north frieze (figures 3–19) and east (gods 38–40) in Athens, a slab in Paris (east 49–56) (pl. 59) and scraps elsewhere. Carrey's drawings help on north and south for some slabs destroyed in the explosion. The figures are conventionally numbered on each side. The west frieze, where the compositions fit the slabs, was probably carved on the ground, but the rest could have been carved on the building, although one imagines this would have been done only as a last resort, under pressure of time.

The composition (see the plan) starts at the south-west corner and culminates at the centre east, over the main temple door. On the west horsemen are preparing (pls. 113–126), among them a striking bearded figure (15) whose face is now broken away. Others attend to dress or harness, several have yet to mount. The mounted cavalcade proceeds on north and south (pls. 82–112; 26–31, 33). The horsemen are brilliantly portrayed in the shallow relief in overlapping ranks. There seem to be ten ranks on the north, and more clearly so on the south, where each rank is also distinguished by dress – Thracian fur hats, or broad-rimmed sun-hats, or helmets; short cloaks only, or tunics, or full armour; boots or sandals.

In front come chariots, ten on the south; ten, eleven or twelve, it seems, on the north (pls. 35, 37, 38, 40; 73–81). Each has a charioteer and warrior, variously dressed and shown leaping on or off the car except where the chariot is stationary (variations of pace are dramatic!), as well as an attendant. In cavalcade and chariot race there also appear solitary figures of marshals (pls. 71, 77, 113).

In front of the chariots the mood and progress of the procession alter significantly. North 43–28 and south 84–101 are old men; possibly the branch-bearers (*thallophoroi*) are included, but the branches are not in evidence nor are easily restored in metal or paint. North 27–20 are musicians with kitharas and pipes, and south 102–5 look like players also, but may be carrying tablets. North 19–16 carry water-jars (pl. 72), necessary for the sacrifice. North 15–13 and south 106 are tray-carriers (*skaphephoroi*). Before

238

North frieze, slab VIII, figure 27 (musician)

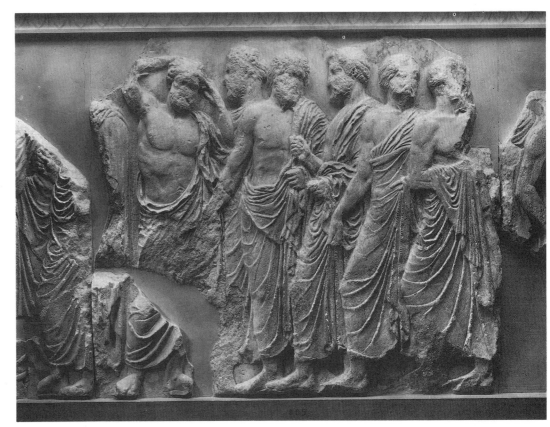

North frieze, slab X, figures 38–43 (elders)

East frieze, slab VI, figures 38–40: Poseidon, Apollo, Artemis

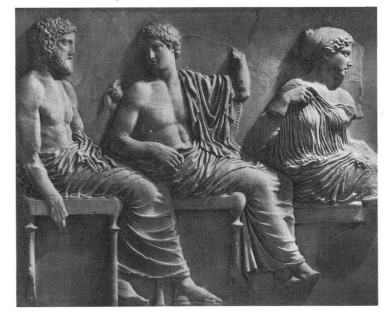

them are men with cattle for sacrifice on the south, with cattle and horned sheep on the north (pls. 32, 34, 36, 39, 41–43; 68, 69).

On the east the scheme is roughly symmetrical. From left and right women move slowly forward, many of them carrying the jugs and *phialai* necessary for libations (the figures on the Caryatid porch on the Erechtheion also carried *phialai*, as it were to greet the real procession). Some are empty-handed, perhaps the *peplos*-weavers. Two pairs (12–15) carry heavy stands, perhaps the loom-legs, and one has an incense burner (57). One marshal (49) (pl. 59) holds a dish (improbably the basket with barley and sacrificial knives, carried by girls), another (47) gestures over the central figures to the other half of the procession. 18–23 and 43–46, at slightly greater scale, are generally taken to be the ten Eponymous Heroes of the Attic tribes (pls. 49, 53, 57, 58). The gods, seated on stools except for Zeus (on a throne) were correctly identified by the Plataean, but Heracles has been suggested for 25, Hecate for 26 (pls. 45–48, 50, 54, 56). The Eros (42) is known from casts made by Fauvel and the figure is now almost totally obliterated. The gods face outwards to greet the procession, the heroes mediate between the divine and the mortal with an element of greeting as well as sacrifice in the girls with *phialai* and jugs.

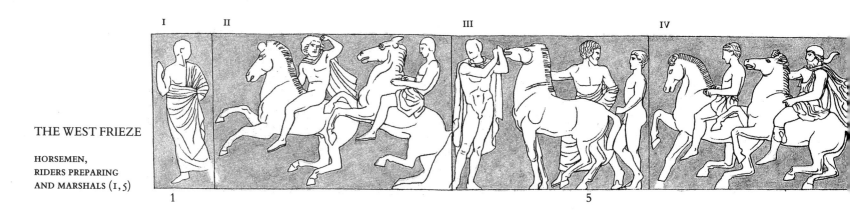

THE WEST FRIEZE

HORSEMEN,
RIDERS PREPARING
AND MARSHALS (1, 5)

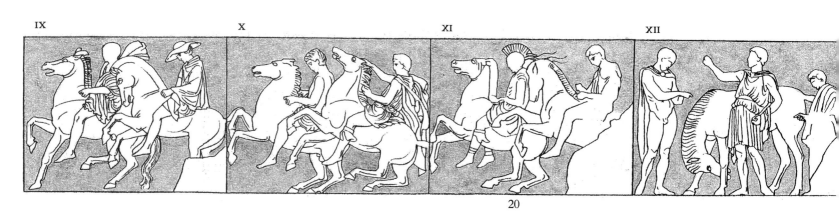

The central group (pls. 62–66), on which the gods turn their backs, comprises two girls holding stools on their heads (31, 32), one also holding a footstool; a woman, surely the priestess of Athena, helping one with a stool, and a man, surely the Royal Archon, receiving the folded *peplos* from a young girl, who must be an *arrhephoros*. She has generally been taken for a boy, but we would expect a girl: the age and dress is appropriate and she has markedly feminine Venus rings on her neck.

Rocks appear along the ground-line on all parts of the frieze, sometimes compositionally useful, as where a man braces his foot on one (west 15), otherwise lending variety, but probably not indicating location. The frieze is studded with drill holes to which would have been affixed metal harness, wreaths, spears or other accoutrements; and of course we must add colour to complete the appearance. All this would have helped the viewer pick out figures and action at the distance and angle imposed on him, and some details.

We know nothing about the payment for sculptors or their origins, but many must have been recruited from outside Athens, and once the Parthenon was finished many turned their hands to carving grave reliefs – a type of monument which had been lacking in Athens since early in the century. A few years later inscriptions tell us much about the marble sculptors working on the Erechtheion.

V VI VII VIII

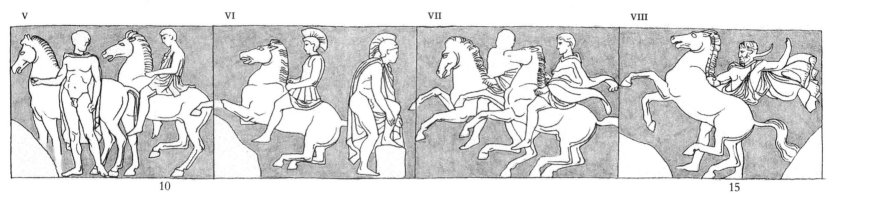

10 15

XIII XIV XV XVI

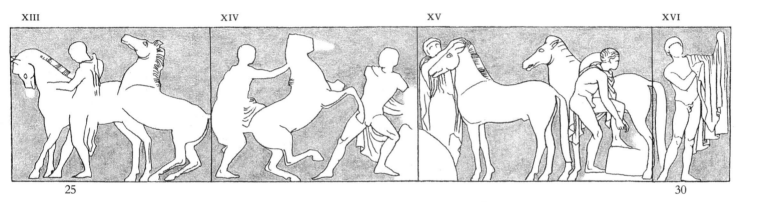

25 30

They were making figures about half a metre high, virtually in the round, to be applied to a darker stone background. The going rate for one adult figure was 60 drachmae.

The method of carving the relief figures described in the narrative, from sketches on the face of the block, is almost certainly correct. There could hardly have been any other way. The pedimental figures present a problem, however. In the Archaic period large marble figures could be carved from sketches on the block sides, since they were mainly symmetrical and were unambitious in pose, except when they were used in pediments where the single viewpoint meant that they could be treated more as major reliefs. With the fifth century's command of anatomy and realistic pose such simple methods could hardly have sufficed. When Roman workshops came to copy Greek statues they worked from plaster casts which they copied, semi-mechanically, into the marble blocks by 'pointing' major features, using a three-dimensional frame. Virtually identical means have been used to the present day, but there is no clear evidence for their use in the Classical period. In the pediment of the Temple of Zeus at Olympia there are traces on some figures of what may be evidence for some sort of pointing process, and so presumably using full-size models; but other figures have mistakes which a full-size model would have obviated. On the Parthenon figures in their present state we can see no such traces, yet I find it impossible to believe that figures of such size and subtlety of proportion, pose and detail, could have been executed except with the help of a detailed model, and that this model was at full-size. Unfinished marble figures of the Classical period show no trace of pointing and are worked from all sides, being whittled down to their ultimate shape, but these are all relatively small figures for which the pointing process would not have been needed.

The models would have been of clay, built up on wooden or metal armatures. Exactly similar techniques were required for the bronze figures of the same period, many of which were very much larger than any marbles. Moreover, it would have been quicker to translate such a model into bronze than into marble. This basic similarity of technique in preparation of major figures for either material probably explains why finished products in bronze or marble are stylistically so similar. One might otherwise have thought that the profoundly different techniques of carving (reducing a block to the desired figure) and modelling (building up a figure in clay for eventual casting in bronze) would have produced profoundly different figures. This is true through much of the Archaic period, the bronzes being noticeably more plastic, but not at all true in the Classical.

The sequence of tools employed can be judged from the marks they leave on unfinished works, or on unfinished areas. A well-protected corner of one of the pediment figures has such a finely polished surface that we should probably assume that all were as carefully finished, but perhaps not where paint was to be applied.

241

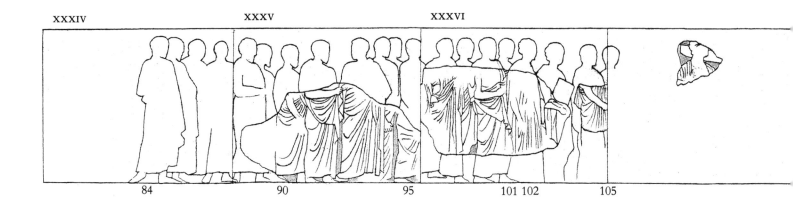

84 90 95 101 102 105

THE SOUTH FRIEZE (east end)
*Figures from Carrey's drawings
(not beyond figure 105) are outlined.*

84–101 elders
102–5 musicians
106–end men with cows for sacrifice

I II III IV

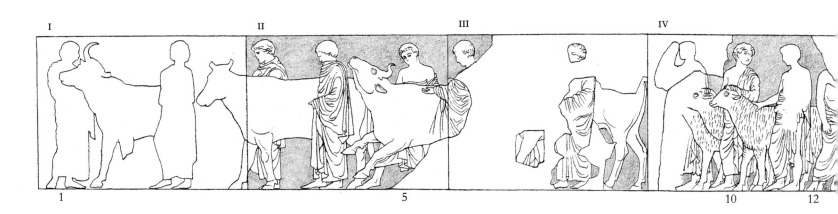

1 5 10 12

VI VII VIII IX

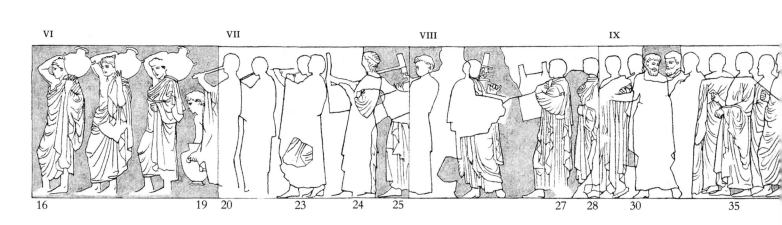

16 19 20 23 24 25 27 28 30 35

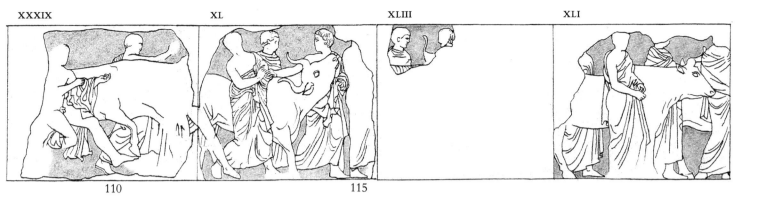

XXXIX XL XLIII XLI

110 115

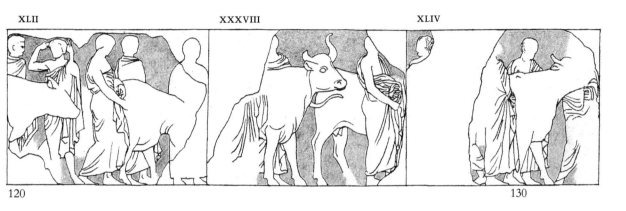

XLII XXXVIII XLIV

120 130

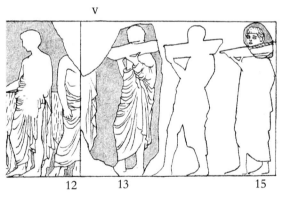

V

12 13 15

THE NORTH FRIEZE (east end)
Figures from Carrey's drawings are outlined.
Described from the back to the front of the
procession, as with the south frieze.

43–28 elders
27–24 musicians with lyres
23–20 pipers
19–16 water-jar carriers
15–13 tray carriers
12–1 men with sheep and cows for sacrifice

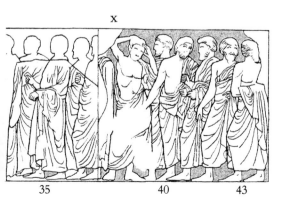

X

35 40 43

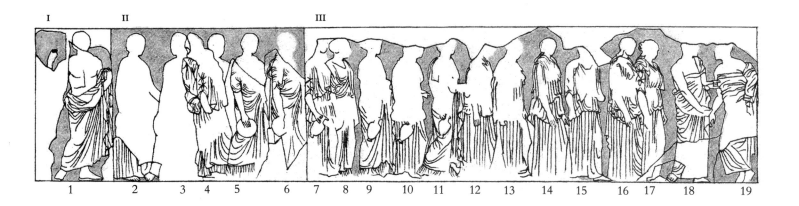

I II III

1 2 3 4 5 6 7 8 9 10 11 12 13 14 15 16 17 18 19

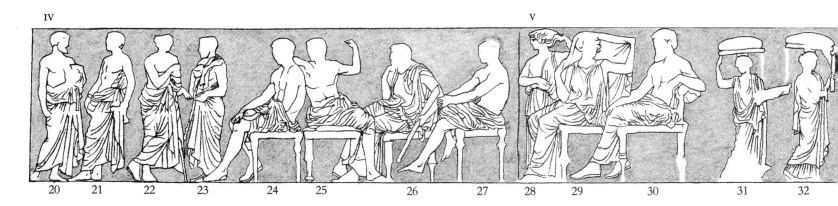

IV V

20 21 22 23 24 25 26 27 28 29 30 31 32

THE EAST FRIEZE

MORTALS AND HEROES
1 marshal
2–11 women with jugs and *phialai*
12–15 two pairs of women carry loom-legs (?)
16–17 women (weavers?)
18–23, 43–46 ten Attic Eponymous Heroes
47–49, 52 marshals
50, 51, 53–57 women (55 with phiale, 57 with incense-burner)
58–63 women with jugs and *phialai*

GODS
24 Hermes. 25 Dionysos. 26 Demeter.
27 Ares. 28 Nike. 29 Hera.
30 Zeus. 36 Athena. 37 Hephaistos.
38 Poseidon. 39 Apollo. 40 Artemis.
41 Aphrodite. 42 Eros.

CENTRE SLAB
31, 32 girls with stools
33 priestess of Athena
34 Archon Basileus
35 girl with *peplos*

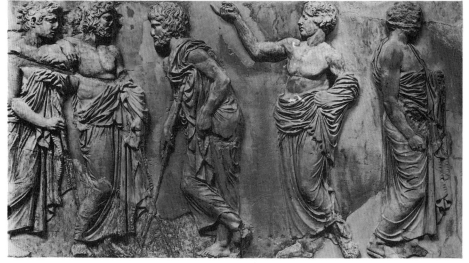

East frieze, slab VI, figures 44–48: three heroes and two marshals. From an early cast. Elgin did not take the slab and the figures are now mainly battered or dispersed

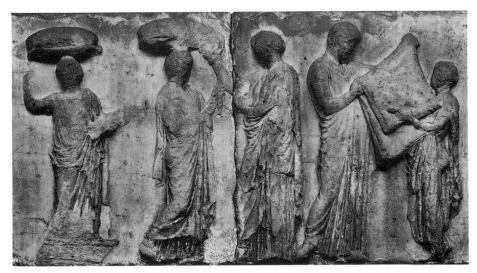

East frieze, slab v, figures 31–35: two stool-carriers, priestess of Athena, Archon Basileus, *arrhephoros* with *peplos*

VI

32 33 34 35 36 37 38 39 40 41 42 43 44 45 46

VII VIII

46 47 48 49 50 51 52 53 54 55 56 57 58 59 60 61 62 63

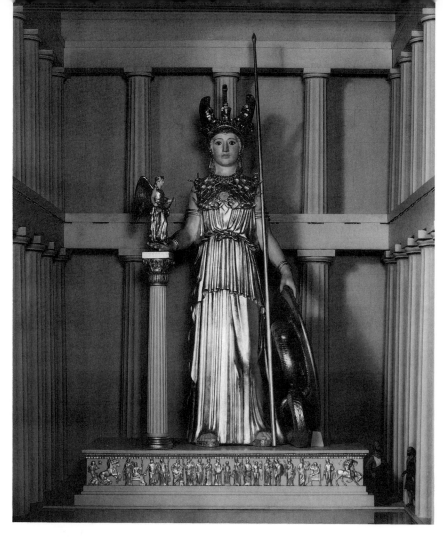

Reconstruction model of the Athena Parthenos within the Parthenon

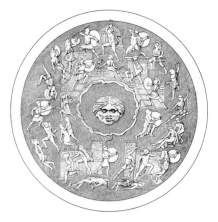

Reconstruction of the shield of the
Athena Parthenos by E. B. Harrison

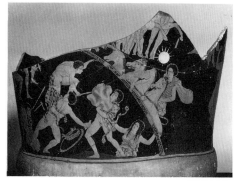

Athenian vase of about 400 BC
showing the battle of gods and giants

THE CULT STATUE

The Athena Parthenos, of gold and ivory, is lost, but texts, copies and finds at Olympia lead us to a close knowledge of her appearance and technique. Pausanias says that her helmet had a sphinx on it and griffins at each side, that there was an ivory Medusa head (on an aegis) on her breast, a Victory in her hand, a spear, a shield and snake at her side, and on the base a representation of the birth of Pandora. This, Pliny says, was attended by twenty gods, and he adds that the fight of Lapiths and centaurs appeared on her sandals and that her height was 26 cubits (about 11.5 m). He also describes her shield, with an Amazonomachy on the outside, a gigantomachy inside. There are several reduced

copies in marble which give the appearance of the whole statue, and several renderings of the head alone in jewellery or gems. For the exterior of the shield, where the figures were in relief, there are several fragmentary copies, some of which economize in the number of figures shown, and life-size copies of duels were made in rectangular reliefs, some of which were recovered from a Piraeus shipwreck. One or two of these carry architectural details which may have been engraved on the shield (the figures were perhaps appliqué gilt bronze) and which appear on the reconstruction drawing shown here. This accommodates, in what must be approximately the correct positions, all the known figures and groups involved. We do not know the gigantomachy on the inside of the shield (probably engraved or painted), except for some shadowy figures painted on the reverse of one of the copies of the shield. The scene on a vase fragment in Athens of about 400, with the giants in a central segment, the gods attacking from outside it, may remotely reflect the scheme on the shield. Notice Helios' chariot rising, as on the Parthenon (east pediment, north and east metopes). There are hopelessly reduced and incomplete versions of the Birth of Pandora on the bases of two copies of the whole statue; nothing of the sandal centauromachy.

Phidias' workshop for the chryselephantine Zeus at Olympia has been excavated and tells us something about the technique for such figures, though Phidias may by then have profited from his experience with the Parthenos, which is earlier. Fired clay 'moulds' for the gold drapery were found, and bone implements for working gold sheets, a goldsmith's hammer, and moulds and wasters for casting coloured glass inlays.

Pieces of two small *stelai* from the Acropolis record the buying of gold and ivory for the Parthenos, and work upon it, from 447/6 to 438 BC. Ancient writers give the weight of the gold as 40 or 44 talents (over a ton), and the cost of the whole statue is likely to have been somewhere between 700 and 1,000 talents. This is around twice that of the building itself and its marble sculptures, but with very much more spent on materials than labour. Surplus gold and ivory was sold off after 438 and credited to the building fund.

Of Phidias himself we know little. He signed his Zeus at Olympia as son of the Athenian Charmides. He was busy before the middle of the fifth century – on the group dedicated for Marathon at Delphi, and on the Athena Promachos for the Acropolis. Other bronze statues of gods made by him are mentioned by ancient sources. None has survived, unless the two Riace bronzes are from his Marathon group. If so, disparity of style between them shows that more than one designer was at work, and we hear of several talented pupils who could have worked for him. A number of stories suggest that he attracted unfavourable publicity for his position of influence and his wealth. The tale that he insinuated portraits of himself and Pericles on to the Parthenos shield is surely untrue, but may have been current in the fifth century, though some believe it to be a Hellenistic invention. He was said to have answered charges of embezzling the gold for the Parthenos by re-weighing the gold plates, which he had made removable. Some even said that he died in prison, or was killed at Olympia by his Eleian paymasters. We do not know the truth, but can well believe that any mere artist who attained such power was likely to be unpopular.

7 THE INTERPRETATION OF THE SCULPTURE

The fifth-century Athenian's views about what we call myth and its origins must have been very different from those of a twentieth-century scholar, a fact the latter often forgets but which is vital to our understanding of the Classical treatment of myth. We may attempt to disentangle different threads in the mythological tradition – folklore, disguised history, explanatory stories (*aitia*) for obscure cult practices, some of which derive from life-styles in places far removed from Classical Greece, the subconscious response to conflict of nature and culture, male and female, human and animal. In the fifth century BC it must all have seemed far simpler in the view of the Athenians, and we should recognize that a study of the fifth-century use of myth is quite different from any study of the origins of myth and its significance in other periods and places. It is of prime importance to understand how and why the stories may change, and to take a historical view of each subject, paying more attention to contemporary or earlier sources than later ones.

From Homer through the lyric poets and Pindar to the fifth-century tragedians, myths are used as parables, to point morals and to praise or blame contemporaries through the behaviour of their myth-historical ancestors. Just as the city states could be represented in story by their patrons – Athens by Athena is the obvious example – so some families, factions and perhaps even individuals could pretend to some sort of equation with heroic figures of myth, ancestors or not. Where the mythical tradition provided no ready parallel it could be enhanced or added to or even turned on its head.

Myth was the regular source of themes for architectural sculpture on Greek temples. We do not know how decisions were taken about the subject matter for the decoration of a temple, but the obscure relevance of many complexes of sculpture suggest the product of committee work, needing to reconcile many different interests – cult, political, personal, financial, the occasion for construction. The problem may not have been exactly the same for the Parthenon for two reasons. First, it was not simply a replacement temple to serve a continuing cult – since another building (the Erechtheion) was to be built for the old cult statue – but the complete re-design of an aborted project which, in some respects, must have been intended to express something other than the continuation of the Acropolis cult of Athena. Secondly, it seems to have been intimately associated with a larger programme of the rebuilding of temples in Athens and Attica, and the repetition of subjects on these temples suggests that an overall programme was in mind, even if not worked out in detail, which would apply to more than the new Acropolis temple. The most obvious exception to what we can discern as a unified programme is instructive. On the Temple of Hephaistos, overlooking the Agora, the metopes are devoted to the deeds of Heracles (nine on the ten metopes) and Theseus (eight). The scheme harks back to that on the Athenian Treasury at Delphi earlier in the century and it does not occur again in the Periclean programme. But it is clear that the Temple of Hephaistos was planned before the Parthenon, and its metopes seem from their style to have been executed before the Parthenon was begun. This may be enough both to explain the old-fashioned choice of subjects, and to highlight the different character of the new programme. Not that all was now to be novelty, since some elements had appeared already in Athens in the murals of the Painted Stoa, with subjects that appear on the Parthenon (Amazonomachy, Sack of Troy) and that seem strongly associated with the Parthenon (battle of Marathon).

Three closely linked themes seem to dictate the subjects for sculpture in the Periclean programme: the glorification of Athens through her goddess Athena; the successes of Greece against the barbarian Persians, and especially of Athens at Marathon; Athens' leadership of Greece. They are unusual for temple planning, and not surprisingly they evoke unusual treatment of old and new subjects. But we have no direct literary evidence for the associations suggested here (though most of them are acceptable to most scholars), partly because the right texts have not survived, and partly because the instinctive and obvious did not require explanation (however earnestly we might crave it). Pericles' funeral oration, placed by Thucydides on his lips soon after the completion of the Parthenon and in the opening years of the Peloponnesian War, well describes an Athenian's view of his city's role as leader and inspiration of Greece.

I take the major themes or figures in order, from Olympian to mortal.

THE OLYMPIAN GODS

We have already noted Athens' special role in establishing worship of the Olympians as a family rather than as individuals, in the foundation of the Altar of the Twelve Gods at the end of the sixth century BC. Their family life and relationships are essentially a poetic confection, based on a variety of mainly independent functions, cults and tales. They appear as a family in Greek art for Olympian occasions, such as the Birth of Athena, which is their role in the east pediment of the Parthenon; or to welcome a newcomer such as Heracles or Dionysos; or to fight side by side against the giants, as on the Parthenon east metopes and within the Parthenos shield. In sixth-century Athenian art they also appear as a family group, sometimes centring on Athena and the newcomer Heracles. Their unity had progressed from poetry into art and cult, at least in Athens. This is not true elsewhere in Greece until much later. Their appearance in Athens all together on a temple is unique, especially when they are seen no less than four times from its eastern aspect (pediment, metopes, frieze, statue base). In the pediment they focus on the new-born Athena; in the metopes Athena is prominent in the fight with giants; in the frieze she has also a prominent place at an occasion devoted to her worship; and her role on the statue base was probably important, bestowing weaving skills on Pandora. But the presence of all the Olympians in these scenes can only be read as a very special compliment both to her and to her city. Individually all the gods were worshipped in

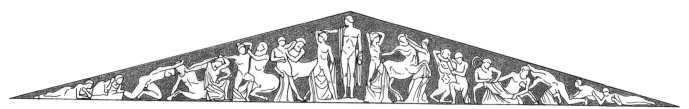

Drawing of the west pediment of the Temple of Zeus at Olympia, 450s BC.

Athens, but not all on the Acropolis and with vastly differing status, so their appearance on the Parthenon goes beyond the prompting of cult.

The fight between Athena and Poseidon for Attica, shown in the west pediment, is first attested here, and it is possible that it was first elaborated or even conceived for this occasion. Poseidon was worshipped on the Acropolis and is occasionally associated with Athena, peacefully, in earlier Athenian art, but there is precious little to show for his cult on the Acropolis in the Classical period.

A selection of gods also appears in the north metopes, attending the adjacent Trojan scenes, as they do on the Siphnian Treasury at Delphi in the sixth century; again, a very poetic conception.

HEROES AND KINGS

Heracles, as protégé of Athena, seems to have enjoyed especial favour in sixth-century Athens. The evidence is largely icono-graphical, including his appearance on several temples, but it is overwhelming, and new or adjusted stories can be seen to reflect political or military events, or changes in cult. The new democracy adopts Theseus and invents a cycle of stories to establish him more clearly as an Athenian prince and as a fitting rival or partner to Heracles. Thus, they share the honours on the Athenian Treasury, dedicated at Delphi to celebrate Marathon, and on the pre-Parthenon metopes of the Temple of Hephaistos. Theseus is prominent in new wall paintings in pre-Parthenon, Cimonian Athens, on Athens-inspired temples (at Eretria and on Keos), in groups on the Acropolis and in literature. By the time of Euripides he could be thought to have favoured or patronized Heracles in Attica rather than vice versa. However, the exploits of the heroes have no serious part to play on the Periclean buildings, except for an acroterial group with Theseus on the Stoa of Zeus in the Agora. Heracles has a continuing role in the gigantomachy and must have been a prominent and identifiable figure. Theseus had a role in both Amazonomachy and centauromachy, but we get the impression that the emphasis is less on his prowess than on the corporate effects of the efforts of his companions. This is why he is never as readily identifiable in these scenes as Heracles is in his, either on vases or in sculpture.

Instead, the local heroes and kings of Athens are accorded more prominent positions in Athenian cult and iconography. They fight beside Theseus in the Amazonomachy; they, and their families, occupy the position in the west pediment of the Parthenon – watching Athena and Poseidon – that is held by the Olympian gods in the east pediment. The ten who gave their names to the new tribes were worshipped in the market-place, and stood before the Olympians themselves on the Parthenon frieze. And they may well have been involved in whatever lies behind the mysterious metopes of the centre south side. This is a significant shift of emphasis, favouring the local heroes and kings where we might otherwise look for Olympians or individual heroes such as Heracles or Theseus.

GIGANTOMACHY

The gods fought the giants, children of earth (Ge), but their victory depended on the participation of a mortal hero, Heracles. The story was often, perhaps always, woven on Athena's *peplos* and is displayed in detail on vases dedicated on the Acropolis from the 560s on, when the Panathenaea were reorganized. It is a pan-Hellenic story, but given Athenian relevance through the role of Heracles and his warrior-goddess patron, and perhaps by some measure of translation of the location of the battle from Pallene in north Greece, to Pallene in Attica (where Theseus too is allowed to fight giants, on the road to Marathon). The giants are at first shown as hoplite warriors, but by the Classical period have become wild men, wearing animal skins and using rocks and torches as weapons.

AMAZONOMACHY

In the sixth century the only Amazonomachy is Heracles', leading an army against the Anatolian woman-warriors who are shown as hoplites or, late in the century, also as Scythians, as a compliment to their skills as archers. Theseus, a womanizer, stole the Amazon queen Antiope, but this is a different story, until he is allowed to join Heracles' expedition. This is attested in later sources, but may be alluded to on the Athenian Treasury at Delphi and seems to have been invented to mirror the Athenian part in the Ionian revolt, and their incursion into Asia Minor and burning of Sardis in 499. The sequel in fact was the Persian invasion of Attica, in myth the Amazons' invasion of Attica thrown back by Theseus, and it is this Amazonomachy that is shown in fifth-century Athens, with the Amazons eventually dressed as Persians.

Fourth-century Attic orators, dwelling on Athena's early ex-ploits, especially mention Marathon, the repulse of the Amazons, the repulse of the Thracians under Eumolpos (a son of Poseidon, defeated by the first Attic king Erechtheus: the battle may be shown, watched by gods, on a frieze on the Temple of Hephaistos), and the saving of Heracles' children by defeating Eurystheus at Pallene.

CENTAUROMACHY

The centaurs were wild men of Thessaly, who came to be depicted as half man/half horse. Their drunken attacks on the lady guests and bride at the wedding of the Lapith prince Peirithoos were repelled with the help of the groom's friend Theseus. The story had long been popular but Theseus not prominent in it, even in Athens. In the west pediment of the Temple of Zeus at Olympia the contest is umpired by Apollo, which seems to suggest a demonstration by the son of Zeus of the rule of law over disorder and hubris. Its repeated occurrence in Periclean Athens suggests that it may also have carried connotations about the conduct of northern Greeks, such as the Thessalians, who collaborated with the Persians, as well as the more general message about the fate of unruly outsiders

Athenian cup of about 460 BC showing the adornment of Anesidora by Athena and Hephaistos

Athenian vase of about 460 BC showing Pandora attended by Olympian gods; from the left, Zeus, Poseidon, Athena, Pandora, Ares

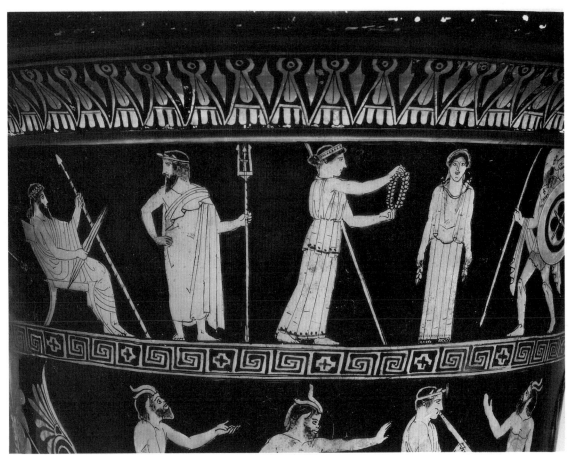

when faced by civilized Greeks defending their homes and women (and led by an Athenian). Peirithoos had also helped Theseus in his abduction of Antiope the Amazon, and they had abducted Helen while she was still a school-girl, and eventually went after Persephone, for which they were both stuck (literally) in Hades.

THE SACK OF TROY

The Trojan War was the obvious myth-historical parallel for any major conflict: Euripides used it to parallel the Peloponnesian War. Its appeal, apart from Homer's inspiring treatment of the wrath of Achilles, lay no little in its ambivalence. The Trojans of the story and in art were easterners (like Persians) but behaved like Greeks, with Greek gods, and generally with better manners than the Greeks opposed to them. The gods, through Paris' rape of Helen which had been contrived by Aphrodite as a reward for his Judgment, were responsible for the Trojans' downfall. The Trojans behaved heroically while, at the Sack, the Greeks behaved with ruthlessness and sacrilege. There were ways in which it might have seemed possible to equate the Sack of Troy with the sack of innocent Athens, but the equation was obviously incomplete, and this was a story too well established to be tampered with in the interests of Athens. The unusual attitude of the Greeks to the Troy story is apparent in their literature, and representations of it could convey the same message. It is interesting to notice how the gods' role, both in council and on the battlefield, is played upon both in literature (from Homer on) and in art (their presence on the north metopes of the Parthenon).

PANDORA

On an Athenian vase of about 460 BC, Pandora, called Anesidora (the same meaning – 'all-giver'), is dressed by Athena and crowned by Hephaistos. On a slightly later vase, still pre-Parthenon, she (unnamed) is crowned by Athena while six other Olympians attend. And on another vase, Epimetheus, Prometheus' brother, releases her from the ground in the presence of Zeus and Hermes, with a little Eros indicating the Epimetheus-Pandora association. There is no hint in these scenes of the dire effect of her arrival among mankind, as in Hesiod's story. We have simply her creation and bedecking by Olympian deities, and her reception by Epimetheus. Given the role of the Olympians elsewhere on the temple, it is difficult to see how they could be portrayed on the statue base as intent on equipping Pandora with powers which

would confound mankind. It was surely a demonstration of pure beneficence, Athena's gift of weaving carrying a hint of the sacred *peplos*, and Hephaistos' role reflecting his role with Athena in Athens. A late source has a Pandora as daughter of Erechtheus, and sacrificing herself for Athens on the occasion of the fight with Eumolpos (see above); Erechtheus was 'son' of Athena and Hephaistos: suspicious coincidences.

GODS AND MORTALS: THE PARTHENON FRIEZE

There is general agreement that the frieze represents the Panathenaic procession, but when and at what stage or stages, and why, is a subject for dispute. Scholars readily dismiss the theories of others on this matter as over-complicated or obscure, in all ways inferior to their own obscure and over-complicated suggestions. None are immune, and the arguments unfortunately serve mainly to conceal the considerable common ground.

The safe view is that it is a generic statement of the procession, with mortal Athenians. Mortal themes are not admissible on Classical temples, however, except for battle scenes which have heroic implications, and then only on the later temple of Athena Nike on the Acropolis itself. The overall scheme may resemble a great votive relief, with a procession to the honoured deity, but these are not naturally incorporated in the structure of a temple, and here it is not the temple goddess who is approached, but all the Olympians, including Athena. Minor discrepancies with the tradition (mainly later, see section 4) about the festival may be ignorable, like the men rather than girls carrying waterjars, but the major omission – of the hoplite soldiers – is inexplicable if this is an ordinary procession (there was plenty of room for them), and so is the unexpected emphasis on riders and chariots. These require explanation.

The notion that the scene is of the first Panathenaea has its attractions, but is countered by the presence of the ten Eponymous Heroes of the new democratic tribes rather than the four of the old tribes. The four tribes still had some significance in cult practice, and the only foursomes on the frieze appear with the mortal attendants of the procession. But the ten are represented by the heroes themselves (east, figures 18–23, 43–46) and the grouping of the riders. The event, generic, real or in-between, is recent and democratic.

Other arguments tend to divide the frieze, in time and place. That the north frieze is for Pandrosos, a minor deity of the Acropolis and daughter of Kekrops, gives her a prominence, indeed priority (since the west frieze goes with the north), unwarranted by any Classical source. We hear that worshippers should give her a ewe when Athena gets a cow but this need not apply to the Panathenaea and we hear little enough of her otherwise. Sheep were appropriate offerings to Athena too. A marshal (east 47), by his gesture, links the two halves of the procession.

Some see the *peplos* scene on the east (figures 31–35) as taking place on the Acropolis, and perhaps showing the old *peplos* being put away (an odd choice of subject in the circumstances). But the cavalcade and chariots have to be in the market-place, and some even place the horse events elsewhere and on a different day. All this diversity does little credit, it seems to me, to the designer of the frieze. We look for unities in Classical art and literature, and the juxtaposition of related events which took place in a short span of time and a restricted area, such as was understood by Pamphilos and his friend in our narrative, answers this expectation. Classical artists composed their narrative by choice of moments or groups of significant action. To choose the opening stages of the procession, in the Agora, was characteristically brilliant. It presents the *peplos* theme, which is the raison d'être for the procession; the honours paid to the gods and heroes en route; and not least the honour paid by the gods and heroes to the procession itself in their reception of it. The Agora too provides the explanation for the choice of riders and chariots to demonstrate the heroic character of the mortals, destined for immortality, and chosen to represent Athens in the marble procession. They are not on their way to Marathon (fought on foot), but on their way to their goddess, and the iconographic scheme of the reception by the Olympians mirrors closely that of earlier art where the Olympians receive others promoted to their company – Heracles or Dionysos. Omitting the charioteers, who are 'props' to the chariot exercises, like the horses, we find that the number of males in the whole cavalcade hovers around 192, the number of the dead at Marathon. The frieze is incomplete and calculations will differ, though only slightly, and the coincidence is at any rate quite remarkable. No matter that few would bother to count them. We do not have to count the stars and stripes on the American flag to know their meaning. There are other indications on the frieze that numbers of figures were calculated and significant.

The connection with Marathon is everywhere: the proximity in date between the Great Panathenaea of 490 and the battle, which seems reflected in the posthumous dedication on the Acropolis for the Athenian commander, Kallimachos, who fell at Marathon; the re-used foundations for the temple; the prayer for the Plataeans; all we know of Athens' regard for the immortal character of her Marathon fighters and their role as founders of Athenian leadership in Greece. Thucydides speaks for Pericles: 'The whole earth is the sepulchre of famous men; not only are they commemorated by columns and inscriptions in their own city, but in foreign lands there dwells also an unwritten memorial of them, graven not on stone but in the hearts of men.' But Phidias and Pericles had immortalized them also in bronze and marble, and let them share with Athena herself a part of the honour which they thought due to their goddess from her Olympian kin and from all Greeks. And in another speech of Pericles, recorded by Plutarch from a fifth-century source, we read the view of the Athenians very well. Pericles was speaking over those who had fallen in operations against Samos in 440: he declared that these men had become immortal like the gods, 'for we cannot see the gods,' he said, 'but we believe them to be immortal from the honours we pay them and the blessings we receive from them, and so it is with those who have given their lives for their city.'

Many scholars have observed that the Parthenon is a temple without a cult. This is probably true, but it is still Athena's house because her image is within it, and if its purpose is not to receive worship and sacrifice, it must be something else – probably something to do with the circumstances in which it was created. The answer must lie in its decoration.

In the first part of this book I have attempted to express what I believe the Parthenon meant to an Athenian who saw it being built, and what its significance might have been to other Greek observers. It depends on what we know of the period from its literature and art, and what we can deduce about the likely responses of its people to the stimuli of images in any medium. The Parthenon's significance to us, as marking a stage in the development of Greek religion, of civic consciousness, of the exploitation of myth for propaganda, and of artistic technique, is a very different matter. The modern approach is more complicated: over-complicated, one might say, in the way it tends to place in competition assessments of society, or religion, or politics, or economics. The more we subdivide our approaches to antiquity the more we distance ourselves from a culture in which these distinctions between considerations of kin, law, patriotism, cult and profit are at best blurred, at worst meaningless. An interdisciplinary approach, looking to the evidence of other cultures, should come after an internal interdisciplinary approach which gives proper attention to all primary evidence available. We understand symbolism in Greek art (and 'symbolism' is probably the wrong word) by looking at all aspects of Greek life first, then at how we believe other cultures to have responded, even, as a last resort, our own.

The message of the Parthenon was an immediate one for the fifth-century Athenian. Apart from its glorious cult statue and the effect of its sheer presence, its message remained significant for as long as the events it celebrated remained significant. So long as Persia remained a power in Greek politics and life the message remained clear. Alexander and his successors could recall it in their dedications for later victories over easterners, but once Greece became a Roman province Athens was regarded as the still honourable seat of an old and respected culture rather than the champion of Greece against the barbarian, and by Pausanias' day the Parthenon's sculptures were simply illustrations of myth and the frieze was unremarkable, its significance forgotten, and therefore ignored.

We cannot easily chart this decline. Within a century of the completion of the Parthenon the philosopher Plato, who was critical of the deceptive realism of the art it displays so well, could use images derived from its decoration to illustrate points in his arguments – the most sophisticated of ancient applications of myth and art.

The effect of the Parthenon sculpture on contemporary and later arts is easy to misjudge. What has survived must represent a minor part of even the marble architectural sculpture of the Classical period. We lack most of that from other Classical temples in Athens and Attica, except from the Temple of Hephaistos, and we have lost virtually all the bronzes and a very high proportion of the major products in other media, including all wall and panel paintings. We probably have barely one per cent even of that humble but informative craft, vase-painting, and this we owe in large measure to the happy coincidence of the Greek export trade to Italy and the conditions of burial in Etruscan tombs which preserve

the vases so well. It is easy to overestimate the Parthenon's importance in this respect, even to declare that individual figures on its nearly invisible frieze were responsible, in detail, for the appearance of comparable figures in contemporary and later arts. This is surely absurd, and we have no reason to believe in the circulation of models or pattern books of motifs for the instruction of artisans. Classical art exhibits none of the mechanical repetition that such behaviour encourages. The echoes of motifs or figures that we see in the marbles reflect a common stock rather than necessarily the marbles themselves. Our inability to recover from other arts the appearance of major groups, like the centre of the east pediment, is a measure of how uninfluential they were. And the absence of any images which clearly derive from the composition on the Parthenos shield should warn us against using, for instance, vase-painting to reconstruct lost works. The Athenas and Victories made in following generations owed much, no doubt, to the Promachos and Parthenos, but did not copy them. Copying begins with the Hellenistic period, in a generalized way for the Greek courts, in a mechanical way for Roman patrons. That the Parthenon frieze in some way inspired the composition on the Augustan Altar of Peace in Rome is as unlikely as that it had itself been influenced by the friezes of tribute-bearers on the buildings in the Persian capital at Persepolis. The 'influence' and 'quotation' of works of art in antiquity are phenomena that need cautious investigation and are not elucidated by comparisons between images that may own common sources but not themselves be related.

The Christians' attitude to the marbles, especially the metopes, we can judge readily from their harsh treatment of these pagan figures. Only in the nineteenth century, when the marbles were restored to that western culture which had for centuries cherished both the literary genius of Greece and the veiled view of her art offered by Roman monuments, did they begin again to bear an influential message. It was a message less well read by scholars, whose view of ancient Greece tended still to be starry-eyed, than by artists. Their knowledge and understanding of Greek art had been formed by almost anything other than original works. The Neo-classical movement of the eighteenth and early nineteenth centuries was nourished by Greek literature and Roman art, reinterpreted by the Renaissance. The arrival of the marbles in London came as a timely shock. Neo-classical artists like Flaxman and Canova acknowledged the force of the revelation, and the words of a minor artist, the historical painter Haydon, vividly describe the novelty which, in our fuller familiarity with original Greek art, we may inadequately prize.

To Park Lane then we went, and after passing through the hall and thence into an open yard, entered a damp, dirty pent-house where lay the marbles ranged within sight and reach. The first thing I fixed my eyes on was the wrist of a figure in one of the female groups, in which were visible, though in a feminine form, the radius and the ulna. I was astonished, for I had never seen them hinted at in any female wrist in the antique. I darted my eye to the elbow, and saw the outer condyle visibly affecting the shape as in

Frieze by John Henning on the entrance arch to Hyde Park, London

Phidias and the Frieze of the Parthenon
by L. Alma-Tadema

nature. I saw that the arm was in repose and the soft parts in relaxation. That combination of nature and idea, which I had felt was so much wanting for high art, was here displayed to midday conviction. My heart beat! If I had seen nothing else I had beheld sufficient to keep me to nature for the rest of my life. But when I turned to the Theseus and saw that every form was altered by action or repose – when I saw that the two sides of his back varied, one side stretched from the shoulder blade being pulled forward and the other side compressed from the shoulder blade being pushed close to the spine as he rested on his elbow with the belly flat because the bowels fell into the pelvis as he sat – and when turning to the Ilissus, I saw the belly protruded, from the figure lying on its side – and again, when in the figure of the fighting metope I saw the muscle shown under the one arm-pit in that instantaneous action of darting out, and left out in the other arm-pits because not wanted – when I saw, in fact, the most heroic style of art combined with all the essential detail of actual life, the thing was done at once and for ever. Here were principles which the common sense of the English people would understand.

This recognition that truth to nature was not incompatible with aspirations to spirituality in classicizing art should have changed the direction and quality of classicizing art dramatically. To some degree it did, but the success of the marbles in the nineteenth century was probably as much as anything the response of a country which was the seat of empire and which regarded itself as a cultural leader, to the presence of works which bore witness to a society in which the western world sought its cultural roots. The superficial effect of the marbles, and especially of the frieze, was soon apparent and still is. The Henning family, for instance, created a small industry producing miniature versions of the frieze, in plaster, mounted in bound volumes. John Henning placed his version of the frieze on the exterior of the Athenaeum in London, and he adapted it for a triumphal procession carved on the gateway at Hyde Park Corner, which gave on to that nineteenth-century expression of life viewed through myth, the bronze Achilles that celebrated the victories of Wellington. But all this is hardly more than the response of the Neo-classical tradition to a new source of inspiration, and examples can easily be multiplied.

The effect of the marbles on scholars was mixed. Some found it difficult to take them as originals at all. Others revised their views about what was Greek, and as more finds were made in Greece and Turkey (and many of them distributed to western museums) and as known works were reassessed, the marbles were able to contribute much to comprehension of the achievement, and to some degree even of the aims of the Classical artist. The archaeological problems they pose have occupied many pages in this book. The search to understand them in terms of the society for which they were made continues to present a challenge to our views about the role of politics, religion and myth in Classical Athens. Their stimulus is registered at many levels, from the scholar's puzzlement, to the public awe, before the calm majesty of these colossal nudes and draped figures. Whatever our motives, the search for truth and understanding, or the instinctive human and even sentimental response to such images, mortal or divine, the Parthenon marbles will never relinquish their hold on our imaginations.

FURTHER READING

The works mentioned here are almost all in English – books and selected articles from journals. A large proportion of the more recent literature on the Parthenon is in German, but the reader should be able to find his way to fuller discussions of almost all the topics discussed in the text from the titles listed below.

HISTORICAL BACKGROUND

A succinct and reliable account of Greek history in the Classical period is S. Hornblower, *The Greek World 479–323 B.C.* (London 1983). The confrontation with Persia is studied in some detail in A.R. Burn, *Persia and the Greeks* (revised edition, London 1984) and the history of the Athenian League in R. Meiggs, *The Athenian Empire* (Oxford 1972). There are good translations of Herodotus and Thucydides in Penguin Classics (by A. de Sélincourt and R. Warner, Harmondsworth 1954 and later) and Plutarch's Life of Pericles and other relevant biographies are published in the same series under the title *The Rise and Fall of Athens* (translated by I. Scott-Kilvert, Harmondsworth 1960).

RELIGIOUS BACKGROUND

The problems of the Acropolis cults are well explored in C.J. Herington, *Athena Parthenos and Athena Polias* (Manchester 1955). There is a good and up-to-date history of Greek religion by W. Burkert, of which an English translation will appear shortly. The Panathenaea are discussed in H.W. Parke, *Festivals of the Athenians* (London and Ithaca, N.Y. 1977) and, with special reference to the Parthenon but in an idiosyncratic way, in E. Simon, *Festivals of Attica* (Madison 1983).

THE PARTHENON: GENERAL BACKGROUND

For the history of the Acropolis and its buildings there is a good general account in R.J. Hopper, *The Acropolis* (London 1971). A special number of *Greece and Rome* (Suppl. 10, 1963), celebrating the 24th centenary of the dedication of the Parthenos and entitled *Parthenos and Parthenon* (ed. G.T.W. Hooker), contains valuable essays on the building of the Parthenon (A. Burford) and the political and religious implications (R. Meiggs, C.J. Herington), inter alia. Relevant inscriptions, including the Parthenon account illustrated here (p.225) are discussed in R. Meiggs and D.M. Lewis, *A Selection of Greek Historical Inscriptions* (Oxford 1975).

THE ARCHITECTURE

The best general study of Classical architecture, with valuable passages on the Parthenon, is still W.B. Dinsmoor, *Architecture of Ancient Greece* (London and New York 1950). J.J. Coulton's *Greek Architects at Work* (London and Woodstock, N.Y. 1977) offers insights into planning and construction. and he has an important essay on Greek temple design in *Annual of the British School at Athens* 70 (1975). J.S. Boersma, *Athenian Building Policy from 561/0*

to *405/4 B.C.* (Groningen 1970) discusses the Periclean programme and its predecessors. R. Carpenter, *The Architects of the Parthenon* (Harmondsworth 1970) presents the theory of the Cimonian Parthenon. The cost of the Parthenon is discussed by R.S. Stanier in *Journal of Hellenic Studies* 73 (1953). G.P. Stevens studied the setting of the Parthenon in *Hesperia* 5 (1936) and Suppl. 3 (1940). The publication of the Basel conference on the Parthenon, *Parthenon-Kongress Basel* (Mainz 1984) contains essays in various languages devoted to aspects of the architecture and sculpture (proportions, the windows) and a full bibliography of Parthenon studies. Recent restoration of the building is described in detail (with English summary) in M. Korre and Ch. Boura, *Melete apokatastaseos tou Parthenonos* (Athens 1983).

THE SCULPTURES

The fullest up-to-date account of the sculptures appears in the three double volumes by F. Brommer (in German) on the pediments, metopes and frieze, which appeared in 1963, 1967 and 1977. He summarizes his work in *The Sculptures of the Parthenon* (London and New York 1979). There is a valuable briefer account in B.F. Cook, *The Elgin Marbles* (London 1984) and the frieze is fully illustrated and neatly discussed in M. Robertson and A. Frantz, *The Parthenon Frieze* (London 1975). B. Ashmole, *Architect and Sculptor in Classical Greece* (London and New York 1972) offers enlightening discussion about problems of creation and interpretation. For the general art-historical background to the Parthenon see relevant chapters in M. Robertson, *A History of Greek Art* (Cambridge 1975) or his *Shorter History of Greek Art* (Cambridge 1981), and J.J. Pollitt, *Art and Experience in Classical Greece* (Cambridge 1972). The present writer's *Greek Sculpture: the Archaic Period* (London and New York 1978) and *Greek Sculpture: the Classical Period* (London and New York 1985) are student handbooks intended also for the general reader and fully illustrated. The latter includes discussion and illustration of other temple sculptures of Attica. Several papers at the Basel conference (see above, under Architecture) discuss restorations of figures and the volume is to be followed by others documenting the metopes and frieze. The work at Basel is reported in *Antike Kunst* (periodical). There is a full publication of Carrey in T. Bowie and D. Thimme, *The Carrey Drawings of the Parthenon Sculpture* (Bloomington and London 1973). The Parthenos is fully discussed in N. Leipen, *Athena Parthenos: a Reconstruction* (Toronto 1971) and for the shield see further E.B. Harrison in *American Journal of Archaeology* 85 (1981).

INTERPRETATION OF THE SCULPTURE

The Basel conference (see above, under Architecture) offered several studies in the interpretation both of figures and of the general complex. The line adopted by the present writer was expressed by him in *Festschrift F. Brommer* (Mainz 1977) and at

Basel. Of other views few have been argued for the English reader but see Simon (above, under Religious Background). On the development of the Amazonomachy theme see the present writer in *The Eye of Greece* (Studies M. Robertson, Cambridge 1982). The gods on the east frieze and their identities have been often discussed, most recently by I. Mark in *Hesperia* 53 (1984). In English it is easier to find works dealing with the content of Greek mythology than explaining it: thus, H.J. Rose, *Handbook of Greek Mythology* (London 1933 and later; New York 1959) or even R. Graves, *The Greek Myths* (Harmondsworth 1955 and later) where the explanations should not be taken seriously. Study of the origins of Greek myth, its significance and application, have fragmented into series of minor essays and repetitive conferences staged by highly vociferous 'schools' (Structuralist, post-Structuralist, anti-

Structuralist). There has never been less consensus. G.S. Kirk, *The Nature of Greek Myths* (Harmondsworth and New York 1974) is useful but not art-conscious.

LATER HISTORY OF THE PARTHENON
This is discussed in most general books but a fuller account appears in J. Baelen, *La Chronique du Parthénon* (Paris 1956), and see B. Ashmole's essay, *Cyriacus of Ancona* (1957) and F.-M. Tsigakou, *The Rediscovery of Greece* (London and New York 1981). For the replaced inner colonnade, A. Frantz in *American Journal of Archaeology* 83 (1979). W. St. Clair, *Lord Elgin and the Marbles* (Oxford 1967, reissued 1983) gives a fair account of their acquisition. For their impact on Britain see also R. Jenkyns, *The Victorians and Ancient Greece* (Oxford 1980).

ACKNOWLEDGMENTS

The extract from Plutarch on page 218 is from *The Rise and Fall of Athens*, trans. Ian Scott-Kilvert (Penguin Classics 1960), pp.177–9, copyright © Ian Scott-Kilvert 1960, and is reprinted by permission of Penguin Books Ltd.

All colour and duotone plates are by David Finn, except for: colour pl.I Daniel Schwartz; pls.59, 68–72 Hirmer Verlag; pls.114, 115, 122–6 Deutsches Archäologisches Institut, Athens.

Sources of illustrations in 'The Evidence' chapter not acknowledged in the captions are as follows: p.213 (l) after Travlos, *Poleodomike Exelixis ton Athenon* (Athens 1960), fig.21; p.213 (r) photo John Boardman; p.214 from the Codex Hamiltonianus, Berlin; p.215 (clockwise from top left) photo Bibliothèque Nationale; Akademisches Kunstmuseum der Universität, Bonn; from Fanelli, *Atene Attica* (1707); after Travlos, *Pictorial Dictionary of Ancient Athens* (London 1971), fig.577; p.216 (19th-century photo) Oxford, Ashmolean Museum, Cast Gallery; p.216 (below left) London, British Museum; p.216 (r) Oxford, Ashmolean Museum, Cast Gallery, photo R.L. Wilkins; p.218 Athens, Acropolis Museum, photo Deutsches Archäologisches Institut, Athens; p.219 (above) photo Colin Cunningham; p.219 (below) photo Royal Hellenic Airforce; p.220 (l&r) photo Hirmer; p.221 (l to r) Reggio, Museo Nazionale, photo Alinari; London, British Museum; Toronto, Royal Ontario Museum; pp.222, 223 New York, Metropolitan Museum of Art, Rogers Fund 1907, 07.286.79; p.224 (below) Athens, Agora Museum S 399, photo American School of Classical Studies at Athens: Agora Excava-

tions; p.225 Athens Epigraphical Museum, *Inscriptiones Graecae* I³ no. 449, photo S. Sherwin-White; p.226 (l) after Travlos 1971, fig.564; p.226 (r) after G. Niemann; p.227 (l) after J.J. Coulton, *Greek Architects at Work* (London 1977), fig.44; p.227 (r) photo John Boardman; p.228 (above) photo D. Widmer; p.228 (below) photo American School of Classical Studies at Athens: Agora Excavations; p.229 photo D. Widmer; p.231 (clockwise from top left) photo Hirmer; photo American School of Classical Studies at Athens: Agora Excavations; photo Hirmer; photo Deutsches Archäologisches Institut, Athens; Madrid, Museo Arqueologico 2.691; Athens, National Museum 200 (cast shown here: Oxford, Ashmolean Museum, Cast Gallery, photo R.L. Wilkins); Athens, Acropolis Museum, courtesy of Professor N. Yalouris; p.232 (above left) photo Deutsches Archäologisches Institut, Athens; p.232 (right, top to bottom) photo Deutsches Archäologisches Institut, Athens; photo Hirmer; photo David Finn; photo David Finn; p.238 (above) photo Alison Frantz; p.238 (below) photo R.L. Wilkins; p.239 (above left) Athens, Acropolis Museum; p.239 (above right) photo Deutsches Archäologisches Institut, Athens; p.239 (below) Athens, Acropolis Museum; p.244 photo British Museum; p.245 photo Hirmer; p.246 (above left) after *American Journal of Archaeology* 85 (1981), 297; p.246 (above) Toronto, Royal Ontario Museum; p.246 (below right) Naples, Museo Nazionale 2883, photo Hirmer; p.249 (l) London, British Museum D4; p.249 (r) London, British Museum E467; p.252 (above) photo John Boardman; p.252 (below) City of Birmingham Museum and Art Gallery.

The maps and drawing on pp.217, 224, 236–7, 238, 240–45, and 248 are by Mrs. M.E. Cox; those on pp.233–5 are by the author.

INDEX

References to illustrations are italicized

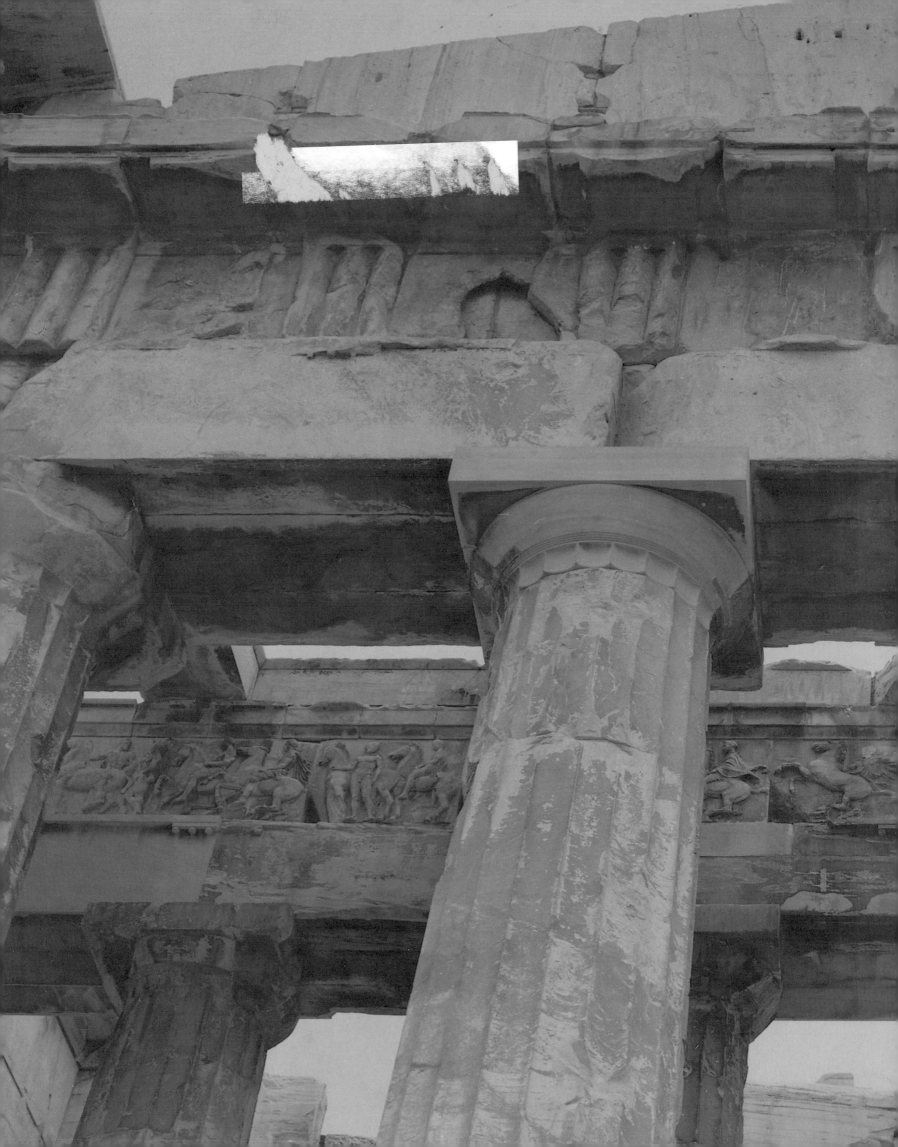